ON
MODERN
AMERICAN
ART

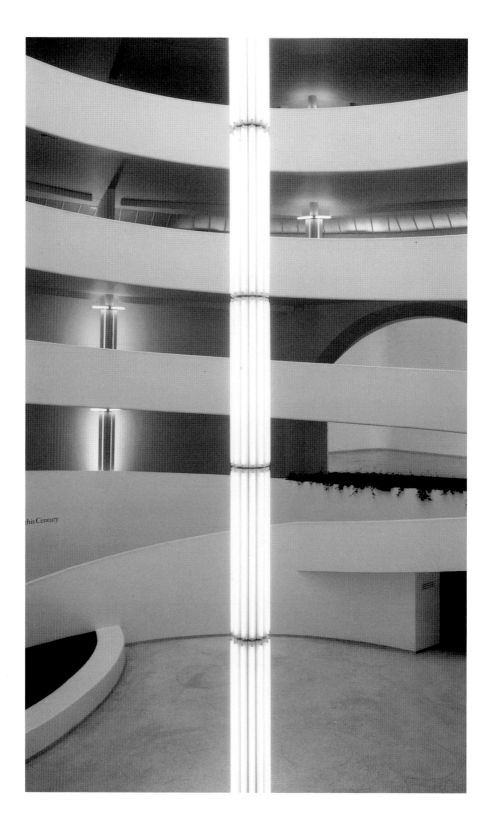

ON
MODERN
AMERICAN
ART

Selected Essays by Robert Rosenblum

With a Bibliography of the Author's Writings

Harry N. Abrams, Inc., Publishers

Editors: James Leggio and Barbara Burn
Designer: Maria Miller
Photo Editor: Jennifer Bright

Frontispiece: Installation of Dan Flavin's *Untitled to Tracey . . .*
in the rotunda of the Solomon R. Guggenheim Museum (see fig. 155)

Page 8: Detail of Jasper Johns: *Untitled (Red, Yellow, Blue),* 1964 (see fig. 100)

Library of Congress Cataloging-in-Publication Data
Rosenblum, Robert.
 On modern American art : selected essays / by Robert Rosenblum.
 p. cm.
 Includes bibliographical references and index.
 ISBN 0-8109-3683-6
 1. Art, American. 2. Art, Modern—20th century—United States.
I. Title.
N6512.R676 1999
709'.73'09045—dc21 99–22015

Harry N. Abrams, Inc.
100 Fifth Avenue
New York, N.Y. 10011
www.abramsbooks.com

CONTENTS

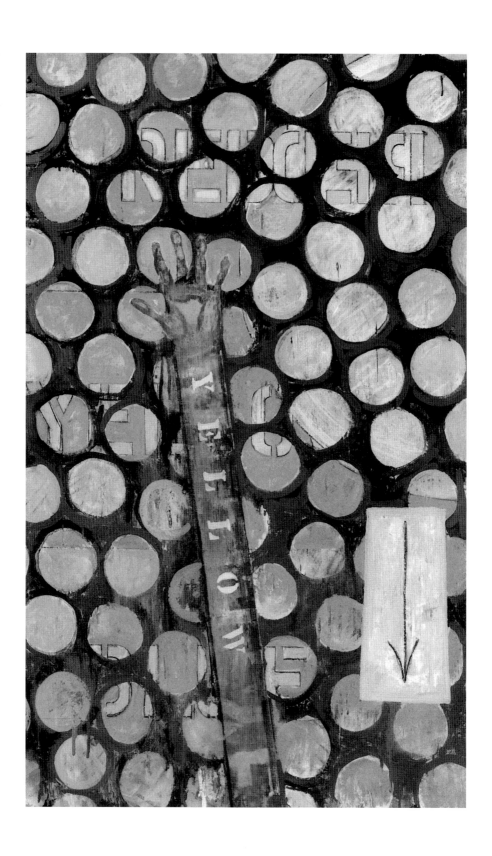

PREFACE

W hat follows—an anthology that covers exactly four decades (1958–98) of my writings about both the aging past and the youthful present of American art—inevitably prompts remembrance of very long-ago things, as well as meditations upon the here-and-now of my ongoing commitment to translating the visceral experience of art into the more rational modes of language and art history. Looking back to my professional beginnings, I realize that I had the enormous good fortune of being in the right place, New York, at the right time, the late 1950s and early 1960s. As a graduate student at New York University's Institute of Fine Arts and then as an instructor in nearby Princeton, I juggled my ivory-tower academic studies in late-eighteenth- and early-nineteenth-century art with an eagerness to keep abreast of the startling visual events taking place at galleries run by such legendary dealers as Betty Parsons, Sidney Janis, and Leo Castelli. Contemporary art back then was a battlefield of pro-or-con passions that continually erupted in combative reactions to everything from the seeming chaos of Abstract Expressionism to the ostensible impudence of early Pop and Minimalism. Although I was rooted in the discipline of art history and continued to write scholarly articles about Neoclassicism, I constantly sided with what seemed to be blasphemous assaults on respectable traditions: Rothko's numbing emptiness, John's fact-into-fiction copies of Old Glory, Stella's deadpan black stripes, Lichtenstein's alarmingly ugly blow-ups.

Luckily, I was early obliged to explain such enthusiasms. To help earn my keep in graduate school, I got a job in February 1954 writing back-page and occasionally front-page reviews for *Art Digest*, where I honed my skills by dutifully describing and implicitly evaluating the shows allotted to me each month. Although most of this was done on automatic pilot (one quickly learns to write quickly about mediocre art), there were also some spine-tingling encounters, thanks to the luck of the draw or to the discretion of the editor (first Sam Hunter and then Hilton Kramer), who sent me off to review some of the first shows by artists few had ever heard of—Pearlstein (1954), Lichtenstein (1954), Johns (1958), Rauschenberg (1958). Thinking grandly, I now realize this was like being a working critic in Paris sent to review an artist named Braque at the Kahnweiler gallery in 1908 or an artist named Picasso at the Vollard gallery in 1910. The muse of Art History, then hovering over New York, had blessed me.

By the late 1950s, however, the demands of full-time teaching and more ambitious writing projects meant a shift of balance between venerable past and journalistic present, prompting me to integrate my navigation of both the academic corridors of art history and the argumentative streets of New York's contemporary art scene. So it was that in the 1960s, I tried to relate my excited response to the structural and emotional extremes of Abstract

there are no truths in art

Expressionism to my growing enthusiasm for their counterparts in Northern Romantic landscape painting. Similarly, I attempted to explain the rude but, for me, tonic assaults of Lichtenstein's early Pop paintings by making reference to the earlier shock of Courbet's Realism or Seurat's quasi-mechanical dots and cartoony style. This dialogue between the lessons learned from art history and the unsettling surprises of Young Turks have become, I now see, a recurrent theme in my work, enabling me and, I hope, the reader to recognize that art keeps living in both present and past tense. In fact, another theme here appears to be how often new attitudes defined in contemporary art may drastically alter our judgments of historic art, so that the wildly craggy abstractions of Still may allow us to see afresh a relatively forgotten painter like Tack, just as Warhol's or Bidlo's fascination with replicas and reproductions may give us unexpected access to, say, the once-vilified late work of de Chirico.

At any rate, my greatest wish in presenting this selection of forty years of looking at American art is to help my readers realize, as I have, that there are no absolute truths in the experience of art. My first words about the likes of Rothko, Johns, and Stella seem almost embarrassingly simple-minded compared to the complex ways I perceived them in later decades. On the other hand, I hope that those early attempts to grapple with what was then disarmingly new work still convey the unmediated thrill of first encounters. It is clear that art, like people and history, keeps changing, and I trust this anthology will confirm my belief that we must remain open and flexible, readjusting inherited prejudices and hierarchies to accommodate the demands of the new and the unfamiliar.

As for the swift and, for me, almost effortless way in which this book was transformed from an idea to a material fact, I have heavy debts of gratitude. The editorial chores of sifting wheat from chaff among the candidates for this selection and of putting what remained into coherent patterns were begun by James Leggio and finished by Barbara Burn. They were both models of efficiency and good humor, turning what might have been the stresses of close-eyed scrutiny into conversational pleasures. Tracking down the more than two hundred illustrations that were essential to my arguments was another major task, and this was accomplished with quiet dedication and proficiency by Jennifer Bright, who magically retrieved works that, over the decades, had been scattered to the four winds. Last and hardly least, I must thank Kathleen Robbins, who took on the daunting project of putting into immaculate order a complete bibliography of my writings from 1954 to the present. It was a great and touching honor to have these four people worry so productively about preserving my achievements for posterity.

<div align="right">

Robert Rosenblum
New York, March 1999

</div>

WHAT IS AMERICAN ABOUT AMERICAN ART?
1990

What was once a burning question in the 1930s and 1940s—"What is American about American art?"—is not asked or answered very often in these days of airport internationalism, when McDonald's can open in Moscow, maple syrup can turn up on the breakfast table of a hotel in Kyoto, and another Disneyland is scheduled to open northeast of Paris. That old question, in fact, seems to have had to do with the cultural inferiority complexes of the Roosevelt era, when it was clear to almost everybody that the best art of the century was coming from across the Atlantic and landing at the Museum of Modern Art and that the native product, if obviously not the equal of Matisse, Picasso, and Mondrian, might be defended by claiming that it had distinctive qualities that could only be found on these shores and that ought to be cherished and preserved against the aesthetic onslaught from alien territories. But with what was to be called in the title of Irving Sandler's important study of Abstract Expressionism *The Triumph of American Painting,* it became equally clear that American artists in the post-Roosevelt era had miraculously emerged as the torchbearers of not only the best and most inventive of modern art, but also of an art that was universal in character, an art so surprisingly cosmic in scope that issues of nationalism seemed piddling. Not only had the once uneven competition between European and American art apparently and unexpectedly been won by the 1950s, but it had been won on so grandiosely abstract a level that the search for an American identity seemed an embarrassing memory of a parochial past.

Nevertheless, that heroic myth, in which a provincial grass-roots patriotism is conquered by a language of international breadth that can be understood around the planet, is, like most myths, both true and false. If it is true that the pictorial worlds of Pollock or Still seemed to leap from American earth to timeless nature and emotions, it is also true that when such paintings were first seen in Europe in the 1950s, foreign critics often commented upon what they felt were peculiarly American qualities—a more expansive sense of scale consonant with the vastness of the American continent; a toughness and crudity of paint handling that spoke of traditions less suave and hedonistic than those familiar to French painting; a rejection, either through intention or incompetence, of the more harmonious compositional conventions common to European painting. Although it was and still is difficult to articulate intuitions about why we feel that something, whether it be an oil painting, the taste of butter, or the cut of a suit, belongs to one country and not another, such efforts to characterize these responses suggest that the question of national character is a very real one. In

fact, just in terms of ordinary experience, even in these days of nonstop tourism with internationalized hotels, fast-food chains, and shopping centers, we know that when we cross a border from one country to another, our antennae are alert to exactly those differences that would distinguish, say, Belgium from Holland or Spain from Portugal. Even in North America, who has not crossed the Canadian border without discerning that something, however subtle, has changed? And though we would be very hard put to define that change in words an outsider might understand, we would still know the experience to be true. But however distinctive, the smallest, not to mention the largest, of nations still belong to communities of international experience, sharing a broad range of space-time coordinates we might lump together under the vague rubric of Western culture.

So it is that the story of more than three centuries of American painting can be read in varying ways. We may concentrate on the American accent of the individual voices, or we may try to hear each voice in the context of an international chorus whose whole is more than the sum of the parts. Characteristically, American museums, at least when dealing with art before 1945, tend to segregate American art from its European counterparts, keeping it to its own galleries, curators, and publications. Europe is elsewhere when we visit, say, the Whitney Museum of American Art in New York, the National Museum of American Art in Washington, the Terra Museum of American Art in Chicago, or the Butler Institute of American Art in Youngstown, Ohio; and if we go to the Oakland Museum, we may even think that California has its own radiant tradition as many light-years away from New York as it is from Paris or London. But there are also other ways of shuffling this familiar deck. For example, at the Spencer Museum in the University of Kansas, American art is completely integrated with its European siblings, so that what emerges is less the particular flavor of the American tradition than a United Nations history of Western art in which American artists join forces with their transatlantic colleagues in the experience of living in, say, 1790 or 1840 or 1890.

Such an approach, in keeping with today's world of jet travel, tends to narrow rather than to widen the Atlantic Ocean, making American achievements belong more to a communal rather than a local history. A telling case in point here concerns the two painters who are generally considered the founding fathers of the American tradition in painting: John Singleton Copley and Benjamin West, both born, conveniently for this venerable genealogical table, in the same year, 1738. As for Copley, it has long been a convention to divide the course of his life and art into two sharply divided, even antagonistic, parts. Act I took place in colonial America, concluding in 1774, two years before the Revolution, when he sailed from New England to Old England, never to return to his birthplace; Act II took place in the center of the Anglo-American empire, London, where Copley lived out his long life as a flourishing artist in the middle of a sophisticated art world. Those who would nurture the values of America versus those of Europe tend to make a case for the probity and the superiority of the portraits Copley painted in Boston, often implying that in London his art was gradually diluted and, by implication, corrupted by association with standards foreign to his roots. Indeed, some early writers on American painting even infer that an act of aesthetic as well as patriotic treason was involved in Copley's switch of allegiance. But this simple parable is far more complex and demands international angles of vision. When Copley's 1765 portrait of his half-brother Henry Pelham, *Boy with a Squirrel,* was sent to London from Boston for exhi-

bition at the Society of Artists in 1766, it became not only the first American painting to be seen in Europe, but a painting that some British artists thought to be a work by one of their own up-and-coming masters, Joseph Wright of Derby, Copley's almost exact contemporary. Wright of Derby's portraits, usually ignored by Americanists seeking the pure American truth in Copley, are in fact in every way comparable to Copley's, look-alikes that also reflect a tough new mid-eighteenth-century breed of well-heeled and hardworking sitters and their wives and children, a social type that grew rapidly in the Midlands as in the colonies and that wanted the material facts of their lives to be painted as if they could be touched, grasped, and bought. Both Copley and Wright of Derby can be seen as brilliant provincial painters in a new Anglo-American world of commerce and industry, standing in a similar relationship to the more artificial and tradition-bound styles of the capital, which, as in Sir Joshua Reynolds's portraits,

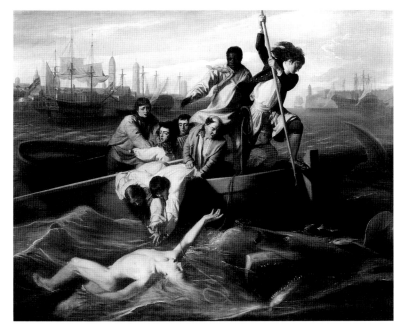

1.
John Singleton Copley,
Watson and the Shark,
1778

were generally more suitable to dyed-in-the-wool aristocrats than to the growing new world of self-made men and women. Moreover, Copley's tough, foursquare Bostonian portraits, with their hard-edged polished tables and sharp-focus still lifes, may even find affinities on the Continent. Many of David's own portraits of friends and family, painted both before and after the Revolution, reveal a like insistence on the palpable facts of faces, clothing, and things unpolluted by arty conventions that falsified the truth of the material world. Seen in such lights, Copley's archetypal Americanism in his Bostonian portraits can also be interpreted as one more manifestation of a new international style that mirrored deep social changes on the eve of revolutions that were gradual and sudden.

But Copley's pictorial output in London is no less blurry when it comes to national classifications. Because *Watson and the Shark* (fig. 1) has always been considered a textbook

classic of American painting, one tends to forget that its hero and patron, Brook Watson, was, after all, a Londoner who commissioned the picture for a London audience at the Royal Academy exhibition of 1778. And the success of this reportorial canvas, with its news-camera clarity of horrific detail, would be amplified by Copley in the next decade with his fancier account of the on-the-spot drama of another Englishman, Major Francis Peirson, giving his life for his country on the island of Jersey. But if these paintings are steeped in British history and culture, they also have American reverberations. *Watson and the Shark* has been convincingly interpreted as, among other things, a contemporary allegory of American independence; and Major Peirson's more rhetorical agonies provided the formula for many American history painters, especially John Trumbull, who would patriotically document the wars of independence for posterity.

As for West, although he, too, is worshiped as an American ancestral figure, it should be recalled that he got out of the colonies even earlier and, in artistic terms, far more prematurely than Copley, sailing in 1760 from Philadelphia to Livorno before settling in 1763 in what he called "the mother country." A resident of London for the remaining fifty-seven years of his life, West loomed so large in the British art establishment that he not only could paint the king and queen, his devoted patrons, but could also become, after Reynolds's death in 1792, the president of the Royal Academy itself. It would be hard to be more British. On the other hand, even if his ambitions could quickly rise to the classical mythologies or biblical ghost stories that were growingly fashionable in the British milieu of the 1760s and 1770s, he shrewdly hawked the wares of his American origin, recording exotic Indians and faraway North American battles, features prominent in his famous *Death of General Wolfe* (fig. 2), which probably had as much issue in Britain and in the circle of David as it did among West's own American students. As for Indians, even if they seemed to be one of West's trademarks and selling points, they were also painted, after all, by Wright of Derby, not to mention many

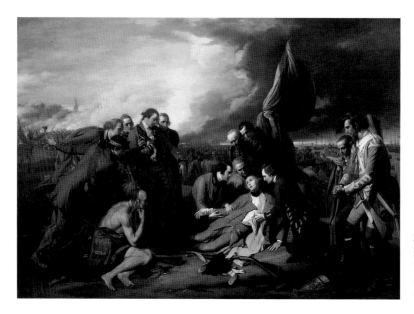

2.
Benjamin West,
The Death of General Wolfe,
1770

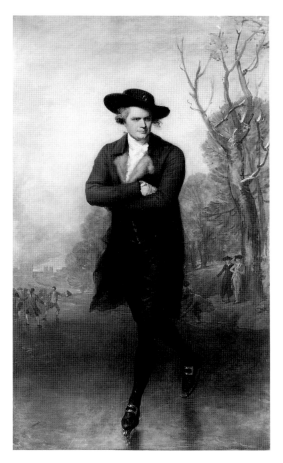

3.
Gilbert Stuart,
The Skater (Portrait of William Grant),
1782

other British and French artists of the period. Indeed, such international exchanges of North American Indian lore continued well into the nineteenth century, when, for example, George Catlin's "Indian Gallery," with its portraits of Indians and Wild West hunting scenes, was displayed to the London of Queen Victoria and the Paris of King Louis Philippe.

Again and again, what might be viewed as something singularly American often turns out to be part of an international network. Gilbert Stuart's picture of a young Scotsman, William Grant, on ice skates (fig. 3), a surprising portrait inspired by an adventure both artist and sitter had had on the thin and melting ice of the Serpentine in Hyde Park, may seem like a one-shot image of daring candor that only an unpretentious Yankee would have the audacity to exhibit at the Royal Academy in 1782; but in fact, there are at least two other late-eighteenth-century portraits of gentlemen on ice skates—one by the Scotsman Sir Henry Raeburn, the other by the Frenchman Pierre Delafontaine—which, together with Stuart's, would compose a beguiling international trio.

Even Luminism, that American style and viewpoint most often singled out as offering an authentic and unique contribution to nineteenth-century painting, though it was only baptized in 1954, a century after it flourished, is better served when seen as part of a phenome-

4.
Martin Johnson Heade,
*Coastal Scene with
Sinking Ship,*
1863

non familiar to many North European landscape painters. To be sure, the eerie, all-engulfing light that dominates the silent, unpopulated landscapes of Martin Johnson Heade (fig. 4) or Fitz Hugh Lane may evoke peculiarly American myths and experiences of an awesomely vast, primeval terrain in which something akin to God casts immaterial rays upon a land of blessed purity and innocence; but such a vision of what has been called "natural supernaturalism" can be found in many earlier European masters, whether as famous as Friedrich and Turner or as up-and-coming in reputation as the Danes Christen Købke and Christoffer Eckersberg, all artists whose comparably "Luminist" visions have begun to work their way into more sophisticated recent studies of American landscape painting.

In many cases, beginning with Copley and West, the practice of declaring artists American because they were born in America might well be challenged. Although Whistler has become an icon of American culture, he, in fact, left the States for Europe in 1855, at the age of twenty-one, and, like West, became a mature painter only within a foreign context. In looking at his *Symphony in White No. 2: Little White Girl,* we might well forget his New England roots, for here it is the tale of two cosmopolitan cities, London and Paris, that counts. Shown in London in 1864, at the Royal Academy exhibition, it absorbs not only the literary aestheticism of both Swinburne and Gautier, but also visual references to both Millais and Ingres. And if we had to locate the painting in a friendly group, it would probably be happiest in the company of works by Whistler's own British and French acquaintances and contemporaries: Rossetti, Degas, Manet, Fantin-Latour. Even more to the point of American birthplaces not making American artists, there is the case of Mary Cassatt, who left her native Pennsylvania for Europe in 1866 at the age of twenty-two and, despite a few short visits to the States, took firm roots in Paris. Not only did she exhibit at the Salon in the early 1870s with Manet, but she was also an integral part of the Impressionist group exhibitions from 1879 to 1886, where she shared the walls with her close friend Degas and other French masters such as Renoir, Monet, and Gauguin. But she could also send her pictures back home for public display, so that, for example, *At the Opera* of 1879 was first shown in New York, in 1881, at the Society of Artists, where it stuck out as a precocious example of an unfamiliar new style of split-second, candid observation in which women could play worldly rather than domestic roles.

In the same expatriate category, there is John Singer Sargent, whose confusing national identity made it possible for him to have, within recent memory, retrospective exhibitions at both the National Portrait Gallery in London and the Whitney Museum of American Art in New York. To thicken this international stew, Sargent, who was actually born abroad, in Florence, though of American parents, traveled widely on the Continent; studied with a French master, Carolus-Duran; exhibited in, among other art capitals, New York, Paris, Brussels, London; frequented and painted the international jet set of his day, who might be found anywhere from Majorca to Blenheim Palace. And if he was grand enough to paint the duke of Marlborough's family, he was also esteemed enough in democratic America to be commissioned to do murals for the Boston Public Library. Yet if we would understand his art, we would do far better to look not to America, but to an international style of around 1900, whose pictorial and social luxuries were also reflected in the equally cosmopolitan work of artists such as the Italian Giovanni Boldini, the Spaniard Joaquín Sorolla, the Frenchman Jacques-Émile Blanche, and the Swede Anders Zorn.

Still, even granting the obvious internationalism of so many artists who hold firm places in American biographical dictionaries, there is always the nagging question of whether their art does not somehow disclose a distinctively American inflection that would single it out from a multinational crowd. The question is relatively easy to answer in the case of such American classics as Winslow Homer and Thomas Eakins. Both of them had experienced art in Paris—Homer on a ten-month visit in 1866–67, when he showed at the Paris world's fair; and Eakins, in a more sustained and influential way, since he studied there between 1866 and 1869 with Jean-Léon Gérôme and Léon Bonnat, two masters whose imprint can often be discerned in his work. In the case of Homer, paintings like *Breezing Up* and *Northeaster* might strike even Europeans as quintessentially American images of the salt-sprayed rigors of the North Atlantic coast, but other paintings of his beg revealing comparisons with their European counterparts. For example, his 1869 view (fig. 5) of the salubrious beach resort at Long Branch, New Jersey (which, for chic, had been dubbed "the American Boulogne"), instantly

5.
Winslow Homer,
Long Branch, New Jersey,
1869

recalls, in its tonic breeze and glare, the Channel coast scenes of vacationers painted by Monet and Boudin in the same decade. But, this said, we also intuit a very different mood in which even such a scene of overt pleasure and camaraderie reveals a bare and lonely emotional skeleton. The two fashion-plate ladies in the foreground, each with a parasol, are aligned in tandem but appear as strangely isolated from each other as the lone male figure on the cabin porch surrounded by drying linens; and the relationship of these figures to this place on the American continent, which juts out into the immensity of the ocean, is almost that of intruders upon a still uninviting and unpopulated land. It is an experience that runs counter to the French sense of layered social history in a territory that has long been inhabited and civilized. Moreover, the white intensity of the sunlight, rather than pulverizing and fusing figures and landscape, produces quite the opposite effect, starching clothing, hardening earth and grass, clarifying simple architectural shapes pitted against the rawness of nature. Looked at from an American rather than a European angle of vision, the feeling here is less akin to Monet than it is to Edward Hopper, whose figures, whether in city or country, similarly seem to intrude upon a bleak environment of blanching light and primitive geometric order.

As for Eakins, this dour mood of lonely human presences in an environment that reaches out to nowhere is equally apparent, especially in the company of French parallels. His 1873 painting of the Biglen brothers in a scull on the Schuylkill River reveals in unexpected ways Eakins's training with Gérôme, who constructed many exotic boating scenes on the Nile with the same perspectival precision and photographic detail that characterize the quasi-scientific approach of Eakins to the facts of the seen world. But the American painter has turned these Orientalist travelogues into a scene of inwardness and solemnity in which each of the two scullers, brothers though they are, seems alone and in which the river and the far bank suggest such vast expanses of water and land that the few people we see recall early settlers on unfamiliar soil. Inevitably, Eakins's boating scenes (see fig. 158) echo the many French paintings of the 1870s and 1880s that depict sportily dressed men and women rowing on the Seine; but here, too, the Parisian mood of cheerful, breezy conviviality on a bustling waterway underlines the austere silence of Eakins's American view. No less telling is Eakins's *Concert Singer* (fig. 6), in which, despite the obvious clues that this is a live performance before a conductor and an audience, we feel that the contralto, Miss Weda Cook, is totally alone, lost in a dark and empty space and absorbed in the private reverie inspired by the aria she sings from Mendelssohn's *Elijah*. It is tempting to discern in this mood and image something that speaks with an unmistakably American voice of a kind that became almost a trademark in Andrew Wyeth's *Christina's World*.

Still, such black-and-white distinctions between America and Europe can always be turned into shades of gray, especially when one recalls, while thinking of Eakins, how the psychological ambience of meditation and withdrawal, often prompted by music, gradually permeated later nineteenth-century European painting as well, a stop on the way to that universal domain of frail, visionary fantasies most conveniently categorized as Symbolism. Americans, too, contributed to this ubiquitous world of twilight reverie that cast an eerie spell over Western art at the turn of the century; and it has recently become clearer that what used to be thought of as a weird cluster of downright eccentric American artists that kept popping up as the century drew to a close—Elihu Vedder, Ralph Blakelock, Arthur Davies, Louis Eil-

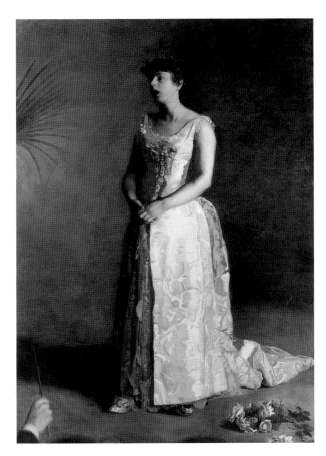

6.
Thomas Eakins,
The Concert Singer,
1892

shemius, Thomas Dewing, and, above all, Albert Pinkham Ryder (fig. 7)—could be put in this pan-European melting pot. All these artists looked so far inward that the visible, palpable world was gradually replaced by wispy dreams of longing and fevered imagination, frequently inspired, as in the more empirical approach of Eakins, by music, whether the long-ago sounds of a lute in a painting by Dewing or the surging new sounds of Wagner's Ring Cycle in a painting by Ryder. It was the kind of search that could lead eventually to the mysteries of pure chromatic abstraction, a goal theoretically justified by analogies with music and one attained in Paris on the eve of the First World War by what was again an international community of artists that, in addition to the Czech Kupka and the Frenchman Delaunay, included two Americans, Stanton Macdonald-Wright and Morgan Russell, who, in the name of Synchromism, would also try to hear the music of the spheres as generated by their fantasies of free-floating prismatic color.

But such adventures into the most daring reaches of modernism, often learned directly at their European sources, could also be translated into a self-consciously American idiom by the choice of specifically American icons of modernity. Whether the New York subway's rush hour, as evoked by Max Weber, or New York's answer to the Eiffel Tower, the Brooklyn Bridge, as praised again and again in works by John Marin and Joseph Stella, it was

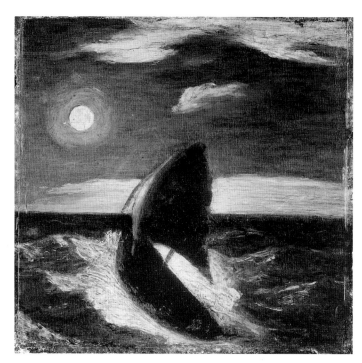

7.
Albert Pinkham Ryder,
Toilers of the Sea,
1880–84

New York's urban themes that often inspired a Machine Age dynamism, which asserted how the most vital energies of the new century were to be found on new American soil. Small wonder that two French masters of mechanical fantasy, Duchamp and Picabia, thrived in New York and, for once, helped to form on the American rather than the European side of the Atlantic a cosmopolitan group of artists that could set on fire the wildest imaginations of Americans like Man Ray or John Covert.

Such alliances preview the accelerating speed of transatlantic dialogues in our own century, when we may often think that the world has become a space-time blur in which the nonstop traffic of art and people instantly homogenizes everything in collections, publications, and exhibitions that can mix David Salle and Anselm Kiefer, Jennifer Bartlett and Francesco Clemente. Indeed, so international has art become in the late twentieth century that many admirers of, say, Jasper Johns or Andy Warhol hardly notice that the choice of the American flag or a Campbell's soup can is as willfully American a subject as was, say, Grant Wood's choice of the Daughters of the American Revolution or Albert Bierstadt's of the Rocky Mountains. Contemporary sophistication, in fact, tends to ignore the old-fashioned question with which we began, "What is American about American art?" Yet Americans belong not only to the world but to their own singular traditions and experiences. When we look at a painting by Rothko, we may well be reminded of many European masters, from Turner to the late Monet, but we also sense indigenous roots whose ancestry might take us not only to the realm of American Luminism but to such oddball visions of American eternity as provided in Elihu Vedder's *Memory* (see fig. 68). And when we look at Eric Fischl's *The Old Man's Boat and the Old Man's Dog,* even though the painting finds its home in an international

collection of contemporary art in London, we would be hard put to understand it without recalling the marine paintings of Winslow Homer in which the dramas of American nature and American passions are played against each other. Like American people, American art lives both at home and abroad.

"What Is American about American Art?" Published as the introduction to Donald Goddard, *American Painting* (New York: Hugh Lauter Levin Associates, 1990), pp. 10–15.

RESURRECTING AUGUSTUS VINCENT TACK

1986

The reputation of Augustus Vincent Tack (1870–1949)—or better said, his lack of one—has always puzzled me, since his work has for years been both recognized and ignored. Thanks to his great patron and good friend, Duncan Phillips, there has always been a mini-Tack show on view at the Phillips Collection; and in fact, it turns out from the 1985 summary catalogue that Mr. Phillips owned more works by Tack (seventy-eight) than by any other artist. (Arthur Dove is runner-up with forty-eight.) Decade after decade, countless art pilgrims in Washington have trekked from the famous museums on or near the Mall to see the Phillips Collection, installed in the family home at 1600 Twenty-first Street N.W. and officially opened to the public in 1921 as a domestic shrine of modern art. And there, almost any alert visitor, wandering through the Bonnards, the Braques, the Klees, must have sat up and taken notice of Tack's paintings, whose quivering explorations of nuanced shapes and colors were totally in tune with Mr. Phillips's own penchant for an anti-realist art of quiet and sensuous refinement. On checking the dates of these crystalline images (the 1920s and 1930s), the paintings seemed clearly to belong to the avant-garde of American art between the wars, pushing their landscape origins to the brink of a translucent abstraction; and on thinking ahead to the pantheon of painters after 1945, one hears them as voices in the art-historical wilderness, heralding everything from the geologic and cartographic patterns of Clyfford Still to the weightless color fantasies of Rothko, Louis, or Frankenthaler.

But as quickly as Tack's unique look and historical precocity were recognized in the intimate ambience of the Phillips Collection, they were no less quickly forgotten as soon as the gallery doors were shut. Somehow Tack remained inside as a kind of effete, hermetic master who might be jostled too much by being forced onto the well-trodden paths of the histories of modern art in America. And despite the fact that, in the Phillips, Tack shares the walls with other pioneers of American modernism—Dove, Marin, O'Keeffe, Hartley, Burchfield—and often goes far beyond them in abstract audacity—he has been denied assimilation in all the standard histories and exhibition catalogues that recount the triumph of the American avant-garde. A search through the familiar texts, old and new—from the days of Brown, Baur, and Ritchie to more recent surveys by Hunter, Rose, Wilmerding, Baigell, Davidson—never turns up even a mention of Tack's name.

Beginning in the late 1960s, however, Tack's oblivion outside the walls of the Phillips Collection became somewhat less total. In 1968, an American Studies group at the Deerfield

8.
Augustus Vincent Tack,
Night, Amargosa Desert,
1937

Academy in Massachusetts honored Tack as something of a native son, for the artist had lived in Deerfield during the early years of his marriage (1901–8) and had later been commissioned by his own church, St. James, in South Deerfield to paint a religious mural. This tribute was in the indispensable form of a scholarly biography, exhibition list, and checklist of all known works; but the publication, a supplement to the *Deerfield Journal* (XXIV, 3), clearly had a parochial flavor. Then, in 1972, in the first mainstream tribute to this alienated artist, he was given a small exhibition at the Universities of Texas and Maryland, with an accompanying catalogue by Eleanor Green (reprinted in abridged form in *Artforum,* October 1972) that still stands as the most informative and insightful study of Tack; and this was soon followed in 1973 by a smaller Tack show at the University of Rhode Island.

Still, these regional, academic exposures of Tack's work were hardly adequate to rein-state him. A longtime convert, I myself tried soon after to locate him in a loftier historical con-text in my book *Modern Painting and the Northern Romantic Tradition: Friedrich to Rothko*

(1975); and in 1976, at MoMA, on the occasion of America's centenary year, Kynaston McShine organized an exhibition, "The Natural Paradise," which unfurled a patriotic panorama of American landscape painting that placed three of Tack's canvases on the long route from the traditions of Bierstadt, Church, Moran, and other late-nineteenth-century masters of awe-inspiring wilderness paintings to the post-1945 domain of the Abstract Sublime. MoMA, in fact, was soon to practice what it had just preached and in 1979 acquired a proto-abstract painting by Tack (*Dunes,* c. 1933), which, in its new installation, has pride of place as a visual introduction to the rooms of American modernists. And more recently, in 1979–80, and in quite a different context, two of Tack's religious paintings were included in Charles Eldredge's innovative and revealing exhibition "American Imagination and Symbolist Painting," at New York University's Grey Art Gallery and the University of Kansas, where in fact Tack began to fit more comfortably into the fin-de-siècle mood of mystical reverie and cosmic weightlessness that climaxed around 1900 and continued to leave its ghostly shadow on many younger artists of a more abstract persuasion, such as O'Keeffe and Dove, whose art did not mature until after 1910.

Nevertheless, Tack still remains an odd man out. Perhaps the problem is that although his works are scattered about in museums other than the Phillips—at the Fogg, the Met, the Brooklyn Museum, the Newark Museum, among others—they have seldom been exhibited or integrated into exhibitions of twentieth-century American art. Had he been a member of the Stieglitz or the Gallatin circle, he might well be nearly as famous today as O'Keeffe or Stuart Davis, but he remained in his life, as in his art, aloof from these groups of artists who preached a new faith. And yet another major stumbling block to his assimilation into art history is the way his work falls into ostensibly contradictory, one might even say schizophrenic, modes. Looking at his daring canvases in which, following Kandinsky's direction, the material world of landscape evaporates into the music of the spheres, one is startled to find that Tack could not only execute publicly acceptable mural commissions in sites of both secular authority (e.g., the Governor's Suite in the Nebraska State Capitol, 1928) and sacred worship (Church of St. Paul the Apostle, New York, 1925), but far more surprising, that he could spend his very long life officially and lucratively painting portraits of esteemed Americans who ranged from the likes of Harry Truman, Dwight Eisenhower, Nicholas Murray Butler, and Helen Keller to a glittering inventory of fashionable women who belonged to Tack's own high-society milieu. (It was rumored that even during the Depression, Tack's income could soar above $100,000 a year.) To see these hack-job portraits side by side with his abstractions is, to put it mildly, disconcerting, rather as if we discovered that Dove, say, had stopped worshiping for a moment the pulsating essences of nature in order to paint Calvin Coolidge in a realist portrait style acceptable to 1920s presidential taste. And then, in what turns out to be far less of a contradiction, Tack also painted dozens of small religious paintings, reflecting his enduring piety. Raised in a strict Roman Catholic milieu, Tack also expanded his faith, by the turn of the century, into the hazy domain of Oriental mysticism and Theosophy, which, as we now know, triggered so many early-twentieth-century pictorial efforts to destroy matter and to cross the threshold of some abstract, spiritual realm.

If we are, in fact, arrested by Tack's abstract paintings, these religious works and the concepts that clouded them in supernatural mist are by no means anomalies but fit quite

comfortably into international patterns of Tack's own Symbolist generation, patterns that will soon be revealed more fully in the major exhibition "The Spiritual in Art: Abstract Paintings 1890–1985," scheduled for winter 1986–87 at the Los Angeles County Museum of Art. The grandest and most obvious analogy to Tack would be Kandinsky himself, whose ambitious early efforts to depict Christian themes would by 1914 swallow up these once legible icono-graphic motifs in a deluge of intangible color. But there are also many more appropriately modest parallels among Tack's transatlantic contemporaries. In Switzerland, for example, there is Augusto Giacometti (1877–1949), cousin of another painter, Giovanni, who was the father of the famous Alberto. Like Tack, Augusto Giacometti alternated between Catholic themes, fulfilling many local church commissions, and precociously abstract landscape and flower paintings that, probably prompted by the decorative potential of his designs for stained-glass windows (the patterns of the leading and bodiless translucence of color), dis-tilled their motifs in nature to near illegibility, making us wonder whether they should be dated in some Symbolist milieu before 1914 or in a more confident period of color abstraction after 1945. And there is also in Switzerland the bizarre Albert Trachsel (1863–1929), who, by 1905, had occupied a visionary perch on Alpine heights that could rival Tack's American mountaintops, from which the believer could look upward and inward to spiritual reaches inaccessible to ordinary earth dwellers below. And in terms of the farthest reaches of Sym-bolist spirit-rapping, there is always the Lithuanian Makalojus Čiurlionis (1875–1911), a painter-musician who, like his contemporary, the composer Scriabin, would waft us off in synaesthetic waves of painted symphonies and color organs to a Nirvana where corporeal presences and the pull of gravity were forever outlawed.

Such mystical excursions to the Great Beyond are, in fact, chronological preludes to Tack's near-abstract landscape paintings of the 1920s and 1930s that have always arrested vis-itors to the Phillips and are sampled in this exhibition (figs. 9, 10). Typically, they elevate us to the dizziest altitudes of rock and sky, as if these literally most distant extremes from the earth below would carry us metaphorically to an unpolluted realm of nature where we could, as in a religious shrine, seek communion with the mysteries of the cosmos. Their titles (e.g., *Ad Astra, Ecstasy, Flight, Aspiration, Outposts of Time*) usually reveal their incorporeal goals as well as alluding (e.g., *Nocturne, Largo*) to the musical analogies which, for a Symbolist generation, so often provided a key to unlock the doors of an immaterial world. And often, too, Tack's quasi-religious ambitions are subtly emphasized by his choice of format or color. His frequent use of finely wrought gold margins and frames, for instance, conjures up a kind of sacred, almost Byzantine altarpiece that would let us worship an icon of the supernatural; and his attraction to an oval shape to enclose his fields of evanescent vision may be meant to conjure up subliminally the egg form, which, in Theosophist doctrine, would rush us back to the beginning of the universe and which was also used by Mondrian in his Pier and Ocean series to evoke the same ritual mysteries. Moreover, the dominance of an ethereal blue, as in *Nocturne* or *Ad Astra,* similarly allies these works with earlier mystical traditions, from Ger-man Romanticism to Symbolist art, of equating the domain of the spirit with the celestial color of the sky. Indeed, in front of Tack's uplifting visions of the infinite and abstract heav-ens above, we often feel that the ghost of Tiepolo himself had been reincarnated by the likes of Mme. Blavatsky.

9.
Augustus Vincent Tack,
Aspiration,
commissioned 1928

10.
Augustus Vincent Tack,
Flight,
commissioned 1928

In his occasional writing, as in a letter to the art critic Royal Cortissoz, Tack could also preach what he practiced, commenting, for instance, on his experience of the Canadian Rockies in 1920 in terms of how in a "valley . . . walled in by an amphitheater of mountains as colossal as to seem an adequate setting for the Last Judgment, glacial lakes lay like jewels on the breast of the world—malachite and jade—greens of every variation." But it should be noted in these words, too, that the calling of Tack's religious spirit was totally tinged by a rarefied sensibility that marked him as an aesthete of a Symbolist generation nurtured on Mallarmé and Huysmans. His dedication to exquisite, whispered nuance is found not only in his ability to transform the natural facts of North American desert, mountain, cloud, and sky into fragile, almost mineralogical patterns of shimmering irregularity, but also in his frail and gemlike palette, in which primary and secondary hues are usually muted to delicate pastel tones, creating, one might say, refined and aristocratic versions of the dreamland iridescence favored in the kitsch landscapes of Tack's exact contemporary, the popular illustrator Maxfield Parrish (1870–1966). And in this Symbolist cultivation of private hothouses of the senses, Tack becomes, too, a close equivalent of the American journalist and aesthete James Huneker (1857–1921), whose writings on art, music, and literature espouse the Symbolist cause and whose last novel, *Painted Veils* (1920), provides in its title an image that might well serve as a description of Tack's own work.

To mention Parrish and Huneker is to realize, too, that for all the affinities to European Symbolism one can find in Tack, he belongs as well to an American context. In terms of future studies of his art, clues to the evolution of his abstract style may well be found in the teaching and practice of the influential art educator Arthur Wesley Dow (1857–1922). Dow's name comes up constantly in the literature on O'Keeffe, who had studied with him at Columbia University in 1914 and whose first forays into landscape abstraction seem to have been inspired by Dow's Gauguinesque and Japanese-inspired emphasis upon the translation of nature into flat, gossamer patterns of Whistlerian subtlety, so it may also come as no surprise that many of Tack's smallest and most abstract studies after nature often resemble closely Dow's own color woodcuts as well as the reductive diagrams he published in his important textbook *Composition* (1899). Furthermore, Tack's attraction to traditions of painting the sublime American wilderness as a vision of timeless natural purity leading to the gates of the abstract and the supernatural might well be thought of in terms of other audacious but little-known Western landscape painters of the 1920s and 1930s, especially such California-based but, appropriately enough, Swiss-born depicters of American rock, lake, and sky as Conrad Buff (1886–1975) and Gottardo Piazzoni (1872–1945).

Still, Tack always remains a bit out of joint in any company. As a fin-de-siècle Symbolist, born in 1870, he is much too retardataire, exploring his cosmic visions only in the 1920s and 1930s; whereas if he is thought of as a member of the interwar period of American abstract innovation, with Dove, O'Keeffe, and Hartley, he not only seems almost neurasthenic in his pictorial effeteness but compromises his visionary abstract cause with his pragmatic approach to painting public murals or journeyman portraits of Washington officialdom. And though he may be construed as a Saint John prophesying the coming of abstract developments after 1945, his impact is more a matter of high probability than demonstrable fact. To be sure, his craggy geologic patterns (especially when blown up to the huge dimensions of

the 1944 fire curtain, *The Spirit of Creation,* in George Washington University's Lisner Auditorium) adumbrate Still's canvases, and his pastel seas of color may look ahead to the perfumed rainbow gardens of Louis or Olitski, yet Tack's lonely spirit continues to recede from the crowd, regressing backward to some mystical never-never land of the 1890s. But if Tack refuses to cling for too long to any category or fixed time-slot, his right to hold a more sustained position in the history of American art is long overdue. And here, a finger needs to be pointed yet again at the fickleness of art fashions. It turns out that when it was only one year old, the Museum of Modern Art included three of Tack's canvases in an exhibition called "Painting and Sculpture by Living Americans" (December 1930–January 1931), though even with this early exposure in the august new shrine of Modernism, Tack sank into oblivion for over four decades. But ironically, it also turns out that those very three paintings shown over half a century ago at MoMA (*Largo,* 1928; *Flight,* 1930; and *Far Reaches,* 1930) are included in the current exhibition. Perhaps, then, the story of Tack's reputation has come around full circle, and he will be properly resurrected at last.

"Resurrecting Augustus Vincent Tack." Published in *The Abstractions of Augustus Vincent Tack (1870–1949)* (New York: M. Knoedler & Co., 1986), pp. 2–4, 15.

A DADA BOUQUET FOR NEW YORK

1996

From Seurat on through Chagall, Robert Delaunay, and Tamara de Lempicka, artists in Paris would depict on their centuries-old skyline that new beacon of technology, the Eiffel Tower, as a symbol of the exaltingly unfamiliar mix of ugliness and beauty that was beginning to soar in modern cities. But this lonely icon could hardly match the full-scale embrace of New York City's modernity, a challenge to both young natives and Young Turks from abroad who wanted nothing less than total immersion in the dawn of a new century and a new era.

For a slightly older generation, the rupture between past and present could still be moderate, as seen in the decorously dappled canvases of the American Impressionist Colin Campbell Cooper (fig. 11).[1] Before 1902, he was off in Europe, signing his aristocratic, triple-barreled name to paintings of Gothic marvels, but then he settled in New York, where, as a critic put it in 1906, "he . . . quickly discovered that Manhattan Island has as much of the striking and picturesque as the Old World towns among which he had been roaming. What is more, the monster buildings that he saw around him, a distinctive New World product, offered an undreamt of field of opportunities . . . the suggestion of sublimity, the spirit of progress and promise, the manifestation of a surging, restless, all-attempting, all-achieving life essentially American."[2] Within less than a decade, however, Campbell's brightly hued, but politely nuanced views of Manhattan's skyscrapers, where even the pollution of smoke from ferries and chimneys has the loveliness of clouds adrift on a summer day, would be toppled by the most explosive "youthquake" of our century, as a generation of artists born plus-or-minus 1880 hit their twenties. With a seesawing balance of raucous excitement and the most refined drawing-room wit, they fell under the frenetic spell of New York, whose blindness to the past and open-eyed welcome to the future could even turn the City of Light into a graveyard of history. Soon, such photographers as Alfred Stieglitz and Alvin Langdon Coburn began to venerate the gravity-defiant heights of New York's rising skyscrapers,[3] recording in 1912, for example, the almost-completed tallest building in the world, Cass Gilbert's Woolworth Building—a "cathedral of commerce," as it was called by a clergyman at its dedication the following year. In Coburn's photograph, the structure seems to float on the pillows of industrial smoke that had replaced the clouds of Christian heavens.

This 729-foot, sixty-story shrine to business and engineering, complete with observation deck reached by the latest velocities in electric elevator technology, summed it all up. After Duchamp arrived in the city on June 15, 1915, he not only claimed that the New York sky-

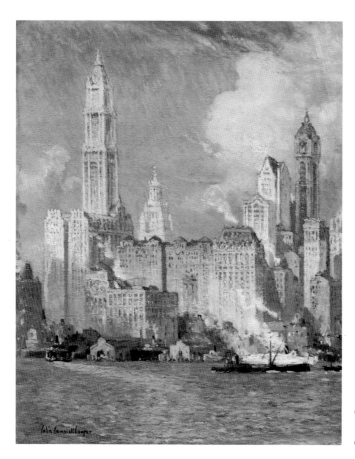

11.
Colin Campbell Cooper,
View of Wall Street ,
c. 1915

scraper was more beautiful than anything Europe might offer, but expressed his hope of finding
a studio in some skyscraper's lofty turret[4] (though, in fact, after several moves, he ended up set-
tling a bit closer to earth, on the third floor of the fourteen-story Atelier Building at 33 West
Sixty-seventh Street, one flight above the Arensbergs). And one year later, shifting from the
practical problems of finding housing in New York to his feather-touched undermining of what
seemed to him B.C. conceptions of art, he wrote in his notes that he wished to find an inscrip-
tion for the Woolworth Building in order to declare it a "readymade,"[5] a lofty aesthetic cere-
bration upon this freshly minted urban symbol of an A.D. world that, by comparison, makes
John Marin's earlier, speed-swept views of the building look as old-fashioned as Cubism.

That Dada spirit of total defiance, of flushing all artistic conventions (as Duchamp was
almost literally to do with the scandalous fountain-urinal of 1917, a tribute to, among other
things, the American plumbing he admired in New York), was particularly well suited to
New York themes, as Man Ray was swiftly to demonstrate. In 1917, jettisoning the traditional
materials of arty sculpture in favor of the grass-roots tools of industry, he fixed a carpenter's
C-clamp around the varied organ-pipe heights of tilted wooden slats, evoking the dizzying
angles and speeds of the city whose name he used for the very title, *New York,* of this hereti-
cal version of three-dimensional art. (After this "sculpture" was lost, he would later recon-

struct it, in 1966, almost as a relic of his past, now using chrome-plated bronze—more permanent than wood, if less Dada—and wittily lengthening these abstract towers as if to accommodate the ever-rising heights of the New York skyline.) No less charged with Dada's spirit of blasphemous invention is another "sculpture" of 1920 titled *New York or Export Commodity* (fig. 12). Perhaps in part a response to Duchamp's 1919 gift to Walter Arensberg of exactly 50 cc. of exported Paris air in a pharmacist's ampule, Man Ray enclosed in a ten-inch-high glass cylindrical jar (inscribed at the top NEW YORK) not the olives it originally contained but regimented clusters of metal ball bearings, a perfect New York export item that might suggest anything from rising and falling elevators to the compact lives of high-rise city dwellers. In fact, the following year he literally exported it, taking it to Paris with him, a bottled souvenir of the city that had nurtured his ironic audacities.

Man Ray also took, and reused, a photograph—likewise made in 1920 and first titled *New York* (in Paris, it was later given a second title, *Transatlantique*). If the bottled ball bearings symbolized the regimented and clinically sterile aspect of New York as the Machine Age city, this overhead photo of the discarded contents of an ashtray told quite another story. Once we look down, it seems to say, from the gleaming, sun-shot heights of the skyscrapers to the shadowy New York earth, we find a chaos of filth at our feet, in this case, a total mess of cigarette butts, used matches, crumpled paper, and ashes, the kind of urban debris that Dada often loved to elevate from the bottom of the garbage pail to the lofty domain of art. It is telling that in the same year, 1920, Man Ray looked downward again to photograph the dust that Duchamp had been "breeding" on top of the immaculate, laboratory-like panes of the *Large Glass*, obscuring its quasi-scientific cast of hygienic sex machines; and that this same New York oxymoron of repellent detritus mixed with glistening glass and metal could be found in the work of Joseph Stella.

Probably inspired by Duchamp's replacement of canvas by glass, a material fraught with Machine Age symbols of transparency and light (especially mythic in the domain of new architecture), Stella painted and pasted a typically New York vignette on a glass ground: a white-collared, black-hatted man neatly sliced through the glazed geometries of a framed window on one of the elevated trains that, running up and down Third, Sixth, and Columbus Avenues and out into the Bronx, Brooklyn, and Queens, could encapsulate the mechanical, radiating excitement of the shuffling of glass, speed, and people in the city of the future.[6] Elsewhere, Stella's attraction to collage techniques (which in *Man in Elevated [Train]* expands to the witty pasting of a magazine clipping to the rear, not the front, of the glass, thereby adding an extra level of transparency) rejects this belt-line precision in favor of the grungiest crushes of material from the bottom of a wastebasket, rivaling even Schwitters in the defiance of sanitary proprieties. In one, reproduced in *The Little Review* of 1922 (fig. 13),[7] Stella constructs a study for a skyscraper from tilting fragments of dirty, tattered paper (the bottom one punched PAID), opposing streamlined feats of engineering with New York's indifference to street-side cleanliness, a phenomenon still apparent to foreign visitors at the end of our century.

It was already apparent in 1913. When Gabrielle Buffet-Picabia arrived in New York with her husband, Francis Picabia, in late January to attend the Armory Show (where, beginning February 15, two of his paintings were to be unveiled to the public), she was shocked, later telling reporters that her "first impression on landing was that New York must certainly

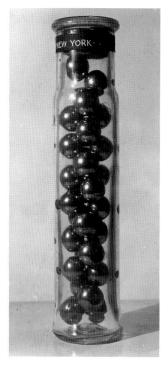

12.
Man Ray,
New York or Export Commodity,
1920

13.
Joseph Stella,
Study for Skyscraper,
c. 1922

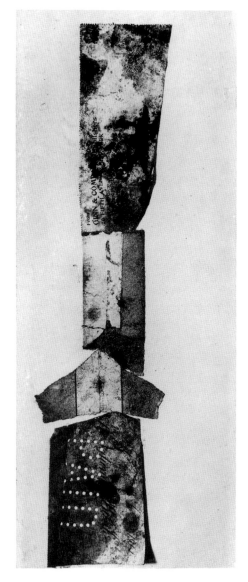

be the dirtiest and dustiest city in the world."[8] Her husband, however, had no problem look-
ing beyond this street-level truth into the city's cleaner, mechanical heart. The American
press was eager to greet this couple from Paris and to capitalize on the antics of those loony
modernist foreigners who were causing such a scandal at the "International Exhibition of
Modern Art" at the 69th Infantry Regiment Armory on Twenty-fifth Street and Lexington
Avenue. In fact, the *New York Tribune* commissioned Picabia to do a group of watercolors
about the city and gave them front-page coverage in its March 9 issue, with the predictable
pro-and-con commentaries.[9] Quite a few steps beyond the two 1912 paintings Picabia put
into the Armory Show, works which, over the decades, have become easily legible even to
the small children to whose art they are often sneeringly compared, these loose-joined rever-
ies, some clearly inscribed NEW YORK at the upper left, keep eluding identities, moving closer
to an impalpable world of thought and feeling, which the artist referred to as *pensée pure*
(pure thought). They evoke not so much particular, tangible objects, whether people or
things, but rather a blurred sense of the city's drifting, perpetual motion against a backdrop
of roughly perpendicular fragments. More mood than fact, they almost look backward, via
the fractured geometries of Cubism, to such late Impressionist city views as Monet's, inspired
a decade earlier by a visit to London. But then, of course, Picabia's first responses to New
York date back to 1913, before the insolent spirit of Dada had fully opened its Pandora's box,
transforming, in his case, modern city dwellers to sex-crazed robots, about as sentimental as
a lightbulb or a carburetor.

Seven years later, in 1920, Picabia's soft-edged watercolors, with their almost gentle
impressions of the city's dynamic flow, could become as hard-edged and impersonal as the
factory. So it was also in Charles Sheeler and Paul Strand's path-breaking, 6 ½-minute silent
movie, *Manhatta*. Using the medium of film whose modernity and ostensibly cold docu-
mentary character seemed ideally suited to recording the greatest metropolis of the new cen-
tury, they paralleled Léger's own postwar hymns to the severe geometry and beauty of the
modern city, but pushed their shifting, fragmentary images to sublime extremes of contrast,
appropriate to the vertiginous drama of the New York experience. Pitting against each other
collisions of large and small, high and low, near and far, movement and stability, and fusing
interior views with expansive thrusts of bridges and harbors to the seas and skies beyond, this
breathtaking cinematic collage of New York's micro- and macrocosms offers a mechanical
god's-eye view of a twentieth-century Jerusalem. And to assert this world's American ances-
try, the prophetic ghost of Walt Whitman looms behind it all, with quotes from his poems
interspersed among the urban images.

Like Picabia's and Duchamp's humanoid populations, Sheeler and Strand's vision of
New York came close to science fiction. But there were other, more relaxed and agreeable
ways to translate New York's realities into art, especially as seen in the hands of two women:
one, Florine Stettheimer, now famous again; and the other, Juliette Roche, known, if at all, as
the wife of a lesser Cubist, Albert Gleizes, who took her to New York in 1915 for what turned
out to be a five-year sojourn. For both these women, depicting New York meant not bowing
before the altar of the machine, but liberating more pleasurable aspects of their imagination
that might deal, in a fresh new spirit, with the kind of leisurely urban themes explored a half-
century earlier by the Impressionists. In awkwardly rhymed verse, Stettheimer described

how in the New York of her childhood memory "skyscrapers had begun to grow / and front stoop houses started to go," and then went on to her modest credo:

> And out of it grew an amusing thing
> Which I think is America having its fling
> And what I should like is to paint this thing.[10]

That fling is captured in a canvas of 1918, *New York* (fig. 14).[11] As cosmic in its panoramic vista as *Manhatta,* Stettheimer's idea of New York is nonetheless the cheeriest spectacle of holiday pageantry, triggered in this case by the flag-waving displays that greeted President Woodrow Wilson on his return from what at last was a war-free Europe. Patriotic fervor has never been less scary, transformed here into a spectator's fantasy, a personal mix of high sophistication and folk art that might be equally at home on a rural signboard or in an aggressively modern art exhibition that experimented with collage, semiotics, and urban simultaneity. Everything comes in amusing inventories of childlike sizes, shapes, and categories. The American flag turns up huge, but with thirty-two stars in the foreground, and is then telescoped to lilliputian scale on the roofs of distant skyscrapers and on the front and top of the destroyer that bears the president. The American eagle, symbol of the "liberty" that is the painting's alternate title, is seen with wings flapping, down, and raised, and emerges as

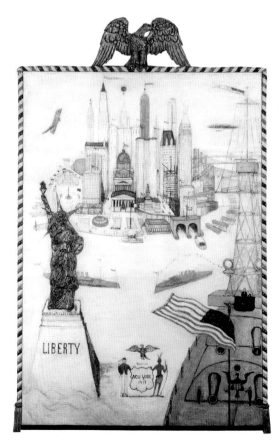

14.
Florine Stettheimer,
New York,
1918

15.
Juliette Roche,
Brooklyn St. George Hotel Piscine,
c. 1918

triumphant sculpture crowning the red, white, and blue rope coil of a frame. And the skies above offer a New York version of Cubist aeronautics, with a lofty trio of biplane, balloon, and dirigible. As for New York's architecture and topography, Stettheimer offers a whimsical scramble of history, from the Greek Revival style of the U.S. Subtreasury Building to the tapered Neo-Gothic heights of the five-year-old Woolworth Building, and blithely relocates Grant's Tomb and Columbus Circle for better stacked viewing. And as a breezy flouting of old-master conventions of painting, a branch off Dada's tree, the Statue of Liberty is rendered not as oil on canvas but as a flattened collage of gilded putty.

Such a freewheeling approach to the holiday-mood potential of New York was shared by Juliette Roche, in both words and images. Separating herself from the more orthodox modernism of her husband, who fit everything from Broadway signage to Brooklyn Bridge cables into generic Cubist molds, she eagerly explored other new avenues in her response to the city they both instantly loved. One was literary. During her New York years, she composed dozens of free-verse poems in French that would seize the thrilling rush of the city's sights and sounds. Sprinkled with words like Biltmore, Jazz-Band, Tipperary, West 88, Cyclone, Triangle Play Film, these verbal collages were published in a limited edition, *Demi Cercle,* upon her return to Paris in 1920.[12] Of these, the most visually adventurous is *Brevoort* (1917), which refers to the chicly international hotel, restaurant, and café on the northeast corner of Eighth Street and Fifth Avenue. Transporting the pleasures of Parisian café life to New York, she first sets the scene, top center, with the most minimal image of a Cubist glass on a table, but then moves on to the more adventurous territory of capturing the

simultaneous buzz of music and conversation around her with sentence fragments that evoke the orchestra playing an Italian song as well as snippets of overheard dialogue, a verbal potpourri of arty Greenwich Village talk that covers everything from Nietzsche and anarchy to Washington Square and Japan.[13] And moving from the liberties charted by avant-garde typography to the perspectival and figural innovations of avant-garde painting, Roche could also pinpoint her tourist's visions of New York with oil paint. Avoiding the obvious landmarks of Manhattan, she turned instead to a surprising locale that must be singular as a theme for art, the swimming pool at the St. George Hotel in Brooklyn Heights (*Brooklyn St. George Hotel Piscine,* c. 1918; fig. 15). With a kaleidoscopic freedom that transcends her husband's more stable Cubist structure, she provides a rapidly shifting aerial view of the pool, splintering its rectangular enclosures into dizzying, jigsaw-puzzle fragments, populated by the lankiest new species of indoor athletes who run, swim, and dive with the anatomical elasticity of such loony comic-strip characters as Little Nemo and Krazy Kat. In her role of a French Gulliver discovering New York, Roche gives us the most delightfully unexpected glimpse of how swarms of diminutive locals enjoy themselves when not crowding into subways or elevators on their way to work in mountain-high offices.

From Man Ray to Sheeler, from Stella to Roche, New York, during the heyday of its soaring twentieth-century youth, could unbridle one imagination after another, tempting artists to remake the world in this crazy but tonic image. And the magic never stopped. Even in its later twentieth-century decades, when other great cities began to challenge its high-speed pulse and its architectural heights and depths, New York can still inspire such total avowals of love as Red Grooms's *Ruckus Manhattan* (1975–76) and Rem Koolhaas's *Delirious New York* (1978). But that is another story.

"A Dada Bouquet for New York." Published in Francis Naumann with Beth Venn, *Making Mischief: Dada Invades New York* (New York: Whitney Museum of American Art, 1996), pp. 258–65.

1. For the fullest and only up-to-date account of this fascinating painter, see William Gerdts, *Impressionist New York* (New York: Abbeville Press, 1994), passim.

2. From Willis E. Howe, "The Work of Colin C. Cooper, Artist," *Brush and Pencil* 18 (August 1906), pp. 76–77, quoted in Gerdts, *Impressionist New York,* p. 31.

3. For an especially well-documented study of these photographic images of Manhattan skyscrapers as well as of all the other related imagery, see Merrill Schleier, *The Skyscraper in American Art, 1890–1931* (Studies in the Fine Arts: The Avant Garde, no. 53) (Ann Arbor: UMI Research Press, 1986).

4. Press interview for the *New York Tribune,* September 12, 1915, reproduced in Francis M. Naumann, *New York Dada 1915–23* (New York: Harry N. Abrams, 1994), p. 36.

5. In note 58 (January 1916), reproduced in facsimile in Arturo Schwarz, ed., *Notes and Projects for the Large Glass* (New York: Harry N. Abrams, 1969), p. 96.

6. Stella's painting is reproduced and discussed in Naumann, *New York Dada 1915–23,* pp. 143–45.

7. *The Little Review* 9, no. 3 (autumn 1922), n.p.

8. Cited in Naumann, *New York Dada 1915–23,* p. 19.

9. Reproduced, ibid., p. 18.

10. Barbara J. Bloemink, *The Life and Art of Florine Stettheimer* (New Haven and London: Yale University Press, 1995), p. 54.

11. Ibid., pp. 52–54, and Naumann, *New York Dada 1915–23,* p. 152, for other discussions of this painting.

12. Juliette Roche, *Demi Cercle* (Paris: Éditions d'Art "La Cible," 1920), a limited edition of 500.

13. Brevoort was first reproduced and discussed in Naumann, *New York Dada 1915–23,* pp. 98–99.

RECONSTRUCTING BENTON
1992

In 1972 the eighty-three-year-old Thomas Hart Benton proclaimed, "Old age is a wonderful thing. You outlive your enemies." Of enemies, he had plenty. For a good half-century, he offended in words and in pictorial deeds the majority of that fervent minority of Americans who believed in the religion of modern art and who hoped to intermarry Europe and the United States in this common faith. In the 1920s and 1930s, when the latest works of Picasso or Mondrian were still talismans of mystery and modernity and needed the enormous efforts of such temples of learning as the Museum of Modern Art to make them comprehensible, Benton was hell-bent on rooting his painting in the common soil of America. He documented everything from cotton fields in Georgia to boomtowns in Texas and, moving to more exalted levels of narrative sweep, envisioned an epic series of canvases that would trace the patriotic pageant of American history, from the earliest cultural dramas of Jesuit missionaries confronting native Indians to the up-to-date thrills of bootlegging in the prohibition era. In the 1940s, when American painters had finally absorbed so fully the lessons of European modernism that they could begin to make contributions of international stature, Benton still clung to his grass-roots vision. While artists like Newman and Rothko were grappling with the apocalypse of the Second World War by taking refuge in a private universe of timeless mythologies and cosmologies, Benton, in a series called The Year of Peril, allegorized the American response to Hitler and Pearl Harbor in paintings whose macho brutality bizarrely echoed the science-fiction violence of contemporary comic strips that, decades later, Lichtenstein would parody. And in the 1950s and 1960s, when a whole younger generation of American artists rediscovered the American scene after its seeming eclipse by the Abstract Expressionist world of prehistoric time and space, Benton was still irritatingly out of sync. At a time when the Pop artists' recycled inventory of Americana, from cartoon characters and barnyards to George Washington and the armed forces, was being translated into artfully mechanized ironies of style and attitude, Benton maintained an ingenuous, uninterrupted faith that Arcadia could be found in a picnic on Martha's Vineyard and that serious artists looked like his own late self-portrait of 1970 in which a tough old plaid-shirted survivor seems to defend with brush and canvas his old-fashioned art and beliefs.

As for those beliefs, they were always against the grain of enlightened modernity. In a period when artists were considered to be intrepid explorers of strange new paths where only the indoctrinated few could follow, he was the very model of a populist who had no qualms

about attacking such sacred cows as Picasso, whom he once described disparagingly in a lecture of 1934 as being "the idol of all the young aesthetes" and the most "complete example of artistic decadence with the exception of Poussin," thereby killing two aristocratic birds with one democratic stone. His siege on the taste and acquisitions of American museums was equally persistent and energetic. Kansas City's Rockhill-Nelson Museum was a special target, for it controlled the artistic life of his own home state, Missouri, where, according to Benton's claim in 1943, a vital art, of and for the people, had expired in the nineteenth century with the death of the regional artist (and one-time politician) George Caleb Bingham, the exemplary painter of the common man doing commonplace American things. Indeed, Benton's ambitions to attract the widest and most democratic of audiences were not just talk. In 1946 he could even be summoned to Hollywood to work with Walt Disney on an operetta based on the Davy Crockett story (the project was abandoned); and if this weren't enough to ruin his reputation in sophisticated art circles, his later endorsement by Harry Truman as "the best damned painter in America" certainly was.

Benton's macho stance, too, was guaranteed to offend. His hatred of modern art and its supporters was tied up with a rabid homophobia about which he minced no words, asserting, for instance, in an interview of 1941 that the cause of all the art trouble was "the third sex" and that American museums were usually run by "a pretty boy with delicate wrists and a swing in his gait." And his approach to gender politics was no less crass. He not only stated that he wanted his paintings to hang in bars and brothels (presumably for real men, and not the museum-going kind), but in 1941 he actually arranged to have *Persephone* (fig. 16), one of his two notorious nudes, hang for a month in a poshly vulgar New York nightspot, Billy Rose's Diamond Horseshoe (an ancestor of Hugh Hefner's bunny clubs), where the canvas could quickly shed the fancy mythological overtones of the title and turn the naked goddess of fertility, nestled among the sexy contours of the earth, into a living stripteaser at rest being ogled by a spectator who used to be Pluto. It is hard to realize that at the same time, on what seems another planet, Benton's former student Jackson Pollock was also struggling with his own turbulent efforts to translate archetypal erotic myths and totemic images—primitive Eves, moon goddesses, Pasiphaë—into paintings that could immediately grab the spectator's passions.

In fact, it was the unexpected connections between these two presumably polar opposites, Benton and Pollock, that may first have triggered the growing efforts to reconsider the older artist's position in the history of modern art. For it turned out that neither Benton nor Pollock was quite so purely black or white as simple-minded ideologies had claimed. As for Pollock, not only had he studied with Benton at the Art Students League in New York between 1930 and 1932, but much later, in 1947, the year of his big breakthrough to pure abstraction, he could even be endorsed by his old teacher in a recommendation for a Guggenheim grant, with Benton claiming that "he was one of the few original painters to come up in the last 10 years." Moreover, Pollock's work has now been recognized as bearing traces, both superficial and deep, of Benton's imagery and structure. Not only do many of his small early canvases of the 1930s (some of which belonged to Benton) deal with American-scene themes—barns, rolling Midwestern hills, cotton picking, cattle, cowboys, migratory workers—but their internal rhythms of a serpentine *perpetuum mobile* echo the restless, coiling patterns that animate Benton's own art. And the rapidly swelling dimensions of Pollock's

16.
Thomas Hart Benton,
Persephone,
1939

own canvases, which literally attained mural size (almost 8 x 20 feet) in a 1943 commission from Peggy Guggenheim, clearly reflected the epic scale mastered by Benton in his own murals of the 1930s. As for these murals, they often shared the style and imagery (and in the case of the New School for Social Research in New York, even the same patrons and spaces) of Benton's friend and occasional co-exhibitor at the Delphic Galleries, the Mexican José Clemente Orozco, who also in turn left a major dent on Pollock's own art. Such overlapping boundaries between Benton, Orozco, and Pollock in the 1930s are yet another indication that many shades of gray surround the traditional prejudice that Benton represented an extremist faith in realist regionalism.

That prejudice, in fact, was further undone by the growing disclosure that, of all unlikely things, Benton had begun his career as the most adventurous modernist expatriate, embracing during his four-year sojourn in Paris (1908–11) every new "ism" (most of these juvenilia, alas, were destroyed by fire in 1917). And even after his return to New York, he continued to work in such avant-garde modes that in 1916 he could participate in the famous

Forum Exhibition of Modern American Painters, where his canvases were completely at home in the flagrant rebellion and internationalism of the Stieglitz circle. It is as if the most right-wing Republican politician were discovered to have once been a card-carrying Communist, a drastic psychological about-face that may help to explain Benton's unusually violent rejection, as a mature artist and man, of the siren song of modernist Bohemia that had lured him in his errant youth.

As early as 1905, in fact, Benton could design a Christmas card that revealed how, even as a teenager, he had a precocious grasp of the patterned, decorative vocabulary of arbitrary color and sinuous line explored in the more effete manifestations of Art Nouveau; and thereafter there was no stopping his head-on embraces with the rapidly changing adventures of early-twentieth-century art. He could paint trees blue, or men yellow and red; he could turn houses into windowless cubes and still-life objects into indecipherable cones, ovoids, and spheres; and he could even join forces for a moment with his friends Stanton Macdonald-Wright and Morgan Russell by adding to the most radically abstract of American avant-garde isms, Synchromism, his own variations upon their disembodied bubbles of color that were meant to waft daring spectators of all nationalities to extraterrestrial climes. After the upheaval of the war, his art could still be clocked by international modernist time. Paintings like his *Rhythmic Construction* of 1919 echo the immediate postwar efforts of a Léger to introduce through rigorously rectilinear armatures an image of abstract reconstruction that could heal a world which had just exploded, an image made more literal in his optimistic depiction in 1923 of robotlike workers erecting the beams and girders of high-rise buildings in the mechanized utopia of New York City, where thoughts of the artist's Midwestern, agrarian roots must have seemed light-years away. And even when he turned to American landscape in the 1920s, it often looked so cosmic in its abstract sweep of hill, cliff, or sea that, as in the work of Arthur Dove, with whom he had exhibited in 1916, we feel that the image pertains not to America between the wars but to a primordial realm of universal nature. As for Benton's excursions in the decorative arts in the same years, he could create, among other things, folding screens whose mural-scaled geometric rhymes instantly earn him a place among the most chicly up-to-date exponents of coiling, zigzagging Art Deco abstraction. Given this welling evidence, it became clear by the 1980s that Benton, once the hated symbol of all things anti-elite, anti-European, anti-modernist, had not only played an essential role in the formation of Pollock, but had himself originally employed the language of modern art with such success that his early works could even win the praise of such pro-modernist critics as Clement Greenberg and Hilton Kramer, who on principle would be completely hostile to Benton's mature work.

But such paradoxes were further compounded by what might be called the postmodernist view of Benton. Already in the 1960s, aspects of Benton's art reemerged in the form of ironic, perhaps even nostalgic quotations from a prewar America whose faith in the epic myths of industrial, agricultural, and social progress reached a utopian climax in the New York World's Fair of 1939. Benton's mural orchestrations of the harmonies of an American society where glistening railroad trains lunge upward into a blue-skied future and where rural and urban dwellers seem to join democratic hands in fields, factories, and city streets provided the blueprint of a defunct Garden of Eden that could haunt the publicly scaled imagery

of James Rosenquist and Roy Lichtenstein. Indeed, their reinterpretations of these panoramic fantasies seemed to measure definitively the quantum leap that poignantly separated the American past from the turmoil of the 1960s present. Even the montage effects of many of Benton's murals were adapted by these Pop artists in their split-screen constructions of the hollow pageantry of an America whose innocence disappeared forever with Hiroshima. Mural epics like Lichtenstein's *Preparedness* (see fig. 121) and *Peace through Chemistry* or Rosenquist's *F-111* speak for the 1960s awareness that America had been expelled from Benton's kaleidoscopic Paradise.

In fact, for still younger generations, Benton's vision of America had become so remote in time and so quaint in character that it totally lost its sting to elicit the battle cry against international modernism that enraged so many partisans of avant-garde art and liberal thought in the 1930s and 1940s. For younger eyes today, a Benton canvas of 1928 depicting the loading of cattle in the Texas Panhandle has the same period flavor of a faraway moment in the early twentieth century as a Benton canvas of 1916 that reaches abstractly for the music of the spheres. The seeming contradictions of Benton's art and beliefs have finally been leveled into the sands of distant time, becoming the dispassionate data for the kind of study of American art and culture that has proliferated in recent years and that would try to encompass once belligerent factions into a broader view of the period. Such publications as Cécile Whiting's *Antifascism in American Art* (1989) and Erika Doss's *Benton, Pollock, and the Politics of Modernism: From Regionalism to Abstract Expressionism* (1991) would see forests instead of trees, and would try to accommodate modernists and anti-modernists in the same historical spaces. It is a viewpoint accompanied as well by the kind of relaxation of aesthetic purities that has made accessible to younger spectators the once vilified later work of early modernist masters such as Francis Picabia and Giorgio de Chirico.

Moreover, the recent tolerance and even enthusiasm for those aspects of interwar realist painting that were once scorned by right-thinking art lovers have made it possible to reconsider Benton in the context of this international style of the 1920s and 1930s. The landmark Paris exhibition of 1980–81, "Les Réalismes," reconstructed a pan-European and transatlantic community of artists working between 1919 and 1939 in related realist modes, embracing Italians like Mario Sironi, Frenchmen like André Derain, Germans like Christian Schad, and Americans like Edward Hopper. And now that this pictorial world has become visible again, Benton has gradually been taking on a new role that would relate even his most regionalist images to an international pattern. It is fascinating to note, for instance, how many of Benton's more caricatural portraits of the 1920s resemble the Germanic farmers painted at the same time by Otto Dix or the way in which his writhing, impacted figure compositions of agitated rural and city dwellers recall those of such British contemporaries as Stanley Spencer and William Roberts. With the hindsight of history, even Benton's purifying myth of American isolationism has begun to vanish, becoming instead an intriguing local specimen of an international phenomenon. The militant Thomas Hart Benton who died in 1975 would hardly recognize himself today.

"Reconstructing Benton." Published in Rudy Chiappini, ed., *Thomas Hart Benton* (Lugano: Museo de Arte Moderna, 1992), pp. 135–44.

DE CHIRICO'S LONG AMERICAN SHADOW
1996

L ooked at from the vantage point of the late twentieth century, the story of Giorgio de Chirico's impact on a broad range of American art and architecture can be divided into two very different acts.[1] Act I takes place in the heyday of modernism, when the Museum of Modern Art, with its magisterial ordering of the bewildering innovations of the early century, rightly crowned de Chirico as a prophet of Surrealism. Here was the artist who, already before the First World War and the official launching of the Surrealist movement, had established all the irrational premises that could turn the realities of the seen world and the logic of traditional perspective systems into a theater where dreams could unfold. In 1936 the Museum of Modern Art established de Chirico's authority by showing seventeen of his paintings and nine of his drawings in its pathbreaking exhibition "Fantastic Art, Dada, Surrealism"; and in the same year it acquired two works that demonstrated his magic both as a still-life painter (*The Evil Genius of a King*)[2] and as a conjurer of haunting cityscapes (*Nostalgia of the Infinite*). Already in the 1930s, then, de Chirico's audience, both in America and abroad, recognized him as a pivotal genius who had led modern art into uncharted territories where it might be possible to fathom what Freud had characterized as the submerged iceberg of the human mind.

But de Chirico's image as a pioneer explorer changed drastically in Act II. Corresponding to what we loosely refer to as postmodernism, de Chirico's work, for some American painters and architects, became a touchstone of retrospection, not only in terms of nostalgia for a historical past—a mood so evident in his early work—but, more to the point, in terms of his strange, about-face career, in which he first renounced his modernist youth by returning to more traditional modes of painting, and then, even more startling, painted countless variations and replicas of his early successes. Vexing questions of authenticity and dating, and no less upsetting problems of evaluation, were raised by a master who looked backward to his own youthful past through the odd practice of counterfeiting numerous variations of his acclaimed masterpieces.

Act I of this story, involving de Chirico's impact on painters who matured during the years between the two world wars, is the more familiar. For a surprisingly diverse range of American artists, whether of realist, Surrealist, or abstract persuasion, de Chirico's funneling urban perspectives and enigmatic joining of commonplace objects provided an exciting catalyst for

17.
Peter Blume,
Parade,
1930

experimentation. A precocious case in point is a Museum of Modern Art classic, Peter Blume's *Parade* of 1930 (fig. 17). A member of the bohemian Greenwich Village set in the 1920s, Blume was exposed early to Surrealist periodicals, and, of the artists he saw reproduced there, he particularly favored de Chirico.[3] That attraction is immediately apparent in *Parade,* the ambitious canvas in which Blume first defined his own vision and a work that might almost be described as a typical de Chirico Italian cityscape transported into the milieu of "American scene" painting. The architectural components, from the industrial buildings to the ship's ventilators, echo the industrial iconography and razor-edge style of the Precisionists. But these pristine parts are now ordered with the swift plunges of fragmentary perspective that de Chirico had locked into place in such classic canvases as *The Enigma of a Day* (fig. 18) or *Melancholy and Mystery of a Street.* The dustless clarity and abstract geometry of Sheeler's and Demuth's factories and ocean liners are now wedded to de Chirico's dreamlike hybrids of modern and historic Italy, of railroads and empty arcaded piazzas. This aspect is even more bizarrely enforced by the human player on Blume's American stage. Malcolm Cowley, Blume's writer friend, makes a startling appearance as a contemporary American who parades a suit of medieval armor, inspired by the collections of the Metropolitan Museum. With grotesquely toothy visor and ventail, this glistening metal carapace, analogous in its clockwork precision to the industrial and maritime forms behind it, unsettles our sense of time, place, and even body image, much as de Chirico's odd conjunctions of mannequins, factory buildings, Renaissance architecture, or classical and nineteenth-century sculpture set off disturbing associations culled from disparate layers of history.

18.
Giorgio de Chirico,
The Enigma of a Day,
1914

De Chirico's shadow crosses the Atlantic in much the same way in O. Louis Guglielmi's *Terror in Brooklyn* of 1941 (fig. 19), which seems to have been instantly recognized as a textbook classic of American Surrealism. Acquired in 1942 by the Whitney Museum, it was included, two years later, in Sidney Janis's landmark publication *Abstract and Surrealist Art in America,* where the artist explained that the painting was "a premonition of war and tragedy."[4] Although clearly related to the American experience of the Depression years and the rumblings of the Second World War across the ocean, the components of this anxiety-ridden environment are again local adaptations of the disquieting urban spaces de Chirico had laid out on the eve of the First World War. Once more, the Italian's grandly historic urban settings have been transformed into an American vernacular, which, in this case, is so specific that the fragmented sign at the right can probably be identified as belonging to Kruger's Diner, which actually stood in Brooklyn, on Atlantic Avenue, in 1941.[5] But de Chirico's ghost is everywhere, as if Guglielmi had worshiped at the shrine of his paintings in MoMA's 1936 show or had perhaps absorbed the fuller pictorial information on the artist newly available in 1941 in James Thrall Soby's first monograph on the master, *The Early Chirico.*

Guglielmi's inventory of the Italian's stagecraft is a long one and includes the rushing perspective that sweeps the viewer to a remote, empty horizon; the threatening clarity of the long, sharp shadows; the lethal mood of inertia and bareness conveyed by the deserted streets and uninhabited buildings. But the American artist adds his own inventions, too, which

19.
O. Louis Guglielmi,
Terror in Brooklyn,
1941

quickly transcend the initial impression of earthbound literalness in the depiction of the brick and wooden buildings. The sense of paralyzing helplessness and anxiety is conveyed by the trio of mourning women trapped forever in a bell jar, and the motif of death is evoked by the empty, coffinlike black cars. Deathly, too, are the streetlamp that, without its electric bulb, can no longer function and the pelvic bone, strewn with ribbons, that hangs from the building at the upper right. More subtly disturbing is the uncanny duplication, reversed as in a mirror, of the sequence of foreground buildings on the other side of the cross street beyond the real-estate office. With such strange metamorphoses of an American urban commonplace, Guglielmi, we feel, earned his right to work under the shadow of his great ancestor.

In the case of a painting by Paul Cadmus, another hyperrealist artist of Blume and Guglielmi's generation, the variation on a theme by de Chirico might almost be more a question of coincidence than influence. His *Night in Bologna* of 1958 (fig. 20) now transports us to Italy rather than remaining in the America whose seamy sides Cadmus had so often painted before the Second World War and directly reflects the artist's sojourns in Italy between 1951 and 1953.[6] Here, the perfectly funneled one-point perspective spaces provided by Bologna's famous Renaissance arcaded streets, together with the angled view of the taller of the city's two Gothic leaning towers, create an almost literal de Chirico setting; and the mystery is further dramatized by the theatrical night lighting, with electric beams pointing up the painting's sexual scenario. Moving from the Italian master's subliminal evocations of erotic desire to a

20.
Paul Cadmus,
Night in Bologna,
1958

more prosaic, streetwise narrative, Cadmus stages a taut triangle composed of a late-night prostitute who vainly tries to attract the attention of a lone male tourist, who, in turn, attempts to catch the eye of the macho soldier in the foreground, who, in his turn, ogles the girl. It is as if a painting by de Chirico had been reconstructed as a set for a Tennessee Williams play.

At times it was de Chirico's bizarre conjunctions of still-life objects rather than his architectural settings that fired the imagination of American artists of the interwar generation, especially those who wanted to venture into more overtly Surrealist territory. So it was with the California-based Lorser Feitelson, who, in 1934, after sojourning in Paris in 1922–27, during the youth of Surrealism, audaciously declared a new movement, Post-Surrealism. It would focus on the mysteries of objects as catalysts in the creation of a symbolic whole that might offer a scenario of coherence rather than a search for the kind of deliberate incoherence venerated by the original Surrealists.[7] For this new pursuit, de Chirico's still lifes provided an essential source. In *Genesis #2* of 1934 (fig. 21), for example, Feitelson fused biological, astronomical, and Christian prototypes of creation through a strange dictionary of images rendered, as was so often the case in de Chirico's still lifes, both as palpable, shadow-casting objects hovering on a steeply tilted table and as flat, schematic drawings. Much as de

Chirico might offer up symbolic marriages of bananas and cannons, mannequins and fish molds, eggs and candles, antique busts and Saint Andrew's crosses, Feitelson attempts here to probe the buried symbolic life of an odd array of objects culled from nature, science, and myth. Among other images, eggshell, seashell, cut melon, telescope, galaxy, mask, skull, bird's nest, lightbulb, the Virgin Annunciate, mother's breast, and baby bottle are meant to quicken, as in the language of dreams, an awareness of the cosmic mysteries of genesis. And the willful flouting of rational spatial construction, in which lucid geometric planes borrowed from one-point perspective schemes are recomposed to produce more flattened, irrational spaces, also suggests a nod in de Chirico's direction.

However, in the case of other American painters who matured between the wars, we may invoke de Chirico as a question more of affinity than of actual influence. A parallel here can be traced in the work of Edward Hopper, whose imposition of an uncanny silence and inertia upon both urban and rural American settings has occasionally been compared to the mood generated by de Chirico's art.[8] In fact, from the year it opened, 1929, through the 1930s, the Museum of Modern Art itself found Hopper's art compatible enough to be acquired, frequently exhibited, and, in 1933, even given an early retrospective (complete with an essay by Alfred H. Barr Jr.), although ostensibly his work remained remote from the revolutionary changes the Modern hoped to document and explain. As for any dialogue between the two artists, it is clear, given the evidence of Hopper's work from his Paris sojourns between 1906 and 1910, that long before de Chirico had created his own silent and depopulated Italian cities, the American abroad could drain even the French capital of its inhabitants and joie de vivre, leaving only the chilly, urban bones of a city that, in his hands, often resembles an evacuated site.

21.
Lorser Feitelson,
Genesis #2,
1934

22.
Edward Hopper,
Early Sunday Morning,
1930

23.
Giorgio de Chirico,
The Enigma of the Hour,
1911–12

Nevertheless, one also wonders whether, later in his career, Hopper did not cast an occasional sideways glance at de Chirico's paintings, which, after all, often shared the same spaces as his during the first decade of the Museum of Modern Art's history. Be that as it may, paintings like Hopper's *Early Sunday Morning* of 1930 (fig. 22) offer, in more traditionally realist terms, an eerie American equivalent of such famous paintings by de Chirico as *The Enigma of the Hour* (fig. 23), in which the unnatural clarity of late-afternoon shadows and a drawing-board architectural facade create a stage set in which any imminent drama would be immobilized. For all of Hopper's presumed literalness, his view of New York, originally titled *Seventh Avenue Shops,* is topographically irrational, for the strong, early-morning east-west light should be running across, not along, the north-south axis of the avenue. Here Hopper, like de Chirico before him, has taken a fragment of vernacular street architecture and, by means of rectilinear bareness and intensity of light and shadow, has created a melancholy scenography, which, in fact, may have been partly inspired by an actual stage set designed by Jo Mielziner for Elmer Rice's *Street Scene,* a production the artist had seen in 1929.[9] Typically, however, Hopper's stage is depopulated, the only actors seeming to be a fire hydrant and a barbershop pole, the New York equivalents of the towers and statues that haunt de Chirico's piazzas. Surrogate human presences are as abundant in Hopper's work as in the Italian's. In *The Lighthouse at Two Lights* of 1929, one of Hopper's many views of Cape Elizabeth, Maine, the lone, tall tower becomes a solitary presence, both sentient and inanimate, recalling the comment of the Italian architect Aldo Rossi (whose own historicizing designs often have a mysterious, de Chirico–like lucidity and bareness) that the lighthouses of Maine are "marvelous high wooden structures . . . houses of light that observe and are observed."[10]

Hopper's affinities to de Chirico, like those of another American scene painter, Ralston Crawford (described as early as 1946 as a combination of de Chirico and Mondrian),[11] are of a very different order from the willful efforts of Surrealist-oriented American artists to adopt the Italian's manner of depicting a world of dreams and longing. Of those who looked with awe at de Chirico as a means of unlocking their own imaginations, only one could make the quantum leap to an entirely original statement, namely Arshile Gorky. Of all major twentieth-century artists, Gorky had the longest and most self-effacing apprenticeship at the feet of the canonic masters of modern art, above all Cézanne, Picasso, and Miró. But amidst this European pantheon, one work by de Chirico, *The Fatal Temple* (1913; fig. 24), had a particular impact. As part of the Albert E. Gallatin collection, it was to be seen on Washington Square, at New York University's Gallery of Living Art, which opened its doors on December 12, 1927, as the city's first museum devoted exclusively to contemporary painting and sculpture.

For Gorky, de Chirico's canvas took on a talismanic quality. Throughout the first half of the 1930s, the painting presided in overt and covert ways over many of the artist's drawings, prints, paintings, and even studies for a mural.[12] It was characteristic of Gorky's pictorial preferences that he was attracted not to the more familiar spatial plunges of de Chirico's cityscapes, but to a work that remained largely frontal, restricted to a shallow space threatened only by the obliquely viewed architectural fragments overhead. Appealing to Gorky, too, must have been the strange juxtaposition of disparate objects rendered in disparate degrees of realism: the delicately paired painted ripples of the waving flags; the blurred imprint of a fish, as in a pencil rubbing; or the three-stage transformation of a fleshy, blond bust, possibly that of Goethe,[13] into an

24.
Giorgio de Chirico,
The Fatal Temple,
1913

opaque black silhouette that leads an ominous life of its own, and then into a fragmented black-board diagram that exposes within the skull the spiraling abstraction of a brain.

Moreover, *The Fatal Temple* offers an unusual abundance of de Chirico's calligraphic fantasy, in which in both black on white and white on black everything from letters, plane geometries, and directional arrows is metamorphosed into cryptic symbols whose emotional reverberations are compounded by such evocative French words as *joie, souffrance, énigme, vie, chose étrange, éternité d'un moment.* For the young Gorky, patiently seeking his identity, de Chirico's alchemist's dictionary of words, images, and private hieroglyphics could open count-less vistas to be explored.

At times, as in an ink drawing of about 1932, he offers a relatively direct homage to de Chirico's invention; but elsewhere, as in the painting *Nighttime, Enigma, and Nostalgia* of 1934 (fig. 25), the sources have been so totally digested that we only have Gorky's evocative title to remind us of the words de Chirico used for many of his own titles and, in the case of "enigma," as an actual inscription in *The Fatal Temple.* Mixing, as de Chirico did, legible images and inde-cipherable configurations, planar geometries and organic fantasies, Gorky seems to have found *The Fatal Temple* an inexhaustible source of early inspiration, even to the point of conflating it with works by Picasso and Uccello in themes and variations of mural ambition. With so total an absorption of de Chirico's distinctive art into his own equally distinctive language, a language that brings us to the brink of the mature Gorky of the 1940s and the domain of Abstract Expres-sionism, the curtain for Act I of de Chirico's influence on America may conveniently fall.

As for Act II, it belongs fully to that chronological period for which "postmodernism" is a particularly apt term in considering the growing reversal of "modernist" attitudes toward de

Chirico's art. For the first half of our century, nothing seemed truer than the *idée reçue* that the great Italian master, to his shame, had dropped out of the proper history of modern art not only by returning to traditional premodernist modes of painting (though he was hardly unique in this), but, more offensively, by willfully replicating, sometimes with minor but equally often with barely visible changes, the museum-worthy canvases of his youth. James Thrall Soby, author in 1941 of the first serious study of de Chirico, concluded his revised text of 1955 with a condemnation that continued to echo throughout the literature of modern art: "Borrowing from an incredible roster of past artists, reverting above all to the Baroque tradition which he had once held in contempt, devoting much of his energy to violent attacks on the twentieth-century visual revolution of which he was once an irreplaceable leader, de Chirico has tried with every means at his power to obliterate his own brilliant youth."[14] And even into the 1960s, few writers or viewers could find anything good to say about his later work.

Yet by the 1970s, the sands of contemporary art had shifted so much that de Chirico's later work began to hold an ever stranger fascination for younger artists and critics, much as the equally scorned late work of Picabia also began to exercise on younger eyes the attraction of forbidden fruit. It is telling that already in 1972 a precocious exhibition organized by Donald Karshan at the New York Cultural Center, "De Chirico by de Chirico," reconsidered the master's later, self-quotational career in what was hoped to be a more favorable climate.[15] And by 1984, the Robert Miller Gallery in New York, which generally focused on advanced contemporary art, would exhibit the half-century of de Chirico's later work[16] that had been censored out of history at the 1982 MoMA retrospective, which surveyed only the artist's early career, coming to a brief and limp conclusion with only a few token works from the 1920s and 1930s.

In America a new license for historical retrospection was particularly apparent in some major architectural projects of the later 1970s, a viewpoint that cast new light not only

25.
Arshile Gorky,
*Nighttime, Enigma,
and Nostalgia,*
1934

26.
Charles Moore,
The Piazza d'Italia,
New Orleans,
1975–78

on the nostalgia for past epochs evident in de Chirico's early paintings, with their quotations from architecture and sculpture ranging from antiquity through the nineteenth century, but also on the artist's later willingness to abandon faith in modernist progress and to recapture, with backward glances, anything from the style of Venetian Baroque painting to that of his own youthful, hard-edged work. This new ambience may be suggested by one of the most imaginative architectural commissions of the late 1970s, Charles Moore's Piazza d'Italia in New Orleans (fig. 26), an urban center that was intended to reflect, by association, the cultural heritage of the city's Italian-American population. Built between 1975 and 1978, the Piazza d'Italia has been called the most telling example of postmodern architecture, "not because the historical forms of the classic orders were used in an almost excessive profusion, but because a fiction was created in a direct way,"[17] a tribute that might also apply to many of de Chirico's paintings, whether early or late.

A scenographic fantasy surprisingly set in the middle of downtown New Orleans, the Piazza d'Italia looks like a walk-through reconstruction of de Chirico's Italianate motifs. Not only are there fragments of historic architecture, whose orders, arches, and colonnades recall everything from antiquity to the eighteenth century, but, on the pavement, a map of Italy, which, as in the case of de Chirico's use of fragmented maps in a group of paintings and drawings of 1916,[18] triggers mental voyages to places far beyond the spectator's ken. Moore's role as a witty and erudite scavenger of a culture distant in time and place could hardly establish a more congenial atmosphere for re-experiencing, in a postmodernist light, the retrospective layers not only of de Chirico's youthful works but also the extra layers of nostalgia and history that characterized his later decades, when, until his death in 1978 at the venerable age of ninety, he continued to excavate his own past.

That year coincidentally marked the arrival of another major landmark of postmodern architecture, for it was in 1978 that the model of Philip Johnson's AT&T (now Sony) Building in New York was unveiled.[19] Coming from an early proponent of modernism, Johnson's adap-

tation of a Chippendale highboy for a building type associated with our century's technology offered an assault on right-thinking pieties that also echoed in de Chirico's direction. Ironically, this 648-foot-tall skyscraper, whose classicizing pediment, imaginatively overscaled apertures, and crisp planar geometries might feel at home in many a canvas by de Chirico, was nearing completion in 1982,[20] the very year of the master's retrospective at MoMA. But Johnson's newly relaxed attitudes toward anti-modernist quotation were completely at odds with the museum's still-doctrinaire approach to de Chirico. In a well-argued, energetic essay, the show's organizer, William Rubin, proposed that de Chirico's early masterpieces could be readily assimilated into the flattened spatial structures of early modernism (as in Matisse and Synthetic Cubism) and should not be viewed as an aberrant survival of conventional perspective systems within the alien territory of modernist spatial innovation.[21] But the larger point, which had already emerged from the new aesthetic milieu of postmodernism, was that it no longer really mattered that de Chirico borrowed from the historical languages of a pre-modernist past; after all, so too did Moore and Johnson, among other architects. Indeed, it might no longer even matter that de Chirico borrowed from his own past or that he copied, almost like a mindless machine, his own works.

Such copying, in fact, could be read more positively than negatively in the light of a younger generation of artists who, among other innovations, could silkscreen photographic images and repeat them ad infinitum on canvas. Confronted with a reproduction of the eighteen nearly identical versions of *The Disquieting Muses* (1917; fig. 27) that de Chirico executed between 1945 and 1962,[22] one might begin to think that, far from being retrograde and irrelevant, de Chirico, in his later career, was a prophet who had foreshadowed, for instance, Andy Warhol's own espousal, beginning in the early 1960s, of an aesthetic of repetition in which the value of unique, handmade originals was seriously threatened. And if this new validation of de Chirico's assembly-line reproduction from his own earlier repertory was implicit in Warhol's work of the 1960s and 1970s, it became explicit in the 1982 MoMA retrospective,

27.
Giorgio de Chirico,
eighteen versions of
*The Disquieting
Muses (1917),*
1945–62

28.
Andy Warhol,
The Disquieting Muses,
1982

which Warhol saw and which rapidly inspired him to do a series of paintings and drawings culled from de Chirico's own recycled works, including *The Disquieting Muses* (fig. 28).

First exhibited in Rome at the Campidoglio (November 20, 1982–January 31, 1983) as "Warhol verso de Chirico," the works were shown again in New York at the Marisa del Re Gallery (April 1985), where they offered, among other things, a bellwether statement of a different generation's growing enthusiasm for precisely that aspect of de Chirico's art which earlier generations had condemned.[23] In an interview with Achille Bonito Oliva, first published in 1982, Warhol, in his deadpan way, stated how much he loved the MoMA de Chirico show and how he had met the great artist in Venice many times, and then added: "I love his art and then the idea that he repeated the same paintings over and over again. I like that idea a lot, so I thought it would be great to do it."[24]

That, in fact, he did, offering his memorial tribute to de Chirico's own self-facsimiles, which by then had become so shuffled with their first versions that in Warhol's own serial re-creations of these canonic images—*Hector and Andromache, The Two Sisters, The Disquieting Muses,* among others—all questions of uniqueness and priority in de Chirico's art vanish, as we enter a new world of multiples in a free-floating image bank. De Chirico was not the only artist Warhol replicated—others, from Botticelli to Munch, may be added to the list—but surely the specific character of de Chirico's late work made him particularly appropriate to Warhol's own aesthetic of appropriation.[25]

The same may be said of a much younger American artist for whom the modernist condemnation of late de Chirico would be more of a plus than a minus. Of all the recent artists who practice variations upon the art of historic quotation, Mike Bidlo is surely the most absolute and, in his insistence on making his own painted replications, perhaps the most old-fashioned. Crafting what he hopes will be exact facsimiles of canonic works in the modern tradition, he has covered artists from Cézanne and Picasso to Pollock and Warhol; but as in the case of Warhol's own dialogues with the hero of this essay, no art has seemed as suitable for Bidlo's enterprise as de Chirico's. In 1990 (June 7–July 20), at the Galerie Daniel Templon, Paris, Bidlo organized the kind of de Chirico retrospective that the later twentieth century was beginning to demand, namely, the entire sweep of his work, which in this case meant from 1910 to 1969, including late replicas of his earlier classics (fig. 29). However, this twenty-eight-work retrospective was of course painted and drawn not by de Chirico, or even by de Chirico imitating himself, but by Bidlo.[26] With the help of this young American artist, the whole question of de Chirico's counterfeiting and falsely dating his own early works throughout his later career expanded into a metaphysical drama of identities worthy of Pirandello. And with this, the curtain may go down on Act II of de Chirico's influence on American art, leaving us to wonder what Act III will disclose.

"De Chirico's Long American Shadow." Published in *Art in America* 84, no. 7 (July 1996), pp. 46–55.

29.
Installation view of Mike Bidlo's exhibition "Bidlo (Not de Chirico)" at Galerie Daniel Templon, Paris, 1990

1. This is a somewhat reduced and altered version of a lecture given at Fordham University (November 22, 1991). In terms of de Chirico's European influence, there is now a full-scale treatment of this familiar theme (Wieland Schmied, *De Chirico und sein Schatten; metaphysische und surrealistische Tendenzen in der Kunst des 20. Jahrhunderts* [Munich: Prestel, 1989]), but the American aspect of the question is relatively unstudied. My own treatment here offers only the broadest overview, omitting, for example, in the earliest period, such different deductions from de Chirico as are found in the work of, say, Arthur Osver and Attilio Salemme, and in the latter period, what seem to be Philip Guston's unexpected borrowings from the master in his own late work, an influence kindly called to my attention by Mike Bidlo. For the most informed and up-to-date survey of the impact of Surrealism on American art, where de Chirico inevitably plays a role, see Jeffrey Wechsler, *Surrealism and American Art, 1931–1947* (New Brunswick, N.J.: Rutgers University Art Gallery, 1977).

2. When first exhibited and acquired, this painting was titled *Toys of a Prince,* but it was given both titles in MoMA's 1946 collections catalogue.

3. For further comments on Blume, Surrealism, and *Parade,* see Frank Anderson Trapp, *Peter Blume* (New York: Rizzoli, 1986), pp. 30, 37–39.

4. Sidney Janis, *Abstract and Surrealist Art in America* (New York: Reynal and Hitchcock, 1944), p. 111.

5. For this and other usefully specific information about the painting, see Patterson Sims, *Whitney Museum of Art: Selected Works from the Permanent Collection* (New York: Whitney Museum of American Art, 1985), p. 85.

6. See Lincoln Kirstein, *Paul Cadmus* (New York: Imago Imprint, 1984), pp. 85–88.

7. For a useful survey of Feitelson's career, see Jules Langsner, "Permanence and Change in the Art of Lorser Feitelson," *Art International,* September 25, 1963, pp. 73–76, where *Genesis #1* is discussed, and more recently, the exhibition catalogue *Lorser Feitelson and Helen Lundeberg* (San Francisco Museum of Modern Art, 1980). Feitelson and his wife, Lundeberg, on whose art de Chirico's shadow also fell, are well discussed in Wechsler, *Surrealism and American Art,* pp. 43–46.

8. See, for example, Robert Hobbs, *Edward Hopper* (New York: Harry N. Abrams, 1987), p. 56.

9. This and other factual comments about the painting offered here depend upon the discussion in Sims, *Whitney Museum,* p. 77.

10. Rossi's remarks are cited in Marvin Trachtenberg and Isabelle Hyman, *Architecture from Prehistory to Post-Modernism/The Western Tradition* (New York: Harry N. Abrams, 1986), p. 578.

11. By Donald Bear in the exhibition brochure *Ralston Crawford: Paintings* (Santa Barbara Museum of Art, 1946).

12. The artistic consequences of Gorky's study of this painting have often been discussed. See Harry Rand, *Arshile Gorky: The Implications of Symbols* (Montclair, N.J.: Allanheld and Schram, 1981), chap. IV; Diane Waldman, *Arshile Gorky, 1904–48: A Retrospective* (New York: Harry N. Abrams, 1981), pp. 29–32; and Jim Jordan and Robert Goldwater, *The Paintings of Arshile Gorky: Critical Catalogue* (New York and London: New York University Press, c. 1982), pp. 29–32, where John Graham's role in introducing Gorky to this work is suggested.

13. See ibid., p. 97, n. 98.

14. James Thrall Soby, *Giorgio de Chirico* (New York: Museum of Modern Art, 1955), p. 162.

15. "De Chirico by De Chirico," New York Cultural Center in association with Fairleigh Dickinson University, January 19–April 2, 1972, and Art Gallery of Ontario, June 16–July 16, 1972. Essay by Donald Karshan.

16. See *Giorgio de Chirico: Post-Metaphysical and Baroque Paintings, 1920–1970* (New York: Robert Miller Gallery, Apr. 25–May 19, 1984), with an essay by Robert Pincus-Witten that eloquently pleads the case for the later work.

17. Heinrich Klotz, *The History of Postmodern Architecture* (Cambridge, Mass.: MIT Press, 1984), p. 130. See also Gerald Allen, *Charles Moore* (New York: Whitney Library of Design, 1980), pp. 110–15.

18. See Maurizio Fagiolo dell'Arco, *L'opera completa di De Chirico, 1908–24* (Milan: Rizzoli, 1984), nos. 96, 102, 103, D30, D31.

19. On the AT&T Building, see *Philip Johnson/John Burgee: Architecture 1979–85* (New York: Rizzoli, 1985), pp. 40–53.

20. It was officially dedicated in 1984.

21. See William Rubin, "De Chirico and Modernism," in *De Chirico* (New York: Museum of Modern Art, 1982), pp. 55–80.

22. Ibid., pp. 74–75, reproduced in turn from *Critica d'Arte,* January–June 1979, pp. 11–13.

23. The most intelligent and sympathetic critical response to this show was by Kim Levin (Village Voice, May 7, 1985), reprinted in her *Beyond Modernism: Essays on Art from the '70s and '80s* (New York: Harper and Row, 1988), pp. 251–54.

24. See the catalogue *Warhol verso de Chirico* (Milan: Electa, 1982), p. 49.

25. For some earlier comments of mine on these works, see "Warhol as Art History," in Kynaston McShine, ed., *Andy Warhol, a Retrospective* (New York: Museum of Modern Art, 1989), p. 33.

26. The show was accompanied by a catalogue, *Bidlo (Not de Chirico),* with an excellent essay by Joseph Masheck, "The Pluperfection of de Chirico," pp. 31–38.

REMEMBRANCE OF FAIRS PAST
1989

For New Yorkers of my generation—I grew up in Manhattan during the Depression years—the thought of the New York World's Fair of 1939 is like the taste of Proust's madeleine or perhaps like deep analysis, a dizzy plunge into memory that, in this case, mixes one's own childhood with what now seems the childhood of our century. It was all, I recall, about the future; but then, what else would I be thinking about as my twelfth birthday approached in the summer of 1939? It was the moment, in fact, that I was anticipating eventual release from a Dickensian public school on Seventy-seventh Street and Amsterdam Avenue to the Elysian fields of the High School of Music and Art, way up on Convent Avenue. I had already had quite a few precocious glimmers of the World of Tomorrow, which for me suddenly took material shape when I fell in love with the wraparound streamlining that gave Cord cars a science-fiction modernity, or with the equally clean velocity of corner windows, open to the health-giving sun of Utopia, that marked the twin-tower Art Deco skyscrapers which loomed like cathedrals along Central Park West and carried *Brave New World* names like "The Century" and "The Majestic." And at a time when children could stroll more fearlessly in the city, I had already stumbled across the threshold of New York University's Museum of Living Art, down at Washington Square, and had seen pictures by Léger and Picasso, Miró and Mondrian that looked like blueprints for a future I hoped would be mine.

But all of these tremors of Things to Come were to turn, miraculously, into a total reality in the form of the Fair. Like something out of Buck Rogers or Flash Gordon, it was to land in Flushing Meadow in time for my own summer vacation of 1939. I remember the previews in the newspapers of extraterrestrial buildings that were called things like "Perisphere," "Futurama," "Trylon"; and as an early addict to roller coasters and amusement parks, I also stared in wonder at artists' renderings of strange new rides that would boggle the imagination of those who had only known the terrestrial pleasures of Coney Island and Palisades Amusement Park: the Bobsled, a version of greased lightning that would put wooden roller coasters back in a pre-industrial era, or the Parachute Jump, which promised the free-floating sublime, appropriate to the new era of space travel. Obsessed, I collected cuttings about the Fair from every imaginable source and then compiled them, with typed commentaries, for my grade-school scrapbook project, which I still preserve today in a plastic wrapper as a crumbling relic of my own history and the world's.

And then, eureka, the Fair opened! As soon as school closed, I rushed out to it on the Flushing IRT, being greeted, I recall, by the enchanted boardwalk of waving flags that led from the real-life grit of the subway to nothing less than the World of Tomorrow. And though I still find it hard to believe, I think I went out there by subway almost every single day of the summer holiday, rain or shine, returning exhausted and happy after sunset, having been dazzled by fireworks and colored beams against the night sky, but never so sated that I didn't long to return the next morning. For someone about to turn twelve and, I suspect, for everyone else too, the Fair was total, complete magic, and I couldn't rest content until I had seen absolutely everything not once, but again and again.

What a rush of memories! There was, above all, the exalting, cosmic Trylon and Perisphere (fig. 30), which announced the arrival on our planet of a new religion I would readily have given my life for. And what about General Motors' Futurama, the Fair's biggest hit? I remember how deliriously excited I was at those off moments when, say, the weather was so miserable or the time of day so offbeat that you could get right up the ramp without the usual two-hour wait; slip into a deeply comforting moving chair; listen to a wise, avuncular voice at your ear; and glide in rapture over a vista of Planet Earth, exploring a vision of promised technological happiness including, I'll never forget, an Amusement Park of the Future that featured a model of a roller coaster even more advanced than the Bobsled, made of—was I dreaming?—something like iridescent Lucite.

And then there was the shock of modernity in art. I remember to this day the thrill of the Finnish pavilion, whose fluid walls of billowing wood—designed, I learned much later, by the renowned Alvar Aalto—produced the same free-form delight I found in the first wiggling Mirós I had spied in Manhattan art museums; or the seductive invitation to Surrealism's

30.
Trylon and Perisphere,
World's Fair,
1939–40

forbidden fruits provided by Salvador Dalí in the facade of his Dream of Venus pavilion, which, for reasons I can't dredge up, I never entered. (Was I too young to get into this mix of sex and modern art, or was it just too expensive?) Am I right in thinking that I really stopped in my tracks before a mural on the Hall of Pharmacy that, in my later life as an art historian, I realized had been executed after a project by de Kooning; or that my ears perked up with excitement at the sound of music accompanying a puppet show in the Hall of Medicine, music that turned out to be by Aaron Copland? With all the other siren songs, Modern Art, Modern Architecture, Modern Music beckoned me into the future.

Like the happiest of homeless people in Utopia, I somehow managed to live at, not visit, the New York World's Fair, still dreaming of it in my Manhattan bedroom. With the shrewdness of a street child, I soon learned that I could virtually have all my meals there free, by discovering which of the many concessions gave out samples. Just as RCA Victor seemed to have a complete set of its bound classical 78-rpm albums, any one of which could be heard at length for the asking, so, too, did the Heinz Dome have samples—could it possibly have been of *all* of its 57 varieties?—available for tasting. And for edible bounty, the Food Building was another free-for-all supermarket for children and paupers, where dessert could be picked up at the "Junket Folks" or, if you were old enough, even a time-saving new product, instant coffee, could be savored. And if a free gulp of milk was wanted, there was always the Borden Company, with its "Rotolactor" merry-go-round of hygienic cows being milked mechanically under the caring reign of its superstar, the photogenic Elsie the Cow, a prototype for Andy Warhol's bovine starlet from a far less ingenuous era, the 1960s.

As for technology, it could conquer not only such archaic chores as milking cows, but also washing dishes in modern kitchens. At the Westinghouse Building (competing with General Electric), I often watched a hilarious skit that involved two women who demonstrated the before-and-after of mechanized happiness. One was a comedienne, à la Joan Davis, who, up to her shoulders in suds, frantically and clumsily washed—and often broke—a staggering load of glasses, china, and flatware. During this slapstick routine, the other housewife enjoyed the blessings of machine-made leisure while a Westinghouse dishwasher took care of her household duties, permitting her to read, in extravagant comfort, a stack of magazines. (Do I remember the *Ladies Home Journal* in the pile?) Such was the women's liberation promised in 1939 by the prophets of the Machine Age!

There was other technological entertainment, too, in the Bell Telephone exhibit, where you were permitted to enter a lottery and, should you be lucky enough to win, to be privileged to telephone long-distance any place in the USA—a luxurious modern dream come true, the catch being that everybody could listen in to the winning phone call on the phones provided by Ma Bell. I still recall the goose pimples when I won at the draw, and the vast public humiliation when I couldn't think of any place farther away to telephone than Connecticut, where my sister was summering at camp. Had I only been sophisticated enough to know someone in faraway California, a sure passport to glamour!

As for other entertainments, who could forget the scary moment when, wandering through the New York Amphitheater, I accidentally found an unlocked door that gave me illegal, unticketed access to, lo and behold, the prohibitively expensive (was it forty cents?) show of shows, Billy Rose's Aquacade. Suddenly, way down below, before my eyes, was the

watery spectacle of Eleanor Holm, the central cog in a fabulous geometric wheel of gyrating aquabelles whose star-shaped, snow-flaked patterns echoed the great Busby Berkeley productions I thought could exist only in the two-dimensional fantasy of a movie envisioned in remote Hollywood.

Still more exotic, the Fair offered most of us, young and old, our first glimpses of countries that we had only seen or heard about in movies and schoolbooks. Who would bother to notice that Germany was absent, when Poland, Iraq, Venezuela, Australia, and every other country were there? And after seeing Japan, Italy, and the Soviet Union on parade together in this pageant of international harmony, I can begin to understand why many Americans still have trouble deciding who was fighting whom during World War II, which broke out, it seemed, on another planet just before Labor Day and only weeks before the Fair closed for the season in 1939, to reopen, minus the Soviet pavilion, in 1940.

Twenty-five years later, I returned to the New York World's Fair, again riding on the tracks of the same old Flushing IRT; but by 1964, everything else, from me to the twentieth century, had changed. The World of Tomorrow we had counted on in 1939 had evaporated together with Hiroshima, and only fools and hopeless provincials could look with wide-eyed hope at the future of modernity and the blessings of the Machine Age. Pop Art was only two years old, and its poker-faced ironies—if you can't lick it, join it—somehow set the stage for my own return to Flushing's version of Arcadia. I loved the 1964 Fair, too, but for the totally new reason that it provided an extravagant surplus of outrageous kitsch, where the collision of postwar realities and prewar fantasies gave one the choice of weeping or smiling. I chose to smile, and there was a lot to smile about. Did I dream it, or was there really a dead-serious movie in the Mormon pavilion about Life After Death, in which blessed souls were filmed ankle-deep in stage smoke? I recall yet another evangelical display about spiritual harmony and the peaceable kingdom which demonstrated its point by a zoolike enclosure in which one could see cohabiting living specimens of a black man and a white woman together with the most oddball variety of house pets and farm animals, or has my memory gone over the edge? Then there was the meal I had at the African pavilion, which consisted entirely of dishes made with peanuts (peanut soup, chicken with peanut sauce, salad with peanut dressing, and peanut ice cream). And I remember, too, a building called the Hall of Free Enterprise, with a screen facade of a freestanding Greek Doric colonnade on whose architrave was inscribed "The Greatest Good for the Greatest Number," a design that was either the last surviving insult to the ardent spirit of Machine Age architecture, so fantasized at the 1939 Fair, or the first straw in the campier winds of postmodernism. The giggling never seemed to stop, even though there were such nods in the direction of right-thinking modernity as Philip Johnson's festive New York State pavilion, and more seriously, the murals Johnson commissioned for it from Andy Warhol, the *Thirteen Most Wanted Men,* which, proving too disturbingly real to survive the Fair's glut of superannuated American dreams, were whitewashed over.

The perfect comments, both grave and smiling, about this moment of disillusion came, in the mid- and late sixties, from James Rosenquist in his *F-111* wraparound mural and from Roy Lichtenstein in his own mural commentaries on the end of the era of progress, *Preparedness* (see fig. 121) and *Peace through Chemistry.* The Age of Innocence had disappeared forever, mine and the century's. Today, twenty-five more years later, even the ironies

of the sixties seem remote, replaced by a World of Tomorrow too chilling to contemplate, except perhaps as safely embalmed at Epcot, with its perfect but hollow simulation of the form and spirit of 1939. As for that form and spirit, I often think of these ghosts on the way to the airport or to Long Island, catching from a swiftly moving car the archaeological site of Flushing Meadow, where one can still see, miraculously surviving, like Roman temples after the fall, scattered, lonely buildings from both fairs that once symbolized the power of New York City and New York State. And way off in the distance, one can still glimpse from the Belt Parkway the spidery silhouette of the Parachute Jump (fig. 31), transported to Coney Island after its initial glory at the 1939 Fair and now left an inert, monumental ruin, at the edge of both land and sea.

"Remembrance of Fairs Past." Published in *Remembering the Future: The New York World's Fair from 1939 to 1964* (New York: The Queens Museum, 1989), pp. 11–18.

31.
Life Savers Parachute Jump,
New York World's Fair,
1939–40

AMERICAN PAINTING
SINCE THE SECOND WORLD WAR
1958

From its seventeenth-century beginnings through the Second World War, America produced no artist of sufficiently high stature to affect profoundly, in respect to quality or to historical innovation, the course of Western painting. Even the possible exceptions to this statement—Benjamin West and James Abbott McNeill Whistler—worked in a European and not an American milieu, so that the phenomenon of the last decade, in which American painting abruptly emerged as a school of major international importance, appears all the more startling, both to Europeans and Americans. In fact, it could well be contended that not since the invention of Cubism in Paris has Western painting undergone such fundamental reorientations as it has in the hands of some half-dozen Americans working recently in New York.

To explain the background of this traumatic reversal of America's earlier artistic provincialism, one must refer primarily to the upheaving cultural migrations from Europe to America that occurred during and after the Nazi terror. In the late 1930s and early 1940s, such masters as Tanguy, Hélion, Mondrian, Léger, Matta, and Lipchitz visited America or settled there. But of perhaps even greater impetus were the activities of American museums. In particular, the Museum of Modern Art provided, as it still does today, the richest and most diverse selection of contemporary European art to be seen in a public collection anywhere in the world. By the end of the war, in fact, the mainspring of artistic vitality seems to have shifted to America and, more specifically, to New York.

Nevertheless, the first tremors of new life appear to have been felt in the geographical and artistic periphery of America, the Northwest Pacific coast. There, facing the Orient and contemplating the remote, untrammeled landscape of pine, rock, and sea, Mark Tobey (1890–) evolved a most personal style that already prophesied the Eastern developments to follow. In *White Night* (1942; fig. 32), for example, Tobey explored a new vocabulary in which a wind-blown, gossamer line spins out a fragile web whose labyrinthine structure undermines that quality of major and minor accent and value contrasts that pertained even to the most diffusely organized paintings of Analytic Cubism. Furthermore, Tobey's images conveyed a kind of nature mysticism that saw matter in terms of teeming, infinite energies suggestive of twinkling constellations, bird migrations, seed fertilizations, or sweeping winds—an imagery, that is, which likewise foreshadows the insistence on endless change,

32.
Mark Tobey,
White Night,
1942

impulse, and activity common to so many artists of the New York School. Yet for all its pre-monitory character, Tobey's art is distinctly unlike that of his younger Eastern contempo-raries. Meditative and miniaturist, it seems like a minor extension of Klee's precious and intimate sensibilities rather than a direct forerunner of the raw violence and extroverted, heroic scale that soon erupted in and around New York.

New York offered not only the opportunity to see the work of the great European mas-ters; it was also the city where two European-born artists, Arshile Gorky (1905–1948) and Hans Hofmann (1880–)—Armenian and German, respectively—produced and exhibited their major works. In fact, the art of these immigrants, which essentially remained that of transplanted Europeans rather than of assimilated Americans, offered a kind of connective link to the native-born generation. Gorky's tragic late work of 1946–48 opened new possi-bilities of pictorial freedom that transcended even the most impetuous calligraphy and emo-tional immediacy of the early Kandinsky; and in Hans Hofmann's art, a whole grammar of the new style was elucidated, not only in his pictures themselves but through his influential activities as a teacher in New York. In a work like *Birth of Taurus* (1945; fig. 33), Hofmann already posits the explosive liberty of paint handling, with its scrawling line, ragged smears, and colors fresh from the tube—features that transform the canvas into an area in which the artist unleashes his energies and emotions, painting from the shoulder and not the hand,

33.
Hans Hofmann,
Birth of Taurus,
1945

from the heart and not the head. The fact of the matter, though, is that Hofmann's art is ulti-mately disciplined in a rigorous way; paradoxically, his intellectual control is at times so strong that we almost feel a discrepancy between the primitive fury implied by his shapes and colors and the methodical, inquiring mind that orders them.

In the case of the short-lived Jackson Pollock (1912–1956), however, we are faced with no such ambiguity of didactic intention, for Pollock's work offers the most vehement, full-blooded statement of the tragic, challenging character of so much recent American art. His *She-Wolf* of 1943 (fig. 34) is almost contemporary with Hofmann's *Birth of Taurus* and even offers a comparable subject of bestial savagery that similarly demands an expressionist treatment of paint. A combination of fangs, blood, and moonlight, Pollock's she-wolf writhes and bristles with a ferocity that becomes, like the animals of Géricault and Delacroix, a pro-jection of the artist's own agitated spirit. Within a few years, Pollock carried these turbulent impulses to an even more dramatic extreme. His paintings began to be executed by dripping paint down upon the canvas, which was laid on the floor, so that the swirling skeins of pig-ment could become an even more direct projection of the artist's momentary feelings. This technical innovation exalted the tragic loneliness of the artist to a radical degree; for now, his art seemed to refer to nothing but the autobiographical record in paint of his own passion, enlarged to so vast a size that it could create an all-engulfing environment. Yet if Pollock's art were simply this, it would only be a cultural or psychological document. Just as the French Impressionists transformed what was the ostensible chaos of rough dabs of paint and unmixed colors into art, so too did Pollock discipline his new techniques. His genius resided

34.
Jackson Pollock,
The She-Wolf,
1943

precisely in his ability to convert his drippings into pictures whose sureness of spatial control in their dense, breathing layers of tangled paint, and whose overall, inexhaustible activity are all the more masterful and conspicuous in quality by contrast with his many imitators. And in addition to his pictorial diversity, his emotional range is comparably broad, moving from moods of surging despair to buoyant, lyrical exuberance. Furthermore, such works as *Composition No. 1, 1949* (see fig. 46 for a similar example) even offer a fascinating imagery which implies all the unimaginable complexity and energy of some phenomenon of nature, viewed either through a microscope or a telescope. Indeed, in later works of Pollock this natural imagery becomes even more explicit. The very title of *Ocean Greyness* (1953; fig. 35), a picture of churning, watery whirlpools, bears this out.

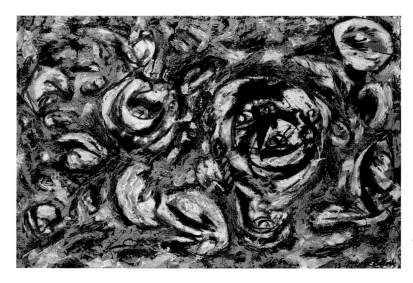

35.
Jackson Pollock,
Ocean Greyness,
1953

The torrential force of Pollock's art is by no means singular. An older master, Willem de Kooning (1904–), born in Holland, likewise investigated the problem of unleashing and then recapturing a vocabulary premised upon flux and impulse. In *Queen of Hearts,* an early work of 1943, the contours that bind the figure are already threatened and the inner color areas begin to slip out of the loosening lines that contain them. The rebellious energies implied by this work are more fully released by the late 1940s; and in a picture like *Attic* (c. 1949; fig. 36), the canvas becomes a track of dynamic outbursts, though the interlocking of black-and-white areas suggests more the tightly woven planar structure of Cubism than the new linear freedom of Pollock's compositions. At the same time, de Kooning began a notable series on the theme of Woman (see fig. 49), in which he carried even further the grotesque, sadistic distortions of the female form that Picasso had begun to explore in the late 1920s. De Kooning's women seem to have coalesced from the lacerating, savage fury that envelops them, as if they were some terrifying Venus of prehistory or a monstrous visualization of the id. But even more, they allude to a specifically American phenomenon; their emphasis on pink flesh, scarlet cosmetics, and assertive sexuality is almost a parody of the popular American ideal of feminine beauty, as embodied by Jayne Mansfield or Marilyn Monroe.

Such a vigorous assault on popular myths speaks for the peculiar isolation of American artists before the growing threat of mass culture. The character of most recent painting affirms this desperate individuality by which the artist would create an exclusive pictorial world divested of everything but some primitive, unspoiled sensation. Most major painting of the 1950s, in fact, goes far beyond de Kooning or even Pollock in the absolute simplicity of its statement. For example, the austere vocabulary of black and white sometimes used by de Kooning (and earlier, by Mondrian) is often employed by other, even more venturesome

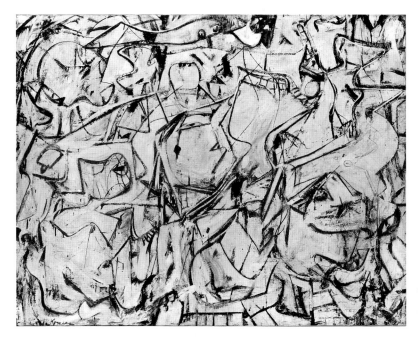

36.
Willem de Kooning,
Attic,
c. 1949

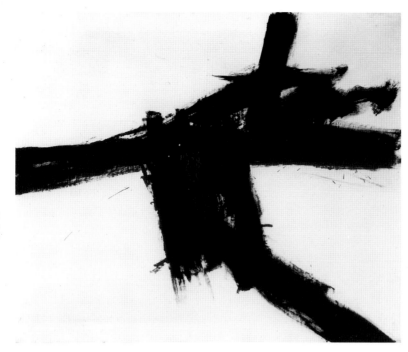

37.
Franz Kline,
Buttress,
1956

artists. The language of Franz Kline (1910–) is reduced almost exclusively to an enormous black scrawl on a white ground, with effects so powerful and rudimentary that they resemble anguished magnifications of a detail from de Kooning. Pictures like *9th Street* (1951) or *Buttress* (1956; fig. 37) offer, as it were, an indivisible nugget of pictorial energy, an explosive core that spreads raggedly beyond the picture's borders. Yet ironically, as in the case of Mondrian, the less such pictures contain, the more sensibility and sophistication are demanded of the spectator. Thus, in Kline's work, every nuance must be considered, whether it be the visual interplay of a black image on a white ground versus the negative white image on a black ground, or the shallow spatial layers suggested by the strident overlapping of brushwork. To speak of Kline is to be reminded of his French counterpart, Pierre Soulages. But if anything, a comparison of the two artists reveals the peculiarly vehement, harsh flavor of Kline as opposed to the suaver, more elegant order the Frenchman creates from a comparably elementary vocabulary.

Something of that lucidity and decorum in the French tradition is evident in another American master of black and white, Robert Motherwell (1915–). In his *At Five in the Afternoon* (1949; fig. 38), he knowingly balances a broad regularity of structure with a subtle irregularity of detail, as well as offering a brilliant equilibrium of light and dark that is richly evocative of some imminent drama.

In general, however, most American artists take more chances than Motherwell, achieving their impact by risking the most astonishing pictorial heresies. Rarely before in our already heretic century has so much been dared and so much been won. Broadly speaking, the most courageous of these artists explore, like Pollock or Kline, the effect of reducing a

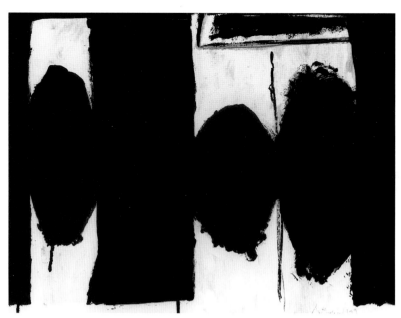

38.
Robert Motherwell,
*At Five in the
Afternoon,*
1949

pictorial vocabulary to a minimal statement, as a result of which each artist has been readily identified with a single, irreducible style. For example, the work of Philip Guston (1912–) appears to be an excerpt from a Monet enlarged to disarming proportions; and its enjoyment depends upon the most refined perception of exquisite modulations of color and brushwork that weave out a quivering mesh of paint which, like an Impressionist canvas, glitters and vibrates rather than delineating ordered relationships in depth. In so concentrating on the drama of a sensuous expanse of paint, Guston, like other Americans, has helped to reverse previously negative critical attitudes toward the late Monet as well as the late Turner, whose works, judged by eyes accustomed to Cubism, may seem defectively vaporous and undisciplined, stressing surface rather than spatial structure.

The hedonistic qualities of Guston's art suggest how ill-suited are the familiar terms "Abstract Expressionism" and "Action Painting" to categorize the recent innovations in American painting; for the elements of violence and impetuousness, so evident in Pollock, de Kooning, and Kline, are by no means all-pervasive in the masters generally included in this group. Action or expressionism is utterly absent, for example, in the awesome canvases (see fig. 43) of Mark Rothko (1903–), which achieve their potency by virtue of such opposite sensations as stillness and meditation. What these pictures share with their contemporaries is the more common denominator of a rudimentary vocabulary expressed in a size that usually transcends the conventional proportions of easel painting. In evolutionary terms, too, Rothko's art conforms exactly to his compatriots' developments; for like them, its mature phase did not emerge fully until the late 1940s, a period of a few years in which virtually every one of these masters brought intimations of originality into sudden fruition. Indeed, not since the years around 1910 has there been so strong a confirmation of a zeitgeist that could awaken in diverse artists a communal spirit of radical innovation.

An early Rothko such as *Vessels of Magic* (c. 1947) demonstrates a premature phase of his art comparable to Pollock's *She-Wolf*. Rooted to a nature mysticism analogous to Tobey's, it seems to be on the verge of discovery in its daring reflections and surprising equilibrium of fragile, horizontal striations. But soon Rothko reached a more absolute statement, producing a series of enormous canvases composed generally of several tiers of thin, glowing paint that attain a rare sensuous and poetic magic. These vast icons have at times the orange and yellow luminosity of high noon, or on other occasions the blue and black mysteries of a moonlit night. Or they may suggest, too, the eternal presence of sky and earth, air and water, as well as offering a sensuous spectacle of quietly burning colors whose mystery is both completely apparent in the remarkable simplicity of a few tiers of light and impossibly remote in the concealment evoked by the dense, vaporous effects of his tinted, rectangular clouds of paint.

Adolph Gottlieb (1903–) is another artist whose vision is involved with a mystic conception of nature. In his early style, he worked with what were usually called "pictographs," compartmenting his canvases into layers of hieroglyphs which, like the paintings of the Uruguayan Torres-García, resemble the magical legends of some archaic race. A case in point is *The Seer* (1950), whose totemic organization of arrows, hands, eyes, circles, and rectangles suggests a primitive oracle's black rituals. But in the 1950s, Gottlieb, like his compatriots, moved toward a more severely restricted vocabulary, though rarely with their single-minded directness. In recent years he has produced a new, startling kind of landscape, which sets into tension a plane of earth and a group of astronomical bodies above, thereby achieving a taut, dynamic equilibrium that parallels the eternal magnetism of a satellite in its orbit. And just last year, Gottlieb reduced these fundamentals to an even more arresting simplicity. In a picture like *Blast I* (1957; fig. 39), a vertical opposition is set up between one colored stellar body and a black explosion below, re-creating something of the elemental contrast of natural forces in Oriental art, but offering a dynamic, heroic inflection and a breadth of scale that are unmistakably Western in feeling.

For perhaps even more courageous investigations into this pictorial style that alternates dangerously between everything and nothing, one must turn to the work of Clyfford Still (1904–) and Barnett Newman (1905–). Even to eyes accustomed to the most disarming enlargements of what would seem to be pictorially primitive ideas, the work of Still and Newman comes as something of a shock. Still will cover giant canvases with a spreading, ominous black, whose ragged, trembling edges seem to threaten the few adjacent color areas like a cancerous growth. The structure of these commandingly large surfaces is fascinatingly unpredictable; their arid, dry pigments expand and flake like the bark of a tree. Above all, they impose their strange world upon the spectator by virtue of their sheer size and their insistent unwillingness to relax into any earlier conventions of picture-making.

Newman's work (see fig. 47) presents a comparably heroic isolation in the face of the past, as if the only way for the artist to assert an honest, independent viewpoint was to rid himself of all pictorial traditions and to stand perpetually at the brink of something unknown. In the case of Newman, the canvas is an enormous expanse of flat, unmodulated color interrupted only once or twice at some wholly unexpected point by a thin, tremulous line or a broad, assertive one. Even more than Still's or Rothko's, Newman's world is frightening in its implications, standing at the very extremity of the boundary beyond which there

39.
Adolph Gottlieb,
Blast I,
1957

is nothing. It has the quality of an ultimate, sacrificial gesture in the face of a completely hostile environment.

Before the visual impact of such innovations, the spectator is constantly forced to abandon preconceptions, for the essence of the most vigorous recent American art is heretic and anti-traditional. Generally, these paintings are larger than any earlier easel paintings and contain very much less, yet at the same time they offer richer rewards and pose more challenging ideas than any pictorial transformation since Cubism. The difficulties of assimilating this new style, however, are not only the tasks of the spectator but those of the artist as well. One of the major problems of this art has been that of sustaining its power over a period of years. But the innovators—all of whom, it should be mentioned, were in their thirties or even forties at the time their art so quickly matured and most of whom had worked earlier in different, often even contradictory styles—have had difficulty in maintaining a high level of achievement with an art whose every statement has the character of a final, absolute simplification. In a century when the tempo of artistic change is increasingly rapid, a major artist is at constant pains to make consistently relevant paintings, and one wonders over how long a period masters like Rothko or Kline can uphold their vitality without making a change as radical as that which engendered their initial statements of the 1950s.

For the younger generation the problem is quite as acute. Artists in their twenties or early thirties have emerged too late to take part in the preliminary definitions of this new style and, in general, are obliged to work out minor and more complex variations on the stark themes stated by their elders. The sheer quantity of talent among these younger artists is encouraging—there has probably never been so high a level of good painting in this country (though the expressionist vocabulary of Hofmann, Pollock, and de Kooning has also produced a host of inept followers)—yet none of them as yet seems to have elucidated a viewpoint as forceful and original as that of their masters. Considering the vast number of impressive new painters, it would be unjust to single out a list of promising names. To characterize the flavor of this generation, however, one might point, for example, to Corrado Marca-Relli's *The Battle* (1956), which provides a brilliant reprise of de Kooning, but adds to it the specific imagery of horses, lances, and armed warriors in a pageant that recalls the patterned disciplines of Uccello's battle scenes. Marca-Relli's close reference to particular objects is characteristic of many younger painters, who often attempt now to combine the more violent, explosive vocabulary of the innovators with a precise grasp of the seen world, so that one is confronted at times with a style that looks like a rough-hewn Impressionism.

It is hazardous, however, to assess the nature and importance of the generation that follows the masters of 1950. Today one can only be certain that exactly in the middle of a century of growing cultural crises, American art produced the most heroic and original assertions of the artist's freedom to feel and to invent in the face of moribund traditions and multitudes of mediocrity.

"American Painting Since the Second World War." Previously unpublished in English. First published, as "La peinture américaine depuis la seconde guerre mondiale," in *Aujourd'hui: Art et architecture* 3, no. 18 (July 1958), pp. 12–18.

THE ABSTRACT SUBLIME

1961

I t's like a religious experience!" With such words, a pilgrim I met in Buffalo last winter attempted to describe his unfamiliar sensations before the awesome phenomenon created by seventy-two Clyfford Stills at the Albright Art Gallery. A century and a half ago, the Irish Romantic poet Thomas Moore also made a pilgrimage to the Buffalo area, except that his goal was Niagara Falls. His experience, as recorded in a letter to his mother, July 24, 1804, similarly begged prosaic response:

> I felt as if approaching the very residence of the Deity; the tears started into my eyes; and I remained, for moments after we had lost sight of the scene, in that delicious absorption which pious enthusiasm alone can produce. We arrived at the New Ladder and descended to the bottom. Here all its awful sublimities rushed full upon me. . . . My whole heart and soul ascended towards the Divinity in a swell of devout admiration, which I never before experienced. Oh! bring the atheist here, and he cannot return an atheist! I pity the man who can coldly sit down to write a description of these ineffable wonders: much more do I pity him who can submit them to the admeasurement of gallons and yards. . . . We must have new combinations of language to describe the Fall of Niagara.

Moore's bafflement before a unique spectacle, his need to abandon measurable reason for mystical empathy, are the very ingredients of the mid-twentieth-century spectator's "religious experience" before the work of Still. During the Romantic movement, Moore's response to Niagara would have been called an experience of the "Sublime," an aesthetic category that suddenly acquires fresh relevance in the face of the most astonishing summits of pictorial heresy attained in America in the last fifteen years.

Originating with Longinus, the Sublime was fervently explored in the later eighteenth and early nineteenth centuries and recurs constantly in the aesthetics of such writers as Burke, Reynolds, Kant, Diderot, and Delacroix. For them and for their contemporaries, the Sublime provided a flexible semantic container for the murky new Romantic experiences of awe, terror, boundlessness, and divinity that began to rupture the decorous confines of earlier aesthetic systems. As imprecise and irrational as the feelings it tried to name, the Sublime could be extended to art as well as to nature. One of its major expressions, in fact, was the painting of sublime landscapes.

40.
James Ward,
Gordale Scar,
1811–15

A case in point is the dwarfing immensity of Gordale Scar, a natural wonder of York-shire and a goal of many Romantic tourists. Re-created on canvas between 1811 and 1815 by the British painter James Ward (1769–1855), *Gordale Scar* (fig. 40), is meant to stun the spectator into an experience of the Sublime that may well be unparalleled in painting until a work like Clyfford Still's (fig. 41). In the words of Edmund Burke, whose *Philosophical Enquiry into the Origin of Our Ideas of the Sublime and the Beautiful* (1757) was the most

41.
Clyfford Still,
Untitled,
1958

influential analysis of such feelings, "Greatness of dimension is a powerful cause of the sublime." Indeed, in both the Ward and the Still, the spectator is first awed by the sheer magnitude of the sight before him. (Ward's canvas is 131 x 166 inches; Still's, 114 ½ x 160 inches.) At the same time, his breath is held by the dizzy drop to the pit of an abyss; and then, shuddering like Moore at the bottom of Niagara, he can only look up with what senses are left him and gasp before something akin to divinity.

Lest the dumbfounding size of these paintings prove insufficient to paralyze the spectator's traditional habits of seeing and thinking, both Ward and Still insist on a comparably bewildering structure. In the Ward the chasms and cascades whose vertiginous heights transform the ox, deer, and cattle into lilliputian toys are spread out into unpredictable patterns of jagged silhouettes. No laws of man or man-made beauty can account for these God-made shapes; their mysterious, dark formations (echoing Burke's belief that obscurity is another cause of the Sublime) lie outside the intelligible boundaries of aesthetic law. In the Still, Ward's limestone cliffs have been translated into an abstract geology, but the effects are substantially the same. We move physically across such a picture like a visitor touring the Grand Canyon or journeying to the center of the earth. Suddenly, a wall of black rock is split by a searing crevice of light, or a stalactite threatens the approach to a precipice. No less than caverns and waterfalls, Still's paintings seem the product of eons of change; and their flaking surfaces, parched like bark or slate, almost promise that this natural process will continue, as unsusceptible to human order as the immeasurable patterns of ocean, sky, earth, or water. And not the least awesome thing about Still's work is the paradox that the more elemental and monolithic its vocabulary becomes, the more complex and mysterious are its effects. As the Romantics discovered, all the sublimity of God can be found in the simplest natural phenomena, whether a blade of grass or an expanse of sky.

In his *Critique of Judgment* (1790) Kant tells us that whereas "the Beautiful in nature is connected with the form of the object, which consists in having boundaries, the Sublime is to be found in a formless object, so far as in it, or by occasion of it, *boundlessness* is represented" (I, Book 2, §23). Indeed, such a breathtaking confrontation with a boundlessness in which we also experience an equally powerful totality is a motif that continually links the painters of the Romantic Sublime with a group of recent American painters who seek out what might be called the "Abstract Sublime." In the context of two sea meditations by two great Romantic painters, Caspar David Friedrich's *Monk by the Sea* of about 1809 (fig. 42) and Joseph Mallord William Turner's *Evening Star* (fig. 43), Mark Rothko's paintings reveal affinities of vision and feeling. Replacing the abrasive, ragged fissures of Ward's and Still's real and abstract gorges with a no less numbing phenomenon of light and void, Rothko, like Friedrich and Turner, places us on the threshold of those shapeless infinities discussed by the aestheticians of the Sublime. The tiny monk in the Friedrich and the fisher in the Turner establish, like the cattle in *Gordale Scar,* a poignant contrast between the infinite vastness of a pantheistic God and the infinite smallness of His creatures. In the abstract language of Rothko, such literal detail—a bridge of empathy between the real spectator and the presentation of a transcendental landscape—is no longer necessary; we ourselves are the monk before the sea, standing silently and contemplatively before these huge and soundless pictures as if we were looking at a sunset or a moonlit night. Like the mystic trinity of sky, water,

42.
Caspar David Friedrich,
Monk by the Sea,
c. 1809

43.
J. M. W. Turner,
Evening Star,
c. 1830–40

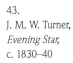

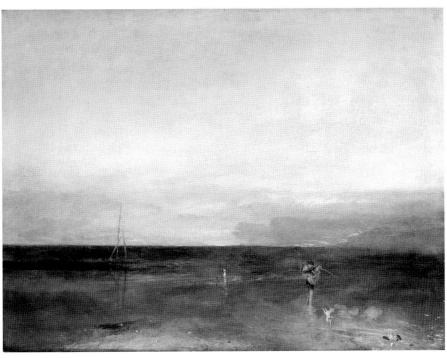

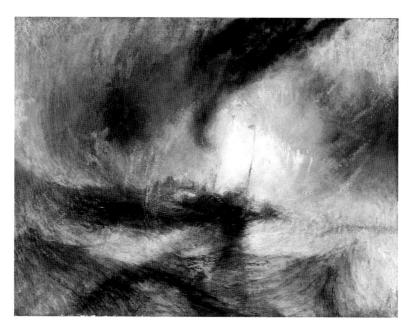

44.
J. M. W. Turner,
Snowstorm,
exhibited 1842

and earth that, in the Friedrich and Turner, appears to emanate from one unseen source, the floating, horizontal tiers of veiled light in the Rothko seem to conceal a total, remote presence that we can only intuit and never fully grasp. These infinite, glowing voids carry us beyond reason to the Sublime; we can only submit to them in an act of faith and let ourselves be absorbed into their radiant depths.

If the Sublime can be attained by saturating such limitless expanses with a luminous, hushed stillness, it can also be reached inversely by filling this void with a teeming, unleashed power. Turner's art, for one, presents both of these sublime extremes. In his *Snowstorm* (fig. 44), first exhibited in 1842, the infinities are dynamic rather than static, and the most extravagant of nature's phenomena are sought out as metaphors for this experience of cosmic energy. Steam, wind, water, snow, and fire spin wildly around the pitiful work of man—the ghost of a boat—in vortical rhythms that suck one into a sublime whirlpool before reason can intervene. And if the immeasurable spaces and incalculable energies of such a Turner evoke the elemental power of creation, other work of the period grapples even more literally with these primordial forces. Turner's contemporary John Martin (1789–1854) dedicated his erratic life to the pursuit of an art which, in the words of the *Edinburgh Review* (1829), "awakes a sense of awe and sublimity, beneath which the mind seems overpowered." Of the cataclysmic themes that alone satisfied him, *The Creation,* an engraving of 1831 (fig. 45), is characteristically sublime. With Turner, it aims at nothing short of God's full power, upheaving rock, sky, cloud, sun, moon, stars, and sea in the primal act. With its torrential description of molten paths of energy, it locates us once more on a near-hysterical brink of sublime chaos.

That brink is again reached when we stand before a *perpetuum mobile* of Jackson Pollock, whose gyrating labyrinths re-create in the metaphorical language of abstraction the superhuman turbulence depicted more literally in Turner and Martin. In *Number 1A, 1948*

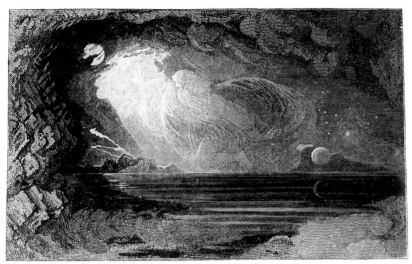

45.
John Martin,
The Creation,
1831

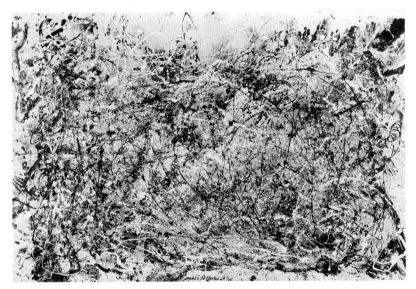

46.
Jackson Pollock,
Number 1A, 1948,
1948

(fig. 46) we are as immediately plunged into divine fury as we are drenched in Turner's sea; in neither case can our minds provide systems of navigation. Again, sheer magnitude can help produce the Sublime. Here, the very size of the Pollock—68 x 104 inches—permits no pause before engulfing; we are almost physically lost in this boundless web of inexhaustible energy. To be sure, Pollock's generally abstract vocabulary allows multiple readings of its mood and imagery, although occasional titles (*Full Fathom Five, Ocean Greyness, The Deep, Greyed Rainbow*) may indicate a more explicit region of nature. But whether achieved by the most blinding of blizzards or the most gentle of winds and rains, Pollock's work invariably evokes the sublime mysteries of nature's untamable forces. Like the awesome vistas of telescope and microscope, his pictures leave us dazzled before the imponderables of galaxy and atom.

The fourth master of the Abstract Sublime, Barnett Newman, explores a realm of sublimity so perilous that it defies comparison with even the most adventurous Romantic explorations into sublime nature. Yet it is worth noting that in the 1940s Newman, like Still, Rothko, and Pollock, painted pictures with more literal references to an elemental nature; and that more recently, he has spoken of a strong desire to visit the tundra, so that he might have the sensation of being surrounded by four horizons in a total surrender to spatial infinity. In abstract terms, at least, some of his paintings of the 1950s already approach this sublime goal. In its all-embracing width (114½ inches), Newman's *Vir Heroicus Sublimis* (fig. 47) puts us before a void as terrifying, if exhilarating, as the arctic emptiness of the tundra; and in its passionate reduction of pictorial means to a single hue (warm red) and a single kind of structural division (vertical) for some 144 square feet, it likewise achieves a simplicity as heroic and sublime as the protagonist of its title. Yet again, as with Still, Rothko, and Pollock, such a rudimentary vocabulary creates bafflingly complex results. Thus the single hue is varied by an extremely wide range of light values; and these unexpected mutations occur at

47.
Barnett Newman,
Vir Heroicus Sublimis,
1950–51

intervals that thoroughly elude any rational system. Like the other three masters of the Abstract Sublime, Newman bravely abandons the securities of familiar pictorial geometries in favor of the risks of untested pictorial intuitions; and like them, he produces awesomely simple mysteries that evoke the primeval moment of creation. His very titles (*Onement, The Beginning, Pagan Void, Death of Euclid, Adam, Day One*) attest to this sublime intention. Indeed, a quartet of the largest canvases by Newman, Still, Rothko, and Pollock might well be interpreted as a post–Second World War myth of Genesis. During the Romantic era, the sublimities of nature gave proof of the divine; today, such supernatural experiences are conveyed through the abstract medium of paint alone. What used to be pantheism has now become a kind of "paint-theism."

Much has been written about how these four masters of the Abstract Sublime have rejected the Cubist tradition and replaced its geometric vocabulary and intellectual structure with a new kind of space created by flattened, spreading expanses of light, color, and plane. Yet it should not be overlooked that this denial of the Cubist tradition is not only determined by formal needs, but also by emotional ones that in the anxieties of the atomic age suddenly

seem to correspond with a Romantic tradition of the irrational and the awesome as well as with a Romantic vocabulary of boundless energies and limitless spaces. The line from the Romantic Sublime to the Abstract Sublime is broken and devious, for its tradition is more one of erratic, private feeling than submission to objective disciplines. If certain vestiges of sublime landscape painting linger into the later nineteenth century in the popularized panoramic travelogues of Americans like Bierstadt and Church (with whom Dore Ashton has compared Still), the tradition was generally suppressed by the international domination of the French tradition, with its familiar values of reason, intellect, and objectivity. At times, the counter-values of the Northern Romantic tradition have been partially reasserted (with a strong admixture of French pictorial discipline) by such masters as van Gogh, Ryder, Marc, Klee, Feininger, Mondrian; but its most spectacular manifestations—the sublimities of British and German Romantic landscape—have only been resurrected since 1945 in America, where the authority of Parisian painting has been challenged to an unprecedented degree. In its heroic search for a private myth to embody the sublime power of the supernatural, the art of Still, Rothko, Pollock, and Newman should remind us once more that the disturbing heritage of the Romantics has not yet been exhausted.

"The Abstract Sublime." Published in *ARTnews* 59, no. 10 (February 1961), pp. 38–41.

ARSHILE GORKY
1958

About 1945 American painting emerged, with an abruptness still difficult to assimilate, as a major international force in both quality and inventiveness. The first artist to achieve that new breadth and originality which make even the best of Marin or Davis look provincial was the Armenian-born Arshile Gorky. Indeed, Gorky's career almost recapitulates the history of abstract painting in this country, for it begins by paying homage to a diverse sequence of European masters—Cézanne, Picasso, Miró, Kandinsky, Léger—and then, in the early 1940s, trembles with a sense of imminent fruition and rapidly blossoms with a brilliance and sureness that seem to belie the painstaking, studentlike transcriptions of the European pictorial languages imported in the two previous decades.

It is most appropriate, then, that the first full-scale monograph on an artist who belongs to this recent phase of American painting be devoted to Gorky. The author, Ethel Schwabacher (who also wrote the catalogue for the 1951 Whitney Gorky exhibition), is unusually well qualified to record the master's arduous and tragic history, for she had known Gorky as a close friend and teacher since 1928. As a result, her text has the flavor of an intimate tribute to the complex fabric of Gorky's personal and artistic biography. With letters and anecdotes, she re-creates his paradoxical personality—at once ingenuous and sophisticated, slow and impetuous, aggressive and retiring—as well as the cruel series of circumstances that maimed his private life, from his early poverty and unsuccessful first marriage to the swift, ultimate sequence of fire, cancer, and suicide. In these terms, Gorky's art becomes more intelligible as the carrier of an emotional burden which, in its final discharge of 1947–48, has the ominous inevitability of van Gogh's crows.

But Gorky's art stands up fully without such biographical allusions, and Mrs. Schwabacher, fortunately, is as concerned with the paintings as with the painter. Her text, in fact, demonstrates that all too rare ability in writers of art books—to discuss particular pictures in a particular way—and offers the reader considerable assistance in seeing the intricate and elusive imagery of, to use her words, "the Ingres of the unconscious." Given the impetus of her analysis, one can understand all the more clearly, for example, how Gorky's early work prefigures his great late period—how the portraits of the 1930s already posit that complex structure of flat, broadly compartmented areas set aquiver by the tremulous, irregular human contours they contain; or how that quality of introspective fantasy, supreme in the final work, is prophesied not only formally in those loosely brushed overlayers of paint that

suggest cumulative memory experience, but also in such subjects as the artist with an imag-inary wife or the artist seen as a child beside his mother in an old, treasured photograph. One realizes, too, how the abstractions of the 1930s, which once seemed to follow so closely and impersonally upon the heels of Picasso, are not only distinctive, accomplished productions in their own right, but are also crucial in strengthening the equilibrium of those expansive spaces which ultimately form the taut, resonant backdrop for the tenuous surface fluctua-tions of color and line.

Or one follows the evolution of the later years, in which Gorky concentrates on achieving an even greater fluency than that afforded him by Miró's example. In one of the versions of *Garden in Sochi,* that of about 1941, this greater freedom of line has already emerged, only to reach a more impetuous liberty in 1945, in such works as *The Unattainable* or *Landscape Table,* where the line darts dizzily across the thinly stained background like a water beetle skimming upon the surface of a pond. And, at about the same time, Gorky's color attains an equally unparalleled liquidity. In *How My Mother's Embroidered Apron Unfolds in My Life* (1944) the canvas teems with those clotted, streaking colors which, while temporarily producing unsuccessful, congested paintings, were ultimately to be combined with their linear counterparts in the masterpieces of the last three years. Indeed, in these final works, Gorky not only weds the structural breadth and security of the 1930s to the fabu-lously fugitive line and color of 1944–45, but he realizes as well direct contact between form and feeling. His colors throb and pulsate like psychic wounds; his line becomes an exposed nervous system of ganglionic clusters that carry emotive charges to the farthest reaches of surface and depth.

In presenting Gorky, Mrs. Schwabacher has devoted almost exclusive attention to the unraveling of the artist and his work. Confronted with so large a task, she has necessarily left to others the problems of assessing Gorky's stature and historical position, as well as the more detailed analysis of the specific pictorial environment that nurtured the final efflores-cence of his art. There is the question of Matta, for instance, whom Meyer Schapiro, in his brief but illuminating introduction, mentions as the decisive factor in Gorky's liberation from copying. How much did Gorky derive from Matta's remarkable formal innovations, from his spidery whirlpools of line and vaporous, running colors? And what of Tanguy, whose Surrealist dreamscapes provide, as it were, sculptural counterparts to Gorky's equally imagined and evocative shapes and whose line drawings offer even closer analogies to Gorky's organic fantasies?

To acknowledge Gorky's debt to Matta or Tanguy is not to diminish his stature, but rather to realize even more acutely his greatness. In *The Calendars,* for example, there are infinite variations of depth and elasticity, yet these are all sustained within a taut cohesiveness of surface that makes Matta's violent spatial collisions look hectic in their sudden protrusions and gaping punctures. And in the same picture, one can admire as fully the unique sensibil-ity of Gorky's color, which is perhaps approached only by certain works of Pontormo. The honeyed, fragrant voluptuousness of his lavenders, milky yellows, and gray greens offset by small, brilliant dissonances of orange or vermilion is singular in Western art; indeed, it has the savor of Gorky's Near Eastern heritage.

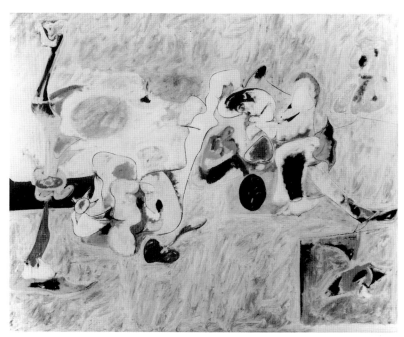

48.
Arshile Gorky,
The Plow and the Song,
1947

Gorky's supremacy is not only apparent in his mastery of pictorial means. Of all the artists of Surrealist orientation, his imagery is surely the most poignant, dense, and subtle in its search for some fundamental mode of experience that would equate the human subconsciousness with the vitality of natural processes in the lower orders of life. In the Plow and the Song series (fig. 48), for example, the animate network of churning, contorted cells and ducts suggests the cycle of fertilization and birth, but on such imaginative and multiple levels that it becomes, at the same time, an image of germinating plants, of crustaceans or insects emerging from their eggs, or ultimately, of some fundamental procreative impulse deep in the human psyche. And in the same way, Gorky's imagery can articulate the most evanescent states of mind, as in *The Limit,* with its slate-green evocation of some remote, arctic extremity of feeling, or in the distraught *Dark Green Painting,* with its frightfully precarious balance and sense of imminent catastrophe.

At his best, Gorky can rival and, I believe, even surpass the finest of Miró—which is to say that he is one of the major painters of our century. As such, his historical role demands close attention. Mrs. Schwabacher indicates that he may be seen as both the culmination of earlier trends (indeed, he seems to synthesize the very best of the Cubist and Surrealist traditions) and the prophet of further developments. In this light, however, it should be stressed how very different Gorky is from his "Abstract Expressionist" compatriots (a term Mrs. Schwabacher wisely avoids) with whom he is so often and so indiscriminately classified. Pollock, Still, Kline, Rothko, and Guston belong to a world that could hardly be more alien to Gorky, and whatever connective links they may be found to have with him must be more apparent than real. Their language is monadic, and their pictures achieve their great potency by magnifying a minimal, irreducible image—a jagged black scrawl, a nuanced fabric of

Impressionist brushwork, a luminous expanse of color—to an enormous scale that dominates, even overpowers the spectator. Gorky, by contrast, belongs to an earlier tradition, for he uses the most complex varieties of pictorial vocabulary and syntax and always remains an easel painter, whose works depend on elaborate refinements of inner relationships rather than on bold assertions of an indivisible unit in a mural scale. It might even be questioned, in fact, whether Gorky's art really belongs to the recent American scene in any but a superficial sense. Indeed, his art is so retrospective and so inward that its fundamental inflections appear to stem from his Armenian childhood—just as Chagall or Miró in Paris always remained a Russian or a Catalan painter, drawing upon experiences of the natal Vitebsk or Montroig. Confronted with the hermetic seclusion of Gorky's memory transformations of the Garden in Sochi legend, one really wonders if his art would have been significantly different had his family first brought him from the Caucasus to Paris instead of to Watertown, Massachusetts. It is not improbable that the only important effect of America on Gorky was a negative one—the postponement of his artistic maturity until the influx of European artists during the Second World War.

In any case, discussions of such questions must await future studies of Gorky and of the whole milieu of American painting during the last fifteen years. In the meantime, Mrs. Schwabacher's book stands as an important landmark in the field, combining, as it does, love and understanding with fact and analysis.

"Arshile Gorky." Published in *Arts Magazine* 32, no. 4 (January 1958), pp. 30–33.

JACKSON POLLOCK
1988

L ike many people in the age of Freud and Surrealism, whether artists like Miró or Gorky or just ordinary human beings, Jackson Pollock had a strong faith that the deepest truths about himself and the rest of the world lay far below the constraints of rational experience. Plummeting into the lowest and darkest levels of personal passion and memory might permit not only individual liberations to surface but might even unite the explorer with timeless, universal constants as true for ancient Greeks or North American Indians as they were for New Yorkers in the 1940s and 1950s. The challenge of this descent into what, in modern parlance, might be called anything from id and archetype to instinct and self is one of the major leitmotifs of twentieth-century art; and among its triumphs are the searches and the achievements of Pollock's art. This anthology of paintings and drawings, from 1943 to 1956, the year of his premature death, offers potent glimpses of, among other things, the master's turbulent exploration of these awesome domains and the way in which he disciplined this gigantically unruly territory of churning passions and fugitive images into an art of such intense originality that it could be both private enough to provide a personal catharsis and public enough to communicate to us still today, more than three decades later.

Everything here points to regressions of form and feeling that would cut through to the core of all truths, starting with those of the individual and ending in loftier generalizations about biology, psychology, and myth. The magisterial totems of the large painting of 1946 *The Child Proceeds* plunge us swiftly into this territory. Reversing evolutionary development, as on the analyst's couch, steadfast adult turns into clumsy, groping child and child into pulsating embryo, a metamorphosis that speaks for the individual, twentieth-century explorer, and for the human race as a whole, here distilled into a pair of humanoid idols, whose polarities of profile versus frontal view, of rigid versus visceral shapes become almost hieroglyphs in a language as yet undeciphered by anthropologists. Indeed, many of these early excursions into primal regions look like magical Rosetta stones, whose concealed messages continue to resist one-to-one interpretation. The long frieze painting of about 1945, with its subliminal suggestions of some narrative legend enacted by crude signs for agitated figures, animals, and celestial bodies, conjures up a drama we feel might be one-part tribal myth and one-part the acting out of Pollock's most deeply rooted personal conflicts.

But one of the marvels of modern art is the way in which Pollock's invented language of private and universal ambitions would, by the late 1940s, dissolve into an abstract picto-

rial maelstrom whose visual and emotional charge immediately demands our belief that some-
one has found his way into the densest and most fearful jungles of the unconscious and then
found the paths to bring this quarry back to light on canvas and paper. In one painting of 1948
we may still sense the specters of three standing humanoid creatures, but the ejaculatory erup-
tion of the enamel paint splatters their core to the four winds. And in the remarkable frieze of
seven red paintings of 1950, originally on a continuous strip of canvas, but separated later,
each image, which in the mid-1940s might have been more literally suggestive of some prim-
itive hieroglyph, has been smashed to the rawest immediacy of the thinnest oil paint immersed
in the canvas, leaving visible the language of spontaneity and accident, of stain and drip. No
longer decipherable as images, they still feel, given our knowledge of Pollock's earlier work,
like Rorschach tests in which some buried demon will suddenly loom to the surface.

That, in fact, is what was soon to happen again in the 1950s. In *Black Pouring over
Color* of 1952 we see the reemergence, through strident contrasts of primary color and more
focused combative thrusts, of an earlier imagery of conflict and narrative; and in such later
drawings as the palimpsest-like fragment of about 1952–56, with its archaeological compila-
tion of a dictionary of enigmatic ideograms, we almost have a reversion to the painted frieze
of about 1945. Within only a little more than a decade, Pollock staked out one of the grand-
est cyclic dramas of modern art, an A-B-A epic structure that moved first, like a deep-sea
diver, into darker layers of archetypal imagery, then plunged still further into uncharted,
oceanic chaos to find new means of aesthetic navigation, and then, finally resurfaced, crys-
tallizing once more, beneath the perpetuum mobile of doodles drawn from the wrist and
swirls painted from the elbow and shoulder, that language of elemental, universal signs and
images through which he originally peered into the lowest depths. Here, in some two dozen
paintings and drawings, are some major and minor landmarks in this heroic quest, works
whose visual range can move from spiderweb delicacy to overwhelming motor force, and
whose imaginative urgency in confronting the impalpable realities of symbol and emotion
always remains at fever pitch.

"Jackson Pollock." Published as the introduction to *Jackson Pollock: Images Coming Through*
(New York: Jason McCoy, 1988), n.p.

THE FATAL WOMEN OF PICASSO
AND DE KOONING
1984

When I was asked in the autumn of 1983 to contribute to this catalogue an essay on Picasso and de Kooning, the topic at first sounded distant and historical, a study of artistic relations between the older and the younger master way back in the 1940s. There might be, for example, a consideration of how de Kooning took the structure of Analytic Cubism, with its shuffled, overlapping planes and fractured chiaroscuro, and then rejuvenated it, electrifying its latent energies with the full force of his pictorial thunder and lightning. As a subdivision of this dialogue with Cubism, there might also be a discussion of de Kooning's use of letters and word fragments, as in *Zurich* (1947) or *Zot* (1949), or his occasional intrusion of clippings from popular imagery—an advertisement for cigarettes (as in *Study for Woman,* 1950), a photograph of a woman's head (as in *Woman I,* 1961)—which would balance the growing illegibility of his torrential labyrinths of paint with a startlingly legible glimpse of prosaic reality. And there might be, too, a discussion of the impact of Picasso's frequent explorations of monochrome, whether in the years of Analytic Cubism or in *Guernica,*[1] upon de Kooning's own restrictions to extremes of black and white in the pivotal years 1947–48. And still more broadly speaking, any thoughts of the importance of Picasso for de Kooning would have to deal with the question of their common psychological approach to the female body, often re-creating it with paint on canvas as if it were the victim of physical or sexual assault.

These questions, however, seemed to belong very much to the past until, by a happy coincidence in the winter of 1983–84, New Yorkers were first able to see the de Kooning retrospective itself at the Whitney Museum and then, shortly afterward, to see at the Guggenheim Museum the illuminating exhibition "Picasso: The Last Years, 1963–1973," which opened many eyes to the continuing vitality of a master whom many considered irrelevant to the history of modern art since 1945. For it soon became apparent that in the 1960s there was a remarkable convergence between these two transatlantic masters of succeeding generations, born twenty-three years apart, almost to the point that they shared an old-age style. And there were other revelations. Although both Picasso and de Kooning were long thought of as cultivating their private gardens, isolated from and sadly irrelevant to the concerns of contemporary art, suddenly both these masters looked freshly topical, intersecting closely with

the most youthful styles and attitudes of the 1980s and moving unexpectedly from the periphery to the center of today's interests. Of these matters, more will be said later.

As for de Kooning's first involvements with Picasso, he worshiped, like any ambitious New York artist in the 1930s and 1940s, at the shrine of the master, whose work was readily available through the presence of the Museum of Modern Art on West Fifty-third Street and the Gallatin Collection at New York University on Washington Square. And Alfred Barr's epochal Picasso retrospective of 1939 also provided for New Yorkers a panorama of his work never before equaled on either side of the Atlantic and one that must have inspired younger American artists either to go on imitating the master or, in a search for individual and national identity, to reject him as entirely as possible. Rejection seems to have been the majority choice of that group of New York artists who came to be known as Abstract Expressionists. But of that group, de Kooning was exceptional, choosing instead to keep, like Picasso, the human figure and especially the female figure in the center of his pictorial stage. Rather than attempting to annihilate Picasso, as did Pollock, Rothko, Newman, and Still, de Kooning became his greatest heir, alluding not only to a multitude of specific works, but perpetuating with full-scale energies Picasso's most powerful muse, the myth of the femme fatale.

Although this cultural fantasy is usually associated with nineteenth-century sexual fears and is assumed to reach its apogee in the 1890s, it in fact had the most vigorous and often horrifying afterlife in the work of exactly those two artists who concern us here. As for Picasso, the theme of a monstrous, feral woman who displays her sexuality as an irresistible and probably lethal trap for the male spectator recurs, with harrowing themes and variations, throughout his career of eight decades. As inventive as the nineteenth-century artists and writers who envisioned modern Salomes, Liliths, Eves, and vampires, Picasso re-created the femme fatale in one fearful guise after another. She might be found in the prostitutes and procuresses of Barcelona and Paris, assembled for a shattering climax in the *Demoiselles d'Avignon,* whose quintet of furies assail the male spectator with the sale of their potentially lethal pleasures. She might be re-created in Surrealist, metamorphic terms in the late 1920s and early 1930s as a biological monstrosity, a humanoid creature who may be part praying mantis, part predatory dinosaur desperate to propagate the species, even if it means the love-death of the male victim. She might be reinvented as a demon of psychological tyranny who, in the years of Dora Maar, reigns like a cruel, demented queen from the throne of her armchair. Or in much later roles from the master's final years, she might be reincarnated as an almost laughably grotesque and clumsy animal who seems grossly united with the forces of nature, nonchalantly displaying her sexual parts to male viewers or shamelessly pissing into the sea. It is astonishing that any artist could follow all these directions with such fresh sexual drive and invention, but de Kooning did. In one painting after another, he becomes the heir to Picasso's vision of women, which is at once intensely personal, fixed by private passions of mind and body, and grandly public and universal, conjuring up mythic pedigrees that take us back to the beginnings of art, religion, myth.

Confronted with the hurricane force of de Kooning's Woman series of 1950–53 (fig. 49), we understand the artist's own words, that the paintings "had to do with the female painted through all the ages, all those idols . . .";[2] and indeed, we feel that the spirit of such Stone Age Venuses as those of Willendorf or Lespugue (of which Picasso owned two copies)

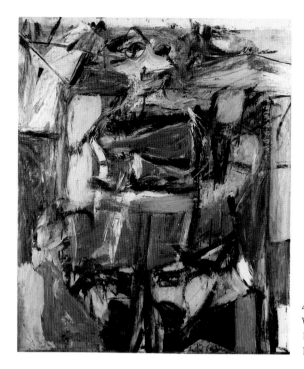

49.
Willem de Kooning,
Woman VI,
1953

lies at the beginning of this genealogical table, as do many ancient Mesopotamian figures, whose bug-eyed stare and threatening frontality de Kooning has acknowledged as influences.[3] Like Picasso's, de Kooning's female figures evoke a dense layering of art-historical associations that almost create a complete ancestral table for every image. Thus, in de Kooning's women one senses not only the mythic range of archaic fertility goddesses and Venuses, but a more modern Western pictorial tradition of virtuoso swiftness in figure painting. The very robust and carnal ghost of de Kooning's seventeenth-century Dutch compatriot Frans Hals, as exemplified in his buxom Gypsy girl (fig. 50), with her exposed breasts, or in his cackling witch of Harlem, *Malle Babbe* (Berlin-Dahlem), is resurrected here as an old-master fusion of slashing brushstrokes with sexual candor or demonic violence. But counter-traditions of bravura facture associated with the fashionable chic of society portraiture from the late nineteenth century are also evoked here, as in the work of John Singer Sargent or, above all, of Giovanni Boldini, who often attacked his wealthy sitters as if he were a fencing master wielding a brush, transforming their clothing into a torrent of paint that almost lacerates exposed faces and limbs. And as for mutilation via paint, there is always the example of Chaim Soutine, whose retrospective at New York's Museum of Modern Art in 1950 must have supported de Kooning's audacity in handling pink and red paint as if he were a wrestler or a rapist attacking resistant flesh. But if de Kooning evokes endless allusions, both direct and indirect, to earlier art, it is nevertheless Picasso's own paintings of women that loom largest in these layers of associations, both in specific and in general terms.

Already in the 1940s, in the many variations upon the theme of a contemporary woman in modern dress seated within an interior defined by suggestions of furniture, of the

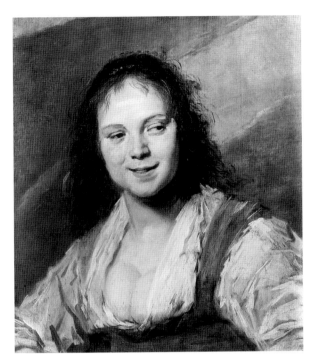

50.
Frans Hals,
Laughing Whore (The Gypsy),
c. 1626

rectilinear frames of pictures, windows, and doors, de Kooning extended one of Picasso's great motifs and one which, for both artists, was associated with Ingres. It is telling that this type, exemplified in *Pink Lady* (c. 1944), closely recalls a Picasso format of the early 1930s,[4] especially the *Woman with a Book* of 1932, and that both types have their source in Ingres's *Madame Moitessier,*[5] just as it is symptomatic of both artists' constant vacillation between extremes of the abstract and the specifically contemporary that at varying points in their careers—Picasso, about 1915; de Kooning, about 1940—they would attempt to offer modern versions of Ingres's pencil portrait drawings. Indeed, what is often startling in both Picasso's and de Kooning's most seemingly generalized images is the sudden intrusion of a banal contemporary detail—a hat easily datable to Paris, 1914; the ankle-strap shoes so familiar to New York, about 1950. Thus, the spirit of the specific and the commonplace that Picasso seized in the two young women who, in *Night Fishing at Antibes* (fig. 51), casually observe the almost mythical scene while holding on to a parked bicycle and licking, in an abundance of sexual double-entendres, a very modern double-scoop ice cream cone seems to have quickly crossed the Atlantic, where de Kooning's most horrendous female idols may also be found standing beside bicycles and also display the countless particulars, from cosmetics to coiffure, one might have encountered in the streets of New York or on the beaches of eastern Long Island.

For both Picasso and de Kooning, even the traditional proprieties of an Ingres portrait situation can set up a highly charged dialogue between what looks like a decorous bourgeois interior, whose geometric components act almost as repressive restraints, and a female sitter whose sexual or demonic character begins to erupt, as if from within the pressures of a

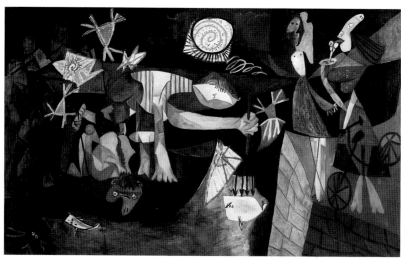

51.
Pablo Picasso,
Night Fishing at Antibes,
1939

corset. Of course, in de Kooning's case, the shattering of contours, the battered smudging of the flesh (almost as with a fist or a hammer) of the typical Picasso female head of the 1930s, bisected into simultaneous profile and frontal views, explode the heavy linear constraints of these figures with the paradoxical sense of breathless velocity and physical force in what is ostensibly a static, sedentary situation. But here, de Kooning looks both backward and forward in Picasso's career; for clearly many clues to this upheaval of pink flesh, which ruptures edges and leaves smears and spills of paint, can be found in the *Demoiselles d'Avignon,* just as in a reversal of historical roles, it is de Kooning's ragged brushstroke, which bears the impact of a physical and psychological assault upon the figure and which also recalls old-master facture in the tradition of Hals, Rembrandt, Velázquez that would later be explored again by Picasso in the 1960s.

As for this violence vis-à-vis the female sitter, there is even a revealing comparison to be made between the two masters' sadistic metaphor of literally nailing the sitters' exposed breasts to the canvas. In Picasso's *Woman in an Armchair* of 1913 the half-nude figure seated decorously in an upholstered armchair and holding a newspaper reveals her bared breasts, which appear to be painfully attached to her torso by a pair of trompe-l'oeil nails. In *Pink Lady* de Kooning draws nipplelike circles on the breasts, which actually refer to the heads of the thumbtacks he had used in nailing together separate pictorial fragments to make the final painting.[6] It was a technique of piecing together the anatomy of a human figure that revives, but in even more visceral terms, Picasso's Cubist methods of creating a human image from dismembered parts. And as a Freudian double image of sexual aggression, the *vagina dentata* also makes its appearance in the works of both masters. It dominates many of the sexualized physiognomies of Picasso's monster-women of the late 1920s[7] and then recurs unforgettably in de Kooning's *Woman and Bicycle* of 1952–53 (fig. 52), where, under a pair of staring eyes which recall the demonic power of the eyes in the *Demoiselles d'Avignon,* a row of sharp white teeth in a lipsticked mouth is made even more menacing by being repeated at the juncture of breasts and neck.

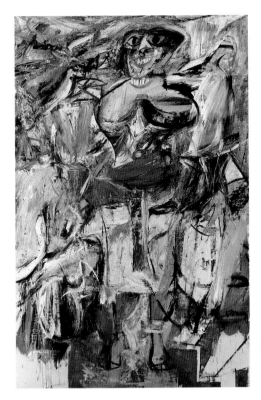

52.
Willem de Kooning,
Woman and Bicycle,
1952–53

Such passages of brutalized anatomy are matched in both masters by some of the most blatant sexual exposures in the history of Western art. Even before the studies for the *Demoiselles d'Avignon,* whether in pornographic drawings or in the 1905 etching of Salome dancing before Herod, Picasso had shockingly displayed the female genitals to viewers either inside or outside the picture; and many of his Surrealist female monsters also reveal their sex organs with the total abandon of an animal in heat. This motif, like that of a Paleolithic fertility goddess or a Venus Impudica, is often subliminal in de Kooning's work of the 1950s but becomes more explicit in the 1960s (fig. 53). And in the same decade, the older master Picasso once more revived this brash theme with a renewed infantile curiosity and excitement, so that the female genitals often become the most magnetic, dominant part of his late paintings and prints. As obsessions of aging artists—Picasso then in his eighties, de Kooning in his sixties—these startling sexual confrontations offer rich material for psychological speculations on their inventors' sublimation of sexual desire in the creation of art.

The convergence of these two masters in the 1960s is, in fact, a growing, complex issue that we are only beginning to recognize. Even on the level of one art-historical coincidence, the topic is fascinating. In Picasso's *La Pisseuse* of 1965 (fig. 54), certainly one of the most candid and disarming works of his entire career, the source has convincingly been shown to be a famous Rembrandt *Bather* (fig. 55),[8] transformed by Picasso into a grotesquely comic creature who almost parodies, in her animal fusion with the waters of the sea, the Birth of Venus myth. The same Rembrandt *Bather* has been suggested,[9] equally convincingly,

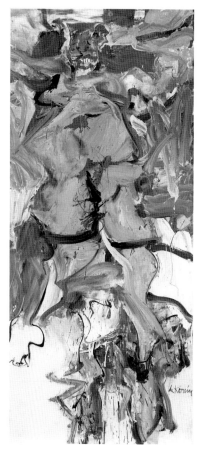

54.
Pablo Picasso,
La Pisseuse,
1965

53.
Willem de Kooning,
Woman, Sag Harbor,
1964

55.
Rembrandt van Rijn,
Bather,
1655

as one of the sources for some of the later paintings in the Woman series (especially III, V, VI) in which the figure raises her dress, exposing her thighs in a gesture that translates the meditative intimacy of Rembrandt's painting to a gross exposure of the female viewed as an animal in nature. It is a posture that de Kooning will repeat throughout the 1960s and 1970s inspired, like Picasso, by the commonplace summer spectacle of women on the beach, in this case the Hamptons rather than the Côte d'Azur. Whether digging for clams, squatting in the water with spread thighs, or standing like a giantess emerging from the sea, these de Kooning women, like their counterparts in Picasso, are clumsy, carnal creatures, so primordial in their contact with the elements that they swiftly become the stuff of primitive myth, remote deities of earth, sand, and water who embody the generative forces of nature.

But it is not only a question of these grand themes, which have so long and complex a history in Western art and culture, but also a question of the almost communal style evolved by Picasso and de Kooning in the 1960s. The seemingly reckless, slapdash abandon of these late works, in which the tauter, almost jigsaw-puzzle structure of Cubism and of firm contour drawing had been wildly discarded, lost both artists many admirers after the 1950s, when it was often believed that Picasso and de Kooning had become artistically senile, dissolving the skeletons of their earlier works in desperate slashes of paint. During those

decades, the influence of these masters on younger artists seemed to have vanished entirely, replaced in the art of Stella or Warhol by the priority of hard-edged, predetermined structures and imagery that destroyed the possibility of impulse and set up a facade of impersonality, which made the private confessions of an aging master look like irrelevant indulgences. Yet by the 1980s, when younger painters from capitals on both sides of the Atlantic—Schnabel, Garouste, Borofsky, Clemente, Baselitz, Lebrun—are rediscovering the possibilities of painting with spontaneity and exploring a repertory of private fantasies inspired by universal myths, the late work of de Kooning and Picasso has suddenly changed in stature, providing a new set of ancestral images to nurture the present.[10] That this is happening is a tribute not only to the endless variety of their genius, but also to the marvelous ironies of history. The art of the present will always alter our view of the art of the past, and both Picasso and de Kooning now seem reborn.

"The Fatal Women of Picasso and de Kooning." Published as "Notes sur Picasso et de Kooning" in Dominique Bozo et al., *Willem de Kooning* (Paris: Musée National d'Art Moderne, Centre Georges Pompidou, 1984), pp. 11–15. Published in English, in abridged form, as "Fatal Women of Picasso and de Kooning," *ARTnews* 84, no. 8 (October 1985), pp. 98–103. The present volume restores the full original text.

1. For some provocative comments on Guernica and de Kooning, see Harry F. Gaugh, *Willem de Kooning* (New York: Abbeville Press, 1983), p. 36.
2. Quoted in Thomas B. Hess, *Willem de Kooning* (New York: Museum of Modern Art, 1968), p. 148.
3. Sally Yard, "Willem de Kooning's Women," *Arts Magazine* (November 1978), p. 101.
4. This analogy was made both by E. A. Carmean Jr., in *American Art at Mid-Century: The Subjects of the Artist* (Washington: National Gallery of Art, 1978), p. 159; and Yard, "Willem de Kooning's Women," p. 97.
5. Robert Rosenblum, "Picasso's Woman with a Book," *Arts Magazine* (January 1977).
6. This technique of collage and thumbtacks is discussed in Charles Stuckey, "Bill de Kooning and Joe Christmas," *Art in America* (March 1980), p. 77.
7. This point is expanded in Robert Rosenblum, "Picasso and the Anatomy of Eroticism," *Studies in Erotic Art,* Theodore Bowie and Cornelia V. Christenson, eds. (New York: Basic Books, 1970), pp. 337–50.
8. Gert Schiff, *Picasso: The Last Years, 1963–1973* (New York: Solomon R. Guggenheim Museum, 1983), p. 34.
9. Carmean, *American Art at Mid-Century,* p. 177.
10. The late work of both de Kooning and Picasso, in fact, presided in this ancestral role in "A New Spirit in Painting," Royal Academy of Arts, London, 1981.

NOTES ON DE KOONING
1990

Those whose art-world memory goes back to the 1950s and 1960s must recall, as I still do, what noisy pro-and-con responses the sound of de Kooning's name would trigger during the heated critical battles of those decades. One big issue was the question of aesthetic good and bad, right and wrong, led mainly by Clement Greenberg, who, while inevitably recognizing, as who could not, the master's world-class genius, began to find in the 1960s that the cutting edge of painting's future depended for its very life on getting out of the painterly muck and mire that had become synonymous with the de Kooning look. Impalpable color stained into the very weave of the canvas was to conquer lather and froth. Another big issue was the myth of "Action Painting," a lofty moral territory mapped out by Harold Rosenberg with de Kooning at center stage as the perfect model of an exalted spontaneity of muscle and emotion. Yet if one was skeptical, as many were, about the paint-on-canvas reality of such macho myths, de Kooning might be the first to be deflated along with such rhetorical heroism. And of course, there was the question of generation. By the 1950s, the huge impact and titanic authority of de Kooning's achievement was such that he became a *chef d'école,* worshiped and imitated with varying degrees of slavishness or originality by dozens of younger artists who were nourished for years, even decades, by his turbulent work. If one wanted something totally young, new, and adventurous, de Kooning's mighty presence was as burdensome as, say, Picasso's was to his own juniors. For many ambitious artists, success depended on the degree to which they had managed to dethrone de Kooning.

Rauschenberg was one of the first to attempt to get de Kooning out of his system, and he did so in unexpectedly literal and witty ways. Already in 1953, he talked the master into giving him one of his drawings which he, in turn, would erase in an impudent act of artistic patricide, with which he tried, as he later explained, "to purge myself of my teaching." And four years later, in 1957, he struck again, this time making a painting, *Factum I,* that bore the earmarks of de Kooning's signature style with the requisite drippings, slather, and whirlwind speed, and then exactly replicated it in *Factum II,* proving that genuine spontaneity and accident could be counterfeited both the first and second time round. A different kind of attack was mounted in the same decade by such other up-and-coming artists as Johns and Stella, who challenged de Kooning's language of impulse by wiping their own compositional slates clean, replacing ragged lunges and thrusts with pre-plotted geometries of stripe, rectangle, and circle, and undoing the master's gorgeous chromatic collisions with completely name-

able colors and non-colors that stayed in their proper places. And by 1965, the definitive assault was made by Lichtenstein, whose benday dots and printer's-ink colors mimicked with deadpan cool and the most willfully impersonal touch the sound and the fury of de Kooning's by then historic brushstroke, flash-freezing the weapon of action painting and burying it forever in the past of art history.

But all of these youthful energies to topple the de Kooning monarchy have also faded into history; and now that the old king has been freed from the polemics that once surrounded him, he can be looked at with very different eyes. Even Stella, who seemed to slam the door on de Kooning forever with his black-stripe paintings of 1959, virtually reincarnated him several decades later in his labyrinthine metal reliefs of the early 1980s inspired by images of velocity. There, unexpectedly translated into Stella's own hard-edge language, were de Kooning's most raucous and rollicking densities of thick, foaming paint. And the master's own once-scorned disciples of the 1950s—Joan Mitchell, Michael Goldberg, Alfred Leslie, Norman Bluhm, among others—have recently been excavated in younger-generation exhibitions that would permit new viewers to see freshly these buried works of decades past.[1]

As the wheel of history turns, de Kooning's own positions have been shifting as well, often making alliances with unexpected territories. For instance, it was usually considered that the master, together with his lusty chums in the New York School, formed a polar opposition to Warhol & Co., standing as they all did for an almost religious faith in the high calling of art. This noble, heroic activity was to pursue, even to the point of martyrdom, the highest truths—truth to newly discovered canons of beauty, truth to honesty of feeling, and truth to the belief that serious art was something drastically different from, and far better than, the visual pollution of the real and vulgar world outside the artist's ivory tower, which, in the case of de Kooning, might be on Carmine Street in Greenwich Village or on Broadway, just south of Union Square. Yet in retrospect we realize more and more that de Kooning's art was not only often sullied, but also invigorated by his constant brush with the crassest facts of life as they were seen, felt, and lived in the big city. Our growing awareness via Warhol's generation of the ongoing dialogue between the elite and the commonplace in the history of modern art has attuned us to some of the coarser asides in de Kooning's career. For instance, it was not only Warhol, in his guise as a commercial artist, who could work for *Harper's Bazaar,* but de Kooning, too, who tried his hand at commercial drawings of little girls' hairstyles for the same magazine back in March 1, 1940;[2] and by now, it has become an art-historical platitude to note how de Kooning's generic image of the living Marilyn Monroe in 1954 was a surprising preview of her post-mortem sanctification in 1962 by Warhol and other Pop artists. We can now recognize, too, that once more in a preview of Warhol's images of only the lipsticked mouth of Marilyn, de Kooning was also fascinated by the disembodied lipsticked mouths of about 1950, even applying one (cut from a Camel cigarette ad diagramming the smoker's magic T-zone) as a collage to an early painted goddess in the Woman series. Moreover, such toothsome smiles, transformed into comic-strip grins, often surface unexpectedly in the abstract shuffles of many canvases of the late 1940s, a piquant reminder of streetwise imagery in an arty realm comparable to the Cubists' occasional references to the jolting crudity of cartoon style in the midst of their most illegible hieroglyphs.

But if time has been revealing that the black-and-white antagonism between de Kooning and a younger, Pop-oriented generation may include quite a few shades of gray, it has also pushed the long shadow of de Kooning backward into more sanctified halls of old-master achievement. Indeed, by now, de Kooning, of all the Abstract Expressionists, looks the most comfortable in the company of the grandest genealogical tables of art history, a tribute not only to his long scrutiny of pictures in museums, but also to his unwillingness to abandon, as so many of his contemporaries and juniors did, the pleasure and the mastery of old-fashioned oil on canvas. Moreover, the phantoms of the figural traditions of Western art refused to expire in de Kooning's hands, which kept conjuring up presences as remote as the Sumerian sculptures at the Metropolitan Museum or as stridently new as the *Demoiselles d'Avignon*'s quintet of femmes fatales. Anachronistic as de Kooning's persistent attraction to the human form may have seemed to many more drastic innovators, it was as essential to him as it was to most of the old masters. When Greenberg told him, "It is impossible today to paint a face," his answer was: "That's right, and it's impossible not to."[3]

His museum orientation, in fact, ranged far and wide, and it is part of the fascinating lore of contemporary Vasaris to recall the hours de Kooning and Gorky spent together at the Metropolitan, marveling at Ingres's portraits and nudes or gazing at the weathered terra-cotta murals from Pompeii, whose dense yellow-ocher walls he hoped to rejuvenate in one of his early male portraits, *The Glazier.*[4] And if he could learn lessons about sinuous line and mural-scale resonances of abstract color from the Metropolitan, he could also take fire from the gnarled and viscous paint surfaces of Soutine, whose retrospective at the Museum of Modern Art in 1950 was providentially timed, it now seems, to trigger the full-blast liberation of succulent, agitated oil paint that launched the Woman series and seemed even more capable of doing bodily damage than Soutine's mangled pigment. But beyond such moments in the art life of Manhattan, there are also the more abiding affinities of de Kooning with his own origins in the Low Countries. Born in Rotterdam and studying art in Brussels and Antwerp as well, he was already twenty-two when he decided to leave his native Holland for New York. It may not be surprising, then, that his painting, despite its obvious American inflections, also seems a vigorous offshoot descended from seventeenth-century Netherlandish roots. To find a match for the grand-scale, muscular turmoil of a work like *Composition* (1955; fig. 56), we might have to go back to Rubens, another master who could miraculously harness the most unbridled explosions of visceral forces. And if we had to find an old-master precedent for the horrendous slashing and cackling of the Woman series, wouldn't the best place to go be Hals's *Malle Babbe,* popularly known as the "Witch of Haarlem"? And Rembrandt might complete this Northern Baroque trinity, especially when we recall that the last two paintings in the Woman series, nos. V and VI, allude to the Dutch master's *Bathing Woman* (London, National Gallery).[5] If one were to elect an heir to the dynasty of virtuoso painting established in seventeenth-century Flanders and Holland, de Kooning could instantly mount the throne.

Old-master memories haunt, too, what has now emerged, in 1990, as an artistic career that has flourished for more than a half century. For of all the innovative painters who emerged in full force after 1945, de Kooning is the one who most grandly follows the evolutionary patterns of what in German is called "Alterstil," that is, the old-age style of a great and long-lived artist. Usually, such names as Titian and Rembrandt, Turner and Monet are called

56.
Willem de Kooning,
Composition,
1955

into play for this honor roll of painters who, in their later decades, appeared to enter an ever more impalpable world of disembodied light, color, and shadow, where earthly, palpable stuff, whether animate flesh or inert objects, dissolves into a boundless, otherworldly radiance. Already beginning in the 1960s, we start to feel in de Kooning's work this obliteration of tangible, particular facts, coinciding perhaps with his permanent move, in 1963, from the congestions of the city to the expansiveness of eastern Long Island, where an ever-present dome of light-soaked sky and an infinity of blue-gray sea can make mere earthlings shrivel into nothingness. By the 1980s, a still more uncanny purification has taken place in which fields of luminous white waft us to an airborne realm. And yet more surprising, de Kooning, the early master of a chromatic sumptuousness for which words like turquoise, cerise, and magenta seemed pallid, began as well to distill his colors to a primary purity, pared to a lithe and weightless skeleton of reds, blues, and yellows that can unexpectedly conjure up another Dutch ghost, that of Mondrian. Even in his eighties, the master can still startle us, not only with new paintings that open fresh vistas but with memories that echo down the most venerable corridors of art history.[6]

"Notes on de Kooning." Published in *Willem de Kooning: An Exhibition of Paintings* (New York: Salander-O'Reilly Galleries, 1990), n.p.

1. Most particularly, Paul Schimmel, *Action/Precision: The New Direction in New York, 1955–60* (Newport Beach, Calif.: Newport Harbor Art Museum, 1984).
2. See Sally E. Yard, *Willem de Kooning: The First Twenty-six Years in New York—1927–52* (Ph.D. diss.,

Princeton University, 1980; New York: Garland, 1986), p. 78. Yard's thesis provides the fullest source of information about this period, and I have borrowed from it extensively.

3. Recounted in Thomas Hess, *Willem de Kooning* (New York: The Museum of Modern Art, 1968), p. 74.

4. As he explained in an interview. See Harold Rosenberg, *De Kooning* (New York: Harry N. Abrams, 1974), p. 49.

5. See E. A. Carmean Jr., "Willem de Kooning, The Women," in *American Art at Mid-Century: The Subjects of the Artist* (Washington: National Gallery of Art, 1978), pp. 177–78.

6. For more comments on the works of the eighties, see my essay, "On de Kooning's Late Style," *Willem de Kooning: Recent Paintings, 1983–1986* (London: Anthony d'Offay Gallery, 1987; reprinted in *Art Journal,* Fall 1989), p. 249.

ROTHKO'S SURREALIST YEARS

1981

In the beginning was the Big Bang theory of Abstract Expressionism. By the 1950s, everyone on both sides of the Atlantic knew that something so drastic and overwhelming had happened in New York in the late 1940s that "The New American Painting"—to use the Museum of Modern Art's title for its international traveling exhibition of 1958–59—seemed to have mythical origins, forged of thunder and lightning. The signature styles of the masters of this new art appeared so extreme in their distillations of primordial elements—energy, color, atmosphere, even the brink of nothingness—that they made one gasp in their willingness to jettison, so it seemed, the entire baggage of Western painting. But after absorbing the impact of what first looked like totally unfamiliar art, spectators and historians became more curious about how these heroic images of rock-bottom purity came into being. For those who wished to support the stunning visual evidence that the grand tradition of European modernism had suddenly crossed the Atlantic, like an American Athena sprung full grown from the head of a European Zeus, sweeping new genealogies could be constructed. For instance, the floating, expansive colors of Rothko, Newman, and Still might be seen as belonging to a dynasty founded by such ancestors as Matisse and the later Monet; and the crackling, dark-light structure of de Kooning, Kline, and Pollock might be read as an electrifying transmutation of the scaffoldings that underlay Analytic Cubism. Similarly, in broader cultural terms, the transcendental vistas and breast-beating individuality of many of the Abstract Expressionists could be located as the most recent manifestations of the legacy of Romanticism.

But what was amazingly slow in permeating our view of this new art was the fact that its origins were not the equivalent of cosmic explosion, but the product rather of a long, slow generative process. So exciting was what looked like the swift emergence of a grand, mature American style that we ignored and were even embarrassed by what was thought of as an awkward incubation period. Judging from birth dates alone, it was obvious that most of the major Abstract Expressionists were only a little younger than the century itself, and that in the late 1940s, when their art seemed to be born, they already were in their forties. But what on earth had they been doing before that? Occasionally, historical surveys would include illustrations of a few "premature" works, in order to fill quickly the gap of decades—the 1930s and the early 1940s—in our knowledge of these masters, but usually they raced ahead to 1947–50, when the action really began. The situation was comparable to the mid-twentieth-

century view of Mondrian, whose pre-abstract work (which covered, in fact, a good two decades of his painting career) was usually swept under the carpet, only to be uncovered later as not only an indispensable means of understanding what his abstract art was about but as offering in itself a body of painting and drawing that is every bit as compelling as Mondrian's signature-style work of the 1920s and 1930s.

Nowadays, our view of Abstract Expressionism is also shifting focus. A younger generation of inquisitive art historians and spectators has registered dissatisfaction with the traditional and patently censored legend that would consign to the scrap heap what used to be considered tentative first steps that had better be left unseen. But was it really possible to understand the art of Rothko and his colleagues if one entered the unfolding drama of their art only at the beginning of the great last act? So now, the lion's share of youthful energy, basic research, and fresh ideas is going into the terra incognita of the 1930s and 1940s, in an effort to discern what passionate ambitions, what modern and ancient Western and non-Western sources could produce eventually a pictorial art of such magisterial purity and grandeur that it seemed, indeed, to come from nowhere, to be the very first light cast upon a new era.

In thinking about such matters, we realize that one of the key words is regression; and, in the case of Rothko's art, the leap from the present to the past, from a contemporary urban environment to a remote mythic world, from twentieth-century man to squiggling protoplasm, was made with jarring abruptness. In 1938 Rothko could still paint the prosaic facts of a Brooklyn subway station, complete with turnstiles, the identifying monogram N (Newkirk Avenue? Nevins Street?), and passengers in contemporary clothing who descend to the tracks below. We know we are in New York in the 1930s every bit as clearly as we do before a Depression painting by Reginald Marsh or Raphael Soyer. But in the same year, 1938, Rothko decided to close his eyes to these facts of modern urban life and plunged back into time, back into the unconscious, back into biological origins to an art from which it is impossible to deduce explicitly that he lived in any historic time and place, least of all New York City in the mid-twentieth century. Between 1938 and 1946 Rothko invented a strange Babel of primitive tongues. We find rude fragments of birds, heads, hands, eyes that, like the pictographs of Gottlieb, might have been uncovered during archaeological expeditions anywhere from Mesopotamia and Greece to Mexico and the Pacific Northwest. We find, with the help of the titles, allusions to archetypal legends that equate Greek and Christian tragedy, whether it be the Sacrifice of Iphigenia or the Entombment of Christ. And on quite another level of the primitive, we find wriggling, microscopic creatures that evoke a biology student's composite fantasy of the pulsating origins of life. Indeed, in an untitled watercolor of 1944, these regressions reach an astonishing point of near-zero. In the lower right-hand corner Rothko has actually signed his name inside the rounded, throbbing contour of a primitive cell that seems to be dividing before our eyes, as if the artist had projected himself back to the beginning of not only his own biological life, but of all life in this cosmos. To be sure, many Surrealists had already tried to re-create the mythic and biological origins of the universe— one thinks of Miró's *Birth of the World* of 1925—but Rothko's empathy into this science-fiction journey reaches a uniquely personal extreme.

Younger scholars, including Robert Carleton Hobbs, Stephen Polcari, and Ann Gibson, have recently published many important revelations about the specific cultural and artistic

milieu that nurtured Rothko and his colleagues.[1] They have told us, for instance, of the importance of Rothko's undergraduate studies in the natural sciences at Yale (1921–23),[2] of the way in which textbook diagrams of geological stratification or cell development might have planted images that could be transformed, two decades later, as an artist's poetic excursions into natural history (a transformation also achieved in the 1940s by Baziotes, who we now know haunted the American Museum of Natural History,[3] and one that goes back not only to Ernst, but to that nineteenth-century world where museums of art and of natural history were often housed harmoniously under the same roof in their common display of truth and beauty). They have also emphasized the importance of such thinkers as Nietzsche, Jung, and Frazer in establishing the myth-making components and tragic goals of Rothko's art, not to mention the personal, inward search for archetypes. Moreover, they have indicated the inspiration of primitive art, especially that indigenous to America as displayed in many exhibitions held in the 1930s and 1940s at the Museum of Modern Art.

But focusing anew on Rothko's Surrealist work of the 1940s, we find there are still many questions to be asked and sometimes answered. For one, there is the big issue of the timing of these works, which, it turns out, coincides grimly—1938–46—with the immediate eve and apocalyptic aftermath of the Second World War. To live in New York at that time was a strange amalgam of the mythical and the contemporary. The daily chronicle of evil reported in newspapers and on the radio, the living presence in the United States of growing numbers of refugees from hell were ample testimony to the actuality of the Nazis, of the war, of the atom bomb; yet the remoteness and monstrosity of these events in Europe and the Pacific could also give them an unreal, almost symbolic character that only an eyewitness observer could force into contemporary fact. For artists like Rothko, the impulse during those years of dread must have been a familiar one in times of unthinkable terror: an eyes-shut flight to primitive beginnings, to the vital sources of life, art, myth. It was a path already taken by Marc and Kandinsky on the eve of the First World War in their blanket rejection of the unbearable present of modern history in favor of a prehistoric world where all might begin again. In Rothko's case, these impulses would continue still further. If ever there was an image of the world after Hiroshima, when all of matter, all of man, all of history might be annihilated, it was to be found in the pictorial format of a numbing, atmospheric void that he began to define fully in 1947.

Rothko's weighty variations upon the cosmic themes of regression existed, to be sure, on an exalted level of twentieth-century cultural history; yet it should not be forgotten that there was at least one immensely popular adventure in this primitivist realm which had vast audiences in the 1940s. I am referring to Walt Disney's *Fantasia* of 1940, which, seen again in a post–Abstract Expressionist world, seems to herald almost every primeval image attained so arduously by Rothko, Still, Newman, or Pollock. Most particularly, the Stravinsky *Rite of Spring* episode provided a spectacular anthology of biological and geological ultimates, in which primeval landscapes, where water, sky, and earth seem interchangeable, were gradually animated by a quivering, microscopic life that unforgettably metamorphosed the biology textbook illustrations of our distant school memories to the territory of myth and art. There, within the huge dimensions of a movie screen, the role of modern men and women in a man-made environment was usurped by oozing, unicellular creatures that throbbed, fed, and

57.
Mark Rothko,
Tentacles of Memory,
1945–46

reproduced in a life-giving aqueous element, a Darwinian fantasy that, in 1940, coincided precisely with Rothko's first efforts, as in a watercolor of that year, to visualize a primitive universe of protozoic beings that, millennia later, would take on human configurations.

Disney aside, there are, of course, legions of high-art sources for Rothko's explorations of the 1940s (fig. 57), and many have been pinpointed in general and specific ways. But I should like to add a few which strike me as having been unusually fertile. Miró, naturally, has been often enough singled out as a major inspiration for Rothko's Surrealist period,[4] but one work in particular, *The Family* of 1924 (fig. 58)—a work included in the Museum of Modern Art's Miró retrospective of 1941—cast an especially long shadow. Not only does its lucid format—a wide field clearly divided by a horizon line—recur throughout many of Rothko's works, but so, too, does the perpendicular trio of spindly, near translucent creatures who shuttle back and forth in biological and historical time from modern pipe-smoking or bejeweled hominids to ciliated protozoans in urgent need of the life supports of food and sex. And Miró's central figure of Mother Nature, with her huge, tree-trunk genitals and her paramecium head, provided Rothko with a prehistoric deity who often presided over the mythic lands he conjured up for a swarm of images which usually went untitled but which, when named, might turn out to be the Jewish female demon, Lilith. Rothko's own penchant for a hazy, Northern ambience, where blurred, frail shapes at once coalesce and evaporate, was at an opposite pole from Miró's Mediterranean clarity of light, shadow, and contour; but this one drawing, at least, could meet Rothko halfway, if only by accident. The incomplete product of many changing ideas at a critical moment in Miró's evolution, *The Family* is atypically clouded by visible ghosts of earlier, partly erased drawings that hover like X rays in the background. For Rothko this shadowy sense of after-image and atmosphere must have been compatible with his own evocations of a filmy, submarine environment whose dimly discernible inhabitants might vanish in the strong sunlight that customarily floods Miró's art.

58.
Joan Miró,
The Family,
1924

I should also like to point out another particular Surrealist source, a book that, published in New York in 1943 by Curt Valentin (whose gallery was central to the New York art world's beaten path), must have generated many of the humanoid fantasies of Rothko and his colleagues. This was André Masson's *Anatomy of My Universe,* an illustrated encyclopedia of mythic beings who race across history and prehistory to create hybrid, imaginary species, within human molds, of everything from plants, trees, insects, and reptiles to demons, astrolabes, and architecture. These metamorphic images (fig. 59), teemingly abundant in their variations, seem to reverberate in many of Rothko's totemic figures of 1944–46, and most fruitfully in one of the most ambitious and successful of these works, *Slow Swirl at the Edge of the Sea* of 1944 (fig. 60). As Diane Waldman suggested in her Rothko catalogue,[5] this large oil painting may be a symbolic portrait of the artist and his wife-to-be, but the male-female couple on the water's edge is so potently mythologized that it can evoke, like Masson's inventions, endless duos of universal Adams and Eves, or biological diagrams describing sexual differentiation, or even awesome nature deities from some primitive culture, like the large Navajo sand painting of the Sky Father and the Earth Mother re-created in 1941 for the Museum of Modern Art's exhibition "Indian Art of the United States" (fig. 61). But for all its suggestions of Masson and Miró, of tribal totems, and even of American colleagues like Gorky, Gottlieb, and Pollock (whose *Male and Female* of 1942 precedes and parallels Rothko's image), *Slow Swirl at the Edge of the Sea* seems now fully to repay its debts, creating a personal world of mysterious fixity and solemnity in which we feel the subliminal ripples of timeless nature—the trinity of sand, sea, sky—as a setting for the magnetic forces of coupling and sexuality that echo light-years backward from a pair of modern human beings to deep and terrifying roots in biology, myth, magic. Figure and landscape, anatomy and pictograph, substance and atmosphere fuse and plummet, with science-fiction speed, toward a veiled, primordial world. Everything, from the muted, evasive

59.
André Masson,
Unity of the Cosmos,
from
Anatomy of My Universe
(New York, 1943)

60.
Mark Rothko,
*Slow Swirl at the Edge
of the Sea*,
1944

61.
Navajo sand painting,
*Sky Father
and Earth Mother,*
1941

colors to the shimmering spiderweb of gossamer angled and rounded lines, conjures up a Book of Genesis universe of as yet unformed images. In its stark confrontation, its ritualistic symmetry, and its exquisitely changing nuances of vibrant shape, tone, and feeling, *Slow Swirl* offers the fullest synthesis of Rothko's ambitions up to 1944, as well as the richest prophecy of the abstract work to come.

For it is inevitable that many of these works will intrigue us as prefigurations of the later Rothko. For instance, one may trace here, via the motif of a "primeval landscape"—to use Rothko's own title for a painting of 1945—the evolution toward that elemental format of floating horizontal strata that make us feel we are facing something akin to this planet on the day of its creation or perhaps on the day after its apocalyptic obliteration. Or one may follow the gradual mastery of fluid and translucent pictorial techniques, whether in oil or water-color, that make us sense that the very nature of organic process has been seized, as if the image were somehow changing quietly before our eyes, re-forming its shapes and altering its colors against a deeper, concealed structure that conveys a total, ultimate stillness. And if one is concerned with the covert religious drama of the late works, especially in the Houston Chapel, there are many overt glimpses here of these preoccupations with Christian tragedy, as in *Gethsemane* of 1945 or a version of *The Entombment*, a theme essayed with several variations in 1946. And in the same solemn domain, there are surprising adumbrations of the monastic, grisaille tonalities we tend to attribute too exclusively to the penultimate works. For instance, Rothko's *Tentacles of Memory* (fig. 57) already establishes the funereal tiers of black and gray that will recur with an even greater sense of renunciation in many works of 1969–70. And if there are hints here of the total darkness and asceticism to come, there are equal celebrations of Rothko's opposing impulse toward an almost Epicurean sensibility of color, in which unnameable, fragile hues blossom and waft away within a steamy, hot-

house atmosphere. Rothko the monk versus Rothko the voluptuary are already at odds here, as they will continue to be throughout the 1950s and 1960s.

But if we are tempted mainly to read these works as evolutionary, embryonic previews of the great Rothkos we know so much better, they are also beginning to look backward to traditions of modern art much older than the Surrealist movement, which may be claimed as their most immediate source. I am thinking particularly of their many affinities with the Symbolist aesthetic and goals of the late nineteenth century, which so often attempted to conjure up, as in a séance, the most elusive, mysterious states of feeling through a vocabulary of evanescent shapes, colors, and tones, and which equally eschewed any contact with the vulgar realities of the contemporary world and its material contents. Even the iconography of many major and minor artists of the Symbolist school foreshadows Rothko's own concerns, whether we consider Redon's Darwinian dreams of submarine or botanical mutations from which human heads may blossom; Gauguin's anthropological speculations about the common universe of myth and mysticism shared by all distant faiths, whether Christian, Maori, or Buddhist; or Munch's terrifying sense of conflict between the human race in the modern world and the overpowering forces of eternal nature, often symbolized as a sperm cell, an image that Rothko himself, a half-century later, would amplify in his own

62.
Mark Rothko,
Hierophant,
1945

meditations upon the unicellular origins of life. But doubtless Rothko's Surrealist period will go on disclosing a complex network of connections with its past and its future. Its high seriousness, its search for forms and symbols that could awaken a sense of awe and tragedy not only assured the emotional gravity of the abstract art that, after 1947, absorbed these mysterious hieroglyphs, but also revealed Rothko's place in a long tradition of modern artists who grappled with an encyclopedic repertory of symbols culled from biology and anthropology in a heroic effort to convey the ultimates of life, death, and faith.

"Rothko's Surrealist Years." Published as "Notes on Rothko's Surrealist Years" in *Mark Rothko: The Surrealist Years* (New York: The Pace Gallery, 1981), pp. 5–9.

1. See especially Robert Carleton Hobbs and Gail Levin, *Abstract Expressionism: The Formative Years* (New York: Whitney Museum of American Art, 1978), pp. 8–26, 116–21; Stephen Polcari, "The Intellectual Roots of Abstract Expressionism: Mark Rothko," *Arts Magazine* (September 1979), pp. 124–34; and Ann Gibson, "Regression and Color in Abstract Expressionism: Barnett Newman, Mark Rothko, and Clyfford Still," *Arts Magazine* (March 1981), pp. 144–53. For an excellent early account of some of these issues, see Lawrence Alloway, "The Biomorphic 40's," *Artforum* (September 1965), pp. 18–22, reprinted in *Topics in American Art since 1945* (New York: Norton, 1975), pp. 17–25.
2. For further remarks on these connections, see the unpublished qualifying paper by James Ward, "The Function of Science as Myth in the Evolution of Mark Rothko's Abstract Style," New York University, Institute of Fine Arts, 1979.
3. As discussed in Barbara Cavaliere, "An Introduction to the Method of William Baziotes," *Arts Magazine* (April 1977), pp. 28–29.
4. See especially Gail Levin, "Miró, Kandinsky, and the Genesis of Abstract Expressionism," in Hobbs and Levin, *Abstract Expressionism,* pp. 27–40.
5. Diane Waldman, *Mark Rothko, 1903–1970: A Retrospective* (New York: Solomon R. Guggenheim Museum, 1978), p. 45.

ROTHKO AND TRADITION

1987

I still vividly recall how, way back in the 1950s, informed and intelligent art-world people in New York would argue passionately and usually angrily about the pros and cons of Abstract Expressionist painting. Hard though it is to believe today, when these masters have all the hoary authority of Matisse or Picasso, some thirty years ago, even in the city that nurtured them, the likes of Pollock or de Kooning, Rothko or Newman were still topics of raging controversy. Turning friends into enemies, they generated a polemic between those evangelical enthusiasts who felt that an overwhelming mutation of new pictorial truth and beauty had just been born on Manhattan Island and those stubborn naysayers from whose eyes the scales had not yet fallen. The battles were bitter and generally fought as a conflict about black-and-white aesthetic rejection or espousal. Some found Pollock's poured paintings ridiculous examples of coagulated chaos, an offense to art, whereas others found in them seraphic release, a thrilling depiction of disembodied energy. Some found Newman's austere reductions to a single or double vertical zip on a monochrome ground an insult to all existing standards of visual nourishment, whereas others found them tonic distillations of pictorial structure to a rock-bottom core. Some found de Kooning's or Kline's jagged contours and bristle-ridden brushwork the equivalent of chimpanzee scrawls or of undisciplined violence, whereas others found them the vehicles of authentic feeling and spontaneity. And some found Rothko's luminous veils of color fraudulent voids, whose nothingness defied any reasonable expectation of what one should look at in a framed and painted rectangle of canvas, whereas others found them mysteriously silent and radiantly beautiful. But whether these paintings were loved or hated, it was generally assumed in the 1950s that they were somehow totally new forms of pictorial art. Created in New York after the apocalyptic conclusion of the Second World War, they seemed to signal a drastic rupture with prewar traditions of both European and American painting. You might find them great or awful, but they clearly belonged to a completely unfamiliar kind of art that bore little if any comparison with what had come before.

Even the imagery of most Abstract Expressionists contributed to this feeling that the historical coordinates of time and space had been annihilated, leaving us before visions closer to the Book of Genesis—primeval chaos, primeval shape, primeval light—than to paintings that might proclaim they were created in New York City in the decade following the war. And even today, it comes as something of a shock to see paintings by Rothko of the 1930s that depict, say, the artist himself, as a flesh-and-blood man wearing the clothing of that

63.
Mark Rothko,
Green on Blue,
1956

decade, or a subway station in Brooklyn, whose turnstiles, cashier, and passengers immedi-ately evoke the Depression years. We still, it seems, expect Rothko to provide a transcen-dental image that would take us beyond history.

Nevertheless, all of this has been changing slowly, at times imperceptibly, so that to our surprise, Rothko, like his colleagues, appears today not so much as an artist so radically new that his art can only face forward, but rather as an artist so thoroughly steeped in earlier traditions of Western painting that his art faces backward (fig. 63), more a grand summary and conclusion than a beginning. Already in the 1950s, especially through the potent author-ity of Clement Greenberg's efforts to place Abstract Expressionism in the modernist tradition of the very greatest prewar painting from Paris, it dawned on many of Rothko's admirers that his dense seas of color might not have existed without the example of Matisse, a point the artist himself acknowledged by entitling a painting of 1954 *Homage to Matisse*. And clearly, the presence at the Museum of Modern Art of such masterpieces as Matisse's *Blue Window* and *Red Studio* could provide the most solid and beautiful touchstones for any artist who would explore the possibility of creating paintings from resonant color alone. (It may be more than a coincidence that MoMA acquired *The Red Studio* in 1949, the very year in which Rothko achieved the full-scaled conviction of what was to become his signature format: tiered clouds of color magnetized before the symmetrical pull of horizontal and vertical axes.) Indeed, the connection between Matisse and Rothko, like the one that had begun to be made via Greenberg's criticism between late Monet and Pollock, gave credence to the Darwinian

64.
Josef Albers,
*Study for Homage
to the Square:
Departing in Yellow,*
1964

evolutionary theory that would bring the grand genealogical table of modernism, whose seeds were planted at MoMA before the Second World War, into glorious fruition with the new species engendered in postwar New York.

Nevertheless in feeling, if not necessarily in form, Rothko did not always fulfill his putative role as a descendant of Matisse; and it began to be seen, too, that in Rothko the brooding element of the mystical, of the ascetic, of a range of gloomy, otherworldly associations was alien to the terrestrial pleasures afforded by Matisse. No less mysteriously, the emotions that Rothko's paintings generated in many spectators, old and young, in no way emanated from the work of a much older artist, the Bauhaus-trained Josef Albers, who, beginning in the 1950s, as in his series Homage to the Square (fig. 64), was also creating iconic images of floating, immaterial color planes that vibrated forward and backward in immeasurable spaces. Indeed, a comparison between Albers and Rothko, artists whose works might be described objectively with similar language, makes clear the difference of subjective response evoked by Rothko's paintings, which, it would seem, create for most sympathetic spectators a living, breathing ambience that is solemn, awesome, even tragic, whereas Albers's paintings convey rather an aura of cool, lean precision, the product of didactic experimentation in the domain of color theory and geometric proportion.

Of course, artists are human beings like the rest of us, and their work may reflect, like any human personality, different, even warring impulses. In the case of Rothko, there is, to be sure, a fully epicurean potential that manifests itself instantly at any Rothko show by the

recurrence of colors and color chords so rarefied that the words for our primary and secondary hues—blue or red or green—which are often applied to the titles of his paintings, seem laughably inadequate to describe chromatic sensations closer to something like tangerine or puce or crimson. In this, Rothko often emerges as a voluptuary who could savor and refine those elusive hues associated with the glories of the French hedonistic tradition, from Monet and Renoir to Bonnard and Matisse. Yet there is always, too, the countercurrent of a monkish opposition to this sensuous facade; and part of these paintings' emotional density resides in what is almost a conflict between pleasure and its denial, between the immediacy of hues that can glow like a sunrise and their inevitable extinction.

In this dialogue, Rothko's wide range of tonal values acts as a constant curb, for his most gorgeous colors are often blotted out by the darkest of storm clouds or evaporated into near-invisibility by an invading stratum of white atmosphere, as if the life of the senses were being assailed or pushed away to some distant realm of memory. And of course, looked at with the chronological sweep provided by a retrospective exhibition, Rothko's art, in terms of the shifting proportions of this renunciatory element, can offer a dramatic scenario, in which the frequently somber brownish or grisaille tonalities that dominate many of his Christian subjects of 1945–46 (e.g., the variations on the theme of the Entombment or Gethsemane) are at first suppressed throughout the 1950s and then reemerge with welling and pervasive force in the 1960s, the final decade of a career terminated by suicide on February 23, 1970. To be sure, this simplistic translation of the pictures into an accelerating triumph of death over life has countless exceptions—there are works of the 1960s as overtly ravishing and seductive in color as anything from the preceding decade—but the overall pattern, with its growing pull toward a vision of a final annihilation of light and color, is unmistakable.

With our hindsight of the tragic conclusion to Rothko's life and the desperate isolation he apparently experienced in his last year, it is tempting to read his darkening palette as a direct projection of his own sense of doom; but it should be said that in this evolution, Rothko's art, as distinct from his personal life, also follows patterns of old-master ancestry. It has often been noted that the old-age style of many of the greatest artists of the Western tradition reveals a final conquest of substance by shadow, of local color by expansive atmospheric veils, of the world of tangible matter and objects by the world of spirit. In terms of nineteenth-century painters, the examples of Turner and Monet are conspicuous; but, before them, Titian and Rembrandt best exemplify this ultimate obliteration of the palpable, sensual world in a resonant ambience of engulfing obscurity where only flickers of golden light remain. Indeed, the murky browns that begin to dominate Rothko's paintings of the 1960s almost suggest the artist's own response, in the language of abstract art, to the drama of dimming chiaroscuro so evident in the final decades of these museum masters.

Even without the constant references in Rothko's own statements to the themes of drama, of tragedy, of rapt immobility, of a preoccupation with death, it soon became clear from the paintings themselves that whether or not their pictorial means depended in good part upon the lessons of the French modernist tradition, their emotional ends belonged to a very different kind of heritage. Already in 1961, after sensing more and more the affinities of feeling and structure Rothko shared with two of the greatest Romantic landscape painters, Friedrich and Turner, I proposed in an article, "The Abstract Sublime" (see pages 72–79 in

65.
Caspar David Friedrich,
Evening (Abend),
1824

this volume) that the ambitions and the achievements of Rothko's art extended these nine-teenth-century masters' efforts to depict the awe-inspiring infinities of the natural world as a metaphor of the supernatural world beyond. It was an insight that I was to elaborate more fully in a book published in 1975, *Modern Painting and the Northern Romantic Tradition: Friedrich to Rothko;* and still today, a quarter-century after my first intuitions about this theme, these art-historical resonances remain valid to me. It is surely Friedrich (fig. 65) and Turner (fig. 66) who first pursued most passionately and successfully the creation of a picto-rial world without matter, usually conveyed through a vision of landscape, seascape, or sky-

66.
J. M. W. Turner,
Seascape with Storm Coming On,
c. 1840

scape that would free us from the pull of terrestrial gravity and immerse us, without ruler or compass, in some primordial element of water, cloud, color, light, or a fusion of all these ungraspable mysteries of nature. This unpolluted realm, in which the very horizon line is apt to vanish forever from sight, becomes almost a spiritual catharsis, a release from the prosaic facts of the often sordid urban realities in which these works were actually painted and exhibited; and by implication, too, this almost sacred domain of nature could be haunted by the ghosts of those Christian traditions that were so ruptured by the late eighteenth century. Often, in fact, Friedrich and Turner in their visions of nature trespass on formerly Christian territory—angels can appear in their heavenly, golden light; a cruciform structure can sanctify a landscape; a solitary figure can be immobilized, as if praying to an altarpiece in a church, while standing before a vista in nature that might carry us to unnameable, uncharted regions: death, resurrection, the deity itself. But without the conventions of an easily intelligible language of Christian symbolism, these messages are often blurred, more suggestive than narrowly legible, casting a wider, vaguer net of associations that, in the modern world, could find responses in a secular audience more easily than the orthodoxies of traditional religion. Rothko's paintings, too, have often elicited these transcendental emotions in spectators; and if it may be wondered how an abstract painting can possibly be religious in character, it should be remembered that Friedrich's contemporaries, too, found that the master's effort to make a landscape painting usurp the place of a Christian altarpiece of the Crucifixion was incomprehensible, even blasphemous.

As for the altarlike character of Rothko's paintings, their impact of unmitigated frontality and symmetry, the equivalent of an iconic symbol of a religious cult, also has deep resonances in the modern tradition, embodying a structure that Friedrich himself, not to mention Blake and Runge, would use to evoke a sense of supernatural truth and permanence. It is worth noting here that perhaps the closest visual parallels in the modern tradition to Rothko's paintings are found in the mountain landscapes of the Swiss Symbolist Ferdinand Hodler, who consciously explored a pictorial structure of spare, skeletal symmetry that could transform not only his figural compositions but his Alpine views into what are virtually secular shrines. In his depiction of Lake Geneva crowned by the Savoy Alps, 1906–7, we seem to have reached nature's Holy Grail. The mountain range at the top is so lofty, so pure, so remote from us and from the tug of gravity that it seems to be made of the same immaterial stuff as the lake below and the clouds above, a floating vision inaccessible by earthbound transport. Moreover, the suggestions of an atmospheric halo that enframes the entire vertical image, with its hovering horizontal tiers, recall the marginal aureole of color that usually sets off Rothko's own intangible clouds from the edge. In the case of both Hodler and Rothko, these visions are seen as emblems of a final truth, awesomely static and distant. And by their sheer frontality and symmetry, they impose an intimate, one-to-one confrontation upon the spectator. To look at these works obliquely is the equivalent of avoiding their command to stand motionless on line with their central axis, so that their embrace may be total.

In the 1950s and 1960s, it was customary in New York to celebrate chauvinistically the triumph of Rothko and his Abstract Expressionist colleagues over European and especially French art; and the rapidly growing international recognition of these new works made it clear, so it then seemed, that the center of artistic vitality had crossed the Atlantic after the

war. The less emphatic implication of this was that these artists, whose imagery was so willfully universal in character, so far beyond the specifics of time and place, had at last overcome the provincialism and indigenous character of American painting and could now proclaim that they and American art at last belonged to the world at large and could close the door with relief upon the parochial traditions of prewar America. But this viewpoint has also been gradually altered by looking backward instead of forward, so that by now, in the 1980s, Rothko appears to belong not only to European, but also to more regional American traditions. Most specifically, he has begun to be seen as the heir to a movement that was first defined and named in the 1940s, Luminism. Referring to a mode of landscape painting (as well as photography) that flourished in the third quarter of the nineteenth century, Luminism has, of course, to do with the dominion of light. To be sure, the many American painters who practiced this mode have strong affinities with earlier European painting, especially with the work of Friedrich and Turner, but there is little doubt that the abundance and intensity of these visions speak for their importance to a peculiarly American experience.

Typically, a Luminist painting confronts us with an empty vista in nature (often a view of sea and sky from the shore's edge) that is more colored light and atmosphere than terrestrial soil; and if there is any movement at all in these lonely contemplations of a quietly radiant infinity that seems to expand in imagination even beyond the vast dimensions of the North American continent, it is that of the power of light slowly but inevitably to pulverize all of matter, as if the entire world would eventually be disintegrated by and absorbed into this primal source of energy and life. A surrogate religion is clearly a force here, too, and scholars of Luminism have been quick to point to the analogies between this perception of a natural American light that can slowly lead us to the supernatural and the transcendental thought of Emerson and Thoreau, who also sought a mystic immersion into the powers of nature. Given the welling enthusiasm for and information about Luminism in the last two decades (it has been the subject of books and exhibitions and has been digested into every standard new history of American art), there is persuasive evidence for its central importance in American visual and cultural traditions; and, with this in mind, we may see Rothko's art as resurrecting, in an abstract mode, the Luminist tradition. Although in their fidelity to a literal description of, say, an irregular coastline, many Luminist paintings veer from an absolutely head-on, symmetrical confrontation with the source of light, some do venture into this fearful territory with compelling results. For example, in John Frederick Kensett's *Sunset at Sea* (1872; fig. 67), the sun is seen as the living core of the painting and of all of nature. Located on a central axis over a starkly unbroken horizon line that stretches to the edge of the canvas (and, by implication, infinitely beyond that), the sun, its circular shape obscured by the blinding gold of heat and light, radiates in all directions, its almost supernatural, halo-like glow, the fountainhead of an unidentifiable deity, turning even the sea below into a weightless mirage and the passing clouds above into an ethereal prelude to an invisible heaven. Before such a painting, it is hard not to think of Rothko, for whom disembodied light and color are also such potent metaphors of an unseen world of spirit and destiny; and even the iconic structure and the aura of hushed silence bear out these strong affinities.

It is fascinating to see, too, how this familiar motif of contemplation by the sea, whose covert messages can lead us to visionary realms, could be pushed by other American artists

67.
John Frederick Kensett,
Sunset at Sea,
1872

68.
Elihu Vedder,
Memory,
1870

into more overt translations that at times make the introspective point ludicrously explicit. So it is that in *Memory* (1870; fig. 68), a painting by the odd Elihu Vedder, often considered a proto-Symbolist, the Luminists' waterside locale remains, but from this centralized view of coast, sea, and sky (a format that evokes Rothko's own familiar trinities), there appears in the dark clouds, as if in a spiritualist's séance, a ghostly head of a woman, a memory, perhaps, of a lost love or relative, but an apparition that clearly tells the spectator how this meditation upon nature's infinitives, as viewed from the water's edge, can guide us directly to a world of spirit.

Such paintings, to be sure, can be found with countless variations, from visionary authenticity to postcard kitsch, and the student of American art may well be able to establish continuities that would take us from the later nineteenth century to Rothko's own genera-tion. As only one indication of the way in which such a motif was transformed into a more audaciously modernist mode, there is a series of three early watercolors of 1917 by Georgia O'Keeffe entitled *Light Coming on the Plains* (fig. 69), which perpetuates, with subtle varia-tions among them, this frontal, symmetrical vision of primordial light, now even further reduced to a quietly vibrant emblem of the horizontal axis of the earth versus the concentri-cally arced radiations of the distant light of a rising (or setting?) sun seen just above it. So dis-tilled is O'Keeffe's image that even though it must be inspired by the austere and parched purities of the desert landscape in western Texas, where she was living that year, it seems,

69.
Georgia O'Keeffe,
Light Coming on the Plains II,
1917

like many Luminist paintings, to transcend the documentary specifics of local geography and to lead us to the brink of a universal source of light. Pushed only a step further toward this brink, the very edge of a mystical void, the vision of Rothko could be born.

Although such transcendental ambitions, whether in their original European guise or their later American variations, have become apparent in Rothko's work, he was, after all, not only a seeker of spiritual truths, but first and foremost an artist who loved to paint beautiful pictures; and indeed, within his career, we often sense a struggle between a desire to create sheerly seductive paintings, in the nineteenth-century tradition that would make the cult of beauty a religion in itself, and a need to check these sensuous urges with the impulses of an artist-monk who had taken vows of pictorial chastity. But even when his ascetic spirit reigns, Rothko can still be seen as a master of exquisite nuance who works within the realm of veiled tonal refinement that was first espoused by Whistler. Connected, like Rothko, with both American and European culture, Whistler could create in both his figural and landscape paintings a kind of puritanical aestheticism that would have as a goal a pictorial surface of delectation for the eye, but would then restrain this hedonistic potential by a constant paring down and muting of sensation. In his seascapes, in particular, Whistler's vision often strikes chords that resound in Rothko's direction, as in his translations of waterside views of the Thames into mysterious scrims of subtly filtered light. It may be the remoteness of Japan rather than of the deity that lies behind these imaginary excursions to a never-never land accessible to cultivated sensibilities even in Victorian London, but Whistler's pictorial means, rather than any spiritual ends, lay the foundations for many of the evocative effects that Rothko was later to explore. In *Nocturne: Blue and Silver: Cremorne Lights* (1872; fig. 70) the most prosaic view across the Thames to a famous pleasure garden has become a totally ghostly mirage, with even the industrial buildings at the upper left bearing no more weight than the evanescent reflection of artificial light on the water. Matter, gravity, perspective have been banished in favor of a spectral world of tiered and floating planes that seem both as immediate as the picture surface itself and as remote as something seen behind closed eyes. Even Whistler's favored format, two or three broad zones of the haziest tonalities both fused and separated by the glimmer of a horizon line, announces the structural combination of elemental clarity and infinitely varied subtlety that Rothko would make his own. (It perhaps should be mentioned, too, in terms of the affinities between Whistler and Rothko, that the American painter Milton Avery [fig. 71], who exhibited together with Rothko as early as 1928 and is usually cited as a formative influence on him, also belongs to the Whistlerian, Anglo-American tradition of puritanical aestheticism, often reducing Matisse's already reductive color and drawing to a bone-dry spareness that undercuts the sensuality of his French prototype.)

In his search for endlessly refined variations upon a single, simple theme, Rothko, like Whistler, embraced a profound faith in the realm of the aesthetic; and in this preference, too, for ever-more-subtle reworkings of the same motif, he again looks backward to a major ancestral table of the nineteenth century. Monet, in particular, had systematically launched the possibility of choosing one subject—a haystack, a row of poplars, a bend in the Seine—and exploring a potentially infinite number of variations upon it in which endlessly elusive sensations of colored light both veil and reveal new aspects of an elementary motif. As in Rothko's chromatic and tonal variations upon his own archetypal structure, Monet's series paintings

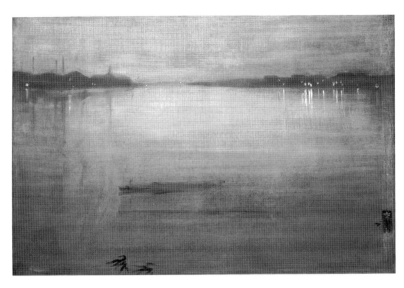

70.
J. M. W. Whistler,
*Nocturne in Blue and Silver:
Cremorne Lights,*
1872

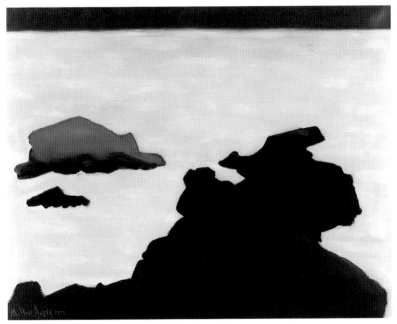

71.
Milton Avery,
White Sea,
1947

72.
View of the first room in the Musée de l'Orangerie, Paris,
of Claude Monet's Water Landscapes,
c. 1919–26

offer the widest possible range of aesthetic discriminations, from the blazing intensities of sunlit reds and oranges with their blue-violet reflections to the near-invisibility of pallid hues concealed by the fog of dawn. In Monet, as in Rothko, this total immersion in the evanescent phenomena of colored light and atmosphere can lead through the looking glass of perception into a more subjective world of dream and meditation; and these reveries could even be physically extended to create a complete visual environment that might become an engulfing shrine, a sanctuary from the outside world. This potential was, of course, realized by Monet not only in the hermetic realm of home, studio, and water gardens he was to create for himself at Giverny from the 1890s until his death in 1926, but also in the mural-sized panoramas of water landscapes that he painted in the 1920s (fig. 72) and that would be installed in Paris, in the Orangerie, in two oval-shaped rooms officially dedicated in 1927, the year after his death. For Monet, and now for the public, his vision of an immaterial watery realm that was both ravishing painted surface and a vehicle to a more introspective voyage into a fluid, floating world without substance or direction had become an all-embracing experience, an almost religious shrine or, as André Masson was to put it in 1952, "the Sistine Chapel of Impressionism."

It is fitting that Rothko's art, too, often evoked and, on several occasions, actually realized these potentials of meditative enclosure. Already in 1960, at the Phillips Collection in Washington, D.C., Duncan Phillips had installed in a separate room its three Rothkos, to which a fourth was added in 1964; and here, within a gallery context, the seclusion and sanctity of a special chapel for Rothko's work were suggested. But as in the case of Monet's series paintings, this kind of grouping could conjure up still grander architectural potentials. Even before the Phillips installation, Rothko had been commissioned in 1958 to paint a series of murals for the Four Seasons Restaurant in the Seagram Building, canvases that the artist then felt inappropriately grave for their locale and which he finally donated to the Tate Gallery in 1969, stipulating that they be seen in a room by themselves; and between 1961 and 1963 he also worked on a mural commission for Harvard University. But the most poignant fruition of

this potential was the product of an enlightened commission by Dominique and John de Menil for an interdenominational chapel (fig. 73) in Houston, Texas, which, alas, was finally completed and dedicated only on February 27–28, 1971, exactly one year after the artist's suicide. Like Monet's oval rooms at the Orangerie, the Houston Chapel hovers between a shrine of art and a shrine of the spirit, an avowal by a great painter to devote the whole of his being to the religion of art, a consuming goal whose hybrid success as sanctuary and museum is affirmed by the countless visitors in our secular world who make pilgrimages there to look and to turn inward. And it is also a reminder that in the Houston Chapel, as in the presence of all of Rothko's canvases, we feel that the artist who decades ago seemed only to face forward, challenging and even destroying the premises of modern painting, now seems only to look backward, a resonant synthesis, perhaps even a conclusion to the most venerable traditions of Western art.

"Rothko and Tradition." Published as "Notes on Rothko and Tradition" in *Mark Rothko, 1903–1970* (London: Tate Gallery, 1987), pp. 21–31.

73.
Interior of the Rothko Chapel, Houston, Texas, facing north-northeast, 1965–66

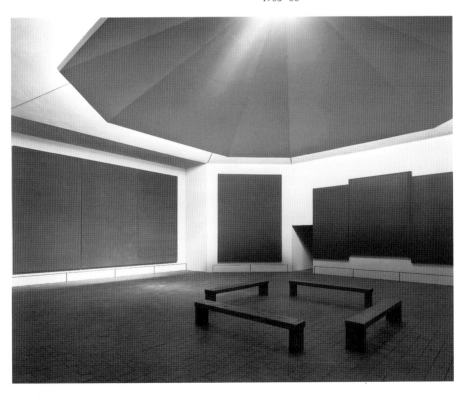

MY LIFE WITH ROTHKO

1998

c. 1953 Amazing to recall, now that he is as permanently enshrined in the pantheon of artist-deities as Matisse or Mondrian, but Rothko, back in the early 1950s, was a fighting word. I remember vividly the combative, black-and-white climate that divided the New York art world into pro-or-con extremes when faced with the unheralded innovations of the Abstract Expressionists. And in my own academic neck of the woods, New York University's Institute of Fine Arts, there were no-less-heated debates among us graduate students about whether such things as a chaos of poured pigment or a few blurry rectangles of color could possibly be serious art. And on a more sophisticated level, someone—I can't remember who—quipped that Rothko's canvases looked like Buddhist television sets. A few of us embraced positively these new experiences, though mainly as an act of faith, a quantum leap into the unknown. What most of us were certain about was that nothing like these paintings had ever been seen before.

c. 1957 With the advent of Johns and Rauschenberg, artists of my own generation whose work startled me into enthusiastic attention, Rothko & Co. suddenly slipped from present to past tense. In the first surveys of art history I taught at Princeton, I proudly and, given the fear most students had of being duped by empty canvases, somewhat riskily concluded the course with a quick run-through of Rothko, Newman, and Still—my pitch for commitment to the cutting edge of art history. And it was then, too, that I met Rothko for the first and last time, when he turned up during a visit I made to Theodoros Stamos's studio on Columbus Avenue. Thrilled to meet the mythic master in the living flesh, I immediately put my foot in my mouth by asking him, in the most pedantic way, what affinity he felt with the other two artists I wanted to put in his category, Newman and Still. He looked angry, said almost nothing, and left me squirming. I blush to realize now how dumb I was. I was totally unaware that already in 1952, following Dorothy Miller's "Fifteen Americans" show at MoMA, which gave Rothko and Still equal time, and then accelerating to fever pitch in 1955, on the occasion of Sidney Janis's first one-man show of Rothko, both Still and Newman had become outspoken enemies of the artist whose work I wished to ally with theirs.

1958 Never mind their towering egos and personal hostilities. For me, Rothko, Newman, and Still were not a serpents' nest but a Holy Trinity, united by the logic of art history. In the

first piece I ever wrote about this new art, published only in French translation as "La peinture américaine depuis la seconde guerre mondiale" (*Aujourd'hui*, July 1958; see pages 62–71 in this volume), I dramatized their common denominator as "frightening in its implications, standing at the very extremity of the boundary beyond which there is nothing." As for Rothko in particular, I offered explanation by way of landscape analogies, the seed, I now realize, of some grander speculations to come. "These vast icons," I proposed, "have, at times, the orange and yellow luminosity of high noon, or, on other occasions, the blue and black mysteries of a moonlit night. Or they may suggest, too, the eternal presence of sky and earth, air and water."

1961 These tentative steps at connecting Rothko with landscape painting could now be given ampler support, thanks to my welling passion and growing knowledge of British and German Romantic painting. With Caspar David Friedrich at the epicenter of a drastic, irreversible change of pictorial structure and emotion that would transform old-master religious art into a secular imagery that thinly veiled transcendental ambitions, I tried a sweeping new construction that could reach from the early nineteenth century to the look and feel of certain Abstract Expressionists. Its ambition, I now realize, was to provide an Old Testament prophecy for the New Testament miracle of what MoMA had called the "New American Painting" in its 1958–59 European traveling show. Usually considered a New World invention, wasn't this strangely minimal pictorial language and weren't these mysteries sensations of nothingness and chaos to be found much earlier, in Romantic landscape painting? Published in *ARTnews* in February 1961, "The Abstract Sublime" (pages 72–79) happened to appear at the same time as MoMA's first Rothko retrospective. It also coincided with a letter to the *New York Times* that many artists and critics (myself included) signed, protesting the hostile treatment of the Abstract Expressionists by the newspaper's art critic, John Canaday. My new view of things gave Rothko center stage, comparing his work to both Friedrich's *Monk by the Sea* (c. 1809; see fig. 41), the ultimate statement of, in Kierkegaard's words, "Being and Nothingness," and a no less filmy version by Turner of some uncharted supernatural domain beyond the water's edge. In particular, the Friedrich–Rothko comparison seemed to register convincingly—to me, at least, and apparently to many others—and I felt destined to fill in the historical blanks that might somehow connect these two painters, so far apart in time, space, and culture, with a convincing genealogical tree.

1966 In two articles, "Caspar David Friedrich and Modern Painting" (*Art and Literature*, Autumn 1966) and "Notes on Mondrian and Romanticism" (in *Piet Mondrian,* The Art Gallery of Toronto, 1966), I began to flesh out with other artists—van Gogh, Munch, Hodler, Mondrian—the dynastic table that would culminate inevitably in the Holy Grail image of a signature canvas by Rothko, a silent, impalpable radiance that would put us on the threshold of a Great Beyond.

1970–72 With happy timing for the art-historical construction that I hoped would create resonance for Rothko's long shadow, I was invited to give two series of lectures in England. For the first one, in June 1970, at the Royal College of Art in London, I delivered the three

Lethaby Lectures on "Romanticism and Twentieth Century Art," which of course whipped out Friedrich and Rothko for a final flourish. The artist's suicide in February of that year gave his role in my scheme an extra poignance. But there was a lot more to be said, and I was happy to say it when asked to give the eight Slade Lectures at Oxford University in April–May 1972 under the title "Modern Painting and the Northern Romantic Tradition: Friedrich to Rothko" (published as a book by Thames and Hudson in 1975). The timing was even better than in 1970; for at last, on February 17, 1971, Rothko's chapel in Houston was dedicated, becoming, among other things, a posthumous tribute to the artist-martyr who had taken his own life one year earlier. This chapel, in fact, now provided an ideal terminus for my evolutionary survey of what was essentially crypto-religious art. With its octagonal shape, inspired by an eleventh-century baptistry in Torcello, and its evocative variations on the triptych format, which once had contained Christian narratives but now had become hauntingly imageless, the Rothko Chapel, as it came to be called, summed up, in my new scheme of things, countless Romantic problems and ambitions, all responses to the crisis of faith in organized religion that launched the nineteenth century. Here were fulfilled some of Friedrich's and Runge's dreams of creating, in their case with landscape, chapels and shrines that would usurp the waning power of Christian iconography. Finally, I had put Rothko firmly in place. But of course it turned out that I was only partially right.

1976 In patriotic synchrony with the bicentennial, Kynaston McShine organized for MoMA "The Natural Paradise: Painting in America, 1800–1950," to which I contributed a catalogue essay that obliged me to look at Rothko with American eyes. If I had grafted his giant branch onto Friedrich's tree, I could also, for this occasion, turn him into a twentieth-century manifestation of what, rightly or wrongly, has been considered an indigenous American phenomenon, Luminism. Weren't the unpopulated, head-on views of spellbinding sunsets and sunrises that enthralled such mid-nineteenth-century painters as John Kensett and Martin Johnson Heade previews of Rothko's own vision of immaterial, luminous color that seems to breathe with an expansive mystery? And moving into the 1940s, weren't Milton Avery's reductive seascapes related to both this tradition and Rothko's own work (as he himself avowed in his 1965 eulogy for Avery)? Could Rothko be turned into a Yankee rather than the transplanted descendant of Friedrich, Munch, Hodler, and Mondrian?

1978 The Guggenheim Rothko retrospective was a liberation from a prison of my own making. The Friedrich–Rothko comparison had all too quickly become a platitude, even providing a rhetorical conclusion for Diane Waldman's catalogue essay. Confronted again with the broad and varied spectrum of Rothko's work, I began to suspect that the Great Chain of Northern Romantic Being to which I had yoked him was painfully single-minded, however useful it had once been in underlining an alternative, parallel history of modern painting. Invited to lecture on Rothko at the Guggenheim in November, I let the artist spread freely in new directions, especially to art-for-art's-sake territory—Whistler, Monet, Bonnard, Matisse—which I had earlier held at bay in order not to adulterate his Northern asceticism. If he was a monk, wasn't he also an epicurean? Hadn't MoMA's acquisition of Matisse's *Red Studio* in 1949 been a major catalyst in his evolution? Had he not painted, only weeks after

the master's death on November 3, 1954, a canvas titled *Homage to Matisse?* And I emphasized, too, his indebtedness to Symbolism, whether in the primordial underwater fantasies of Redon or in such oddball American manifestations as Elihu Vedder's *Memory* of 1870 (see fig. 68), which almost literally illustrates (ectoplasmic head floating above a symmetrical view of sky and water) the kind of supernatural presence often discerned subliminally in Rothko's cloudy tiers of paint.

1981 The Pace Gallery asked me to write a catalogue essay (see pages 100–108) for a show about Rothko's Surrealist years; and for this, too, I had to relocate him, this time to New York's 1940s hotbed of Modern Art, from MoMA to Fifty-seventh Street. Considering ambitious works like *Slow Swirl at the Edge of the Sea* (1944), I could now connect Rothko to the likes of Miró and Masson (artists whose sensual, Latin character would have polluted the spiritual Nordic pedigree I had once traced for him), not to mention the Navajo sand paintings shown at MoMA in 1941 that had also left their mark on Pollock. And moving outside these arty precincts, I also suggested the surprising affinities between the Darwinian fantasies of unicellular life in the *Rite of Spring* sequence from Disney's *Fantasia* (1940) and Rothko's pulsating, microscopic creatures of the 1940s. Was this zeitgeist or just a coincidence, given what we know now about Rothko's absorption or comparable biology and geology textbook illustrations during his student years at Yale, 1921–23? (Newman's zips, by the way, are also prefigured in *Fantasia*, in the daring "abstract" sequence of orchestral sounds made visible that opens the movie.)

1987 The Tate Gallery asked me to do a catalogue essay for its Rothko retrospective (see pages 109–121), which gave me a chance to put some of my newer connections in print, whether about parallels to Albers's *Homage to the Square* or how Monet's panoramic water landscapes at the Orangerie offered perhaps a better analogy to the Rothko Chapel than my German Romantic holy landscapes. But when I actually saw the Tate show, something sad happened. Exactly that component of mystical brinkmanship that had initially thrilled me in Rothko's art and that could make him a soulmate of Friedrich's had died. It was not that I doubted for a moment the authenticity of Rothko's own exalted ambitions or my own earlier responses. It was simply that such goals now seemed to belong to a distant era. Rothko and his equally high-serious colleagues had become endangered, perhaps extinct, species, the last heirs to Friedrich's or van Gogh's fervent faith that paintings, like preachers, might even change people's spiritual lives. What I now saw was only a profusion of largely similar canvases differentiated by a gorgeous variety of colors and tones.

1998 In preparing this chronology, timed for the opening of the Rothko retrospective at the National Gallery of Art in Washington, I leafed through the galley proofs of the catalogue and immediately fell upon a moment in 1952 when the artist refused to let the Whitney acquisition committee review two of his paintings, claiming that he had a "deep sense of responsibility for the life my pictures will lead out in the world." I can't imagine any artist I like saying this now, but I'm glad Rothko could say it then. Now, as our century comes to an end, such a passionate belief in art's magical power to save souls and to open transcen-

dental vistas may seem as remote as the Middle Ages. With much nostalgia for these earlier, lost pieties that Rothko's canvases could inspire during his own lifetime and my own youth, I am curious, but nervous, about how totally unspiritual my response will be when I get around to seeing again these once hallowed portals of mystery.

"My Life with Rothko." Published as "Isn't It Romantic? The Art of Mark Rothko" in *Artforum* 36, no. 9 (May 1998), pp. 116–19.

A VIEW OF ANDREW WYETH

1987

For its seventy-fifth-anniversary issue of November 1977, *ARTnews* asked a group of art-world people to name the most underrated and overrated artist of our century. I responded with what I thought was a witty one-liner, nominating Andrew Wyeth for both awards. Back then, in the 1970s, Wyeth triggered what seemed to me excessively wild extremes of disagreement. On the one hand, in 1976, the would-be populist museum director Thomas Hoving elected Wyeth to be the first living American artist given a retrospective in the old-master sanctuary of the Met. On the other, Wyeth-phobia was so virulent that it could unite in sputtering hostility even such unlike critics as Hilton Kramer and Henry Geldzahler, whom one expected never to share an opinion, pro or con. Today, ten years later, I find the situation surprisingly the same. The appearance last summer of Wyeth's portraits of Helga on the covers of *Time* and *Newsweek* (not to mention *Art & Antiques*) was an ongoing testimony to Wyeth's stature as the supreme icon maker for the greater part of the American public (and soon, perhaps, the Russian one, after a projected Wyeth family show is seen in the Soviet Union); but his name continues to provoke grimaces of disgust or anger in most right-thinking people who take modern art seriously. In short, he may still be the most underrated and overrated artist, which in turn may mean that it's time to temper such black-and-white emotions of love and hate with a few shades of gray.

Wyeth's case is in many ways like Bouguereau's. Both artists, in their time, became symbols of overwhelming popular success that could easily be transformed into an imaginary enemy who tried to combat those artists and spectators who fought for the cause of modernism. And although that battle has been won so long ago that today "postmodernism" is a household word, there is enough knee-jerk reflex left from those venerable struggles to kick up old passions. Amazingly, the Bouguereau retrospective of 1984–85 could still be experienced as an assault on the beauty, truth, and goodness of the Impressionists and their progeny, even though a closer look also indicated how this much beloved and much despised academic master shared many goals, forms, and sentiments with Renoir, Cézanne, and even Picasso. And Wyeth, too, needs to be looked at closely as simply the artist he is, rather than as a cunning demon whose grass-roots constituency would win a landslide election against the modernist party. (A comparable phenomenon is found in Canada, where those who espouse the cause of modern art furiously grin and bear the coast-to-coast popularity of Alex Colville, who paints chilly, sharp-focus scenes of Canadian outdoor life with an ascetic spirit

and a dry, immaculate brushwork that closely resemble the work of Wyeth, his senior by three years.) More to the point, Wyeth is best looked at as an American artist, which may be why his most sympathetic critics so far—Wanda Corn, Barbara Novak, Brian O'Doherty— have been primarily students of American painting, and why *Christina's World,* whose crowd-pleasing power seems to contradict the lessons preached by the museum which owns it, nevertheless feels quite at home with MoMA's other American holdings of the period, whether the parched tempera surfaces and bleak asymmetries of Ben Shahn's *Liberation,* the lonely inertia of Edward Hopper's *New York Movie,* or even the blanched, minuscule, abstract scribbles of Mark Tobey's *White Night* (see fig. 32). But why does nobody see red at the sound of these other artists' names? Indeed, at MoMA, Wyeth fit seamlessly into the 1976 bicentennial survey of American landscape painting, "The Natural Paradise," in the company not only of his contemporaries but also of nineteenth-century masters such as Thomas Eakins and Fitz Hugh Lane, both of whom are represented in Wyeth's personal collection.

One lesson underlined by that exhibition was one that is learned in all of Wyeth's work, namely, that there has always been in this country a tremendous mythic momentum to reject the overpowering realities of the modern industrial world by clinging to the dwin- dling realities of unspoiled nature and rural America; and in this light, Wyeth should no more be chastised (as he has been) for depicting the anachronistic experience of Chadds Ford, Pennsylvania, or Cushing, Maine, than Winslow Homer should be sneered at for working in Prouts Neck, Maine, or Georgia O'Keeffe in Abiquiu, New Mexico. It is fascinating to see how Wyeth occasionally suggests these intrusions of modernity but also keeps them at bay, as in *Oliver's Cap* (1981), where the austere old board-and-batten white house seems a fortress against the lean horizontal network of automobile road and telephone wires that con- nect with the outside world of the twentieth century at only, one feels, the most infrequent intervals. (How long will it be before the next car passes or the telephone rings again?) And the people who populate these real, yet mythic, domains are no less survivors of a remote human species. *The Scalloper* (1985) belongs to that race of hardy pioneers familiar to Homer's and Eakins's hunting scenes, evoking a closeness to the primal facts of country life that is baldly stated in *The Huntress* (1978), in which the fancy myth of Diana is translated into the plain prose of a hefty, healthy, naked girl whose companion, a country dog, echoes the very posture and expression of his mistress. Wyeth's detractors have often scorned the somber, puritan flavor of his usually unsmiling female nudes, whose innocence of the com- plex sexual charades of modern advertising and of jaded city folk may squelch most erotic appetites; but here, too, Wyeth feels at home with much American art, especially with the nudes of Eakins or even of Philip Pearlstein, both painters who turn pink, soft flesh an unyielding brown, beige, and gray, and who, in heroic resistance to European traditions, refuse to suggest that a nude on canvas might be painted to seduce a living spectator. Simi- larly, in the emotional scenario Wyeth so often prompts us to invent before his silent and static figures, whose eyes seek out unseen distances, seductivity would be the most alien response to the female nude in *Spring Evening* (1948; fig. 74), who, her face hidden, unwit- tingly exposes her naked back to us as she lies alone in a bedroom whose restriction to white sheets and an oil lamp strikes the mood of a nunnery. This denial of the pleasures of the flesh, this stripping of the most ordinary observations to an avowal of the awkward and lonely facts

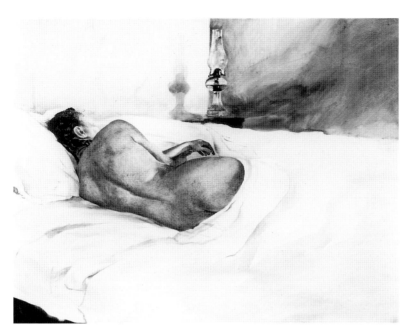

74.
Andrew Wyeth,
Spring Evening,
1948

of body and feeling sound deep chords in earlier American cultural traditions, as do Wyeth's often desiccated and barren landscapes in which every living presence, animal, vegetable, or human, evokes survival against enormous odds, and in which the sensuous, life-giving colors of the rainbow and warmth of the sun seem banished forever. And the spaces of Wyeth's paintings, with their abrupt collisions of near and far (window enclosure versus empty vista, microscopic foreground detail versus infinitely remote horizon), perpetuate, too, actualities of rural American experience, as well as deeply ingrained Western formulas inherited from the pathos-ridden structures of Romantic painting.

In this, Wyeth may be one of the last authentic survivors of a very endangered nineteenth-century species, whose lingering presence in our own desperately complicated century can be at once balm to the innocent and poison to the sophisticated. But the realization is long overdue that Wyeth is neither Satan nor Jesus. He is merely a mortal and genuine artist who can and should live in a Peaceable Kingdom of paintings by his American contemporaries and ancestors.

"A View of Andrew Wyeth" (1987). Previously unpublished.

MORRIS LOUIS AT THE GUGGENHEIM MUSEUM
1963

Among the heroic generation of American painters, the impulse toward an elemental image was so strong around 1950 that it is easy to pinpoint what might be called the platonic ideal of each of their new styles. The archetypal Pollock or Kline, Rothko or Newman may be quickly described or sketched on paper. Often, in fact, the evolution of their work suggests a three-part development, in which the artist first struggles to pare his pictorial language down to an irreducible term; then, having at last extracted this primary image, repeats it triumphantly for a few precious vintage years; and finally begins to lose this monolithic power either by venturing into more complex and alien vocabularies or by relaxing into self-imitation.

For those accustomed to this historical pattern, Morris Louis's last and best-known works of 1961–62—those rainbow trajectories that speed across an open plane of unprimed and unsized canvas—may look like the definitive distillation of a style that had just then reached maturity. And if they are equated, in evolutionary terms, with a newly emerged personal style, like the first giant Kline calligraphs in black and white or the first symmetrically tiered Rothkos, then Louis would seem to belong to a later historical phase. Slowly, however, his achievement of the 1950s is being disclosed. By presenting only seventeen canvases from an ostensibly premature period, the Guggenheim Museum has obliged us to reconsider not only Louis's stature but also his proper historical position. It should be said that the sheer visual assault of these huge canvases is so breathtaking in its direct sensuousness that matters of history, of influence, of better or worse instantly wither into pedantry. But once one's habitual critic's and historian's breath is caught again—a very long wait that attests to the numbing beauty of these works—a good deal of juggling has to be done.

Thus, as Lawrence Alloway persuasively suggests in his catalogue text, Louis is perhaps best aligned historically with, and not after, the first great generation of American abstract painters. If, indeed, he was able to paint a picture like *Intrigue* in 1954, then he was already an accomplished master, whose work could be looked at as the equal, and not merely the promising reflection, of his more famous contemporaries. And if such a picture can hold its own next to a Rothko, Newman, or Still of the same year, as well as sharing the exhilarating impact of these masters' sublime scale and immediacy, then Louis may well be situated more comfortably with these artists than with their progeny. Born in 1912, he belongs chronologically to their generation; and if his art lags a few years behind theirs in achieving full stature, this can be explained by his relative seclusion in Washington from the New York scene.

Of the 1954 canvases exhibited, two, *Terrain of Joy* and *Spreading,* do, in fact, suggest an as-yet-unrealized style. In the former (fig. 75), echoes of action painting are curiously combined with what was soon to be the characteristic Louis touch, so that the picture might almost be described as an X-rayed de Kooning. Impulsive, frothing streaks of color that recall brushwork with palpable pigment are paradoxically dematerialized; the painter's *matière* becomes an oddly translucent stain that lies not on, but somewhere in, the weave of the canvas. But in *Salient* and *Intrigue,* also of 1954, these intimations are fully realized. Here, painterly agitation is suddenly stilled in pictures of a languid, expansive beauty that newly evokes the exquisite hothouse atmosphere of the most precious Art Nouveau gardens.

The organic metaphor in Louis's art is in part the product of his unique working methods; for he would apply an unusually strong dilution of pigment to a canvas laid flat and, by tilting and folding the unstretched cloth, let the paint flow like a river or spread like waves. Louis's technique, like Pollock's spattering and dripping of paint, involves an interplay between the will of the artist's overall design and the natural configurations of accident; yet unlike Pollock, Louis worked at a slower, more sensual tempo that permitted a luxurious savoring of the most refined sensations. Thus, the gently expanding stains and quivering overlays of *Intrigue* create a fragile, organic image of uncommon beauty, as if we were examining a butterfly wing or a quartz deposit through the startling magnifications of a microscope; and even the texture of the cotton-duck canvas, soaked as it is with liquid pigment, yields a kind of breathing porousness that affirms this vitalist quality. In the same way, the painting's magical iridescence slowly shimmers before our eyes like some rare phenomenon of nature rather than a fixed and predetermined work of man. Like Pollock's churning labyrinths or Still's burnt and flaking edges, Louis's pictures seize the quality of organic growth and change, but within an atmosphere that substitutes an epicurean sensibility for one of almost brutal vigor.

75.
Morris Louis,
Terrain of Joy,
1954

In this, Louis's strongest affinities are with Rothko, particularly in some of the enormous untitled canvases of 1958. In one of these a wall of gaseous yellow expands like a giant flame, whose heat and energies, strongest at the core, appear slowly to cool and weaken. The delicate layers of color, particularly in the ghostly halo that emanates from the lateral edges, generate an extraordinary atmospheric density that, as in Rothko, seems part liquid, part vapor, part fire. Not since Turner have artists created so powerful and all-embracing an image of the intangible core of nature's energies—a vital, chromatic substance that may alternately dissolve into thin air or crystallize into a geological stratum. And again, as in Rothko, the mystical quality of this most recent affirmation of modern painting's long tradition of Romantic vitalism is further emphasized by Louis's tendency toward a grandiosely symmetrical and heraldic design that is sensed, but never absolutely stated, behind these glowing walls. In this connection, one would like to explore further the twentieth-century American background of this pantheistic vision. Arthur Dove's organic abstractions offer analogies of shape and feeling, though obviously smaller in scale and often provincial in technique. Even more, the enormous murals of Augustus Vincent Tack, also admired and exhibited by Duncan Phillips in Washington, where Louis lived from 1947 until his death in 1962, reveal a belated fin-de-siècle sensibility to elemental landscapes that would conceal a pseudo-religious mystery. And seen in this light, Louis's own work often seems an extension of the Symbolist mood of the turn of the century, whether in the lavender twilight of Monet's gardens, the evanescent dramatis personae of *Pelléas,* or the color-light that was to be played with Scriabin's *Prometheus, Poem of Fire.*

Saraband of 1959 (fig. 76) enlarges this voluptuous sensibility in multiple spectrums that proliferate in a chromatic forest whose jungle density is suggested by the infinite overlappings at the margins and whose granular surface—again the weave of the canvas—seems to produce its own changing heat and light. Remarkably, the sheer gorgeousness of such a canvas stands on this side of the cloying or pretty, perhaps because of the stark four-part vertical skeleton that may be felt within its depths. And in other works of 1959, such as *Floral,* this tropical luxuriance again explodes, here looser in organization and more erratic in pattern, but even more brilliant in the growing isolation and purity of the liquid hues steeped into the canvas. Not the least beautiful thing about this work is the large passage of gray in the lower left, which not only counters the risks of chromatic surfeit, but also produces in itself an uncanny luminosity that never before seemed within the potential of this matte and ascetic shade. Similarly, in other works of 1958 and 1959 (fig. 77) these darker tones are again exploited, this time in a volcanic eruption that appears to be caught just at the moment the last fires are turning into an ashen, but still glowing blackness.

In the last of the works exhibited, those dating from 1960, Louis extracted even greater purity from his floods of color. In *While* of 1960 (fig. 78), they are distilled into a great fan of luminous reeds that create an environment whose immediate chromatic brilliance can be matched only by some of the late paper cut-outs of Matisse. Here, the ostensible simplicity of this peacock-plume arrangement is elegantly enriched by the slow, unpredictable sinuosity of these fragile rays, and by the alternations of contiguous, freestanding, and overlapping hues that produce simultaneously an opaque and translucent effect.

In the last work exhibited, of 1960 (fig. 79), the security of such patterns is recklessly abandoned in favor of a canvas whose daring openness and breadth is one of the triumphs of

76.
Morris Louis,
Saraband,
1959

77.
Morris Louis,
Untitled,
1958

78.
Morris Louis,
While,
1960

79.
Morris Louis,
Pi,
1960

recent American painting. Here, Louis's familiar relation of color stains to canvas is reversed: the rivulets of color now trickle off diagonally at the corners, whereas the central area is nothing but the pure white canvas itself, a seventeen-foot-wide expanse of space that sweeps boundlessly outward. Against the marginal brilliance of the chromatic streams, this gigantic field acquires an astonishing luminosity and depth, like the untouched white paper in a Baroque landscape drawing that is suddenly transformed by a few pen strokes on the earth, into an infinity of sky. And looking forward to the last works of Louis, not exhibited here, one remembers how their virgin canvases also provide an open, vibrant ambience for searing paths of color.

At a time when historical consciousness is so great that 1963 seems to be chronicled and shelved already, it is a rich gift to discover that a decade of activity by a major American artist has largely eluded public knowledge. It is a pleasure to think of the dozens of canvases yet to be seen, and a challenge to think of the reassessment of the 1950s that their presence will compel.

"Morris Louis at the Guggenheim Museum." Published in *Art International* 7, no. 9 (December 1963), pp. 24–27.

LOUISE NEVELSON

1959

In some ways, Louise Nevelson's newest and most astonishing achievements—her vast wooden walls—recall the iconoclastic innovations of the new American painting rather than the more tradition-bound character of the new American sculpture. In scale alone, the architectural magnitude of these forests of black boxes parallels the awesomely large paint expanses of Rothko, Still, or Newman, which similarly impose upon the spectator an engulfing sensuous environment. In structure, too, Nevelson's creative heresies evoke pictorial rather than sculptural analogies. Like the churning labyrinths of Pollock, her shadowy facades are inexhaustibly complex, affording endless explorations to the eye. As the works are looked at in detail, each visual focus is caught in a separate adventure that involves a unique configuration of irregular shapes and unfathomable depths. Looked at as an entirety, her walls, like Pollock's mural spaces, are boundless, for what we see is only a fragment of elements that are infinitely extendable. And in imagery as well, these walls suggest, like so much recent painting, organic metaphors. Almost the product of natural growth or decay, they allude to the mysteries of thick, dark woods, to the unimaginable scope and impalpable substance of the night sky.

As far back as the early 1940s, Nevelson had begun to define the component parts of this poetic and pictorial architecture. In a wooden construction of 1945, *Ancient City* (now destroyed, like most work of this period; fig. 80), the premises of her later achievement are apparent. Raised on a primitive wooden pedestal, the weathered majesty of an exotic ancient metropolis (is it Mycenaean, Inca, Oriental?) is re-created by a pair of ceremonial lions and a totemic baluster-column that still ennoble these strange, hovering ruins. And here in genesis, one can find not only the wooden architectural fantasy of Nevelson's later work, but also her particular fascination with the constructive and destructive powers of nature.

The extraordinary prophecy of *Ancient City* was more than fulfilled in the 1950s. In works of both small and large scale, Nevelson investigated the problems that were ultimately to reach a synthesis in her wall sculptures. The *Bouquet* of 1957 is a case in point, establishing as it does her characteristic elegance of detail and her familiar interplay between organic and man-made structures. Working here within a painter's rectangular framework, Nevelson opposes the given geometry of reason with the burgeoning, irrational forms of nature. With a delicate yet vital pressure, the tendril-like fragments of the bouquet expand toward and even beyond their rectilinear confines, creating a nuanced tension between the forces of

80.
Louise Nevelson,
Ancient City,
1945

nature and the control of man that can withstand comparison with Arp's finest reliefs. The material, too, contributes to this fragile and exacting equilibrium in its combination of unpredictable wood-grain patterns and the imposed perfection of precise and polished contours.

The vocabulary of such a work, with its balance of organic and geometric shapes, succinctly expresses the Nevelson dialogue between art and nature. This duality becomes more extravagantly evident in a view of her reliefs exhibited against a garden wall. Like the outdoor sculptures of Brancusi, Arp, or Moore, Nevelson's work fits comfortably into a natural environment, without attempting camouflage. If these reliefs with their gnarled wooden surfaces and ragged edges are, for a moment, almost indistinguishable from the tree that shades them, their vestiges of geometric pattern, their unifying blackness, their elegant contrasts of smooth and rough also locate them in the world of art. Like a painted picket fence that has undergone the eroding effects of time, Nevelson's garden wall belongs to both a natural and a man-made realm. In this respect her work often suggests a reprise of the late eighteenth century's artificial ruins, though one that is endowed with a peculiarly contemporary and feminine sensibility. Like the poems of Marianne Moore, Nevelson's sculpture extracts a gossamer evocativeness from objects that most people would overlook—a nailed plank of wood, the hinge of a door, the leg of a discarded chair.

Nevelson's ability to metamorphose such mundane materials into art for the eye and the imagination is still more remarkable in a pedestal sculpture of 1957, *Moon Landscape.* In this, a sturdy pier of fragmented boards—the heir of the abbreviated foundations that support the odd relics of *Ancient City*—rises so high above the ground that the landscape it supports can satisfy the lunar expectations of the title. Belying the terrestrial solidity of this Brancusi-like column and the geometric purity of its flat, horizontal base (so remote from the plane of the ground below), a crowded cluster of delicate splinters, half upright and half windswept, creates a landscape that no longer seems to be an earth-bound artifact but rather the ghostly aftermath of an unnamed destructive power.

The magical unworldliness of such a work is in part the result of Nevelson's pervasive black paint, which saturates the pores of all her wooden sculpture. This ubiquitous blackness, so essential to her art, functions on many levels. For one thing, it tends to deprive her wooden matter of its substance, transforming tangible forms into something mysteriously absorbent and bodiless. The softened darkness of her sculpture rejects the tactile properties of metal, stone, or unpainted wood and contributes by this very impalpability to the nocturnal penchant of her imagery. Equally important, this use of black is integral in Nevelson's almost pictorial approach to sculpture. Like a painter, she can create dense mazes of multi-layered spaces with her luminous sequence of overlapping black planes—a phenomenon especially apparent in the many cabinet sculptures of 1958. In *Windscape,* for example, the opening of a hinged door unveils the lugubrious illusion of impenetrable depths whose crumbling, floating components dramatically contradict the actual shallowness and rectilinear precision of the palpable box that contains them.

If Nevelson's new wall sculptures—her Sky Cathedrals (fig. 81) and Moonscapes—can be simply described as a quantitative multiplication of these smaller parts, their overall

81.
Louise Nevelson,
Sky Cathedral,
1958

effect involves a more complex qualitative change. Traditionally, the fragile, private quality of Nevelson's imagination implies (and here one thinks of Klee) an equally intimate scale; and to see this personal world magnified to public dimensions is a startling experience for which perhaps only the architectural fantasies of Gaudí or the largest Abstract Expressionist paintings offer adequate preparation. So complete is the sheer physical domination of the spectator that in the installation of some of these walls, the lighting itself is calculated to play an essential role in materializing the uncanny environment of a dream world. Yet even after one has assimilated the disarming scale of this imagination, further heresies remain. An unfamiliar lack of permanence and aesthetic inevitability is intended here, for not only are these physically separate but visually fused boxes capable of infinite rearrangement, but even their number might be diminished or increased. Moreover, the fantastically varied excrescences of this architectural framework—splats, moldings, a carved leaf—appear to be growing slowly but irrevocably, like stalactites in a darkened grotto, and underline the sense that the whole exists in an animate state, almost transforming itself as we observe it. Is there perhaps here a surprising translation of those qualities of chance so prominent in today's painting into the less accident-prone realm of constructed sculpture? Yet in Nevelson's art, as in that of the best painters who work with a vocabulary of constant flux, each seemingly random configuration is guided by an experienced intuition which stamps both the parts and the whole with the quality of a distinctive and controlled style. And like the best of recent painting, too, Nevelson's work has the authority to compel the spectator to re-examine his prejudices—as well as the sensuous and imaginative richness to repay this effort.

"Louise Nevelson." Published in *Arts Yearbook 3: Paris/New York* (1959), pp. 136–39.

JAMES BISHOP: REASON AND IMPULSE

1967

One way to approach James Bishop's paintings, seen in New York this fall for the first time at the Fischbach Gallery, is to stress the advantages of their expatriate origin. Bishop has lived in Paris since 1957, returning to this country as a visitor only once, in 1966. His relation to the last decade of American painting, then, has been that of both an outsider and an insider. On the one hand, his art depended fully on the traditions of his native country; but on the other, he has been free from the yearly pressures of abrupt and modish changes exerted upon younger artists who wanted to survive in the New York scene. The results in Bishop's works are clear. He was able to evolve from the 1950s to the 1960s with slow and measured steps that move in the overall direction of recent American painting yet remain unfrenzied by the pulse of New York.

From his more meditative vantage point in Paris, Bishop first assimilated quietly such major transatlantic stimuli as the heroic scale of Rothko, Still, and Newman and the light-dark heraldry of Kline and Motherwell, and then achieved a personal distillation that now belongs fully to the mid-1960s. Works of 1964 teeter on the brink of what could be learned from the secure triumphs of an earlier generation. The emblematic simplifications of these paintings offer a particularly Motherwellian duality between the predictability of pattern and the marks of impulse. Thus, the pure geometry of the square framing edge is first mirrored in the continuous white border, then cracked by the broken-square fields of blue, and then further challenged by the internal canals of more fluid streams of color that seem to have erupted from the intense pressures of a predetermined design. These taut dialogues between the whole and the parts, between the dictates of reason and the rebellions of feeling, reach an even more razor-edged extreme in the newest works of 1965–66 (see fig. 82). Here, the pictorial architecture partakes more overtly of the 1960s preference for a lucid, systematic order, insisting characteristically on austere zones of absolute symmetry that echo the perfect square of the canvas's shape. Generally, a rectangular area of white is set off against smaller rectangles of color in an evocation of those quattrocento altarpieces with side panels or predellas that Bishop, during his frequent trips to Italy, had studied with the erudition of an art historian and the love of a connoisseur. Yet these stark geometric formats are dramatized by hairbreadth irregularities that refine and heighten the more apparent visual conflicts of the earlier work. Thus, at the points of juncture between the major zones of white and the minor zones of color, there are quivering pressures not only of vibrant, irregular edges in collision,

82.
James Bishop.
Installation view of exhibition at Fischbach Gallery,
November–December 1966, showing (from left to right)
Bathing and Fading, Roman Numbers, Other Colors, Folded, and *Reading*

but even of an occasional tiny splattering of paint. Moreover, these areas vie with each other for readings as foreground or background, as surfaces that are simultaneously being concealed or unveiled, as energies that are slowly expanding or contracting against the explicitly flat and static geometries of the pictorial architecture. The colors, too, bear out this interplay between the austere and the sensuous. Monochrome expanses of astringent ochers and olive greens, of chilly blues and somber brick reds betray an unexpected warmth and glow beneath such overtly puritanical hues and surfaces. And often, the ostensible regularity of the painting's structure is subtly countered by an almost imperceptible variation in tonal value that adds still another pressure within the binding rigor of the dominant symmetries.

Like so many recent American paintings, whether by Stella or Noland, Bishop's impose upon the traditions of Abstract Expressionism a new kind of discipline that is largely generated by the rectilinear ground plan established in the picture's framing edge. Yet within the severe logic of this plotted territory, Bishop maintains a private passion and vibrancy that give his works their distinctive stamp. In the best sense, they are the paintings of an expatriate who has been able to choose, free from the exigencies of the New York art world, what is truly relevant to him. Not surprisingly then, they are pictures that, like the strong and weathered stones of the Renaissance architecture that so often inspired them, emanate a durability and resonance rare in American painting today.

"James Bishop: Reason and Impulse." Published in *Artforum* 5, no. 6 (February 1967), pp. 54–55.

CY TWOMBLY
1984

The earliest Twombly in the Saatchi Collection transports us swiftly to the New York City of 1956, the place and the time that this untitled canvas was painted and scrawled upon. As the work of a twenty-eight-year-old, trying to find his identity in a territory occupied by the heavyweight authority of the likes of de Kooning and Pollock, it is a triumph. Bowing respectfully to these ancestral figures, it nevertheless speaks with its own voice. To be sure, the flavor of the New York School is everywhere apparent: the veneration of ragged, graphic impulse; the staking out of a field of teeming, perpetual motion, where traditional structures of major and minor, central and peripheral are challenged; and the reduction, as in so many works of de Kooning, Pollock, Kline, and Motherwell, to a language of black and white. Yet we immediately sense not discipleship, but a uniquely personal flavor. The elbow and shoulder movements of de Kooning and Pollock are replaced by a gentler calligraphy of wrist and finger. The raucous, colliding tracks of movement give way to a more muted, whispered ambience, as if we were experiencing through many veils of memory the record of some earlier actions and thoughts that had gradually been effaced both by long exposure and by later

83.
Cy Twombly,
Untitled
[Lexington, Virginia],
1956

overlays of graffiti. Indeed, though the works of Pollock and de Kooning tend to speak in the present tense of an immediacy of visual and emotional outpourings, Twombly's canvas already speaks in a kind of layered past tense, in which we recognize long-ago beginnings and erasures, near-invisible strata that lie below the surface like ghost memories of earlier impulses. In a way which may be more than fortuitous, given Twombly's close friendship with Rauschenberg (they even had a two-man show in New York in 1953), this canvas recalls Rauschenberg's notorious act of patricidal exorcism, his willful erasure in 1953 of a de Kooning drawing, an act whose results would symbolically and literally annihilate the forceful, animate presence of de Kooning's lightning-bolt drawing style and reduce it to a shadowy memory in the historical past.

Twombly's untitled canvas of 1956 can, of course, be associated as well with other earlier works that liberate calligraphic impulse for a wide spectrum of effects, whether the fine threaded webs spun out so quietly and exquisitely by artists hailing from the Pacific Northwest like Morris Graves and Mark Tobey, or the grander, international Surrealist tradition of believing that unedited doodles might convey deeper psychological truths than would more premeditated styles of drawing. Nevertheless the effect here remains very much that of New York, 1956, not only in terms of the echoes of the reigning Abstract Expressionist masters, but also in terms of a sensibility to that derelict but pulse-quickening urban environment which also nurtured Rauschenberg so richly in the 1950s, a microcosm of infinite density where every city wall and public sign might be defaced by layer after layer of random scribbles, a chaotic fossil deposit of psychological detritus comparable to a scrap heap of discarded automobile parts. And here, within this Lascaux of the twentieth century, tantalizing suggestions of letters and words surface and disappear, illegible brambles that leave traces of lost or as yet unformed inscriptions. But if these are only graphological phantoms that throw us back to the origins of written language, there is at least no mistaking, in the upper left-hand corner, Twombly's own name and the date, 1956, a longhand scrawl, which already seems to be vanishing behind a smudge of white paint that threatens eventually to efface the artist's very signature.

For among the other triumphs of Twombly's sensibility is the sense of seizing an organic world of change and process, at once rapid, attuned to the pursuit of a private impulse, and of long duration, attuned to what feels like decades and centuries of public historical layering, comparable to an archaeological site of multiple strata. Note, incidentally, that this ability to create layers of temporal resonance recalls that of another New York friend of Twombly's in the 1950s, Jasper Johns, who, in that decade in particular, through techniques of dense encaustic and just-visible underlays of the daily newspaper, could evoke a similar aura of historical accretion, in which the literally multilayered surfaces convey a quality of survival and potential change that reaches nostalgically back into the past and forward to a future where messages that lie deep beneath these painted strata may either be more fully revealed or disappear entirely.

This poetic character, drawn to meditations like those of a romantic wanderer upon things past, may well have seemed displaced in the perpetual present of New York's antihistorical tempo; and with hindsight it seems right and inevitable that Twombly would become an American expatriate living in that world of maximum historical memory and mystery, the Mediterranean. A resident of Rome since 1957, and a traveler in Spain and North Africa,

84.
Cy Twombly,
Sahara,
1960

Twombly seems to have absorbed the magic and the myths of both the classical world and its outlying exotic terrains. In *Sahara* of 1960 (fig. 84), the signature in the lower right is like a private variant of an ancient Roman inscription, beginning with the artist's personal scrawl for name and place, but then dated with Roman numerals MCMXXXXXX, as if Twombly were reincarnating some ancient historian and traveler, a modern Herodotus who explores the North African desert, which here surfaces and again vanishes in the uncertain recall of a voyager's memory. Echoing the sketchbooks of earlier artist-travelers in North Africa, such as Delacroix, Twombly's canvas is a loose-jointed composite of a tourist's notations about sights, facts, and feelings. The faintly inscribed jottings range from spare strokes of blue crayon, which may evoke the limpid sky of the desert, to diagrammatic fragments that seem to chart, topographically, the contours of distant hills, to elementary numerical sequences (1, 2, 3, 4, 5, 6, 7 . . .), which as in the work of Johns may rejuvenate the magic of primitive commensuration. And here and there other words, images, symbols surface palely in these hazy souvenirs—suggestions of shrubby landscape; rounded forms that conjure up female anatomies; an unexpected node of overlapping intense colors that may shroud the memory of a gorgeous native costume; a passage of cubic geometries that may describe some rudimentary stepped architecture; a startling inscription, "A Bubble of Beauty / to Fragonard for Sappho," attached to a swollen, eroticized shape; and much, much more. A field of nostalgic free associations, but all oriented to the same desert motif, quivers immaterially before our eyes in a strange language where shapes and symbols are only beginning to congeal and where wide and low framing rectangles, as in the sequence at the right, begin to offer some preliminary constraint of reason in which to grasp, as in the imagined rectangular form of a drawing or canvas, the horizontal infinities of the desert.

The archaism of Twombly's imagination, in which everything regresses to its mysterious birth pangs, can rekindle, too, pictorial traditions of illustrating classical myths, whose

waning vitality in our own century generally required the genius of a Picasso to be temporarily sparked back to life. But in Twombly's introspective musings, this great if moribund Western heritage seems reborn, as in the 1960 *Leda and the Swan* (fig. 85), one of his many meditations on this venerable erotic metamorphosis, which, in its coupling of Leda with Jupiter in the form of a swan, is at once carnal and ethereal, a fusion of the most physical sexuality with a white-winged airborne fantasy of Mallarmé-like frailty. Perhaps the memories of Correggio's or Leonardo's visions of Leda set off Twombly's own meditations on this theme, which, in this canvas, merge words and images to re-create the wonder of the Greek narrative, as if it had just been invented in some ancient poet's mind or illustrated by the very first artist of the classical world. The protagonists are present both as crudely inscribed words, as in a written fragment from an archaeological site where the tale was sacred, and as rudimentary ideograms, in which the profile of the long-necked bird, framed as in a hieroglyphic, is opposed to a softer, ovoid form, Leda, set beside a pool and surrounded by suggestions of orifices and rounded anatomies. Below, a flurry of numbered, featherlike forms and a more intense reddened nexus of organic parts convey the physical encounter of, in Yeats's phrase, "a sudden beat of wings." And, typically, other elementary motifs surface as weathered graffiti, from the implication of some primitive system of mensuration above, as if the first illustrator of this myth were marking out the dimensions of his image; to the suggestion of a framed landscape setting at the upper right; to the inventory, center right, of crayon colors that would be used to give erotic pungency to this otherwise ghostly recall of the most sensual of myths.

Such whispers of color generally seem repressive elements in Twombly's work, but on rare occasions, they can surface in surprisingly visceral exposures that play on moods of sexual and emotional violence. *Red Painting* of 1961 is one of these canvases in which we feel that the muffled sensuality of such earlier works as the untitled canvas of 1959, whose drama seems concealed behind scrims of white paint, has suddenly burst its floodgates in a ragged clash of reds so intense by Twombly standards that we respond to it as to the bloody aftermath of a psychic or erotic battle. That there seems to be so private, so one-to-one a correlation between the artist's personal experience and the impulsive, associational character of his art is one of the many ways in which Twombly perpetuates, particularly in a painting like this, the tradition of Gorky's late work, where the most fluid, multilayered paint surfaces are activated by gossamer linear traces and by sudden blossoms or wounds of color that, we feel, record directly graphs of personal memory and emotion. And we feel this intensely, too, in more fragile and oblique works like *A Roma* of 1964 and an untitled canvas of 1968 where we almost discern the components of an autobiographical narrative, flickering entries in a private journal that may suggest glimmers of erotic longing or encounter within the smudged environment of number and letter graffiti that allude to the specifics of time and place.

Often, too, Twombly will return to what becomes for him, in this domain of the most ephemeral daydreams, a recurrently disciplinarian image, as if he were regaining control of his meandering, spiderweb doodles, the better to liberate them once again. This is the case here in four untitled works of 1968–69 (fig. 86), two of which repeat the obsessive rhythms of an archaic exercise in the rudiments of cursive script, as if we were looking at the archetype of all classroom blackboards on which a teacher first taught us the principles of penmanship. Indeed, the colors, or rather, non-colors—slate gray and chalky white—underscore

85.
Cy Twombly,
Leda and the Swan [Rome],
1960

86.
Cy Twombly,
Untitled [New York City],
1968

87.
Cy Twombly,
Untitled (Bolsena),
1969

this association, as does the sense of approaching a ruled, horizontal order, as in a primitive system of writing. This blackboard imagery is equally evident in another painting of this group, but here the rotating, oval rhythms are replaced by an equally windswept memory of some archetypal, pre-Euclidean geometry lesson, a mental tornado of as yet undisciplined rectangular planes that are occasionally defined further by numbers and letters, which, in a more rational world, would fix and measure them precisely. And in the last of this quartet, *Untitled (Bolsena)* of 1969 (fig. 87), we are almost back to the tabula rasa except for the tremulous marks of lines that seek out the parallelism of two horizontal axes, and of phantom streaks of paint that recall the marks of chalk erased on the blackboards of our childhood memories. It is fascinating as well to see how these austere yet spontaneous exercises in reconstructing the origins of calligraphy and geometry bear fruit in both earlier and later works of a more fanciful, free-wheeling character. Thus, the untitled painting of 1969 recaptures, together with other fugitive images, some of the breeze-blown geometries in the more severe painting of 1968. Indeed, like any master, Twombly has created his own universe of forms, a language of metamorphic wisps that not only plunge us deeply into our own most primitive memories, but into the origins of history, myth, civilization. Abstractly stated, of course, such goals are those shared by some of the greatest artists and thinkers of the first half of our century, such as Miró or Freud; yet when resurrected by Twombly, they seem the most primitive of birthrights, the unique dream of an artist whose precious sensibilities keep eluding mainstream categories.

"Cy Twombly." Published in *Art of Our Time: The Saatchi Collection,* vol. 2 (London: Lund Humphries, 1984; New York: Rizzoli, 1985), pp. 24–27.

JASPER JOHNS

1960

The situation of the younger American artist is a particularly difficult one. If he follows too closely the directions established by the "old masters" of that movement inaccurately but persistently described as Abstract Expressionism or Action Painting, he runs the risk of producing only minor embellishments of their major themes. As an alternative approach, he may reconsider the question of a painting's reference to those prosaic realities banished from the Abstract Expressionist universe. Like many younger artists, Jasper Johns has chosen the latter course, yet unlike them he has avoided the usual tepid compromise between a revolutionary vocabulary of vehement, molten brushwork, and the traditional iconography of still lifes, landscapes, or figures. Instead, Johns has extended the fundamental premises rather than the superficial techniques of Abstract Expressionism to the domain of commonplace objects. Just as Pollock, Kline, or Rothko reduced their art to the most primary sensuous facts—an athletic tangle of paint, a jagged black scrawl, a tinted and glowing rectangle—so, too, does Johns reduce his art to rock-bottom statements of fact. The facts he chooses to paint, however, are derived from a non-aesthetic environment and are presented in a manner that is as startlingly original as it is disarmingly simple and logical.

Consider his paintings of the American flag. Suddenly, the familiar fact of red, white, and blue stars and stripes is wrenched from its everyday context and forced to function within the rarefied confines of a picture frame (fig. 88). There it stands before us in all its virginity, an American flag accurately copied by hand, except that it now exists as a work of art rather than as a symbol of nationalism. In so disrupting conventional practical and aesthetic responses, Johns first astonishes the spectator and then obliges him to examine for the first time the visual qualities of a humdrum object he had never before paused to look at. With unerring logic, Johns can then use this rudimentary image as an aesthetic phenomenon to be explored as Cézanne might study an apple or Michelangelo the human form. But if this artistic procedure of reinterpreting an external reality is essentially a traditional one, the variations on Johns's chosen theme seem no less extraordinary than its first pristine statement.

To our amazement, the American flag can become a monumental ghost of itself, recognizable in its tidy geometric patterns, but now enlarged to heroic size and totally covered with a chalky white that recalls the painted clapboards of New England houses. No less remarkable, this canvas-flag can be restored to its original colors, but unexpectedly considered as a palpable object in space from which two smaller canvas-flags project as in a stepped pyramid. Or, in

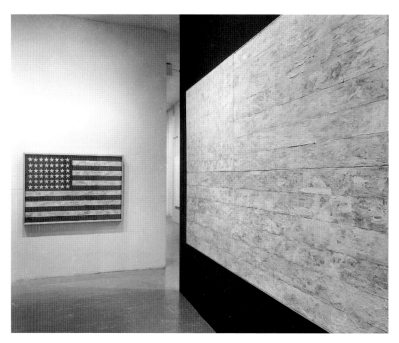

88.
Installation view of
two Flag paintings by
Jasper Johns in the exhi-
bition "16 Americans"
at The Museum of
Modern Art, New York

another variation, the flag, instead of being tripled outward into space, can be doubled verti-
cally, colored an arid slate gray, and painted with erratic and nervous brushstrokes that threaten
the dissolution of those once immutable geometries of five-pointed stars and parallel stripes.

If we expect to salute flags, we expect to shoot at targets. Johns, however, would have
us realize that targets, like flags, can be the objects of aesthetic contemplation and variation.
The elementary patterns of concentric circles, as re-created by Johns in a monochromatic
green or white target are to be stared at, not aimed at, and offer the awesome simplicity of
irreducible color and shape that presumes the experience of masters like Rothko, Still, and
Newman. Again, as with the flags, this symbolic and visual monad can be transformed and
elaborated. Such is the case in another target, whose circles are painted in different colors
and whose upper border is complicated by a morbid exhibition of plaster body fragments (fig.
89). Or then, there is a target drawing in which, as in the double gray flags, the impetuous
movement of the pencil disintegrates the circular perfection of the theme (fig. 90). Johns's
capacity to rediscover the magic of the most fundamental images is nowhere better seen than
in his paintings of letters and numbers. In *Gray Alphabets* he makes us realize that the time-
worn sequence of A to Z conveys a lucid intellectual and visual order that has the uncompli-
cated beauty and fascination of the first page of a children's primer. Similarly, the *Gray
Numbers* presents another chart, whose inevitable numerical patterns are visually translated
into that ascetic geometric clarity so pervasive in Johns's work. At times Johns even paints
single numbers, as in *Figure One*, in which the most primary of arithmetical commonplaces
is unveiled as a shape of monumental order and a symbol of archetypal mystery. Such works
look as though they might have been uncovered in the office of a printer who so loved the
appearance and strange meaning of his type that he could not commit it to practical use.

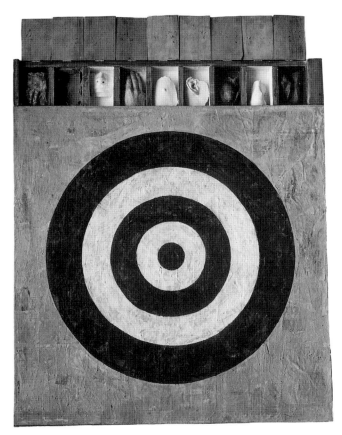

89.
Jasper Johns,
Target with Plaster Casts,
1955

90.
Jasper Johns,
Target,
1958

91.
Jasper Johns,
Tennyson,
1958

If the almost hypnotic power of most of Johns's work is in part the result of his disconcerting insistence that we look at things we never looked at before, it is equally dependent upon his pictorial gifts. In general, he establishes a spare and taut equilibrium of few visual elements whose immediate sensuous impact is as compelling as the intellectual jolt of monumental flags and targets in picture frames; and his colors have a comparable clarity and boldness. Nor should his fastidious technique be overlooked. Most often he works with a finely nuanced encaustic, whose richly textured surface not only alleviates the puritanical leanness of his pictures, but also emphasizes the somewhat poignant fact that they are loved, handmade transcriptions of unloved, machine-made images. Although Johns has devoted most of his young career to the manipulation of target, flag, number, and letter themes, he has also made many other discoveries. There are, for example, the chilly expanse of mottled gray geometries that becomes a tombstone for the Victorian poet whose name seems to be carved at its base (fig. 91); and the small open book, transformed from reality to art by the process of painting, and therefore concealing, the print on its page, and by fixing its mundane form in a position of heraldic symmetry within a framed box (fig. 92). And no less inquisitive about the interplay between art and reality are the Hook paintings (fig. 93), an intellectual and visual speculation on the curious mutations of two- and three-dimensional illusions when a canvas with two projecting hooks is viewed from both the front and the side; and the more recent *Thermometer* (fig. 94), in which painted calibrations, fixed by the artist's brush,

92.
Jasper Johns,
Book,
1957

93.
Jasper Johns,
Hook,
1958

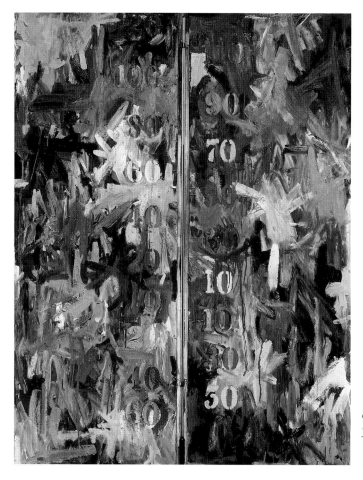

94.
Jasper Johns,
Thermometer,
1959

permit us to read on a real thermometer fluid variations of temperature determined by nature rather than by art.

It remains to be said that Johns's adventurous inquiries into the relationship between art and reality have often been equated with Dada, but such facile categorizing needs considerable refining. To be sure, Johns is indebted to Duchamp (if hardly to other, more orthodox Dadaists), whose unbalancing assaults on preconceptions were often materialized in terms of a comparably scrupulous craftsmanship, yet he is far more closely related to the American Abstract Expressionists. For if he has added the new dimension of prosaic reality to their more idealized realm, he has nevertheless discovered, thanks to them, that in the midtwentieth century the simplest visual statements can also be the richest.

"Jasper Johns." Published in *Art International* 4, no. 7 (September 1960), pp. 74–77.

JOHNS'S *THREE FLAGS*
1980

The year was 1958, and I still remember the jolt of seeing *Three Flags* (fig. 95) for the first time down at Johns's Pearl Street studio. I was hardly unprepared, having already been stopped in my tracks that January by Johns's first one-man show at Leo Castelli's, where what then looked like the most candid restatement of the Stars and Stripes suddenly ground the traffic of all of American painting to a halt that made you stare and stare again. But even with that picture some months behind me, *Three Flags* almost literally bowled me over. For here, that red, white, and blue platitude, preserved for eternity as a flat painting, leaped out of the middle of the canvas like a jack-in-the-box, defying gravity and assaulting the viewer head-on. Especially for eyes accustomed to the murky, private labyrinths of color and shape in most painting of the 1950s, the strident clarity of *Three Flags* looked the way a C-major chord played by three trumpets might sound: a clarion call that could rouse the sleepiest spectator.

Today, twenty-two years later, and even after *Three Flags* has become an internationally famous textbook image via a colorplate in H. W. Janson's renowned *History of Art,* its astonishing impact—not only visual and mental, but even physical—has barely diminished.

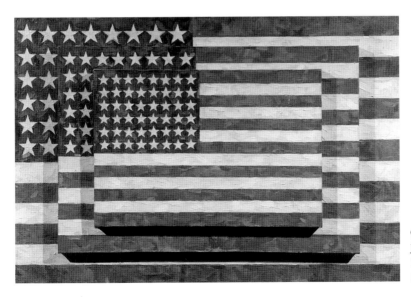

95.
Jasper Johns,
Three Flags,
1958

For it still grasps and merges just about every yes-and-no contradiction that makes the best of Johns's art both so simple and so complicated, so direct and so elusive. Is *Three Flags* totally paralyzed or could its pop-up book potential startle us again? Is this one painting, three paintings, or a relief sculpture? Is the "real" picture the largest, most distant flag, with the nearer two blocking our view, or is it the nearest one, with the two behind it only echoing after-images or enclosing frames? (Johns himself has related *Three Flags* to the commercial illustration of the little girl on the Morton's salt box who carries a Morton's salt box with her image repeated, which in turn carries another salt box, etc.) Are the hidden surfaces of the two more distant flags actually painted, or must we finish their patriotic heraldry in our mind's eye? Are these paintings as flat as their canvases or as thick as their three-tiered carpentry, or do they fuse in paradoxical illusions of speed and depth? Indeed, the abrupt change in size from one flag to another creates a swift, funneling effect, like a zoom shot of an oncoming parade, but this is then flatly denied by the inversion of traditional perspective (the biggest stars and stripes are in the back, not the front) and by the hypnotic fixity of the concentric, targetlike triple pattern. The literal, material facts of two and three dimensions are transformed here into an expanding and contracting bellows of shifting illusions.

And then there is Johns's wedding of the opposites of public and private, of the ephemeral and the permanent. Though at first glance Old Glory seems merely replicated in an impersonal fashion, the quietly vibrant, luminous quality of the thick encaustic paint is of a lovingly personal handicraft light-years away from the machine-made emblem that circles our planet in the twentieth century. In fact, time, even historical time, plays a role here. Johns may not have known in 1958 that the imminent conferring of statehood upon Alaska and Hawaii would quickly relegate the forty-eight stars of *Three Flags* and its antecedents to an obsolete period in American history; but he surely sensed that by re-creating the forty-eight stars and thirteen stripes with the dense, layered technique of encaustic, so common in ancient classical painting but so alien to the rapid tempo of modern art and life, the time-bound American flag would be wrenched out of context and embalmed like a miraculous relic of a civilization unearthed in an archaeological excavation. The contemporary becomes remote; the commonplace, extraordinary.

In its shuffling of clarity and mystery, *Three Flags* illustrates perfectly the results of Johns's deceptively simple description of his working procedure: "Take an object / Do something to it / Do something else to it." No wonder it continues to resonate so deeply in the eye and the mind.

"Johns's *Three Flags*" (1980). Previously unpublished.

JASPER JOHNS: THE REALM OF MEMORY

1997

"When this you see remember me." Gertrude Stein's unforgettable six-word couplet not only sums up a wealth of human experience, from photographs and postcards to tombstones and paintings, but it also pinpoints the uncanny ways in which Jasper Johns's art obliges us to be constantly aware of his presence, whether of his body, his mind, or his feelings. In endlessly inventive surprises, both overt and covert, Johns hovers within his own art, almost looking at us as we try to look at him. And when we focus, as we do here, on an anthology of fifty-two works from the mid-1950s to the mid-1990s that Johns chose to keep for himself, then the implication of their significance to the artist is further intensified. The parallel with Picasso's private collection is inevitable. He, too, preserved for himself over the decades an abundance of works that we feel must have had special meaning for him, marking private as well as public turning points in his life and art.

A useful point of entry into Johns's bell-jar world of self-exploration is a canvas of 1964 (fig. 96), the first of two versions of a composite image titled *Souvenir.*[1] In the most direct and obvious way, this can be read as a confrontational self-portrait with the artist staring directly at himself as well as the viewer. But in every other way, it sabotages all expectations of self-portraiture. For one thing, the likeness of the artist, rather than being hand-painted by him, is, in fact, a tourist souvenir from a sojourn in Japan in May of that year. A mug shot of Johns, taken by the artist himself in a photo booth in Tokyo, has been transferred to a white china plate, providing this particular tourist, like countless others, with a literal souvenir of a visit. But this rendering of the artist's face, as impersonal as a passport photo or an image in a high-school yearbook, looks at us blankly in the midst of a strangely personal assortment of words and objects that would probe backward and forward into Johns's life and art. For instance, the words RED, YELLOW, BLUE have been added to the Japanese souvenir plate, creating an emblem (the three primary colors) in an impersonal style (stenciling) that, ironically, turns into a recognizable symbol of Johns's work. Earlier, he had often embedded in his art this verbal reference to the holy trinity of a painter's palette, and this would remain a persistent motif. Much as in Picasso's art, where the presence of a guitar of the figure of Harlequin would suggest a projection of the artist himself, so too do these three words—red, yellow, blue—become almost a surrogate signature for Johns.[2] Indeed, in this photo-portrait they encircle his image as if they were an integral part of his personal identity, like the attributes of a saint.

96.
Jasper Johns,
Souvenir,
1964

But as usual with Johns, *Souvenir* has far more complexities in store for the viewer than the instantly legible self-portrait image. Attached to the canvas are a rear-view mirror and a flashlight, objects that, among other things, evoke not only a vehicle, like a bicycle, moving through time and space (an appropriate souvenir of a distant voyage), but also a metaphoric image of personal biography, in which one hovers between a forward gaze (the direction marked by the thrust of the flashlight) and a reflection of what belongs to the past. Even in terms of imaginary optics, the beam of the flashlight would presumably shine on the mirror, which, in turn, is angled at a position that would frame the subject of this voyage, the artist himself, who, judging from the agitated blackness of the painted encaustic setting, seems to be traveling alone, at night, through paths of memory. And the fact that a flashlight had already figured in Johns's work as a motif for a group of sculptures of 1958 in which this utilitarian object was rendered useless, as if embalmed, gives *Souvenir* a further layer of retrospection.

Although *Souvenir* boldly declares the artist's physiognomical presence and subtly conjures up as well his psychological aura, it remains characteristically elusive, making us feel as if we were puzzling over a secret diary. Even when Johns literally uses his own body, as he often does, he remains equally remote from our efforts to grasp clearly a tangible whole. This is conspicuously the case in a quartet of charcoal drawings he made in 1962 (fig. 97) on the theme of skin, that human surface which Johns, in his sketchbook notes, had associated with something to be folded or bent or stretched, like what he might do to a canvas.[3] Again, these ghostly drawings radiate Johns's physical presence, while at the same time negating the effect of a palpable face or body. What we see, in fact, are the blurred and shifting impressions of

97.
Jasper Johns,
Study for "Skin I,"
1962

the artist's own head and hands on sheets of drafting paper, like the rubbings taken from tombstones. The results may make us feel as close to him as the breath on a mirror, but at the same time they allow him to evaporate once more, leaving emanations rather than hard facts.

Other artists have left handprints on their work—Miró and Pollock, among them—but these surrogate signatures convey a sense of momentary, physical energy, like the imprint of a slap, whereas Johns's body prints look like disembodied after-images, as distant from reality as a photographic negative. As in the case of the photo-portrait in *Souvenir,* with its almost iconic frontality and heraldic halo of words,[4] there is an unexpected religious aura about these drawings that seem more spirit than body. We may even be put in mind here of such Christian relics of a supernatural presence as Veronica's veil or the Holy Shroud of Turin.[5] But in more secular terms, this group of drawings captures the mysterious way in which Johns always seems to be both near and far, observed and observing in his work; and their inclusion in his personal collection again points to their particular role as touchstones of his art and personality. And continuing this phantom presentation of his corporeal self, in 1973 he made two more charcoal impressions of portions of his body, in this case what were literally the most private parts, genitals and buttocks, camouflaged to near-invisibility by the charcoal smudges. Almost predictably, these, too, were retained by Johns. Moreover, like the earlier group of Skin drawings, these may also have evoked long-ago artistic and personal memories, insofar as they recall the early experiments of body images on photographic blueprint paper made about 1950 by Rauschenberg and his then wife, Susan Weil.[6]

Typically, these clandestine references to male sexual organs resurface in different guises in this anthology, whether in the 1960 *Painting with Two Balls,* Johns's well-known retort, in the form of a visual pun, to the macho Abstract Expressionist myth of making a "painting with balls" (the equivalent of Cézanne's *style couillard*); or, twenty years later, in 1980, in a drawing and three paintings titled *Tantric Detail* (fig. 98), where, as Mark Rosenthal observed,[7] these metaphoric testicles become explicit, although distanced once more

98.
Jasper Johns,
Tantric Detail,
1980

from anatomical immediacy by the symbolic allusions to Buddhist meditations on the relation between sex and death. Moreover, they become part of a ghostly heraldic pattern that includes the rhyming circular voids of the eye sockets in the skull below that floats over a spinelike axis of symmetry. Remembering the trio of words encircling Johns's photo-portrait in *Souvenir,* one notices how in the first of the painted versions of *Tantric Detail* the predominantly gray, lugubrious hatchings flicker for a moment into red, yellow, and blue at the left but then become muffled and are finally extinguished in the second and third versions as a bone-white tonality slowly pervades the whole field in a subliminal triumph of death.

In a century like ours, when such grand, universal themes have become an endangered species, Johns has managed to resurrect their mysteries, reawakening visions of the passage of time, of the dialogues between life and death, love and art. Probably the most famous of these quasi-philosophical meditations is the four-part series the Seasons (1985–86), which, characteristically for Johns, translates one of the most common cyclical allegories of Western art into a quartet of private diary entries, riddled with fragmentary references to his own and other artists' works.[8]

It was almost to be expected that of the four seasons, he would choose to keep *Fall* (fig. 99), the point in the cycle that corresponded most closely to his own age, fifty-six, at the

99.
Jasper Johns,
Fall,
1986

time of its creation. Here, as in the other paintings, the artist is represented by an almost ethe-real vision of his own body, namely, his shadow, which he had actually projected, outlined, and turned into a template. In *Fall* this shadow is split in two, evoking a passage in time from the left to the right of the painting. And as if behind shut eyes, remembrances of other art float by, whether of the artist's own work (such as the fragment on the lower edge of the twenty-six stripes of two paired American flags, now painted in their complementary color and value, green and black), of work by Duchamp (the hovering profile, even more disembodied than Johns's shadow), or by Picasso (such as the cast shadow itself, quoted from a 1953 painting, *The Shadow*, or the ladder, here broken in two, that figures prominently in the 1936 allegory *Minotaur Moving His House*).[9] And the cyclical progression of the seasons is given a further layer of circularity in the fragmentary presence of a recurrent Johnsian motif, a moving circle that here seems to tick like a timepiece. As Kirk Varnedoe put it, "From flat, static geometric devices, Johns found his way stepwise to the idea of a cosmic order of time."[10] And now, the concentric arrow, like the minute hand of a clock, pushes in the direction of an outstretched human hand that, on its palm, bears a grisaille version of the stigmata. We seem to be at a penultimate moment in Johns's life and art, over the midway mark and facing the realities of the last act. Nevertheless, three years later, in an ink drawing that Johns also kept for himself,

100.
Jasper Johns,
*Untitled (Red,
Yellow, Blue),*
1984

he re-created the entire quartet of paintings on one long sheet of plastic, arranging them in a more optimistic sequence (reading from left to right: summer, fall, winter, spring) that also underlines the continuities of this primordial pulse of life, death, and regeneration.

It is fascinating to see how often the theme of art and time, of life and death is reinvented. In the triptych *Untitled (Red, Yellow, Blue)* of 1984 (fig. 100), the words for the primary colors, so evocative of the artist himself, are presented, though often almost entirely concealed, in the shadowy layers of each panel. And in each panel, a large, thrusting shape plunges through the edge, energizing the murky grisaille fields where these abstract colors are buried. In the first panel a directional arrow, also suggesting the hand of a clock, appears, and recurs in the other panels; in the second panel this shape is stylized into the outstretched arm and hand of the artist; and in the third the artist's working limb is transformed into a paintbrush, a metaphor often found in Picasso's metamorphic self-portraiture. And within each panel there are variations on the circle, one of Johns's oldest motifs, that conjure up chronological and cyclical rhythms. Moreover, these circular forms also look back to the targets that had become one of his signature images of the 1950s and to *Periscope (Hart Crane)* of 1963, also preserved by the artist, where the black hole of a circle that swallows an outstretched arm and hand is at once an image of the gay American poet's suicide by drowning and a rendering of his poetic image of a periscope that could rise from submerged depths and survey the joys and sorrows of one's past life.[11]

Still more subliminal a variation on this theme is the series of variations, *Between the Clock and the Bed* (1981–83), a title borrowed from Munch's harrowing late self-portrait of 1940–42, painted as the artist approached his eightieth birthday and as his country suffered under the Nazi occupation.[12] The aged Norwegian artist stands between a tall grandfather clock we can almost hear ticking and his bed, covered with a blanket that bears the hatch pattern Johns had already been using since 1974. To the right of the bedroom, one of the artist's paintings of a female nude is just visible behind a door, a reminder of the obsessive sexual force that marked his early life and art. Characteristically, Johns thoroughly translates Munch's emotionally high-pitched contemplation of his own mortality into a cryptic language defined almost exclusively by the abstract hatch pattern that had become for him a basic pic-

101.
Jasper Johns,
*Between the Clock
and the Bed,*
1981

torial alphabet. In the 1981 version of *Between the Clock and the Bed* that he kept for himself (fig. 101), the predominant hatch marks across the three fields of the triptych are yellow, blue, and red—primaries that, in the left and center panels, generate their complementary hues, purple and orange, giving the painting an uncannily vital glow, as of a burning energy. At the right, this field is broken by a windowlike shape, perhaps inspired by the white doors and doorframes in Munch's self-portrait. Within this rectangular frame Johns re-creates the hatch pattern on a much smaller scale, as if it were in a remote space beyond the horizontal bars. And the colors change into a blinding luminosity of white versus black, as if a vista beyond the enclosing wall were suddenly unveiled. Miraculously, the emotional charge of Munch's painting, with its poignant contrast of confinement versus release, of life against death, is distilled in this abstract language, which somehow conveys the image of a lone artist in his studio with another world beckoning outside.

Even through the surprising medium of entomological illustration, Johns could deal with such lofty themes. *Cicada,* a 1979 watercolor and crayon drawing (fig. 102), also presents an abstract field of hatch patterns in the three primary and three complementary colors; but below, it offers a sequence of hieroglyphics about life and death that include references to the strange evolution of the cicada, an insect that lives underground for as long a period as seventeen years and then, in a magical metamorphosis, emerges anew as a winged creature with the startlingly brief life span of a week.[13] But entomology and life cycles aside, it should also be recalled that the hypnotic sounds of cicadas during their periodic mating seasons must have been an intense memory for someone who, like Johns, was raised in the southern United States, where these insects proliferate.

Such reveries upon the past recur throughout Johns's career and help to account for the way in which, like Picasso, he would rework, decade after decade, an image from his youth, altering it in both subtle and obvious ways. Of the image that became his public signature, the painting of an American flag of 1954–55, he made dozens of variations in every medium.[14] Of those he kept, one was the startlingly large *White Flag* of 1955, which immediately casts a shroud over the vivid red, white, and blue of the motif's first appearance, transforming it into a yellow-white ghost or skeleton of its former self. And in a small graphite

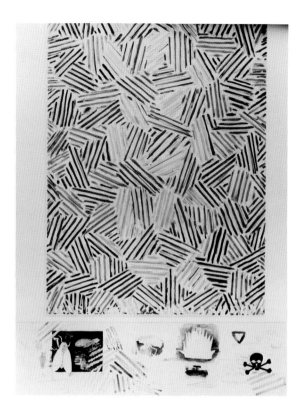

102.
Jasper Johns,
Cicada,
1979

drawing of a flag of 1957 the image seems submerged behind closed eyes, discerned, as it were, through a dark and twinkling scrim.

But these layers of space and memory could become almost literal in more recent variations on the flag theme. In 1994 he altered a set of lithographs of the flag dating from 1972 by adding to their printed surfaces another handmade flag. In one that he retained (fig. 103), the black carborundum-wash flag on the new surface almost eclipses or buries the earlier printed flag, intensifying the sense of mortality and death that haunts so much of the artist's recent work. And the memory of the past becomes all the more poignant when we notice that Johns has preserved the forty-eight stars of the original flag that was a symbol not only of his country in the 1950s but also of his emergence in that decade as a famous young artist. Later, in the 1960s, 1970s, and 1980s, he would often alter his flags to include the new field of fifty stars, a change officially effected in 1959 after the addition of Hawaii and Alaska and a change that immediately gave the flags he painted, drew, and sculpted before 1959 an archaic flavor, like that of the Confederate flag. But here, once more, he reverted to the original forty-eight-starred image of the flag. Like Hart Crane's periscope, it obliges us to look backward, remembering at a distance of now some forty years a remote decade in the history of the artist's nation, life, and work.

"Jasper Johns: The Realm of Memory." Published in *Jasper Johns: Werke aus dem Besitz des Künstlers/Loans from the Artist* (Basel: Fondation Beyeler, 1997), pp. 25–32.

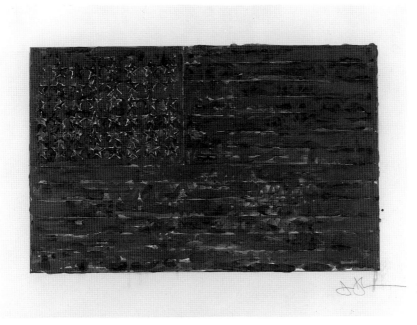

103.
Jasper Johns,
Flag,
1972 and 1994

1. For an early lucid description of this work, see the catalogue entry by C.L.Y. (Christine L. Young) in J. Kirk T. Varnedoe, ed., *Modern Portraits: The Self and Others* (New York: Wildenstein, 1976), no. 52.
2. One wonders, incidentally, whether Barnett Newman's series Who's Afraid of Red, Yellow, and Blue?, begun in 1966, might not have been partially triggered by the younger artist's appropriation of this chromatic trio.
3. See John Russell and Suzi Gablik, *Pop Art Redefined* (New York: Praeger, 1969), p. 84.
4. An analogy with the decapitated head of Saint John the Baptist on a plate has even been suggested. See Barbara Rose, "Self-Portraiture: Theme with a Thousand Faces," *Art in America* (January–February 1975), p. 73.
5. As proposed by C.L.Y., in Varnedoe, *Modern Portraits,* no. 53.
6. See Walter Hopps, *The Early Rauschenberg: The 1950s* (Houston: The Menil Collection, 1991), figs. 5–9.
7. Mark Rosenthal, *Jasper Johns: Work Since 1974* (Philadelphia: Philadelphia Museum of Art, 1988), p. 48.
8. For some detailed accounts of The Seasons, see Judith Goldman, *Jasper Johns: The Seasons* (New York: Leo Castelli, 1987); Barbara Rose, "Jasper Johns: The Seasons," *Vogue* (January 1987), pp. 192–99, 259–60; and Rosenthal, *Jasper Johns,* pp. 89–103.
9. On these particular borrowings from Picasso, see Nan Rosenthal and Ruth E. Fine, *The Drawings of Jasper Johns* (Washington: National Gallery of Art, 1990), no. 105; and Roberta Bernstein, "Seeing a Thing Can Sometimes Trigger the Mind to Make Another Thing," in Kirk Varnedoe, *Jasper Johns: A Retrospective* (New York: Museum of Modern Art, 1996), pp. 57 ff.
10. Varnedoe, *Jasper Johns,* p. 29.
11. For the most penetrating discussion of *Periscope (Hart Crane)* in terms of its personal meanings for the artist, see Kenneth J. Silver, "Modes of Disclosure: The Construction of Gay Identity and the Rise of Pop Art," in Donna de Salvo and Paul Schimmel, eds., *Hand-Painted Pop: American Art in Transition, 1955–62* (Los Angeles: Museum of Contemporary Art, 1992), p. 184.
12. For some fascinating observations on Johns's relationship to Munch, see Judith Goldman, *Jasper Johns: 17 Monotypes* (West Islip, N.Y.: ULAE, 1982), n.p. For further comments on *Between the Clock and the Bed,* see Rosenthal, *Jasper Johns,* pp. 50–54.
13. For a full account of the mysteries of *Cicada,* see Rosenthal and Fine, *The Drawings,* no. 79.
14. For the fullest anthology of these variations on the flag theme, see *Jasper Johns Flags, 1955–1994,* with an essay, "Saluting the Flags," by David Sylvester (London: Anthony d'Offay Gallery, 1996).

FRANK STELLA: FIVE YEARS OF VARIATIONS ON AN "IRREDUCIBLE" THEME

1965

In the twentieth century, ambitious artists have often chosen rock bottom as their precarious goal. Whether in terms of Duchamp's relentless pursuit of the devastating consequences of logic or Mondrian's pruning of all but the bare and vital skeleton of pictorial illusion, the path that leads to the brink of nothingness has created en route some of our century's most exhilarating adventures and enduring works. Since 1945 this irrepressible tradition has fathered, among other things, the impulse that stimulated masters like Rothko, Still, Newman, and Louis to reduce their vocabulary to the most elemental components and thus to create the full power of their mature styles, as well as the dilemma of how then to continue. And it is this tradition, too, that has compelled many younger artists to challenge these old masters in turn, by taking their own risks in the dangerous domain of the reductio ad absurdum, where one can lose all or gain all. Of this new generation, few artists, if any, have produced a more consistently intelligent and vigorous sequence of first-rate paintings than Frank Stella.

Stella's radical position became publicly apparent in 1959, when, at the age of twenty-three, he was represented in the Museum of Modern Art's "Sixteen Americans" show by four huge canvases that rivaled in size the acknowledged masterpieces of Abstract Expressionism and that disconcerted their audience by what seemed to be an impudent monotony and emptiness (fig. 104). The predicament of those critics and spectators who condemned Stella's work as a kind of Dada joke was perhaps understandable. How quickly could one have recognized, say, the qualities of four austere 1920s Mondrians if one had never seen a Mondrian before? Indeed, with Stella, as with Mondrian, an evolutionary context is almost essential before the individual painting can be properly perceived. The black pictures of 1959 were not born suddenly but, in fact, were the logical and patient distillation of a series of remarkable early works. In these, Stella, like many precocious young artists, did battle, as it were, with some of the major pictorial forces of the 1950s—the bold compartmented armatures of Gottlieb, the atmospheric tiers of Rothko, the heroic scale and openness of Newman. From such pictorial premises and many others, Stella slowly drew the surprising conclusions of his Black Paintings, works that contested the authority of their sources through an uncompromising logic difficult to ignore. Thus, most of the values upheld by the masters of the 1950s were attacked by Stella in terms of their own grandiose dimensions. With clues taken from the refreshingly

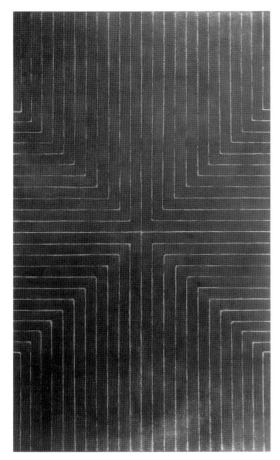

104.
Frank Stella,
Die Fahne Hoch,
1959

clear parallel and concentric geometries of Johns's early flags and targets, Stella managed to turn these old masters inside out. Exquisite chromatic subtleties and individualized choices of shape and brushstroke were suppressed in favor of predictable patterns of heraldic symmetry, a palette restricted solely to monkish black and white, and an impersonal application of paint. Above all, these black pictures tried to reject the illusionism still practiced in the 1950s. Atmospheric density, spatial overlays, discreet forms seen against grounds were all eradicated with disarming thoroughness and consistency. Stella's paintings seemed to iron out the pictorial spaces of the 1950s to an unprecedented flatness: the picture was no longer an illusion above or behind its surface but was rather the flat surface itself. In order to squeeze out any vestiges of depth and atmosphere, Stella insisted on recognizing the shape of the canvas as the essential fact of the picture. Like a surveyor assessing the extent and nature of a newly acquired territory, he plotted out every square inch of pictorial land in patterns of even stripes reiterating the simple perpendicular and parallel relationships of the frame. No forms overlapped; none seemed secondary. Instead, the entirety of the rectangular field was recognized as being of one importance. The picture could no longer be reduced to major and minor components but had to be accepted as a whole, as a flat and irreducible

object. The pictorial field was thus redefined as the picture itself and not as a neutral space in which something happened at occasional points.

The stark reduction of these strong and ascetic paintings posed the perennial twentieth-century question of where the artist could go next. As is proper, the artist, not the critic, answered this question with a series of new canvases of 1960 that demonstrated, amazingly enough, that their somber predecessors had not been dead ends, but rather generators that could create another set of problems to be resolved. Thus, the paths marked out in the black paintings toward utter flatness, calculated regularity of pattern and surface, and the use of the framing edge as the sole basis for the internal design were pursued still further and with even more unexpected consequences.

In place of black stripes, which, in the context of the 1950s, looked impersonal and emotionless, Stella now chose a tone still more chilly and achromatic—the glossy, factory coldness of aluminum paint. All things being relative in art, the black stripes of 1959, with the weblike fragility of their white interstices, began to look vibrant and softly luminous by comparison with this new assault upon 1950s sensibility. The aluminum stripes and the white rivulets of bare canvas that separated them moved now in the direction of a still more mechanical evenness and hardness, a persistent goal in Stella's work that remains, however, an elusive one, thanks to the spectator's gradual accommodation to increasingly slight and subtle irregularities of edge and surface.

Even more inventive was the shape of the canvas, for it deviated here from traditional rectangularity in favor of symmetrically placed notchings. This innovation both created and reflected the internal geometries of stripes that now ran only parallel, and not perpendicular, to the enclosing edges. If the black-striped canvases implied that the picture was a plane surface defined by the frame, these new aluminum paintings made the point explicit. The result was a picture or, better said, an object of extraordinary tautness and indivisibility. The striped geometries and the picture's framing edges were inseparable functions of each other; the rectilinear notches of the borders determined the patterns they enclosed and vice versa.

Once Stella had broken with the inherited rectangularity of the picture frame, the new possibilities were endless. Characteristically, his working methods took the form of a theme and variations, that is, a set of related pictures each offering a unique solution to the problem posed by the group as a whole. This time, in a series of 1961, exhibited in New York in 1962 (fig. 105), the paint moved from aluminum to an equally shiny and metallic copper, and the notchings on the frame now expanded into wide-open rectilinear shapes—a T, a U, an H—that first looked alarmingly unfamiliar as arenas for pictorial activity. Indeed, these works, even more than before, established the identity of the shape of the canvas with the parallel patterns of stripes, so that the pictures appeared to be almost fragments of frames, the bones rather than the flesh of painting. And in a later series of 1963, exhibited in New York in 1964 (fig. 106), this unerring structural logic produced a group of polygonal canvases— among them, a decagon, a pentagon, a trapezoid—that became yet more closely united with the picture's frame rather than with its contents. In these canvases, which complicated Stella's vocabulary by the introduction of acute and obtuse angles, the very core of the picture was hollow, so that the usual relationship between the picture and the picture frame was reversed. And here, too, Stella's willful rejection of the precious palette of the 1950s reached

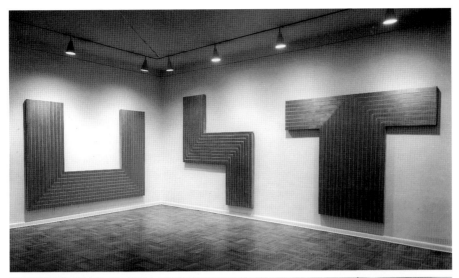

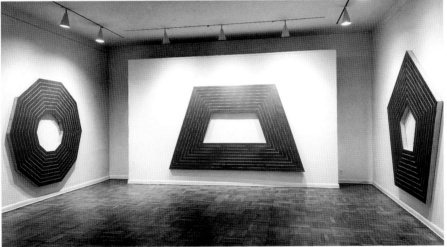

105. (top)
Installation view of Stella exhibition,
Leo Castelli Gallery, New York,
1962

106.
Installation view of Stella exhibition,
Leo Castelli Gallery, New York,
January–February 1964

a new extremity of harshness in the choice of a metallic purple sheen that smacked of the vulgar, spray-gunned commercial colors exploited in much Pop art as well as in the automobile fragments of Chamberlain's sculpture.

Just as Stella studied the question of the structural relationship of the picture to its frame, he also, in other works, reexamined the question of color. Concurrent with the anti-colors (aluminum, copper) of the shaped canvases were pictures that rediscovered, as it were, the raw pleasure of the simplest primary and secondary hues. Monochrome paintings

of the flattest red, blue, or green startled the eye after the chromatic nuances of the 1950s, much as Stella's elementary geometries provided a similarly drastic structural housecleaning, not unlike Johns's early flags and targets. With typical logic, Stella then built up complex relationships from these chromatic building blocks, arriving at a kind of basic color chart that ran the whole gamut of red, orange, yellow, green, blue, purple. In so juxtaposing different colors, Stella raised another set of questions, for these luminous candy stripes created variations in light value that reinstated in fresh terms the kind of spatial illusionism rigorously excluded from the monochrome paintings. His keen awareness of this new problem was nowhere better demonstrated than in a diptychlike canvas, *Jasper's Dilemma* (1962–63; fig. 107), which, with topical reference to Johns's own problems of color versus grisaille, places side by side two pictorial charts that enumerate light values as perceived, on the one hand, through eleven graduated hues and, on the other, through a series of nine grisaille variations ranging from black to white. Far from resulting in a pair of arid textbook diagrams, such a canvas creates a field of scintillating counterpoint between a painting in color and, as it were, its accompanying reproduction in black and white; and, lest the optical dazzle run askew, Stella harnesses it firmly in a complex rectilinear labyrinth coiled tight as a spring. Indeed, it is this same hard-won awareness of the painting's structural bones that gives Stella's more recent color-stripe paintings of 1964 (fig. 108) a vital tension and inevitability that reduce most other optical paintings to the level of decorative frissons.

A restless and inquiring artist, Stella has also continued to expand the potentials of the shaped canvas in works that may surprise even those accustomed to the earlier rectilinear and polygonal forms. In one series, exhibited in London in 1964, the complex angles of the polygons burst from their self-enclosure into sweeping paths of energy that zigzag recklessly across the wall with the kinetic charge of an abruptly veering automobile. The paint quality, too, contributes to this sharp mechanical bite; for, like many young artists of the 1960s—both Pop and Abstract—Stella prefers the resistant quality of industrial colors and machine-made surfaces, produced, in this case, by metallic powder in polymer emulsion.

Other shaped canvases offer even more primary nuggets of a kind of new American Futurist energy—for instance, an icy green vector of concentric chevrons that dart across space like the comparably abstract hubcaps and arrows that speed through the unprimed fields of Noland's latest canvases. From such dynamic units, Stella constructs intricate wholes, and in other works of the 1965 Los Angeles exhibition, these wedges of steely Pop colors collide in duets and trios of breathless, yet disciplined, energy. With lean and perfect precision, these swift forces seem to be caught just before take-off, clinging to each other momentarily, as if magnetized.

That these explosive clusters of velocity are ultimately the descendants of the static sobriety of Stella's black-striped canvases of 1959 may at first be surprising; yet, in retrospect, this five-year evolution unfolds with a rigorous logic and persistent invention rare in the 1960s. Indeed, the uncommon strength and integrity of Stella's young art already locate him among the handful of major artists working today.

"Frank Stella: Five Years of Variations on an 'Irreducible' Theme." Published in *Artforum* 3, no. 6 (March 1965), pp. 20–25.

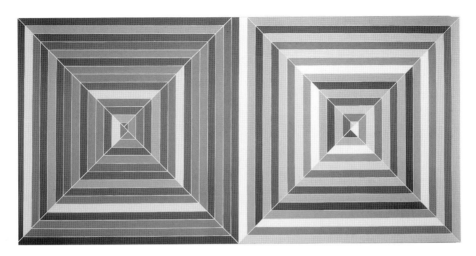

107.
Frank Stella,
Jasper's Dilemma,
1962–63

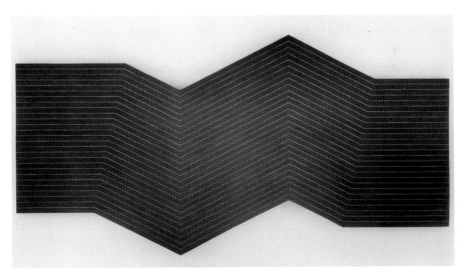

108.
Frank Stella,
Nunca Pasa Nada,
1964

FRANK STELLA, 1958 TO 1965

1986

Works of art are supposed to be timeless and immutable, but as decades pass, they may also change unrecognizably. The *Demoiselles d'Avignon,* for instance, is not the same picture it was back in the 1950s. If it then looked like the first pictorial earthquake to announce the future fracturing of Cubist planes and spaces, these days it seems mainly to be charged with overwhelming emotions about sex, fear, and death, more akin to late-nineteenth-century anxieties than to the creation of new twentieth-century formal alphabets. Back in the 1950s, too, the Jackson Pollock we saw unleashed a torrent of chaos and unbridled passion, whereas these days he has turned into a quite different-looking painter, whose tempests have become delicate shimmers and whose wildness has been tamed to the propriety of museums and art-history textbooks, fit to stand in the company of late Turner or late Monet. Such changes, often drastic and contradictory ones, especially mark the later experience of works of art which, like those by Picasso or Pollock, may seem to announce, when newborn, a total revolution, wiping earlier slates clean and inaugurating what, at the moment, appears to be a new visual era. But in retrospect, the sands of history have a way of smoothing over the shocks of aggressively unfamiliar art, leaving it in the usual historical position of looking both backward and forward and of having both proper ancestors and progeny.

Such thoughts are prompted by my own task here of introducing the first volume of a multivolume catalogue raisonné of the work of Frank Stella, who began his public career in 1959 as an enfant terrible ("Is it really important," asked one hostile critic, "for the public to see the work of a twenty-three-year-old boy who has only been painting for three or four years?"). Today, in the mid-1980s, he has become, where art is spoken of at all, an international household word and even a street-side word (his name, mystifyingly, is inscribed in a pavement block for all the world to see on the southeast corner of Broadway and Tenth Street in New York City).[1]

My credentials for doing this are long-term. I was lucky enough to have been teaching at Princeton's Department of Art and Archaeology in the late 1950s when Stella was a student, and I knew him then and looked hard enough at his paintings to want to go on looking at them after he graduated in 1958 and moved to New York. There, in what seemed an unusually narrow and cramped loft on West Broadway, he quickly produced an almost military lineup of black-stripe paintings that were to rock the art world when a sample quartet of them was seen at Dorothy Miller's "Sixteen Americans" show at the Museum of Modern Art

during the winter of 1959–60. I remained a Stella enthusiast in the 1960s, first publishing in 1965 an article that tried to explain to myself and to others what it was he might be doing and then in 1969 preparing a short monograph on him for the Penguin New Art series, which was meant to be published just before the major Museum of Modern Art retrospective and catalogue of 1970, but which got delayed in publication until 1971. And I have tried to keep up since, writing more recently, in the 1980s, about the seemingly irreconcilable about-face of his latest work (from monkish austerity to jukebox extravaganza) and hoping to explain it as a consistent development not only within the framework of his own art but also with that of his contemporaries.

With this background of Stella-gazing for almost three decades, I am now happily obliged to look backward, and from the vantage point of now, the mid-1980s, to think about the way the first lap of his Olympic career may have changed in our eyes. The period covered in this volume begins with his student years at Princeton (1954–58) and ends in 1965, by which time he had become an establishment figure, albeit a controversial one, in the New York art scene. One constant, at least, of this decade is the importance of the Black Paintings as epochal art history; for now, as then, they retain the watershed quality so apparent when they were first seen in 1959. Today, too, they have the character of a willful and, one might add, successful manifesto that would wipe out the past of art and establish the foundation stones for a new kind of art that, as it turned out, was not only Stella's own but the core of a group style of the early 1960s to be labeled Minimalism.

But if our awareness of the pivotal nature of the Black Paintings as a starting point of no return in the evolution of American art has been sustained in the last decade, our actual experience of them has not. Back in 1959, the newness of these works was so conspicuous that they seemed, whether one was pro or con, to be characterized only by negatives, by a list of rejections of the immediate past. Within this aggressively nay-saying regiment of black stripes, an iron fist annihilated any glimmer of pleasure, impulse, mystery. A new regime of the most predetermined systems, the most impersonal brushstrokes, the most neutral emotions, had been proclaimed. Indeed, Stella's Young Turk mentality in 1959, his eagerness to destroy an old order and to build a new one from scratch, is even apparent in the titles of a pair of small works of that year listed in this catalogue—*The First Post-Cubist Collage* and *The Last Cubist Collage*—titles that reflect his preoccupation with wiping out the long and increasingly moribund tradition of Cubism, whose vestigial illusions of luminous, layered spaces he hoped to replace with another, fresher kind of spatial construction.

In the Black Paintings Stella clearly, almost programmatically, achieved this, forcing, as he was to put it in a lecture given at the Pratt Institute in early 1960, the "illusionistic space out of the painting at a constant rate by using a regulated pattern." Yet gradually our perception of these pivotal paintings, which to many looked like unfeeling geometric diagrams, began to change, supported by the insights of art historians who would explore the nuances, whether historical, visual, or emotional, of these poker-faced works. Already in 1968 John Coplans included Stella in his historic survey "Serial Imagery," which, from this new perspective, located him not so much at the beginning of a tradition but rather at the end of one that had its most illustrious forefather in Claude Monet, passing through masters as unlike as Jawlensky and Mondrian, Albers and Morris Louis. At least for me, it was the

paternity of Monet that began to loom larger and larger for the early paintings as they receded from the vantage point of the 1970s into the historical past. This pedigree was strengthened at William Rubin's major ten-year retrospective of Stella's work at the Museum of Modern Art in 1970, where one series after another was reassembled in separate bays or rooms; but it was distilled six years later to a magical intensity in what turned out to be one of the greatest exhibitions in my memory and one that was surprisingly unvisited and uncommented on.

In the winter of 1976–77 at the Baltimore Museum of Art, Brenda Richardson rounded up for view sixteen of the twenty-three Black Paintings (or twenty-four, if the transitional *Delta* is included). In the magisterial catalogue that accompanied the show she documented the entire series with a prodigious bounty of scholarship, entailing scrupulous discussions of bibliography, chronology, provenance, and, particularly important, the references and meanings of these paintings' often cryptic titles. At the exhibition itself, the full force of the Black Paintings began, as never before, to be disclosed. Preconceptions about the mechanical, impersonal, quasi-mathematical quality of these works (Stella, after all, had worked as a house painter in New York in 1958) vanished swiftly as one was faced with an environment of the kind of sanctified mystery associated with a shrine or a private revelation.

The blackness of these surfaces, which once appeared cold and impenetrable, looked dense and lugubrious, and the rivulets of white canvas that showed between the insistently repetitive black stripes began to quiver and twinkle. As in Monet's series paintings, one sensed the search for the most finely calibrated nuance of vision and feelings, and, as in the case of the cathedral and poplar series in particular, a rectilinear skeleton seemed immersed, like a subliminal presence, beneath a veiled and shimmering surface. Perhaps most overwhelming was the literal and figurative darkness of these paintings, which created a relentless ambience of sensuous denial, of funereal melancholy, oddly akin to the pervasive blue of Picasso's early work with its comparable tone of a young man's, indeed an adolescent's, world-weary despair. And as Richardson indicated, the titles of these paintings generally alluded to a wide spectrum of human sorrows, from New York tenements (*Arundel Castle*) and a Chicago cemetery (*Getty Tomb*) to a London insane asylum (*Bethlehem's Hospital*) and the Nazi concentration camp at Auschwitz (*Arbeit Macht Frei*). Such elucidations helped to deny the usual early response to these paintings—that they were thoroughly hermetic and cerebral—and to confirm the growing revelation that they reflect an awareness of such universal gloom that they may even end up as younger-generation counterparts to the somber, life-denying mood of many of Rothko's own late series paintings.

Thinking about Stella and Rothko together is also to be reminded of the way recent winds are blowing. When Stella became news in 1959, the usual reflex in the New York art scene was to look only forward, signaling with trumpet blasts the major signature works that marked the entry of an artist into the public arena and sweeping under the carpet the more tentative, nominally immature works that preceded them. Nobody much cared what most of the Abstract Expressionists had painted before they hit their stride in the late 1940s and announced what then seemed a totally new world. But by the late 1970s, as exemplified by the exhibition "Abstract Expressionism: The Formative Years,"[2] curiosity about what had happened, so to speak, before the curtain went up had accelerated, and a new audience was eager to see what Still or Pollock or Rothko might have looked like in the years before they

at last achieved those Big Bang images, which first were thought to have sprung full-blown, like Athena from the head of Zeus. This growing concern with historical roots, an acknowledgment that nothing is as drastically new or unprecedented as it may seem, began to be reflected in responses to Stella's work as well. The pre–Black Paintings of 1956–58 began to reappear and to be looked at with sympathetic eyes alert not only to their intrinsic beauty but to the way in which they reflected and absorbed, with amazing swiftness, a variety of older-generation sources. The more Darwinian approach to Stella's formative phase could single out such ancestors as Rothko's luminous fields of Epicurean color, Motherwell's occasional experiments with structures of parallel stripes (particularly *The Little Spanish Prison* of 1941–44) or, closer to Stella's own generation, Jasper Johns's first flags and targets, with their simplistic, predetermined patterns of stripes and concentric circles.

Today, in fact, many of the pre-1959 paintings, rather than looking irrelevant in their prematurity, are already marked by Stella's individual imprint, a contradictory mix of an ascetic logic and a seductive resplendence, as if Rothko and Mondrian had been fused. The sheer, insistent gorgeousness of the sun-drenched apple green in *Plum Island (Luncheon on the Grass)* or the blast of chrome yellow in *Astoria* are irresistible, but intellectually countered by the modular beat of striped structure that measures out these fields of color. Throughout these early works, it is fascinating to confront Stella's voracious cannibalizing of his elders, an Oedipal rebellion in which he claims his independence from one master after another. Motherwell, for instance, is knocked down and devoured in the brilliant, if somewhat schoolboyish, ripostes of 1958 to the older master's "Je t'aime" series of the mid-1950s, *Mary Lou Loves Frank* and *Your Lips Are Blue.* Here the scribbled inscriptions of Stella's titles insolently vulgarize Motherwell's fancy French and the tougher, right-angled planed divisions clean up the older master's more arty and irregular boundaries. And now that we know Stella's future, other works, like *Them Apples* or the untitled triptych of 1958, may jump to our attention as heralding, in their carpentered construction of cardboard and wood, such later canvases in relief layers as the Polish Village series of 1971.

Even Stella's post-1959 works began to look more and more rooted in earlier twentieth-century traditions as the impulse to look historically backward rather than forward quickened in the late 1970s (a reflection, some would say, of a postmodernist mentality). In the 1960s, formalist criticism tended to concentrate on Stella's remarkable innovation of "the shaped canvas," presumably the inevitable, internal deduction from the primary premise of the black paintings. The logical, forward thrust here was breathtaking, and to follow the development from the Aluminum Paintings of 1960, in which the enclosed, right-angled patterns seemed to impose the notched shapes of the canvas (and vice versa), to the Running V Paintings of 1965, in which the velocity of swerving parallel stripes seemed to force the angled twists and turns of the canvas edge, was to enter what first seemed a totally new realm of palpable picture-objects that would make even Pollock's paintings look like the traditional, window-framed illusions of the old masters.

But after the shock was absorbed, these shaped canvases, in which the literal format of the edges coincided with the geometric format of the image contained within them, could also begin to be viewed retrospectively, recalling comparable experiments from the domain of geometric abstraction of the 1920s and 1930s. Already in 1977, Bernhard Kerber pointed

out relations between Stella and the Constructivist tradition in general and the Hungarian Las-zlo Peri's shaped canvases of the 1920s in particular. By now, in fact, the many shaped can-vases that keep turning up in recent anthologies of early geometric abstraction, whether by Eastern Europeans like Peri or by Americans like Charles Shaw (fig. 109), have taken on a prophetic character vis-à-vis Stella's work, although to be sure such voices in the wilderness usually seem diminutive and experimental by comparison with the full-scale authority and iconic force of Stella's shaped canvases which, already large in dimension, radiantly dominate their environment. Indeed, the broader connections between Stella and this Constructivist ancestry were even to become explicit two decades later in his own work when he did a reprise of El Lissitsky's Hadgadyah illustrations (1984), as if Stella himself had reversed the once counter-historical tradition of his rebellious youth and wished to reestablish overt dia-logues with a pre-Stella past in early modern art.

Less overtly, too, many of Stella's early works have begun to take their place in ongo-ing traditions. His Moroccan Paintings of 1964–65, whose exotic titles (*Rabat, Sidi Ifni, Fez, Meknes*) were largely ignored in the 1960s, now seem, in their heraldic dazzle of candy-stripe collisions, to belong to a Western mode of Orientalist painting. No less than Kandinsky or Klee,

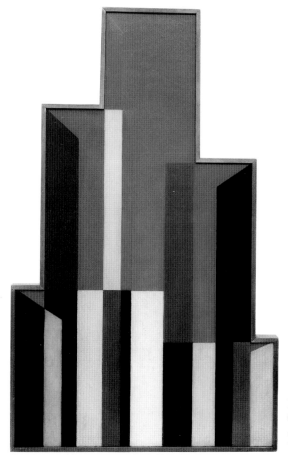

109.
Charles Shaw,
Untitled,
1937

Delacroix, Renoir, or Matisse, Stella found his own trip to North Africa (in 1961) a revelation that would soon inflect his art. And Stella's tentlike patterns of glaring, rainbow stripes (the theoretical, emotional, and perceptual opposite of the black-stripe paintings) would continue echoing as well in the work of a much younger abstract painter of the 1980s, the Irish-born American Sean Scully, who resurrects, a generation later, Stella's own capacity to make decorative striped patterns of exotic flavor lock into place with a Western tautness and logic.

But more generally speaking, the once airtight armor of Stella's work has been punctured. The earlier view that his art provided a paragon of ivory-tower formalism (his most famous quote may be "What you see is what you see") and that his working procedures parallel the most methodical deductions of a mathematician, itemizing all possible permutations and combinations of a chosen theme in form and/or color, no longer satisfies. The seeming purity of his art, with the implacable logic of its internal sequences, created a vacuum that is now being filled with an abundant onslaught of associations that Stella himself has usually provided through titles or notes in working drawings. The Black Paintings, with their far-reaching title references to an anthology of miseries, helped to confirm our quickening sense that they were not, as first billed, merely formalist exercises and as such emotionally blank. Thanks in large part to the exhaustive research of Christian Geelhaar for the 1980 Basel exhibition of Stella's earlier working drawings (1956–70), we now have still more material to complicate (some might say adulterate) our experience of the paintings included in the present volume. My own hunch (expressed cautiously in the last footnote of my early monograph on Stella) that his evolution broadly paralleled that of Hiberno-Saxon manuscripts was borne out not only by the fact that, as a Princeton junior in 1957, he had written an essay on these medieval marvels of geometric madness and order, but that, as published by Geelhaar, two drawings of 1960–61, which were never to become paintings, are entitled *Lindisfarne* and *Iona.*

Other art-historical references keep surfacing. Two landmarks of American architecture, for example, figure in these early works. *Getty Tomb* of 1959, which comes in two subtly different versions, alludes not only in its title but in its symmetrical patterns to Louis Sullivan's famous mausoleum in Graceland Cemetery, Chicago, a masterpiece of elemental volumes and curving versus right-angled ornament that looks back to Celtic decoration and ahead to Stella's own insistent geometries (fig. 110). And in the 1963 Dartmouth Paintings, in which many paintings are named after cities in Florida, it is not hard to find an instant confirmation of Stella's enthusiastic visit, in March 1961, to the buildings at Frank Lloyd Wright's campus for Florida Southern College in Lakeland, whose kaleidoscopic interlockings of diamond-shaped and triangular modules (especially in the Annie Merner Pfeiffer Chapel of 1938; fig.111) find immediate responses in paintings like *Dade City, Plant City,* and *Tampa.*[3] A still more surprising reference in the history of American art is to a painting by Whistler, *Crepuscule in Flesh Color and Green: Valparaiso,* which, as Geelhaar pointed out, was the catalyst for the Valparaiso paintings executed at Dartmouth in the summer of 1963. It was the trapezoidal and triangular patterns of the filmy sails in Whistler's painting of the Chilean harbor that triggered Stella's schematic translation of these compact geometric combinations, a maritime source that was further expanded in the naming of many of the Notched V Paintings of 1964 after British clipper ships (*Black Adder, Empress of India, Quathlamba*), paintings that become, with such associations, a regatta of taut sails and masts.

110.
Louis Sullivan,
the Getty tomb at
Graceland Cemetery,
Chicago, 1890

111.
Frank Lloyd Wright,
Annie Pfeiffer Chapel,
Lakeland, Florida,
dedicated 1941

And of course, Stella's references to the art of his own contemporaries keep multiplying in the work of the early 1960s. There are such specific allusions to another artist's stylistic polarities as *Jasper's Dilemma* of 1962–63 (see fig. 107), which visually objectifies Johns's compulsion, so close to Stella's own, of alternating between diagrammatic color choices and their opposite, an antichromatic vocabulary that passes from white to black through a grisaille spectrum. But there are also intricate visual dialogues with other works by Stella's friends and contemporaries in the early 1960s. In the case of the sculptor Carl Andre, who had even suggested titles for Stella's Benjamin Moore Paintings, the years 1959–60 also produced explorations of the most elementary 90- and 180-degree angles and similarly insisted on the raw material facts (a variety of woods and bricks) in the way that Stella respected the color and texture of paint just as it came out of the can. Moreover, Andre's 1959 pyramidal constructions (like the abstraction of a log cabin) offer, in their diagonal versus right-angled patterns of interlocking wooden strips (fig. 112), a close parallel to Stella's diamond-patterned paintings of 1959, such as *Delphine and Hippolyte* or *Zambezi*. Kenneth Noland, too, looms large as a visual presence at a somewhat later moment, 1963–65. Stella's fascination with the streamlined thrust of arrowhead vectors (Notched V Paintings), with the mechanized velocity of multiple swift tracks rushing horizontally across our range of vision (Running V Paintings), and with the possibilities of chromatic dazzle in the abrupt collision of contrasting hues (Moroccan Paintings) all find their counterparts in Noland's work, as if the two painters were examining together the potentials of a new vocabulary of speed and of color vibration.

Here too the working drawings published by Geelhaar give us glimpses into Stella's mentality, for he once projected a never-executed series of paintings on the theme "Art on Art,"

112.
Carl Andre,
Cedar Piece,
original 1959,
reconstruction 1964

composed of schematic distillations of characteristic shapes in the work of his contemporaries (Kenneth Noland, Donald Judd, Larry Bell, Larry Poons, Walter Darby Bannard, Richard Smith, Dan Flavin), as well as in older-generation artists (Kupka, Magritte, O'Keeffe). Thinking ahead to Stella in the 1980s, these early demonstrations of an acute self-consciousness about analyzing the internal workings of twentieth-century artists, both old and young, in the context of his own concerns, seem to foreshadow his more ambitious efforts in the Charles Eliot Norton lectures given at Harvard University in 1983 and 1984 to come to grips with the art of the pantheon of old masters, from Raphael and Michelangelo through Caravaggio and Rubens. An old master himself in the 1980s, he could pause to examine the deeper roots of the traditions to which he was heir, analyzing these venerable painters in terms of his own recent preoccupations with creating an abstract equivalent to their illusions of human beings moving with heroic energies in deeply carved spaces.

Of course, no matter what associations may turn out to be relevant as reverberations to Stella's paintings, they are always fully digested into the artist's own rigorous visual language, whether they be inspirations as diverse as a foreign verbal language or the excitement of racing cars. As for the former, it is fascinating to learn from Geelhaar that the Running V Paintings of 1963–64, with their Spanish titles, were inflected by the artist's experience of the (to him) incomprehensible sounds of that language during a visit to Spain in the fall of 1961. He savored the sounds abstractly, as he might savor the abstract structure of a figurative master's paintings, and explained that he enjoyed the sound, say, of "Cuidado!" with its bumpy accents better than its English equivalent, "Watch out!" It is an avowal that makes us realize how the breathtaking horizontal velocity of these paintings, with their abrupt shifts of axis, not only continues Stella's earlier dialogue with Noland's speeding, Neo-Futurist vector thrusts, but reflects visually, almost like lengthy phonetic diagrams, the fluent, but consonant-filled sounds of such titles as *Adelante, Claro que sí,* or *De la nada vida a la nada muerte.*

As for racing cars, we have known since William Rubin's catalogue of 1970 that the title, *Marquis de Portago,* of one of the 1960 aluminum series was a reference to the Spanish aristocrat who, in 1957, at the age of twenty-eight, was killed in an auto race. This tragedy, which also took the lives of some spectators, has been totally sublimated in Stella's shaped canvas, though the artist claimed to associate the four corner protrusions of this metallic surface with the fenders of the marquis's Ferrari. Nevertheless, such motifs, buried under the opaque shield of his art, were early allusions to Stella's enduring infatuation with racing cars not only in his life (he was once arrested for speeding in one in upstate New York), but also in his art (in 1976 he painted a race car for BMW; in 1981 he named his Circuit Paintings after international racetracks; in 1980 he dedicated a series of graphics to the racing driver Ronnie Peterson, who had died from injuries suffered in the 1978 Grand Prix races). So here once again a fresh scrutiny of the early work can uncover themes that will be pursued by Stella long after the last reproduction in the present volume.

Nevertheless, for all the accumulation of outside references that are beginning to cling to our experience of Stella's paintings and for all our growing awareness that there is an unusually wide range of emotions—denial, deadlock, melancholy, vertigo—trapped within them, there remains today, as always, the sense of the obdurate purity of his art, which finally resists any facile interaction with either the artist's own emotional graph or the teeming

world outside his New York studio door. To be sure, interlocking vectors may evoke, as in *Valparaiso Green,* the masts of clipper ships; cruciform structures, such as *Ouray,* may recall religious icons; the combination of two shaped canvases, one a trapezoid, the other an equilateral triangle, might be fitted together to make a larger triangle that would symbolize the personal connection between two of the "sitters," the then-married art dealers Leo Castelli and Ileana Sonnabend, in the series of abstract portraits of 1963. Yet the overriding effect of Stella's work continues to affirm his unswerving faith in the absolute autonomy of art and in abstraction as the only viable language. Powerfully challenged as these beliefs were by many other artists in Stella's lifetime, from Johns and Rauschenberg in the 1950s to Salle and Fischl in the 1980s, he has stuck to them with a ferocious tenacity that gives his work the force of a closed world regulated by rigorous internal rules. Meanwhile, to see spread large in this volume the austere pictorial events that marked the first decade of his career is to watch the construction of the foundation stones of Stella's expanding universe, whose potential for infinite growth and complication is borne out by glimpsing beyond the terminal date of this book, 1965, to the riotously exuberant, but no less straitjacketed energies of his achievements in the 1980s.

"Frank Stella 1958 to 1965." Published as the introduction to Lawrence Rubin, *Frank Stella: Paintings, 1958 to 1965—A Catalogue Raisonné* (New York: Stewart, Tabori & Chang; London: Thames and Hudson, 1986), pp. 16–23.

1. The inscription is no longer there.
2. Robert Hobbs and Gail Levin, *Abstract Expressionism: The Formative Years* (New York: Whitney Museum of American Art, 1978).
3. A general parallel between Wright and Stella was already suggested in 1969 by Joseph Masheck in "Frank Stella at Kasmin," *Studio International* (February 1969).

STELLA'S THIRD DIMENSION

1983

In 1969 I wrote a short monograph on Frank Stella. It was easy enough to begin the text with an enthusiastic, full-scale treatment of the black-stripe paintings of 1959, works by a twenty-three-year-old that still loom large as watershed masterpieces of twentieth-century art. But it was not so easy to end my text, which had to stop short after only a little more than a decade of Stella's work. Hanging in midair, I resorted to a rhetorical flourish and claimed that we could "look ahead confidently to as much, even more, from the Stella of future decades as we have had from the Stella of the 1960s." The truth was that I didn't believe this. I felt that to leave him dangling in 1969, a time when his work looked solid but unchallenging, was in effect to wrap up and put to rest a brilliant, decade-long career in which a genius entered art history and changed its course drastically with a long run of great paintings in a short run of vintage years, after which he became increasingly irrelevant. There had been ample precedent for this relentless, almost Darwinian pattern in the heroic generation preceding Stella's. For our art-historical time capsules, wouldn't just three or four critical years of, say, Pollock, de Kooning, Rothko, or Still give us not only the major glories of their art but also the exact point at which they left their huge imprints on history? Following this cruel yet demonstrable logic, it was not hard to think in 1969 that, final diplomatic sentences aside, Stella belonged more to the past than the future.

To my continued amazement, my instinct turned out to be wrong and my hollowly sanguine prophecy to be right. For after 1969 Stella's work accelerated so rapidly in invention that beginning in 1976 with the Exotic Bird series (fig. 113), every new show provoked the same kind of jaw-dropping response demanded by those first black-stripe paintings of 1959. Once more it looked as if a totally fresh, youthful artist had appeared, almost from nowhere, to confront us with numbingly unfamiliar experiences that we could not blink away. Furthermore, the new work seemed entirely to negate the monkish austerity and renunciation with which Stella had entered the art scene in 1959. He started as a young Savonarola who banished from the vocabulary of painting everything suggestive of pleasure, freedom, and impulse, leaving us only with a bare skeleton, immobilized in rectilinear patterns of noncolors (black, aluminum, copper). But now he pushed to the opposite extreme, assaulting us with an overwhelming glut of every color in the plastic rainbow, with hard-edged arabesques of decorative curves and serpentine circuits, with every imaginable ragged doodle and scribble in an alphabet of reckless graffiti. Even more, he steered painting and sculpture into a

113.
Frank Stella,
Steller's Albatross,
from the Exotic Bird series,
1976

head-on collision, creating a gravity-defiant instability, as if an explosion of wildly disparate shapes had been caught midair.

Now that we are beginning to regain our balance after the almost physical attack of his painted relief sculptures (the South African Mines and the new Shards series), some stock taking is in order. Looking over what amounts to a quarter century of Stella's work, how do we explain that the artist who first defined himself in 1959 by scraping his painting to the flattest, leanest, most minimal bones is the same one who, less than twenty years later, embraces a vocabulary so maximal that the very plane of the painting's surface has to burst forward in ever-multiplying layers to accommodate this teeming profusion? Is this merely a reversal of the familiar binge-and-purge cycle, or does it involve more complex constants in Stella's art that, as in the case of Picasso's, stamp even the most seemingly contradictory works with an immediately identifiable personality? And what do these overt collisions of style, from the 1960s to the 1970s, have in common with broader changes in the art of the last quarter-century?

As for the constants, there remains, from the most pithy to the most prolix of Stella's work, the overriding sense of method in his madness. Whether one looks at the all-negating asceticism of the Black Paintings, the rollicking somersaults of the Protractor series of the late 1960s (fig. 114), with their spinning rainbow arcs, or the tropical luxuriance of the Indian Bird series of 1977–78, with their junglelike tangles of seething curves, an obsessive control is there. Having chosen a language of forms as simple as stripes or as intricate as the railroad curves used to mark out the turning patterns of railway beds, Stella will then explore within that one language a rigorously connected series of permutations and combinations, giving each work, however superficially riotous it may at first appear, an underlying sense of inevitable order. His wildest exuberances, we realize after prolonged looking, finally tick away with the same clockwork order as his most taciturn reductions. Moving from the early work

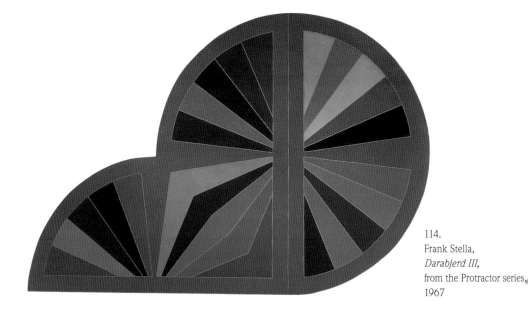

114.
Frank Stella,
Darabjerd III,
from the Protractor series,
1967

to that of the past five years is like escalating from an introductory lesson in plane geometry, where the ninety-degree angle and the circle reign supreme, to a course, taught by the same great mathematician, in advanced calculus, where beneath eye- and mind-boggling complexities, his consistent logic still obtains. And in psychological terms as well, Stella's work persists in gripping what seem titanic passions in the iron fist of reason. The spontaneous, the improvised are anathema to him. Even in front of the wriggling labyrinths of the Circuits series of 1981, with their allusions to the fluent, careening speed of racing cars, we end up recognizing that each of these serpents' nests of cutout shapes is an immaculately calculated variant on a preordained form. We know exactly what Stella meant when he explained that "in order to start painting, I have to have a structure worth painting on."

These underlying structures, moreover, have always been physical as well as mental. Combating illusion with a determination unmatched by any painter of our century, Stella began his career by both thinking away and painting away all vestiges of the spatial fictions left over from Abstract Expressionism. Swiftly, he pared things down to stripes and then arcs of flat paint—almost literal, ribbonlike materials, which looked like tapes that could be applied to or peeled off the canvas. And when, in the Polish Village series of the early 1970s, he wanted to explore the planar intricacies of overlapping and underlying structures, he chose not visual fictions but literal, material facts. He subtly tilted, in shallow reliefs, one plane against another, while no less subtly differentiating component parts by variations in texture, from felt and plywood to Masonite and paper.

The vocabulary of these material strata became more elaborate in the 1970s, moving from a variety of acute and obtuse angles to a multiplicity of irregular yet standardized curves culled from the instruments of railroad engineers and of architectural and marine draftsmen. And the works began to take on a surprisingly new relationship to exactly that kind of 1950s Abstract Expressionist style that the young Stella had counterattacked in 1959 with the full

force of his single-minded energies. From the Exotic Bird to the Circuits series, the ghosts of de Kooning and Pollock seem to be resurrected in Stella's hard-won language of literalism. The foaming, billowing densities of Pollock's infinite spaces, the frothing, athletic sweep of de Kooning's colliding brushstrokes, are re-created in Stella's tours de force of visual contradiction. The painted emotional and physical turmoil of Abstract Expressionism, where all is open, ragged, impulsive, is transformed, however, in the deep freeze of Stella's literalism. The illusions of Pollock's or de Kooning's restlessly shifting depths are made palpable in planes that actually do float and hover in overlapping painted cutouts, casting real shadows. These planes can even be looked at obliquely, the better to perceive the intricate engineering of their layered depths or to find painted passages concealed by a frontal view.

By reincarnating Pollock and de Kooning in his own image, Stella came full circle in terms of his career in art history. Just as he had first become his own master in 1959 by purging his art of their overwhelming influence, so could he finally, a generation later, take them on in positive terms, rejuvenating in his tyrannical language what were by then their venerable, historic styles. In this leapfrogging of a generation, Stella revitalized his art and at the same time joined forces with a new generation. By the mid-1970s, the Minimalist aesthetic with which Stella in 1959 had defined his relationship to the immediate past had run its course, not only for the man who invented it but for countless younger artists as well. An expressionist mode, whether abstract or figurative, could provide a temporarily invigorating antidote to the diluted cerebral and visual purities of a late phase of Minimalism, and the floodgates opened. Occasionally, a brilliantly inventive artist like Judy Pfaff could parallel Stella's goals by re-creating, in a maelstrom of colored materials that flood through actual spaces, the imaginary environment evoked by the Abstract Expressionists' volatile torrents of paint. But much of the NeoExpressionist painting, both here and abroad, looked like a de Kooning or a Kirchner in quotation marks, knowing adaptations that usually left their historical debts unpaid.

Stella's core, however, is even stronger and more enduring than his changing surfaces; and his recent ambitions indicate far more than a timely response to a tired style. In fact, in February 1982, in a lecture at the College Art Association's annual meeting, he articulated at length the issues he was facing, explaining how he felt that Cubism and abstract painting had really eroded and destroyed the dense and active spaces evoked by the human figure in old-master painting. This triumphant flattening and dematerializing of pictorial space had been achieved at a price he was clearly no longer willing to pay. He cited Picasso's post-Cubist treatment of the human figure in a language of continuous, swelling volumes as an exciting redirection and pointed with particular enthusiasm to his *Bather with Beach Ball* of 1932 (a painting that creates so potent an illusion of pneumatic humanity that the Museum of Modern Art even considered reconstructing it as a float, in the Macy's Thanksgiving Day Parade tradition, to be wafted above its great Picasso retrospective of 1980). Briefly put, Stella was bewailing how abstract painting had wiped out those physical energies of expanding and contracting organic volumes earlier conveyed by the illusion that human beings moved and breathed in the spaces of art. And being an artist who, from the beginning, adhered absolutely to a faith in abstract art—"My painting is based on the fact that only what can be seen there *is* there" succinctly states his literalist position—he would never try, as did

de Kooning and Pollock before him, to reintroduce the human figure as a way of reactivating the abstract territory he had staked out for himself.

Artists' statements can as often obfuscate as illuminate their work, but Stella is always as clear in his verbal as in his pictorial language; and in this case, his complaints about the thinness of abstract art as opposed to the density of old-master figural art clarify what he has been doing. For in fact, the recent painted reliefs produce intense, visceral responses in the viewer. The flattened planes of abstract art seem to have been animated by the abstract equivalent of figures that move, twist, and collide in a shallow space about to burst at the seams. In these works, abstract art suddenly seems to have a new kind of bone and flesh that muscles its way from two to three dimensions with the epic struggle we recognize from centuries of old-master figural compositions. Even the rapidly scribbled graffiti that agitate these cutout shapes seem to echo the chiaroscuro techniques of hatching and shading that in the old masters conveyed the effect of light and shadow on the turning volumes of the human form. Already in the late 1950s, as a student at Princeton, Stella had begun to admire in particular Botticelli and Rogier van der Weyden, painters whose incisive figural drawing in contracted spaces offered clues to the way in which Stella would soon straitjacket animated shapes in razor-sharp contours. But lately, the welling strength of these surrogate figural energies has reached such heroic dimensions and such sheer physical presence that they almost literally invade the galleries whose walls now seem barely able to support these enormous, restless weights.

Of course, living in the twentieth century, Stella experiences energy not only in human, organic terms but also in mechanical ones; and a good part of his subliminal imagery, as in Kenneth Noland's chevron-and-stripe paintings of the 1960s, alludes to the superhuman velocities of our time—especially the swift, sleek movement of multilaned highways and racing cars. Recently, in fact, these references have become more explicit: Stella painted a race car for BMW in 1976, he named his 1981 Circuits series after international racetracks, and he dedicated a series of graphics (recently seen at MoMA) to the racing driver Ronnie Peterson, who died as a result of injuries in the 1978 Grand Prix races. These disembodied tracks of mechanical force have haunted modern artists since the days of Turner's 1844 vision of the Great Western Railway, a phantom that bullets toward us across the Maidenhead Bridge, up to the streamlined vector patterns that Futurists and then Art Deco designers invented to symbolize our age of abstract speed. But more and more, mechanical force has fused in Stella's work with its organic counterpart of irrational, churning human force.

With their acute awareness of sources and their search for cause-and-effect explanations, art historians have already turned up suggestive precedents in the history of modern American sculpture for Stella's break from flat painting to ever more complexly layered reliefs and sculpture. He owns, we know, work by David Smith (a painted iron sculpture of 1937) and John Chamberlain (a 1962 wall relief made of compacted, brashly colored automobile fragments), and his work often surprisingly, if superficially, resembles Herbert Ferber's wall reliefs of the 1950s. But when all is said and done, the spirit of Stella's new work recalls the kind of epic forces of mind and matter for which only the loftiest old-master analogies in figural art will do.

It is no surprise, then, to learn that the old masters will dominate in the six Charles Eliot Norton lectures that Stella is delivering at Harvard during this current academic year, 1983–84. The first abstract painter invited to speak in this prestigious series, Stella, ironically,

is the very antithesis of the last painter to deliver the Norton lectures, the programmatic humanist and antiabstractionist Ben Shahn. Yet it is Stella who will be talking about such sixteenth- and seventeenth-century deities of figural painting as Raphael and Michelangelo, Caravaggio and Rubens, whose work he has studied fervently and at first hand while traveling in Europe and sojourning at the American Academy in Rome. These masters' changing approaches to the problems of ordering figures in spaces that, by 1600, began to break away from earlier mural traditions in favor of a modern concept of the easel painting make up a central theme of Stella's Norton lectures, which will also consider related issues in the work of Kandinsky and Picasso. Clearly, by now Stella not only is eager to construct a heroic genealogical table for his own ambitions but is willing to measure against these venerable standards his success in repopulating the insistently flat and airless spaces of an abstract art that he created in 1959 and bequeathed to the 1960s. To experience the old-master fusion of monumental turbulence and monumental control that marks his latest work is to realize that he may well have earned the right to those noble ancestral thrones.

"Stella's Third Dimension." Published in *Vanity Fair* 46, no. 9 (November 1983), pp. 86–93.

POP ART AND NON-POP ART
1965

So sensitive are the art world's antennae to the symptoms of historical change that, in 1962, when some New York galleries began to exhibit pictures of vulgar subject matter, a new movement, Pop art, was instantly diagnosed and the mindless polemics began. As usual, the art in question was seldom looked at very closely and questions of definition and discrimination were ignored. Instead, things were quickly lumped together into a movement that called for wholesale approval or rejection. Presumably one had to take sides, and various critics were considered to be either vigorously for or against it. But what was "it"? Considering that "it" was equated with viewpoints as divergent as those of Barry Goldwater and Terry Southern, one suspected that less violent politicking and more temperate thinking and seeing were in order. In fact, the term "Pop art" soon blanketed a host of artists whose styles, viewpoints, and quality could hardly have been more unlike. When one insisted that names be named, things got foggier. Were Rivers, Rauschenberg, Johns Pop artists? Well, yes and no. And what about Marisol, George Segal, Peter Saul? Well, maybe. But arguments, without names and definitions, continued.

If some common denominator was felt to run through all these artists thoughtlessly bracketed together, it was probably a question of subject matter. But here was an odd turn of aesthetic events. How, after all the formalist experience of our century, could a new kind of art be defined on this basis alone, and didn't this give rise to contradictions? If admirers of de Kooning usually scorned Andy Warhol, hadn't both artists painted Marilyn Monroe? And were Warhol's Coca-Cola bottles really to be mentioned in the same breath as George Segal's or Rauschenberg's? Using iconographical criteria, Pop art produced illogical groupings, but logic never seemed to bother the art-political parties that insisted on condemning or praising Pop art without saying what it was. Writers who could never have paired two 1930s artists of the urban scene, Reginald Marsh and Stuart Davis, because their pictures looked so different, had no trouble pairing new artists who had in common only the fact that, on occasion, they depicted George Washington, dollar bills, or sandwiches.

If Pop art is to mean anything at all, it must have something to do not only with *what* is painted, but also with the *way* it is painted; otherwise, Manet's ale bottles, van Gogh's flags, and Balla's automobiles would qualify as Pop art. The authentic Pop artist offers a coincidence of style and subject, that is, he represents mass-produced images and objects by using a style that is also based upon the visual vocabulary of mass production. With such a criterion, the number of artists properly aligned with the movement dwindles rapidly. Thus,

when Rivers and Rauschenberg introduce fictive or real cigarette wrappers and news photos into their canvases, they may be treading upon the imagery of Pop art but in no way touching upon the more fundamental issue of style. Painting as they do with techniques dependent on de Kooning's dedication to virtuoso brushwork and personal facture, they cling to pictorial formulas of the 1950s that are, in fact, largely rejected by the younger artists of the 1960s. Even some of these still offer a hybrid mixture of Pop subject and non-Pop style, as in the case of Peter Saul, who fuses Donald Duck and TV commercials with Gorky; or Wayne Thiebaud, who arranges cafeteria still lifes under a creamy impasto of pastel sweetness derived from Diebenkorn. And in the case of the recent work of Jasper Johns, who may have fathered Pop painting in his early flags and Pop sculpture in his ale cans, there is the curious phenomenon of an increasingly wide discrepancy between the geometrically lucid objects represented and the abstract, painterly milieu that clouds them.

In terms of definition, and not necessarily of quality, the real Pop artist not only likes the fact of his commonplace objects, but, more important, also exults in their commonplace look, which is no longer viewed through the blurred, kaleidoscopic lenses of Abstract Expressionism, but through magnifying glasses of factory precision. When Roy Lichtenstein paints enlarged benday dots, raw primary colors, and printer's-ink contours inspired by the crassest techniques of commercial illustration, he is exploring a pictorial vocabulary that would efface the handicraft refinements of chromatic nuance, calligraphic brushwork, and swift gesture pursued in the 1950s. When Andy Warhol claims he likes monotony and proceeds to demonstrate this by painting ten times twenty cans of Campbell's soup, he uses the potential freshness of overt tedium as an assault upon the proven staleness of the de Kooning epigones' inherited compositional complexity. When James Rosenquist becomes infatuated with the color of Franco-American spaghetti or a slick-magazine photograph of a Florida orange, he employs these bilious commercial hues as tonics to the thinning blood of chromatic preciosity among belated admirers of Guston or Rothko. And when Robert Indiana salutes the heraldic symmetry, the cold and evenly sprayed colors of road signs, he is similarly opposing the academy of secondhand sensibility that inevitably followed the crushing authority of the greatest Abstract Expressionists.

Thus, such artists as Lichtenstein, Warhol, Rosenquist, Indiana, Wesselmann, and the recent Oldenburg (but not Rivers, Rauschenberg, Johns, Dine, Thiebaud, Marisol) all share a style that would stem the flow of second-generation adherents to the styles of the American old masters of the 1950s. It is no accident that most pictorial values affirmed by the older generation have been denied by the newer one. A late Romantic imagery referring to remote myth and sublime nature is replaced by machine-made objects from ugly urban environments. Gently stained or shaggily encrusted brushstrokes are negated by an insistence upon hygienic, impersonal surfaces that mimic the commercial techniques in which several Pop artists were, in fact, professionally trained (Rosenquist as a billboard artist; Warhol as a fashion illustrator). Structures of shifting, organic vitality are challenged by regularized patterns of predictable, mass-produced symmetry. Colors of unduplicable subtlety are obliterated by the standardized harshness of printer's red, yellow, and blue.

This historical pattern of rejection is familiar. One thinks particularly of the Post-Impressionist generation, when an artist like Seurat controverted Impressionism through an

almost mechanized system of brushstrokes, colors, shapes, contours, and expressions, often inspired by such 1880s Pop imagery as fashion plates and posters. In the case of the 1960s Pop artists, this rebellion against the parental generation carried with it an espousal, both conscious and unconscious, of the grandparental one. In fact, any number of analogies can be made between the style and subject of Pop artists and those of modern masters active between the wars. The purist, machine-oriented shapes and imagery of Léger, Ozenfant, Le Corbusier, and de Stijl artists are often revived in the current enthusiasm for poster-clean edges, surfaces, and colors (Lichtenstein, for example, provides many parallels to Léger's industrial images of the 1920s and has twice paraphrased Mondrian's black rectilinear armatures and primary hues). More particularly, American art before Abstract Expressionism has begun to strike familiar chords, so that artists such as Charles Demuth, Joseph Stella, Stuart Davis, and the newly resuscitated Gerald Murphy all take on new historical contours as predecessors, when considered in the light of the 1960s. (Davis's Cubist Lucky Strike cigarette wrapper of 1921 suddenly becomes a prototype for Warhol's flattened Campbell's soup can; Stella's *Brooklyn Bridge* and Demuth's *I Saw the Figure Five in Gold* are explicitly restated by Indiana; Niles Spencer's and Ralston Crawford's immaculate cityscapes and highways are re-echoed in Allan d'Arcangelo's windshield views.) Even Edward Hopper, whose 1964 retrospective occurred at a time of maximum receptivity (in 1955 he might have looked merely provincial), has taken on the stature of a major pictorial ancestor. His poignant, American-scene sentiment of the 1930s and 1940s survives not only in those inert, mummified plaster figures of George Segal, who suffocate amid the ugliness of Coke machines and neon signs, but also in the poker-faced exploitation by anti-sentimental Pop artists of the anesthetizing blankness and sterility of a commercial America. And the time may soon come, too, when the WPA mural style of the 1930s will look like a respectable grandparent to Rosenquist's public billboard imagery of giant urban fragments.

If the most consistent Pop artists can be located in the heretic position of refusing to believe in those aesthetic values of the 1950s, which, with the irony of history, have suddenly become equated with venerable humanist traditions rather than with chimpanzee scrawls, are they, in fact, so singular in their rebellion? The most vigorous abstract art of the last five years has also stood in this relation to the oppressive grandeur of de Kooning, Pollock, Kline, Guston, Rothko, Still, and Newman, and soon the cleavage between Pop art and non-Pop art (solely an iconographical, not a stylistic, distinction) will no longer seem real. So obtrusive was the subject matter of Lichtenstein's or Warhol's first Pop paintings that spectators found it impossible to see the abstract forest for the vulgar trees. Anybody, we heard, could copy a comic strip or a soup can, the implication being that, as in the case of criticism directed against Caravaggio or Courbet, the Pop artist dumbly copied ugly reality without enhancing it by traditional pictorial idealizations. Yet disarming subject matter has a way of receding so rapidly that it becomes well-nigh invisible. When first exhibited, the early flags of Jasper Johns looked like such unadulterated replications of the Stars and Stripes that most spectators dismissed them as jokes of a Dadaist trickster. Today, within a decade of their creation, the same flags look like old-master paintings, with quivering, exquisitely wrought paint surfaces not unlike Guston's, and with formal distinctions that permit us to talk casually about Johns's white flags, gray flags, or flags on orange grounds, just as we might talk about Matisse's blue,

red, or green still lifes. In the same way, the initially unsettling imagery of Pop art will quickly be dispelled by the numbing effects of iconographical familiarity and ephemeral or enduring pictorial values will become explicit. Then, one hopes, the drastic qualitative differences among Pop artists should become clear even to those polemicists who think all Pop art is either good, bad, or irrelevant.

Already the gulf between Pop and abstract art is far from unbridgeable, and it has become easy to admire simultaneously, without shifting visual or qualitative gears, the finest abstract artists, like Stella and Noland, and the finest Pop artists, like Lichtenstein. The development of some of the Pop artists themselves indicates that this boundary between Pop and abstract art is an illusory one. Thus, Indiana began as a hard-edged abstractionist in the vein of Ellsworth Kelly and Leon Polk Smith. That he then introduced highway words like EAT or USA 66 into his emblematic geometries should not obscure the fact that his pictures are still essentially allied to Kelly and Smith, who, for purposes of art-political argument, would be forced to run on another ticket. And some of the recent landscapes of Lichtenstein, if taken out of context, might even be mistaken for chromatic abstractions or new optical paintings. This party-split between Pop and non-Pop art—the result of argumentative factions and rapid phrase-makers—is no more real than the line one might draw between, say, the abstract work of Léger and Stuart Davis and the work in which their urban subject matter is still clearly legible. Pop imagery may be momentarily fascinating for journalists and would-be cultural historians, but it should not be forgotten that the most inventive Pop artists share with their abstract contemporaries a sensibility to bold magnifications of simple, regularized forms—rows of dots, stripes, chevrons, concentric circles—to taut, brushless surfaces that often reject traditional oil techniques in favor of new industrial media of metallic, plastic, enamel quality; to expansive areas of flat, unmodulated color. In this light, the boundaries between Pop and abstract art keep fading. Al Held's giant paintings recall abstract billboards; Krushenick's blown-up, primary-hued patterns look like imageless comic strips; Dan Flavin's pure constructions of fluorescent-light tubes smack of New York subways and shop windows. Art is never as pure or impure as aesthetic categories would make it. Who would want to separate Mondrian's *Broadway Boogie-Woogie* from its urban inspiration? Who would want to ignore the geometric rightness of Hopper's realist wastelands? For the time being, though, we shall go on hearing wearisome defenses of and attacks upon some vague domain called Pop art, a political slogan that can only postpone the responsibility of looking at, defining, and evaluating individual works by individual artists.

"Pop Art and Non-Pop Art." Published in *Art and Literature,* no. 5 (Summer 1965), pp. 80–93.

ROY LICHTENSTEIN AND THE REALIST REVOLT
1963

In the twentieth century, the tempo of artistic change is frighteningly rapid. In America, what was only recently seen as a triumphant new constellation of major painters (whose styles ranged from the "action painting" of Pollock to the "inaction painting" of Rothko) has suddenly receded into a position of old-master authority that poses a heavy burden upon the younger generation. Some of these "old masters" themselves have found difficulties in maintaining the superb quality they achieved a decade ago; and for their successors, the problem has been even more acute. To yield to the power of what had quickly become a tradition meant an a priori condemnation to a secondary, derivative role. One might be certain of producing beautiful, virtuoso paintings by working within these given premises, but one also risked never creating any truly new ones. To be sure, some recent painters have succeeded against these enormous odds in producing work of extremely high quality and originality (Stella, Louis, and Noland, among them); but in general, most abstract painting of the later 1950s and early 1960s has begun to look increasingly stale and effete. Even in the hands of the most gifted satellites, it has often turned into a kind of academic product in which rapid, calligraphic brushwork—once the vehicle of daring innovation and intensely personal expression—was codified into a mannered, bravura handicraft à la Sargent; and large-scaled formal simplifications—once majestic and emotionally overwhelming—have frequently become merely decorative and hollow.

Moreover, a commitment to a purely formal realm, untainted by references to things seen outside the confines of the canvas, began to be felt by many as a narrow restriction that prevented commentary on much that was relevant in contemporary American experience.

Some artists responded to this predicament by reintroducing fragments of reality, either in fictive or in actual presence, within a style that remained essentially dependent upon the old masters and especially upon de Kooning. A newer and more adventurous path has rejected still more definitively this dominating father-image by espousing, both in style and in frame of reference, exactly what most of the masterful older generation had excluded.

The early flags, targets, and numbers of Jasper Johns were decisive signposts in this new direction. Not only did they reintroduce the most unexpectedly prosaic commonplaces in the poetic language of abstraction; but, equally important, they at first used the actual visual qualities of these images as positive pictorial elements. The flat objects Johns originally painted were painted as flat objects, identical with the picture plane, and not as seen through

Abstract Expressionist lenses that shuffled and fractured colors, contours, and planes. What was rejuvenating about these works was not only the bald confrontation with a familiar object in the arena of a picture frame, but also the bald clarity of the pictorial style, which accepted the disarmingly simple visual data of these signs and symbols—total flatness, clean edges, pure colors, rudimentary design. To spectators accustomed to the dominant modes of abstract painting, these pictures were a jolting tonic, like a C-major chord after a concert of Schoenberg disciples. In the same way, Johns's recent sculptures—beer cans, flashlights, lightbulbs—challenged the complex spatial lacerations of abstract sculpture by accepting wholly the lucid solid geometries of these mundane, uncomplicated forms.

In the past few years, Johns's brilliant solutions to the problems of a younger American generation have borne new fruit in the work of an amazing number of artists who have attempted, with varying degrees of success and many failures, to undermine the authority of both the abstract and expressionist components of Abstract Expressionism. The sheer quantity of these artists amounts virtually to a revolution or, at the very least, a revolt, among whose major manifestos are the paintings of Roy Lichtenstein.

In a sense, Lichtenstein's position may be compared to Courbet's. To the French master in the 1850s, both sides of the Ingres–Delacroix coin presented an artificial idealism of style and subject, which he combated not only by the intrusion of vulgar content—whether toiling workers or sweating whores—but also by the adaptation of vulgar styles, particularly popular prints, *images d'Épinal,* whose still composition and childlike drawing offered an earthy antidote to the weakening stylistic conventions of the Romantic and Neoclassic modes. In the same way, Lichtenstein embraces not only the content but also the style, of popular imagery in mid-twentieth-century America as a means of invigorating the moribund mannerisms of abstract painting. It is revealing that negative criticism of his art has generally been phrased in the same terms as negative criticism of Courbet's art—the subjects are considered too ridiculously ugly, the style too preposterously coarse for "art." The idealist voice of the mid-nineteenth-century academy has been replaced by the no less idealist voice of the mid-twentieth-century one.

Like Andy Warhol and James Rosenquist, Lichtenstein has chosen the ugliest and most ubiquitous kind of commercial imagery—comic strips, soapbox diagrams, cheap advertising illustrations—as a source for his reformatory art. In place of the aesthetic idealism of recent abstract painting, he substitutes the most vulgar realism of a mass culture's visual environment. The Abstract Expressionist's veneration of personal brushstroke and private emotion is now opposed by a machine-produced style derived from an industrial, public domain. But just as Stuart Davis and Léger obliged us to realize that twentieth-century urban imagery could be metamorphosed into works of art, so, too, does Lichtenstein force us to examine American commercial illustration in terms of its aesthetic potential. As in the case of Johns's early flags, what is important is not only what is painted, but how it is painted. It is at first most unsettling, of course, to see the humanoid figures of a comic-strip frame blown up to easel-picture size; but the same comic-strip imagery painted in a style borrowed from, say, de Kooning would have far less conviction and force, creating instead a tepid compromise between the true nature of the subject and an alien pictorial manner. What is remarkable about Lichtenstein is that he has absorbed not only the sociological aspects of commercial

115.
Roy Lichtenstein,
Little Aloha,
1962

illustration, but also its pictorial implications. With an irony familiar to the twentieth-century tradition, he has transformed non-art into art. His pictures are not only fascinating as imaginative commentaries on their popular sources, but also as abstract pictorial inventions whose power may initially be concealed by the unfamiliarity of his choice of subject. A case in point is *Little Aloha* (fig. 115). Enlarged to the dimensions of an oil painting and therefore placed in the context of a work of art, this Hawaiian love goddess obliges us to scrutinize her as we never did before. She may first be looked at as a distressing sociological phenomenon, a member of a strange new race bred by the twentieth century. Embodying a popular American erotic fantasy, this vulgarized descendant of Ingres's and Gauguin's odalisques is startlingly ugly, though her monstrous vapidity, alternately grotesque and comical, is consistently hypnotic. Her fascination, however, resides not only in the cultural shock of really examining for the first time a spectacle so common that we have always closed our eyes to it, but also in the visual surprise of perceiving closely the mechanized pictorial conventions that produce this creature. Much as many nineteenth- and twentieth-century artists were excited by the unfamiliar flatness and simple linear means of styles that ranged from Greek vase-painting and Japanese prints to children's drawings and primitive textiles, Lichtenstein now explores the mass-produced images of the crassest commercial illustration. By magnifying these images, he reveals a vocabulary of uncommon rudeness and strength. Coarse and inky contours, livid primary colors, screens of tiny dots, arid surfaces suddenly emerge as vigorous visual challenges to the precious refinements of color, texture, line, and plane found in the Abstract Expressionist vocabulary.

Like all artists, however, Lichtenstein has chosen his visual sources discriminatingly and has learned to manipulate them in the creation of a style that has become uniquely his.

From the multiple possibilities offered by commercial illustration, he has selected those devices which produce a maximum of pictorial flatness—thin black outlines that always cling to a single plane; an opaque, unyielding paint surface that bears no traces of handicraft; insistently two-dimensional decorative patterns—woodcut arabesques and mechanically regimented rows of dots—that symbolize texture and modeling. Thus, the Hawaiian girl is first seen as an illusion of the most voluptuously contoured anatomy, but these sensual swellings are quickly and brutally ironed out by the two-dimensional conventions of Lichtenstein's style. Like the nudes of Ingres, whose anatomies become so monstrous when extracted from their compressed spaces, Lichtenstein's exotic lady offers a compelling tension between the abstract autonomy of sinuous contour and compositional flatness, and the resulting distortions of a jointless arm, a muscleless throat, a boneless face. Throughout the painting this interplay of style and subject commands attention, whether one looks at the rude contrast between a flat black and flat red shape that creates a lipsticked mouth; the rich, curvilinear inventions that indicate shading and texture in the cascades of black, perfumed hair; the totally flat pattern of tiny red dots that alternately become rounded, pink flesh. *Head, Yellow and Black* belongs to the same generic and pictorial race. The American counterpart of her Hawaiian cousin, she is a pretty girl of the domestic variety; but again, studied closely, the total vacancy of expression and the amphibian physiognomy provide a shocking sociological observation, which, in turn, is supported by an equally startling pictorial invention. The cosmetic complexities of mascaraed eyes, tweezed eyebrows, and permanent waves are transformed into linear abstractions of almost Art Nouveau fantasy. This rich visual incident is then contrasted to the taut and bleak expanses of empty skin surface, monotonously textured background, and matte-black dress, so that the whole creates a calculated pictorial intricacy surprising in what seems, to begin with, so crude an image.

In *The Kiss* (fig. 116), the "girl next door" meets her mate, a virile Air Force pilot who seems to have dropped from the clouds in order to provide the total ecstasy that, in a less-secularized society, was once experienced by a swooning Santa Teresa. This fervent embrace—a crushing fusion of blond hair, a military uniform, polished fingernails, deeply closed eyes, and a momentarily grounded airplane—is again masterfully composed in terms of a remarkable variety of linear and textural invention, witness only the sweeping descent of erotic abandon that begins with the pilot's visor and continues downward through the forehead of Miss America, the part in her hair, and finally the knuckles of the clenched male fist.

Lichtenstein's sociological exploration of American mores is further elaborated in the *Eddie Diptych* (fig. 117), which describes the dramatic rupture between teenage daughter and disapproving parents so common in popular fiction. Ironically reviving the narrative means of a medieval religious painting (a diptych with long verbal description, here both soliloquy and dialogue), the *Eddie Diptych* presents a comic-strip crisis in which the ingredients of Western tragedy are bizarrely reflected. Youthful rebellion, parental opposition, omnipotent love are re-created by the dramatis personae of this vulgar literary medium with results that are at once funny and disturbing as an accurate mirror of modern popular culture. Pictorially, the diptych is no less intriguing. The colors—the harshest yellow, green, blue, red—produce flat and acid surfaces of unfamiliar visual potency; and the complex lettering is used ingeniously as both a means of asserting the composition's taut flatness and as a delicate dec-

116.
Roy Lichtenstein,
The Kiss,
1962

117.
Roy Lichtenstein,
Eddie Diptych,
1962

118.
Roy Lichtenstein,
Step-on Can with Leg,
1961

orative pattern of black and white that relieves the assaulting intensity of the opaque colors. The enclosing white frame of the right wing and the structure of the lettering in the left wing—a column arranged around a vertical axis of symmetry—are particularly handsome pictorial devices culled from comic-strip sources but assimilated to Lichtenstein's personal style.

If Lichtenstein has imagined new heights and depths of American comic-strip drama, he has also considered the more prosaic domain of American advertising. The national fetish for domestic cleanliness revealed in ads for everything from soap flakes to bathroom deodorizers is reflected in a number of pictures that extol the virtues of Good Housekeeping. In *Woman Cleaning* the gigantic head of a synthetic housewife smiles down at us to register the pleasure and ease of a periodic refrigerator cleaning. In other pictures, these sanitary rituals are further dehumanized. Following the images of mechanization that Léger had explored in the 1920s, Lichtenstein at times shows a disembodied hand performing a simple functional operation. In *Spray* only the pressure of a housewife's manicured finger is necessary to freshen domestic air; in *Sponge* the effortless sweep of a lady's left hand works cleansing miracles. Here again, the mass-produced coarseness of Lichtenstein's visual sources—the diagrams on the labels of sanitary products—is unexpectedly transformed by a witty pictorial imagination. In *Sponge,* for instance, the blank, untextured areas vividly convey textures as unlike as skin, sponge, and enamel, just as the familiar screen of dots derived from cheap printing processes is instantly identified with a coat of dust and grime.

Similar hygienic concerns dominate *Step-on Can with Leg* (fig. 118), where the compartmented, sequential arrangement of "how-to-use" diagrams inspires a two-part pictorial demonstration of how a flowered garbage pail is opened by stepping on the pedal. The dainty pressure of a high-heeled shoe, as seen on the left, is apparently sufficient to raise the lid, as seen on the right. Pictorial as well as mechanical rewards are offered in Box Two, where the checkered pattern of a dress, now visible in the upper-left-hand corner, and the changed position of the garbage pail complicate the simple symmetry of the image in Box One. A diptych

is again used in *Like New*, in which the before-and-after demonstrations of American advertising are transformed into a painting whose abstract qualities are more explicit than usual in Lichtenstein's work. Here an ad for invisible weaving is surprisingly enlarged in a two-part symmetrical design. What first seems, however, a boringly tidy regularity of mechanically repeated dots and sawtooth edges is unexpectedly upset by the darkened, irregular aureole in the left panel, which is suddenly recognized as a cigarette burn in a swatch of cloth. There could hardly be a better example of Lichtenstein's ability to re-create the tawdry visual environment of commercial imagery as an extraordinary abstract invention.

Lichtenstein's inventory of American popular culture includes any number of cherished objects that range from ice-cream sodas and new tires to beefsteaks and dishwashers. Like the machine-made creatures who use them, these objects are mass-produced forms of unforgettable ugliness. *Black Flowers* provides the Woolworth's contribution to the art of flower arrangement—a hideous china vase stuffed with a cornucopian abundance of poppies that must be made of plastic; and, similarly, the art of jewelry descends to the kitsch splendors of an advertised engagement ring whose crowning glories must surely be a glass pearl and two zircons. These 1984 horrors of mass production extend as well to food. *Turkey*, the American dream of a holiday dinner, becomes an inedible, inorganic merchandising product; and Lichtenstein's other selections from supermarket and drugstore displays are no less synthetic and indigestible conclusions to the pleasures and graces of the Western still-life tradition.

Even more startling are Lichtenstein's recent comments on another familiar product of American merchandising—great works of art. Appropriately, for a period in which the Sistine ceiling can be bought together with toothpaste and breakfast food, Lichtenstein focuses the mechanized lens of mass production on these sacrosanct, handmade relics of the Western tradition. *Man with Folded Arms* (fig. 119) looks at a great Cézanne portrait through the eye, first, of a reductive compositional analysis in a published study of Cézanne, and then through the eye of Lichtenstein's own style in which wall plane and dado become a screen of printer's dots, infinitely reproducible, and the figure becomes a simplified linear diagram that transforms it into the pictorial equivalent of plastic flowers. This reinterpretation of artistic tradition in the commercial light of the 1960s is even more astonishing in Lichtenstein's version of Picasso's *Femme au chapeau* (fig. 120). Here the horror of a Picasso head of the 1940s—part human, part bull, part dog—becomes still more bizarre when read through Lichtenstein's vocabulary. The flat, opaque colors and vigorous black outlines are consonant enough with Picasso's own style to permit the grotesque force of the original painting to be felt; but this comical ugliness is further compounded by imposing the mass-produced schematizations of a comic-strip image upon it. In the realist tradition of the nineteenth and twentieth centuries, Lichtenstein has found his content in a fresh examination of the shocking new commonplaces of modern experience that had previously been censored from the domain of art; and in that tradition, he has suddenly rendered visible what familiarity had prevented us from really seeing, whether comic-strip dramas or Picasso reproductions. More than that, he has succeeded in assimilating the ugliness of his subjects into new works of art, whose force and originality may even help to reconcile us to the horrors of the Brave New World in which we live.

"Roy Lichtenstein and the Realist Revolt." Published in *Metro,* no. 8 (April 1963), pp. 38–44.

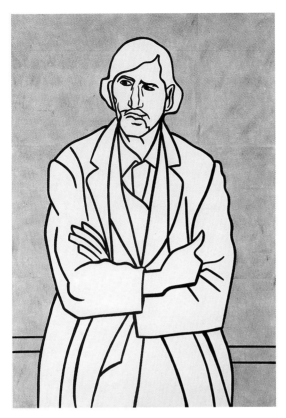

119.
Roy Lichtenstein,
Man with Folded Arms,
1962

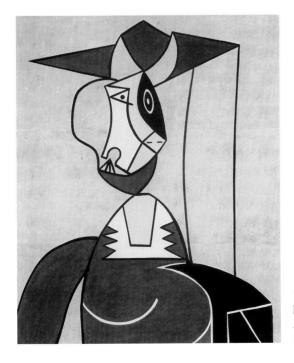

120.
Roy Lichtenstein,
Femme au Chapeau,
1962

ROY LICHTENSTEIN: PAST, PRESENT, FUTURE
1991

My memories of Roy Lichtenstein go so far back that they might almost be called prenatal, both for him and for me. For most of the world, Lichtenstein was born at the Leo Castelli Gallery in February–March 1962, at an exhibition that dumbfounded with horror or delight everybody who saw it, and that can still jolt the memory. But by an odd coincidence, our professional paths had crossed exactly eight years earlier, in 1954. As a graduate student of art history, I began at just that time to earn some extra money by writing back-page reviews for *Art Digest,* and one of my very first chores was to preview and write a paragraph or two about a show to be held at the John Heller Gallery in March by an artist I had never heard of. His name was Roy F. Lichtenstein (the F., like my own middle initial, H., was soon to disappear). In fact, I never thought of him or heard of him again until the explosion of Pop art in 1962, when his work so totally unbalanced me with its outrageous but tonic assault on everything that was supposed to be true, good, and beautiful, that I completely forgot I had once encountered his name and work before. And when, just now, I decided to track down my first written words about Lichtenstein (*Art Digest,* February 15, 1954), I was amazed that this Proustian madeleine still couldn't stir up any recall of those early paintings and even more amazed at what I said about them. I complained that his subjects, then taken from American cowboy and Indian themes, were at odds with his style, which was clearly indebted to the Braque contingent of the School of Paris. My diagnosis concluded with the comment that "caution and good taste characterize his personality."

Caution and good taste? As it turned out, the overwhelming effect of the 1962 show, whether you loved it or hated it, was anything but that. In fact, the walls of the Castelli Gallery seemed to have been invaded by a sudden attack of the ugliest kind of reality that had always been kept far away from the sacred spaces where art was to be worshiped. Next to Lichtenstein's crass emblems of American grass-roots truth—fast food, washing machines, comic strips—even such earlier forays into the public domain as Johns's flags and Rauschenberg's urban detritus looked positively old-fashioned and handmade.

I remember being totally shocked by all of this, but the shock was one of release and rejuvenation. First I smiled with amazement at the colossal, confident gall of an artist who could insult so many pieties by embracing all these images we lived with but had somehow managed to censor out of the art world; and then I rubbed my eyes with equal disbelief at what appeared to be the unprecedented coarseness of the way in which these confrontations

with American life were painted. We had all, for instance, seen paintings that distilled the world to black and white and to three primary colors—Mondrian's utopian abstractions were familiar paragons of such purity—but who had ever seen anything like Lichtenstein's version of red, yellow, and blue? Each of the three hues looked as though it had come not from the expensive pigments available at art-supply stores but from the cheapest printer's inks used by a newspaper so vulgar that no art lover would ever buy it. (As I recently realized, incidentally, the yellows of these paintings have developed over the decades a greenish, acidic tone that alters their original, deadpan simplicity.) As for the black drawing around these flat, inert colors, this, too, punched you in the eye: for the total rejection of personal touch in favor of the coarse, utilitarian shorthand of the commercial illustrator was a blow to even the most flexible idea of acceptable standards of draftsmanship in a painting we were expected to take seriously. As for the rendering of light, texture, and chiaroscuro, this was even more of a joke; for these effects were conveyed through the wholesale adaptation of the grainy, repetitive micropatterns of the benday process used in photoengraving. The first impression was that totally artless fragments of comic strips and impoverished advertising images were exactly replicated by a jokester; yet magnified to the alarmingly large dimensions of an easel painting, they provided a disturbingly accurate mirror of things we had lived with all the time but had never really looked at before.

Being young enough to enjoy the bewildering force of something that could disarm me by opening uncharted vistas of a new world while temporarily shutting the door on an old one, I instantly fell in love with these paintings, long before being able to say why or before realizing that perhaps they weren't quite as ugly or quite as unfamiliar as they at first seemed to everyone. In fact, their impact was so strong that they usually stunned rational response. Suddenly, the art world seemed divided into passionate pros and cons, with former friends often turning into enemies. Something evil was detected in Lichtenstein's work, as if this mild-mannered, if impish, man, whom most had never laid their eyes on, were the devil incarnate who was hell-bent on poisoning eternal aesthetic values. By the end of the year, 1962, many critics had voiced their outrage and many more were to follow. Dore Ashton, Peter Selz, Hilton Kramer, and others who had sneered at earlier changes in the art of the young, from Johns to Stella, were united in their contempt. And many other artists, of course, were equally scornful of this rebuff to painterly traditions. I remember Cleve Gray being shocked that I, presumably a sober art historian, could even begin to take this stuff seriously; and I recall, too, how the Olympian Robert Motherwell was so offended by the art of Lichtenstein and his Pop colleagues that when the Sidney Janis Gallery held a landmark show of their work, "The New Realists," in November–December 1962, he parted company with the gallery and moved to Marlborough-Gerson. As for the dean of American art critics, Clement Greenberg, I still savor vividly an evening in the early 1960s when, as usual, heated arguments about Pop artists were rampant. Edward Fry and I were united in singing Lichtenstein's praise, upon which Greenberg said, "In ten years, nobody will have heard of him." Fry asked Greenberg if he would be willing to put this in writing and date it, which, to our surprise, he did. (Alas, years later, when we both remembered this incident, neither one of us could track down this informal document.) In fact, it is hard to imagine now the degree of absolute scorn and creeping anxiety Lichtenstein's work could generate in the 1960s. *Life* magazine could

even title what was actually a sympathetic, reportorial article about his work, "Is He the Worst Artist in the U.S.?" (January 31, 1964)—a clear echo of the incompetence most viewers apparently discerned in his paintings. But the best story I can recall about the degree of satanic threat Lichtenstein embodied for an older generation came from the Art Department of Rutgers University, where he taught between 1960 and 1963. I happened to visit the school just at the end of Lichtenstein's sojourn and talked to the resident painter-teacher, Reginald Neal, who complained bitterly about the impact this young rebel had had on the students. "Before Lichtenstein got here," he moaned, "those kids could draw a sensitive line." (Later, I tried to imagine a painting by Lichtenstein titled "Sensitive Line.") Even an art historian and critic as open-minded and open-eyed as Leo Steinberg had trouble with Lichtenstein at the beginning. On December 13, 1962, at a symposium on Pop art at MoMA, he confessed that although he wanted to be fair in his judgment, the subject matter in Lichtenstein's work was still so intensely present for him that he could not as yet get beyond it to discern any painterly qualities in his art. (Exceptionally, Don Judd, reviewing Lichtenstein's first Pop show [*Arts Magazine,* April 1962], discussed almost exclusively the formal changes the artist had made upon his comic-book sources and virtually ignored the startling subject matter entirely.)

For me, too, the subject matter was the most obvious, obtrusive confrontation in his art. Who had ever before been forced to stare at the most mundane and unaestheticized facts of our daily American life—a baked potato or a comic-strip frame—ennobled in the spaceless center stage of a painting as if they were disembodied icons? But luckily, I was hypnotized rather than repelled by these offenses to iconographic decorum, the farthest cry imaginable from the heroic, empyrean domain of will, myth, religion, and cosmic nature that had fired the generation of Abstract Expressionists. My enthusiasm for Lichtenstein became quickly known, and I was soon obliged to educate myself in public in the form of an article I was asked to write about him for the magazine *Metro* in 1963 (see pages 190–96). There, my faculties as a professional art historian finally came into play, and I began to realize that the kind of shock Lichtenstein produced had many echoes in past art in moments when, as in the case of Realist rebels like Courbet, the raw truths of the ordinary that were thrust into the face of the spectators were so upsetting that the artfulness of the paintings was temporarily concealed. Looking at *The Stonebreakers* for the first time in 1851, most viewers could only see that an oversized pair of ugly workers had polluted the pure air of the Salon and not that a new master painter, Courbet, had arrived with not only a new subject but a new way of painting it. It became apparent that Lichtenstein's style was not only as fully offensive as his subject matter, but it also worked in perfect harmony with his total acceptance of the visual and material facts of this commercial imagery. (A hot dog painted by Larry Rivers in his old-master style would have upset very few people.) As for Lichtenstein's style, insolently coarse as it looked at first sight, this, too, began to settle into art history. Already in 1962 Don Judd astutely noticed its resemblance to Léger (an artist whom Lichtenstein would later quote directly), and a fuller genealogical table was rapidly created. I, for one, began to realize the surprising analogies between Lichtenstein and Seurat, not only in their common fascination with the flat and grotesquely caricatural images of human beings invented by the commercial illustrators of their time, but by their common use of the microtechniques of color reproduc-

tion—the tiny, regularized dots of color, which, in Seurat's case, also move to the three primary hues in his late work, reflecting the new processes of chromolithography invented in the 1880s. Were the bizarre human beings in Seurat's *Le Chahut* or *Le Cirque* not the ancestors of Lichtenstein's equally strange, bodiless creatures who played out comic-strip dramas or helped to sell refrigerators in newspaper ads? And come to think of it, hadn't many other artists before Lichtenstein been eager to embrace the fact and the look of ads, comic strips, commercial illustrations? Perhaps Picasso and Gris, Duchamp and Schwitters played some ancestral role here. And in the United States, there was always the presence of Stuart Davis, whose populist embrace of modern packaged goods, from cigarettes to disinfectants, and even newspaper front pages with cartoons, provided a preview of Lichtenstein in the more localized tradition of American painting before the Abstract Expressionists leaped out of New York City and into a domain of epic and timeless universals.

Gradually, too, the abstract power of Lichtenstein's graphic patterns began to devour their commercial origins. No less an aesthete than Kenneth Clark could make a passing but incisive remark, in an article on Aubrey Beardsley (*New York Review of Books,* December 9, 1976), about the effete British artist's resemblance to Lichtenstein, a surprising aperçu that illuminated both the connection of the ultra-refined Beardsley to the swift, eye-grabbing economics of commercial art, as well as the extraordinary refinement of Lichtenstein's adaptation of vulgar graphic sources. Was it even possible that far from dragging art down into the mud of the coarsest imagery that we tried to shield from our eyes, Lichtenstein had actually introduced by the most subtle manipulations a new kind of sensitivity and good taste, reconciling, as it were, the grossest facts of the American visual environment with, of all unlikely things, the demands of beautiful art? Within only a few years, in fact, Lichtenstein's paintings, far from looking like the ugliest things ever seen in a gallery, began to look like the most elegantly precise adjustments of presumably hideous sources. The ironies of this reversal of expectation kept growing and reached a climax at the end of the 1960s, when Lichtenstein did his own versions of the art-historical ne plus ultra of exquisite sensibility, Monet's series paintings of the 1890s, the haystacks and the Rouen Cathedral facades. Who could imagine more refined calibrations of colored dots than those Lichtenstein produced to update and parallel the nuances Monet had extracted from his own theme and variations?

Considering the shocking blow of his 1962 debut, Lichtenstein, in fact, turned every assumption about his work inside out. For an artist who had presumably slammed the door forever on high art by descending to the level of Mickey Mouse and ice-cream sodas, what was he doing with the likes of Monet? Now, a quarter-century later, we are beginning to realize that in the 1960s, Lichtenstein clearly defined the retrospective attitudes we call, for want of a better word, postmodernism. For already in that decade, Lichtenstein announced in his art that we were living in an age that had been born after the expiration of the modernist epoch, an age in which the heroic story of the evolution of modern art from Cézanne and Monet to Picasso and Mondrian at last seemed a finished chapter, an era that lay on the other side of a huge historical gulf. One by one, he flash-froze this once thrilling dynasty of art monarchs who had struggled to power against the public's blindness and hostility but who had finally been so triumphant that images of their art were rolled off the press with the same mechanized abundance as the comic strips with which Lichtenstein launched his Pop career.

Diagnosing the moribund state of modernism, Lichtenstein set out to bury its heroes and period styles, one by one, including a special exorcism of the Abstract Expressionists, who, for artists of his generation, had become overpowering deities. In the brushstroke series of 1965–66 he created, in effect, a witty and definitive epitaph to the tyranny of their myth by re-creating heroic, muscular gestures and ragged swaths of paint as tidy emblems of calculated order. How could one take seriously again the legacy of turbulent pigment that had been interpreted, in the paintings of Kline and de Kooning, as marking the release of unbridled emotions? How could one believe any longer in impulse when Lichtenstein translated drips and spatters of thick paint into his language of immaculately smooth, impersonal surfaces plotted, so it seemed, by a mechanical replicator that could only master an ABC vocabulary of black lines, screens of dots, and three or four flat colors? And in the same years, 1964–65, Lichtenstein did in the other branch of Abstract Expressionism, transforming Rothko's floating tiers of mystical, atmospheric color into landscape and seascapes that looked like cartoon versions of American luminism.

Moreover, Lichtenstein occasionally enjoyed spoofing his purist, abstract contemporaries, whose unpolluted geometries in the 1960s and 1970s were often seen as defending ancient modernist faiths against the onslaught of Pop art. The perfect, cerebral triangles of his Pyramids of 1969 are not only a joke about modern tourism in ancient sites, but also about the planar and volumetric severities of Minimal sculpture in that decade. The crazy interlocking geometries of the frequently mural-size Modern Paintings of the late 1960s are not only parodies of Art Deco, but dialogues with Frank Stella's equally large series of irregular polygons and gyrating protractors painted in the same years. The neat horizontal stripes of his Entablatures of the early 1970s are not only satirical Machine Age versions of handmade classical beauty in ornamental moldings, but responses to the uninterrupted velocities of Kenneth Noland's parallel streaks of abstract color. Indeed, Lichtenstein's postmodernist view of the history of modern art kept expanding in every direction, until all the canonic isms and movements of the art-history textbooks—Cubism, Futurism, Blue Rider, Purism, Expressionism, de Stijl, Surrealism—had been embalmed. Over the decades, in fact, he created an entire museum of modern art that raised all of those questions of irony, appropriation, mechanical reproduction, and simple nostalgia for a heroic past that are raised again and again in discussing the work of artists of a much younger generation such as Sherrie Levine, Philip Taaffe, Mike Bidlo.

In many other ways, too, Lichtenstein now seems a prophet. His rear-view vision of the age of modernism is tinged with considerable longing for those decades of his youth (he grew up, after all, in the 1930s world of Rockefeller Center), when the ideas of progress through science and industry and through the doctrines of the Museum of Modern Art were all still fresh and optimistic. By the 1960s, however, these faiths had become relics of a lost and painfully naive world that had vanished in 1945 with Hiroshima. With his usual on-target accuracy, he was one of the first artists to revive the period look of Art Deco, offering already by 1966–67 a loving as well as a parodistic replay, in both painting and sculpture, of this first popular language of the Machine Age, which only later, in the 1970s, was to rival and then replace Art Nouveau as the younger generation's favorite decorative style from our century's youth. Moreover, he put his finger on the cultural myths that accompanied the

121.
Roy Lichtenstein,
*Study for
Preparedness,*
1968

Art Deco style, most accurately in two murals of 1969–70, *Preparedness* (fig. 121) and *Peace through Chemistry.* Their titles and imagery, which might have been created with unquestioning faith on the eve of the Second World War, produce for us, especially in 1991, after the Gulf War, both a shudder of horror and a poignant smile at the memory of what, by comparison to what we now know, looks like a 1930s world of Arcadian innocence. And quite a different surprise was in store here, too. Who could have imagined from the relatively modest dimensions of Lichtenstein's first Pop easel paintings of 1961–62 that this presumably heretic art, often misinterpreted in its beginnings as resurrecting the insolent, nose-thumbing spirit of Dada, could be amplified to public dimensions that eventually would become capable of satisfying decorative demands for huge spaces in museums and office buildings?

Yet here, too, Lichtenstein revived the past with a smile, remembering, as he did, the 1930s, when artists as unlike as Thomas Hart Benton and Arshile Gorky could expand their art to accommodate the public domain of schools, state capitols, or airports and when even de Kooning could be commissioned to provide a mural for the New York World's Fair of 1939–40.

Such retrospection is particularly potent in the series of murals Lichtenstein executed in the late 1980s. In Los Angeles, at the Creative Artists Agency, there is a reprise of Oskar Schlemmer's *Bauhaus Staircase,* a painting of 1932, which not only takes us back to a nostalgic memory of the Bauhaus years, when human beings who looked as though they were turned on a lathe inhabited a Brave New World of purist architecture, but also takes us back to the old Museum of Modern Art in New York, to the decades when Schlemmer's painting hung in the stairwell, transporting the utopian faith of the Bauhaus (which was closed by the police in 1933) to American shores, where good design, modern art, and the myth of the machine could continue to reign. As for the murals in New York (at the Equitable Center) and in the Tel Aviv Museum, these, like the temporary installation of the earlier Greene Street mural, are more personally retrospective, offering to the public at large a kind of anthology of Lichtenstein paintings from the 1960s on, fragments of his full and now venerable career that have been immaculately locked into permanent place with the hard-edged, poster-flat precision that evokes the mural style of Léger and Gorky at the Newark airport murals.

This, of course, was the kind of compilation of earlier motifs that Lichtenstein had begun to explore already in paintings of the 1970s, which, often within a quotation from Matisse's own studio retrospectives of 1909–11, would anthologize his past history, as if he were organizing for himself a mini-exhibition in a small museum. And here, too, his art mirrors that of his equally famous contemporaries Johns and Warhol, who also began in the 1970s to explore self-quotation, an introspective domain that can yield results ranging from the privacy of a diary entry, as with Johns, to art fit for a lobby, which is more Lichtenstein's style. But at times, his view of his own past achievement can take on a more intimate tone, as in a series of easel paintings of 1990, which repeat earlier compositions now seen, however, through a trompe-l'oeil glass that, in turn, conjures up his own mirror paintings of the early 1970s. These strange abstract patterns of transparency and reflection, through which familiar early work was glimpsed, added an unexpectedly poignant layer to these remembrances of Lichtenstein's past, as if he were burying his own now famous works of the 1960s, which had ironically become historic monuments, much as he had put to rest the still older ghosts of twentieth-century art. Yet with Lichtenstein, any such sentimental speculations must always be held in check, since he is sure to ward us off with a smile just when we are about to get too serious. At least we can be certain that the enfant terrible of 1962 has turned, by the 1990s, into a paragon of the "caution and good taste" I had diagnosed in his juvenilia in 1954. That he has matured into exactly the kind of establishment figure whom he had dethroned in his youth must surely bring another smile to his lips. So official, in fact, has he become in an art world that once jeered at him that he has now been elected as the designer of a new logo, to be called a "Roy," which will be the equivalent of an "Oscar" for professionals in the field of modern art: a small brushstroke sculpture to be given to the curator of modern art who wins the annual prize for the best show of the year. Who knows what else lies in store for Lichtenstein? His portrait on a United States postage stamp? But then, who knows what else he has in store for us?

"Roy Lichtenstein: Past, Present, Future." Published in *Artstudio* 20 (Spring 1991), pp. 34–43.

ANDY WARHOL: COURT PAINTER TO THE 70S
1979

If anybody had been asked in the 1950s to check the pulse of contemporary portraiture, the diagnosis would have been gloomy. "Moribund" might have said it discreetly; "dead" would have been more like it. Were any humanoid presence to emerge from that distant, mythic world conjured up by Rothko, Newman, and Pollock, it could only have been the Holy Shroud, Adam, or Thor; and even if one of de Kooning's women were to congeal into an identifiable being, she would probably turn out to be Lilith or the Venus of Willendorf. The prospects of any mortal, not to mention contemporary, man or woman, surfacing in that lofty pictorial environment seemed slim indeed.

But art and history are full of surprises, and few were more startling than the way the younger generation of the 1960s wrenched the here-and-now (which are now the then-and-there) facts of American life back into art. The doors and windows of the ivory-tower studios were suddenly opened wide, and the pure air inside was instantly polluted (or some would say rejuvenated) by the onslaught of the ugly but irrefutably vital world outside. Of the many things that demanded immediate attention, from city streets, highways, and supermarkets to billboards, newspaper print, and television sets, the pantheon of 1960s celebrities was high on the list. If everybody in the civilized and not-so-civilized world instantly recognized Elvis Presley or Marlon Brando, why should their image be censored out of the history of serious art? If a pall was cast on this planet in the summer of 1962 when news of Marilyn Monroe's suicide instantly circled the globe, why shouldn't a painter commemorate her for posterity? If, in the following year, Jacqueline Kennedy helped the nation and the world bear their collective grief by maintaining a public decorum worthy of a Roman widow, why shouldn't there have been a living artist who could record for future generations this modern Agrippina? Luckily, there was.

Andy Warhol, in fact, succeeded virtually single-handedly in the early 1960s in resurrecting from near extinction that endangered species of grand-style portraiture of people important, glamorous, or notorious enough—whether statesmen, actresses (fig. 122), or wealthy patrons of the arts—to deserve to leave their human traces in the history of painting. To be sure, this tradition, which grew ever more feeble in the twentieth century, occasionally showed a spark of life in the hands of a few ambitious painters, above all in England. Here one thinks of Graham Sutherland's portraits of the 1950s and 1960s of the likes of Lord Clark, Sir Winston Churchill, Helena Rubinstein (fig. 123), Dr. Konrad Adenauer, or the Baron Elie

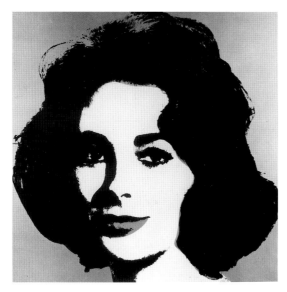

122.
Andy Warhol,
Liz #3,
1963

123.
Graham Sutherland,
Helena Rubinstein in Red
Brocade Balenciaga Gown,
1957

124.
Walter Sickert,
H. M. Edward VIII,
1936

de Rothschild, where the tradition of Titian, Velázquez, and Reynolds seems not quite to have given up its ghosts and where, for a moment, the sharp facts of universally known physiognomies seem to blend with a pictorial environment of old-masterish resonance and aristocracy. And a decade or two earlier, and again in England, one thinks of the neglected late portraits of Walter Sickert, who, in the 1920s and 1930s, often used for his depictions of eminent contemporaries the most informal news photographs, which provided an underlying image of reportorial truth for, say, a glimpse of King George or Queen Mary passing by in a royal automobile or of King Edward VIII greeting troops (fig. 124). Indeed, as Richard Morphet has already proposed, there are prophecies of Warhol in Sickert's strange amalgams of London press photos and the lofty traditions of state portraiture.[1]

More often than not, however, paintings of public figures in the last decades belong, especially in the United States, to the domain of Portraits, Inc., and its ilk. When confronted with the prospects of eternity in depicting a great man of state, most official painters rattle around in a graveyard of traditions. A pretty funny case in point is Wayne Ingram's portrait-apotheosis of Lyndon Baines Johnson (fig. 125) in the LBJ Library, in Austin, Texas, where the thirty-sixth president of the United States first faces us real as life, and then ascends, via a

125.
Wayne Ingram,
*Portrait of
President Lyndon B. Johnson,*
1968

shower of de Kooning-plus-LeRoy Neiman brushstrokes, to a secular baroque heaven where his watchful spirit still floats on high.

It was Warhol's masterstroke to realize (as Sickert and even Bacon had tentatively suggested in eccentric ways) that the best method of electrifying the old-master portrait tradition with sufficient energy to absorb the real, living world was, now that we see it in retrospect, painfully obvious. The most commonplace source of visual information about our famous contemporaries is, after all, the photographic image, whether it comes from the pages of the *Daily News* or *Vogue.* No less than the medieval spectator who accepted as fact the hand-made images of Christian characters who enacted their dramas within the holy precincts of church walls, we today have all learned to accept as absolute truth these machine-made photographic images of our modern heroes and heroines. When Warhol took a photographic silkscreen of Marilyn Monroe's head (fig. 126), set it on gold paint, and let it float on high in a timeless, spaceless heaven (as Busby Berkeley had done in 1943 for a similarly decapitated assembly of movie stars in the finale of *The Gang's All Here*), he was creating, in effect, a secular saint for the 1960s that might well command as much earthly awe and veneration as,

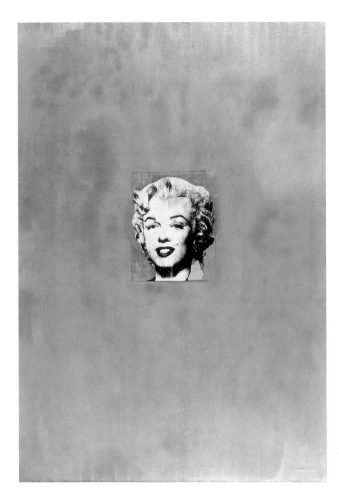

126.
Andy Warhol,
Gold Marilyn Monroe,
1962

say, a Byzantine Madonna hovering for eternity on a gold mosaic ground. And when he reproduced the same incorporeal divinity not as a single unit, holy in its uniqueness, but as a nonstop series, rolling off an invisible press in endless multiples, he offered a kind of religious broadsheet for popular consumption, suitable to the staggering, machine-made quantities of our time, where the tawdry imperfections of smudged printer's ink or off-register coloring have exactly the ring of commonplace truth we recognize from the newspapers and cheap magazines that disseminated her fame.

By accepting the photograph directly into the domain of pictorial art, not as an external memory prop for the painter's handmade re-creation of reality but as the actual base for the image on canvas, Warhol was able to grasp instantly a whole new visual and moral network of modern life that tells us not only about the way we can switch back and forth from artificial color to artificial black-and-white on our TV sets but also about the way we could switch just as quickly from a movie commercial to footage of the Vietnam War. For Warhol, the journalistic medium of photography, already a counterfeit experience of the world out there, is doubly counterfeit in its translation to the realm of art. He takes us into an aestheti-

cized Plato's cave, where the 3-D facts outside, whether concerning the lives of a superstar or an anonymous suicide, are shadowy factions of equal import. In terms of portraiture, this second-degree reality dazzlingly reinforces the inaccessible human presence of those remote deities—a Liz Taylor or a Happy Rockefeller—whom only a select few have actually seen at eye level in three corporeal dimensions; and in terms of our more general awareness of what is really happening on the other side of our movie and TV screens, it frighteningly reflects exactly the way in which, for the television generation, which has now become our future population, the eyewitness fact of Jack Ruby's on-the-spot shooting of Lee Harvey Oswald in a Dallas police station was almost to be confused with the fictional murders that followed and preceded this real-life, but scarcely believable, event on the same channel.

That Warhol could paint simultaneously Warren Beatty and electric chairs, Troy Donahue and race riots, Marilyn Monroe and fatal car crashes, may seem the peculiar product of a perversely cool and passive personality until we realize that this numb, voyeuristic view of contemporary life, in which the grave and the trivial, the fashionable and the horrifying, blandly coexist as passing spectacles, is a deadly accurate mirror of a commonplace experience in modern art and life. It found its first full statement, in fact, a century earlier in the work of Manet. Like Warhol, Manet wears the disguise of an aesthete-reporter whose camera-eye range extended from the haut monde of famous people (from Mallarmé and George Moore to Clemenceau and Chabrier), of proto-Fauchon luxury edibles (from salmon and oysters to brioche and asparagus), and of pampered dogs (from poodles to terriers), all the way to contemporary events which would earlier have been interpreted as harrowing tragedies (a bullfighter killed in the ring, a barbaric execution of an Austrian emperor, a hair-raising maritime escape of a political prisoner from a penal colony, an unidentified man who has just shot himself on a bed). The familiar complaints that Manet painted the harshest facts of death with the same elegant detachment, cold-blooded palette, and unfocused composition that he used for still lifes, picnics, pet animals, and society portraits is one that could be leveled at Warhol. But in both cases, it perhaps is not blame but gratitude that we owe these artists for compelling us to see just how false our conventional moral pieties are when judged against the truth of our usual shoulder-shrugging responses to what often ought to be the shattering news of the day. And in both cases these reportorial observations about the facts of modern life are lent further distance by being seen literally through a pictorial skin that insistently calls attention to itself. The subtle chill of Manet's and Warhol's view of current events through the aesthete's tinted glasses often cuts more deeply than the louder screams of expressionist psychology.

For Warhol's seeming moral anesthesia, his poker-faced rejection of the conventional hierarchies of the tragic and the silly, become still more detached and ironic through his manipulation of the look of commercial photography as a new vocabulary to be explored as an aesthetic language in itself. The blurrings of printer's ink, the misalignment of contours, the flat graininess of shadows, the brusque and arbitrary change from one colored filter to another, the new plastic spectrums of chemical hues both deadly and gorgeous—such products of the mechanized world of photographic printing and retouching are isolated by Warhol and provide him with a fresh range of visual experiences that usurp the earlier artifices of picture-making. They become, in fact, the stuff from which new cosmetic layers are made,

ugly-beautiful paint surfaces that turn the truth of the silkscreened photographs on the canvas into a distant shade of an ever more intangible reality.

The contradictory fusion of the commonplace facts of photography and the artful fictions of a painter's retouchings was one that, in Warhol's work, became a particularly suitable formula for the recording of those wealthy and glamorous people whose faces seem perpetually illuminated by the afterimage of a flashbulb, and whose physical reality might be doubted by the millions who recognize them. In the 1970s, Warhol's production of such society portraits accelerated to a point where he and his paintings constantly intersected the world of paparazzi and of high-fashion photography. If many of the celebrity portraits of the 1960s, whether of Jackie or Marilyn, smacked of the *New York Post* or *Screen Romances* and almost made us feel that our fingers might be stained with cheap newsprint if we touched them, those of the 1970s belong to the glossy domain of *Vogue* and Richard Avedon. The Beautiful People have replaced the dreams and nightmares of Middle America; the world of the Concorde, that of the U.S. highway accident. From those first days of Bonwit Teller window displays and starry-eyed adolescent pin-up fantasies, Warhol's upward mobility was supersonic. Instead of getting the superstars' photos from movie magazines or the Sunday color supplement, he himself quickly invaded their society on equal terms and could be begged by prospective sitters to turn his own Polaroid camera on their fabled faces in both public and private moods. He had become a celebrity among celebrities, and an ideal court painter to this 1970s international aristocracy that mixed, in wildly varying proportions, wealth, high fashion, and brains.

With Warhol's gallery of contemporary faces, the decade of 1970s high society is instantly captured. In this glittering realm, light and shadow are bleached out by the likes of Baskin-Robbins; and brushstrokes offer an extravagant, upper-income virtuosity, which appears to be quoting, for conspicuous consumption, a bravura tradition that extends from Hals through de Kooning. By comparison, the look of Warhol's 1960s paintings was often of lower-income austerity and dreariness, of Brillo boxes and Campbell's soup cans, of the faces of criminals, innocent victims, or remote superstars who could barely sparkle through the smeared newsprint. On more than one level, Warhol had wrapped up two decades for our social time capsule.

But however time-bound these portraits of the 1970s may be, they also belong to a venerable international tradition that had its heyday in the late nineteenth century. In the familiar way that new art alters our perception of old art, Warhol's society portraits may have given a fresh lease on life to the achievement of those moneyed, high-fashion portraitists who, at the turn of the last century, were feted as honored guests in the drawing rooms and villas of the fabled patrons whom they also painted.[2] This lustrous roster can count as members the Italian Giovanni Boldini, the Spaniard Joaquín Sorolla, the Swede Anders Zorn, the American John Singer Sargent, the Frenchmen Jules Clairin and Jacques-Émile Blanche, and hordes of others who aspired to be accepted as equals in the company of Sarah Bernhardt and Ellen Terry, Marcel Proust and Henry James, Isabella Stewart Gardner and Mrs. Potter Palmer. The Warholian connections here are not only social but aesthetic. In a typical Boldini portrait, that of Mme. Charles Max of 1896 (fig. 127), the truths of physiognomy, of mannered gesture, and designer clothing are first seized but then submerged under a pictorial veil

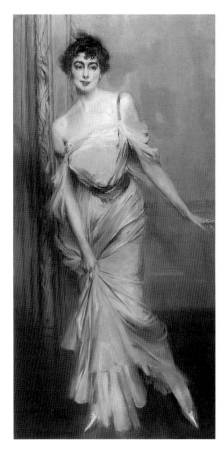

127.
Giovanni Boldini,
Portrait of Mme. Charles Max,
1896

of artifices, which here include bravura brushstrokes that evoke the most supple human animation but are then contradicted by grisaille tonalities that immobilize the sitter in an environment of chilly aristocracy.

That Warhol himself is hardly unaware of this tradition is evident in, for instance, his choices for the "Raid the Icebox" exhibition held (1969–70) at the Rhode Island School of Design in Providence, where he was allowed to select a show from the storage vaults and came up with, among other things, some late-nineteenth-century American examples of this elegant, brushy portrait tradition by William Merritt Chase and Frank Benson, as well as sterner royal prototypes from earlier decades, such as Joseph Paelinck's state portraits of King William and Queen Hortense, the Napoleonic rulers of the Dutch Netherlands. (It should be no surprise either that Warhol's 1978 auction-purchases included first-class replicas of Allan Ramsay's full-length coronation portraits of King George III and Queen Charlotte, which, like many official royal portraits of the eighteenth and nineteenth centuries, were turned out by highly skilled assistants in the artist's studio as multiples for wider image distribution. As usual, Warhol had shrewd intuitions about his own art-historical pedigree.)

If it is instantly clear that Warhol has revived the visual crackle, glitter, and chic of older traditions of society portraiture, it may be less obvious that despite his legendary indif-

ference to human facts, he has also captured an incredible range of psychological insights among his sitters. From the utter vacuity of the camera-oriented smile of the wife of an international banker to the startling disclosures of moods fit for a private diary, these painting-snapshots add up to a *Human Comedy* for our time, in which pictorial surface and psychological probing are combined in differing proportions and in which the very existence of not one but two or more variations on the same photographic fact adds to the complex shuffle of artistic fictions and emotional truths.

Take the pair of Liza Minnelli portraits. What we may first see is how a familiar face is flattened to extinction by the blinding glare of a flashbulb or by the cosmetic mask of lip gloss, hair lacquer, mascara. Almost like Manet in *Olympia,* Warhol has here retouched reality to push his pictorial facts to a two-dimensional extreme. Middle values vanish (the nose and shoulders are swiftly ironed out to the flatness of paint and canvas), and we are left with so shrill and abrupt a juxtaposition of light and dark that Courbet's quip about *Olympia*'s resemblance to the Queen of Spades might be repeated here. But as in *Olympia,* this insistent material facade of opaque, unshadowed paint cannot annihilate a psychological presence. From behind this brash silhouette, a pair of all too human, almost tearful eyes return our gaze.

Or take the portraits of Ivan and Marilynn Karp. Even if we don't know that Ivan, the art dealer, thinks, moves, and talks faster and clearer than most of us mortals, Warhol has told us all by fixing a momentarily steady gaze, in synch with the cool puff of a cigar amid a nervous flutter of brushwork that first dissolves the hand and then leaves centrifugal traces of wiggling, linear energy at the edges of hair, shoulder, lapel. As for his wife, Marilynn, a counterpersonality is instantly indicated by Warhol's revival, so frequent in these portraits, of Picasso's use of a profile on a frontal view to evoke an external-internal dialogue with the more concealed recess of psychology. Here, the furtive glance of the pink profile, underscored by a stroke of blue eye shadow, is given even greater emotional resonance by the murky glimpse of the far side of the face, which anxiously meets our gaze from the deepest shadows.

The range of human revelation, both of public and private personality, is no less dazzling in these portraits than their seductive surfaces. (For comparison, one might check the inert products of an imitator like Rodney Buice, who uses the Warhol formula for everyone from Arnold Schwarzenegger to Prince Charles.) Here are Leo Castelli, at his dapper and urbane best; Alexandre Iolas, in an intimate glimmer of frightening vulnerability worthy of the portrait of Dorian Gray; Brooke Hayward, at once ravishingly worldly and devastatingly innocent; Carolina Herrera, a queen tigress among tiger-women; Henry Geldzahler, his cigar and elusive gaze forever poised for public view; Sofu Teshigahara, in a cool flash of yen-to-dollar business acumen; David Hockney, with that beguiling shock of blond hair above a lovably callow face; Marella Agnelli, a living embodiment of patrician elegance and hauteur; and Norman Fisher, as a bone-chilling phantom, a white-on-black negative image all too grimly appropriate to a posthumous portrait of a snuffed-out life.

Even when Warhol leaves, from time to time, the jet-set world of art, business, fashion, the results are equally incisive. It is something of a miracle that a contemporary Western artist could seize, as Warhol has, the Olympian Big Brother image of Mao Tse-tung (fig. 128). In a quartet of canvases huge enough to catch one's eye at the Workers' Stadium in Peking, Warhol has located the chairman in some otherworldly blue heaven, a secular deity of stag-

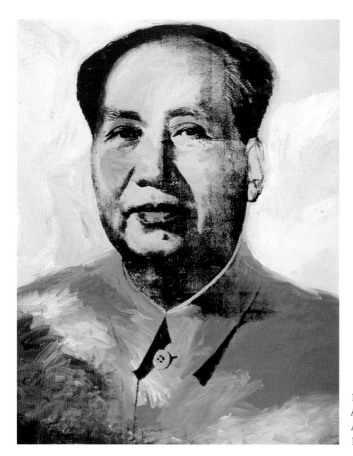

128.
Andy Warhol,
Mao,
1973

gering dimensions who calmly and omnipotently watches over us earthlings. Not since the days of rendering Napoleon as God or Jupiter has an artist come to successful grips with the frighteningly serene and remote authority of the leader of a modern totalitarian state. One need only look at Warhol's cornily matter-of-fact portrait of the all too earthbound and fallible Gerald Ford and Jimmy Carter to realize how much has been said.

At the opposite end of Mao's daunting image of inscrutable power, the posthumous portraits of Julia Warhola, the artist's mother, cast an alien spell. That she has gained access at all to this International Portrait Gallery may not be so surprising when one remembers that another famous artist-dandy, Whistler, could paint, almost as pendants, portraits of both his mother and Thomas Carlyle, as if the sitters' human realities were secondary to the decorative reality asserted by the artist's titles, *Arrangement in Grey and Black, Nos. 1 and 2.* But if Warhol's aestheticism is often close to that of the nineteenth century, implying that all is sheer surface and that art levels out the distinction between great men and flower arrangement, here, with Julia Warhola, the posture cracks. For beneath these virtuoso variations there presides in both clear focus and ghostly fade-outs a photographic image of a bespectacled old lady, the artist's mother, a haunting memory at once close and distant. In the midst of this racy and ephemeral company of *Women's Wear Daily* and *Interview,* her glamourless

countenance is all the more heart-tugging, an enduring and poignant remembrance of family things past. She reminds us of the last thing we expected to think about in Warhol's fashionable Hall of 1970s Fame: that art and life, personal and public history may overlap, but, in the end, are very different things.

ANDY WARHOL: PORTRAIT OF THE 80S A POSTSCRIPT

1993

The magic of numbers would give every decade its period stamp, a rule proved by the above essay. Completed at the very end of the 1970s, in time for the opening, on November 20, 1979, of the Whitney Museum's "Andy Warhol: Portraits of the 70s" show, it was meant to wrap up a distinct phase in the artist's career as a portraitist, mirroring what seemed, after the 1960s, a clear change in style, sitter, and finances, whether viewed as art or as social history. Who could have guessed then what Warhol's portraits of the 1980s might look like, and who would have dreamed that for him, the eighties would come to an abrupt conclusion on February 22, 1987, when a ridiculous hospital botch took his life?

Now, in 1993, on the occasion of this new and, alas, posthumous publication, I want to add a few thoughts about what turned out sadly to be the final seven years of Warhol's portraiture. Was it only the seventies extended or were there also some new winds blowing? To be sure, his roster of celebrities—rock stars, glamour-pusses, jet-setting artists, even royalty— went on soaring to ever loftier international heights, mirroring, as was always the case with Warhol, the rich, the famous, and the universally popular and creating a silkscreened version of *People Magazine.* As before, the flashbulb images of superstar sex goddesses of every stripe, from motherly (Dolly Parton) to femme fatale (Joan Collins, Grace Jones), were distilled to satiric, artificial essences, leaving us awash in a kissing-distance sea of fake hair, lipstick, mascara. And with his unerring sense of social pecking order, Warhol even got to the ultimate top, meeting the most daunting of court-portraitist challenges—Prince Charles and Princess Diana—by keeping us at a humble, ground-hugging distance as we look way, way up past the royal jewels, the gilt, the venerable insignia in order to catch a glimpse of indifferent gazes leveled at aristocratic altitudes far above our heads. (Here, Warhol seems to have learned quite a few useful tricks from the fine copies of Allan Ramsay's coronation portraits of King George III and Queen Charlotte that he bought in 1978.) And speaking of dynasties and history, the growing retrospection of the 1980s also cast its rear-view shadows on Warhol's portraiture, with many resurrections of the faces of the dead and the great added to the icons of those who were famous for only fifteen minutes. His new inventory included, among many others, Lenin, Hermann Hesse, the series Ten Portraits of Jews in the 20th Century (ranging from Freud to Groucho Marx), and even went back to towering giants born too early for the age of photography, such as Beethoven and Goethe, whose likeness Warhol had to reincarnate not from a Polaroid but from the German painter Wilhelm Tischbein's textbook portrait of the writer.

But despite this encyclopedic expansion into past celebrity, Warhol's grasp on the present never loosened, adding, for instance, to his *Who's Who in Art* such new stars as Francesco Clemente, captured with European, fashion-plate elegance, and Julian Schnabel, documented as a scrapbook image of grass-roots American machismo. Yet even dealing with the present tense, Warhol's new portrait gallery of the 1980s turns out in retrospect to have a peculiarly melancholic cast that joins in memory the sudden disappearance of the artist himself. Whether maturely or prematurely, a startling number of Warhol's sitters of the eighties, especially from the art world, died only years after he pinpointed their young or old faces. Both Georgia O'Keeffe and Joseph Beuys died in 1986, six years after Warhol had had his say about their shamanlike features; and in the world of drugs and AIDS, grimly topical in the 1980s, Warhol's eerily prescient obituaries include his youthful painter-buddies Jean-Michel Basquiat and Keith Haring, as well as Rudolf Nureyev. These pictorial tombstones remind us not only of fame, one of Warhol's constant motifs, but of death, a no less persistent presence in his life and work.

"Andy Warhol, Court Painter to the 70s." Published in David Whitney, ed., *Andy Warhol: Portraits of the 70s* (New York: Whitney Museum of American Art, 1979), pp. 9–20. Reprinted, with the addition of the postscript "Andy Warhol: Portraits of the 80s: A Postscript," in Henry Geldzahler and Robert Rosenblum with Vincent Fremont and Leon Paroissien, *Andy Warhol: Portraits of the Seventies and Eighties* (London: Anthony d'Offay Gallery, in association with Thames and Hudson, 1993), pp. 139–53.

1. Richard Morphet, "The Modernity of Late Sickert," *Studio International* (July–August 1975), pp. 35–38.
2. Warhol's relation to this tradition of upper-class portraiture has already been pointed out in David Bourdon's excellent and informative article, "Andy and the Society Icon," *Art in America* 63, no.1 (January–February 1975), pp. 42–45.

WARHOL AS ART HISTORY

1989

D espite his maxim, Andy Warhol's own fame has far outlasted the fifteen minutes he allotted to everyone else. During the last quarter-century of his life, from 1962 to 1987, he had already been elevated to the timeless and spaceless realm of a modern mythology that he himself both created and mirrored. And now that he is gone, the victim of a preposterously unnecessary mishap, the fictions of his persona and the facts of his art still loom large in some remote, but ever-present, pantheon of twentieth-century deities.

On the popular level alone, the evidence for his secular sainthood is everywhere. What other artist could have covered the entire front page of the *New York Post* not once, but twice? (On June 4, 1968, the day after he almost died; and on February 23, 1987, the day after he did die.) For how many others do we remember the exact moment and place we first received the jolting news of their untimely death, as if it were a personal trauma? (If we are old enough, for Marilyn Monroe, John F. Kennedy, and Elvis Presley—all, ironically, Warhol subjects.) Like Marilyn and Elvis, Andy, too, was referred to and recognized by his first name alone, a modern variation upon the affectionate, prayerful ways classical gods or Christian saints could be addressed, beings both close to our hearts and close to heaven. And in more earthly terms, who but Warhol could have inspired, just after his death, a limited edition of 2,500 counterfeit commemorative postage stamps, privately printed in Paris by Michel Hosszù, then affixed to letters sent all over our planet, and honored, albeit illegally, by countless postal clerks who apparently recognized the image of Warhol's 1967 *Self-Portrait* and his name and dates inscribed below?[1] And in these days of *glasnost,* what better relic of Western modernity could be treasured by a willfully hip young Muscovite painter and rock musician than a can of Campbell's tomato soup with a mock Warhol signature?[2]

Warhol's lofty role in our modern Olympus is recognized not only by the world at large but by his own artist-contemporaries, young and old, at home and abroad. Two examples of the many symbolic portraits of Warhol poignantly bracket the date of his death. The earlier one, painted in 1986, the last full year of Warhol's life, is by the Italian Neo-Neoclassicist Carlo Maria Mariani and represents him as a resurrected Davidian image of Napoleon as emperor (fig. 129). Bewigged, cloaked in ermine, decorated with imperial eagles, and holding a laurel-wreath crown, Warhol gazes sternly down at us. Even within the context of Mariani's other allegorical portraits of artists, which include mythic re-creations of Francesco Clemente, Jasper Johns, and Julian Schnabel, Warhol is clearly the reigning deity, as the painting's golden tonality affirms.[3]

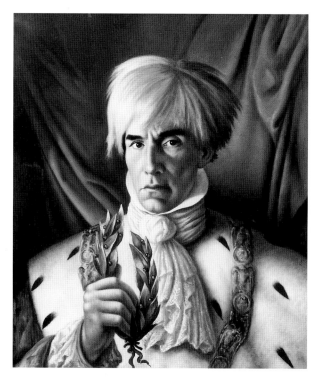

129.
Carlo Maria Mariani,
*Solemnis Caerimonia:
Andy Warhol,*
1986

The later example, painted in 1987, is by the American artist-duo David McDermott and Peter McGough (fig. 130). Working here in their Neo-Victorian mode, they offer a memorial tribute to the just-deceased Warhol that would take him and us on a time-trip to exactly a century ago, when his Christian name would have been properly recorded as Andrew, not Andy, and his dates given as 1828–1887. A winged putto, seated on a crescent moon inscribed in a star-studded globe, mourns the passing of this many-faceted genius whose multiple accomplishments, radiating outward from this heavenly sphere, are defined in eight Victorian categories: ART, MUSIC, JOURNALISM, THEATRE, SOCIETY, PHOTOGRAPHY, PHILOSOPHY, LITERATURE. (To avoid anachronism, FILM is not included.)

Moreover, Warhol's universality in the art world united the conventional factions of modernist and avant-garde versus conservative or hopelessly square. Just as he exhibited with LeRoy Neiman and with Jamie Wyeth (who painted Warhol's portrait, as Warhol painted his, in 1975),[4] so, too, could he join forces in 1984 on the same canvas as Jean-Michel Basquiat, thereby covering all bases and toppling all hierarchies of elite and populist image-making. Similarly, although museums of conventionally "modern" art throughout the world have collected and exhibited his work, Warhol was equally at home with the more neoconservative or, put more positively, postmodernist establishment. After all, the New York Academy of Art, which opened in 1980 to promote the revival of traditional instruction in drawing from life models and plaster casts, can claim Warhol as one of its founding board members.

As for Warhol's own images, from the beginning, they have nourished not only the vast public domain of everything from advertising to gingerbread cookies (as baked in New York by

130.
David McDermott
and Peter McGough,
*Andy Warhol:
In Memoriam, 1987,*
1987

Patti Paige in the form of Brillo boxes or Campbell's soup cans), but—the sincerest form of flattery—the work of other artists. As early as 1963, Bill Anthony offered a penciled gloss on a then one-year-old *Campbell's Soup Can* that was clearly an instant icon (fig. 131); and thereafter, not only have fashionable commercial portraitists like Rodney Buice imitated Warhol's formulas (as in a multiple portrait he did of Prince Charles in 1976) but on more conceptually elevated levels, his art has been appropriated and simulated by, among others, Elaine Sturtevant, Richard Pettibone, Mike Bidlo, and his sometime alter ego, Allen Midgette (who impersonated Warhol on lecture tours in the sixties). And, as another memorial tribute to Warhol, Mark Lancaster exhibited in London in 1988 over 179 historicizing variations on the theme of the master's now classic image of Marilyn Monroe (fig. 132). Small wonder, then, that the word *Warholism,* originally coined in 1965 to deride the artist's seeming indifference to traditional values,[5] may have become indispensable in defining the ever-expanding mythological mixture of art and public notoriety with which he created, after 1962, a new empire that, in retrospect, may make the last quarter-century be known as the Age of Warhol.

By now, in fact, the phenomenon of Warholism has covered so many different territories—from the populist to the elite, from old-fashioned drawing on paper to films, performance art, and globally recognized logos—that no single view of Warhol ever seems adequate. Hearing about this or that symposium on Warhol (and since his death, such events have proliferated), one can barely guess which cast of characters will speak on what wild variety of topics. Indeed, Warhol may end up rivaling Picasso himself in providing to all comers the most daunting breadth of approaches.

131.
William Anthony,
Campbell's Soup Can,
1963

132.
Mark Lancaster,
Marilyn, Sept. 7th, 1987,
1987

For one thing, the subject matter of his work, now that we are beginning to see it in full retrospect, covers so encyclopedic a scope of twentieth-century history and imagery that, in this alone, it demands unusual attention. To be sure, in the early sixties, his work could be sheltered under the Pop umbrella shared by Roy Lichtenstein, James Rosenquist, Tom Wesselmann, and others, joining these contemporaries in what can now be seen more clearly as an effort to re-Americanize American art[6] after a period of Abstract Expressionist universals that renounced the space-time coordinates of the contemporary world in favor of some mythic, primordial realm. Within this domain, Warhol quickly emerged as a leader, choosing the grittiest, tackiest, and most commonplace facts of visual pollution in America that would make the aesthetes and mythmakers of the fifties cringe in their ivory towers: advertisements for wigs, trusses, nose jobs, cut-rate appliances; a comic-strip repertoire that ran through Superman, Dick Tracy, Nancy, and Popeye; packaged food from the lowest-priced supermarket shelves with grass-roots brand names like Campbell's, Mott's, Kellogg's, Del Monte, Coca-Cola; American money, postage stamps, and bonus gift stamps; vulgar tabloids (*Daily News* and *New York Post*); the most popular stars, from James Dean and Elvis Presley to Elizabeth Taylor and Marlon Brando.

This alone, if only in terms of inventory, would have been enough to make him the king of Pop art. But what is less obvious is how Warhol's initial inventory of ugly, counter-aesthetic Americana expanded to unexpected dimensions. Looking back at his entire output, the sheer range of his subjects becomes not only international (indeed, universal in its concern with death) but mind-boggling in its journalistic sweep. What other modern artist's work comes so close to providing a virtual history of the world in the last quarter-century? In terms of the role of the artist as chronicler of his times, Édouard Manet, a full century before Warhol, might be something of a contender. Recording cross-sections of both the lowest and the highest strata of Parisian society, from beggars to fashion plates, as seen in the streets, in cafés, in parks, or in bed, he painted and drew portraits of every kind of celebrity, starting with the world of his fellow artists (Monet, Morisot, Desboutin), and continuing into literature (Baudelaire, Poe, Zola, Mallarmé, George Moore), politics (Rochefort, Clemenceau), the art establishment (Duret, Antonin Proust), and the stage (Lola de Valence, Faure, Rivière). He also depicted front-page events that ranged from the American Civil War and an execution in Mexico to the barricaded streets of Paris under the Commune and the escape of a leftist politician from a penal colony in New Caledonia, and even threw in, as Warhol would, several disturbingly poker-faced Christian subjects viewed, along with pampered dogs and high-style costume, from the most secular of modern societies. Picasso, too, cut a wide swath, commenting directly or indirectly on every war he lived through, and leaving us a portrait gallery of twentieth-century pioneers, from Gertrude Stein and Igor Stravinsky all the way to Stalin. But Warhol's art is itself like a March of Time newsreel, an abbreviated visual anthology of the most conspicuous headlines, personalities, mythic creatures, edibles, tragedies, artworks, even ecological problems of recent decades. If nothing were to remain of the years from 1962 to 1987 but a Warhol retrospective, future historians and archaeologists would have a fuller time capsule to work with than that offered by any other artist of the period. With infinitely more speed and wallop than a complete run of the *New York Times* on microfilm, or even twenty-five leather-bound years of *Time* magazine (for which, in fact, he did

several covers),[7] Warhol's work provides an instantly intelligible chronicle of what mattered most to most people, from the suicide of Marilyn Monroe to the ascendancy of Red China, as well as endless grist for the mills of cultural speculation about issues ranging from post-Hiroshima attitudes toward death and disaster to the accelerating threat of mechanized, multiple-image reproduction to our still-clinging, old-fashioned faith (both commercial and aesthetic) in handmade, unique originals.

The diversity of Warhol's subject matter is staggering, embracing the kind of panoramic wholeness aspired to in John Dos Passos's *U.S.A.,* a literary trilogy of the thirties that covered the first three decades of our century's history. As for people alone, almost everybody is there: a generic *American Man—Watson Powell* and the *Thirteen Most Wanted Men*; artists like Robert Rauschenberg, Frank Stella, Joseph Beuys, and David Hockney; stars like Elizabeth Taylor and Mick Jagger, statesmen like Chairman Mao and President Nixon, sports champions like Muhammad Ali, and literary celebrities like Truman Capote. But this encyclopedic Who's Who is only one facet, if a major one, of Warhol's vast image bank of our age. There is a documentary history of modern catastrophes, both man-made and natural, like the jet crash reported on June 4, 1962, which took 129 lives, or the Neapolitan earthquake of November 23, 1980, which may have taken some ten thousand lives. There are inventories of modern ways of death, whether by such lethal commonplaces as knives and revolvers, car crashes, leaps from high-rise buildings, and canned-food poisoning, or by such specialized technological horrors as the atom bomb and the electric chair. There are anthologies of endangered species, both human (the American Indian) and animal (the giant panda and the Siberian tiger), that right-thinking people concerned with our planet's natural, social, and economic history worry about; and there is a pantheon of mythic beings, from Santa Claus and Dracula to Uncle Sam and Mickey Mouse, that both right- and wrong-thinking people the world over simply know about, much as they would recognize Warhol's international symbols culled from art, money, and politics: *The Last Supper,* the dollar sign, the hammer and sickle. And if one includes the hundreds of even-handed, seemingly effortless drawings that Warhol quietly and continuously produced from the fifties to the eighties, the range of his imagery is infinitely amplified, taking in Christ and Buddha, gay sex and breast-feeding.

Even when looked at in terms of more venerable hierarchies of subject matter, Warhol covers all bases. Although, by earlier standards, he might be classified primarily as a history painter and portraitist, he ventured into other traditional territories as well, translating them into his own language, which as often as not means the language of our times. For instance, he occasionally tried his hand at still life, updating age-old conventions with Space Fruit or an after-the-party mess of empty glasses and bottles, and even metamorphosing flower painting into a repeat pattern of poppy emblems (taken from a photograph) that could be expanded from the dimensions of easel painting to floor-to-ceiling coverage. He could rejuvenate moribund landscape formulas through the mythic American idylls reproduced in do-it-yourself paint books or by suddenly reviving the unlikely theme of Mount Vesuvius in eruption (fig. 133),[8] once a major motif in Romantic nature painting; and he could even venture into animal painting, at times perpetuating earlier traditions with intimate portraits of his own and other people's pet dogs and cats and at times shaking up these traditions drastically, as in his

133.
Andy Warhol,
Vesuvius,
1985

wallpaper pattern of the head of a totally vacuous cow, the most unexpected postscript to the Western pastoral convention of cattle grazing in a landscape.

This remarkable breadth might in itself be enough to make Warhol a singular artist of our century, a strange hybrid of major journalist, chronicling the broadest spectrum of public experience, and media master, who can be at once painter, photographer, draftsman, decorator, sculptor, filmmaker, and illustrator. But it also turns out, looking ahead and back across the decades, that Warhol, essential to any account of Pop culture, commands fully as much attention within the more elite world of high art.

From the sixties to the very last months of his life, Warhol's art, in fact, constantly intersected the major concerns of other artists—seniors, contemporaries, and juniors—casting its glance not only backward to the now remote world of Ad Reinhardt and Mark Rothko but forward to the most youthful activities of the eighties, from the making of art based on reproductions of reproductions, as in the work of Sherrie Levine or Mike Bidlo, to the bald use, in both two and three dimensions, of the most ordinary imagery and commodities from the world of commerce and advertising, as in the work of Jeff Koons or Haim Steinbach. To be sure, in the sixties, when the initial impact of Pop art appeared to threaten the fortified towers of abstract art with a bombardment of visual and cultural pollution, Warhol, like Lichtenstein, was seen on the other side of an unbridgeable gulf that separated a faith in aesthetic purity from the vulgar reality of the life outside the studio door. But in retrospect, this black-and-white antagonism, like the Classic Romantic, Ingres–Delacroix polarity of the 1820s, has grayed and become a larger whole, making it possible to see forest as well as trees, to see how Warhol, for instance, fully participated in the structural changes conventionally associated with the march of formalist innovation from the late fifties onward.

Already in the sixties, in fact, critics began to notice how Warhol, despite the seeming heresies of Pop imagery, could be located on both sides of the high-art/low-art tracks.[9] In

1968, for instance, John Coplans traced in an exhibition and more expansive catalogue the important genealogical table of serial imagery in modern art from Monet and Mondrian through Reinhardt and Stella, and concluded with Warhol, whose Campbell's Soup Cans and Marilyns may at first have looked like illegitimate heirs in this noble modernist ancestry, but gradually settled firmly into historical place.[10] Typically, Warhol himself, with his customary no-nonsense succinctness (often worthy of Gertrude Stein), later declared his allegiance to this exalted and primarily abstract tradition by claiming, "I like Reinhardt when he began painting those black paintings and they were all the same black paintings."[11] Within this context, we might note, too, how not only Reinhardt's repetitive, rectilinear blackness could provide foundations for Warhol's own version of serial monotony, but how even Rothko's procedures might also be invoked as a precedent from the fifties. For just as Rothko would prune his pictorial world down to the most elemental, head-on format of a few hovering planes, released from the laws of gravity, and then complicate this image with infinitely nuanced chromatic combinations, so, too, would Warhol take his disembodied soup cans, floating frontally on an abstract ground, and embellish their initial fidelity to the crude factory colors of the original product with a series of lurid variations upon a new Day-Glo spectrum of artificial hues, from torrid orange to sultry purple.

In the seventies, another of Warhol's characteristic devices, the grid, generally used by him to evoke impersonal, belt-line replication, began to be recognized and included in rigorous discussions of this format in primarily abstract art, first by John Elderfield[12] and then by Rosalind Krauss,[13] both of whom located Warhol within the more cerebral company of artists like Agnes Martin, Kenneth Noland, and Sol LeWitt. And even more broadly, seeing the aesthetic skeleton as well as the cultural flesh of Warhol's art, Richard Morphet, in 1971, caught Warhol in a wide net of American abstract artists, quickly suggesting many analogies between the variety of structures characteristically employed by Warhol and those explored by artists ranging from Reinhardt and Kelly, Stella and Andre, Judd and Morris, all the way to LeWitt and his wall drawings.[14]

Now, almost two decades later, when the first battles between Pop and abstract art may seem as remote as our century's earlier theoretical conflicts between the partisans of Cubism and the supporters of pure abstraction, such affinities between Warhol's work of the sixties and that of his contemporaries have become far more apparent, to the point where he now looms large as one of the major formal innovators of the period. For instance, he shares with Johns, Lichtenstein, and Stella an attraction to what might be called a bifocal composition, that is, one that obliges the spectator to look side by side, or above and below, at two identical or equally compelling images, whether of the *Mona Lisa,* a car crash, or Marlon Brando. This vision, often transformed literally into a diptych structure, undermines the absolute authority of those unique images so precious to artists of a pre-Warhol era, setting up instead an either/or situation, or else creating a world of multiple replication, where even the artist's self-portrait is doubled as a means of diffusing any one-to-one focus on what might once have been a singular revelation of face and feeling at a particular time and place. In any anthology of this art of the double, so abundant in the late fifties and early sixties (as in Rauschenberg's *Factum I* and *Factum II,* 1957; Johns's Ale Cans, 1960; Lichtenstein's *Step-on Can with Leg,* 1961 [see fig. 118]; and Stella's *Jasper's Dilemma,* 1962–63 [see fig. 107]), Warhol

must play a central role, exploring every aspect of the structure of duplication, from a shoulder-shrugging indifference toward direct, unique experience to a tonic visual assault on what had become a tedious formula of seemingly spontaneous compositions.

As for the latter, Warhol again occupies center stage in the history of Minimalism, first as a master of rock-bottom reduction, which, in the case of the single Campbell's Soup Can or the *Gold Marilyn Monroe* of 1962 (fig. 126), could convey an aura of sanctity; and then as a master of modular repetition, which, in the case of Coca-Cola bottles or air-mail stamps, would evoke the endless monotony of mass production and consumption. It is telling that beyond, or underneath, these rich cultural associations, the structure of Warhol's art bears close affinities to the abstract innovations of such contemporaries as Stella and Andre, much as they look backward to the crossword-puzzle patterns of Johns's Alphabets and Numbers of the mid-fifties. And within this context, it should also be noted that like Andre and Morris, Warhol, in the sixties, often polarized his structures into two compositional extremes: an obsessive order and an equally obsessive disorder. As early as 1962, Warhol could arrange eight-by-twenty-four tidy rows of dollar bills in a perfect grid while, at the same time, he could explode this graph-paper regularity with a total disorder of dozens of dollar bills that seem, like a dropped deck of cards, to have landed all over the surface of the canvas.

The sense of the rigorously disciplined versus the willfully aleatory (to use the buzz-word of the period) was apparent as well in Warhol's three-dimensional art. His *Brillo Box (Soap Pads)* of 1964 (fig. 134), for example, is the supermarket doppelgänger of Judd's and Morris's ideal cubes, a building block of almost sacred, elemental clarity. Replicated in more secular quantities, however, and piled up not in neat rows but haphazardly stacked at casual heights and angles, as they were in their first installation at the Stable Gallery in 1964, they subvert their inherent geometries. It is a dialogue of extreme contradiction that was equally explored by Morris and Andre in the sixties, when both artists would switch back and forth

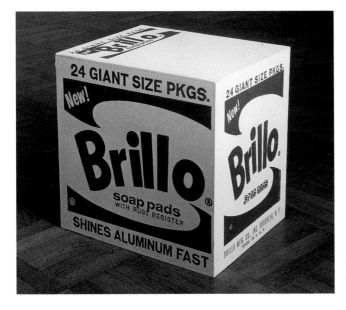

134.
Andy Warhol,
Brillo Box (Soap Pads),
1964

between abstract structures of cerebral purity and an elegant chaos of controlled spill and scatter, as if the theoretical principles of reason and its negation had been isolated in a laboratory and illustrated with palpable forms.

On other levels, too, Warhol's new structures joined forces with the most audacious explorations of the sixties and early seventies. His exhibition of helium-filled Silver Clouds at the Castelli Gallery in 1966, consisting of airborne, ballooning "pillows"—cool but glitzy and festive—once more employed the language of chance and clearly belonged with the kind of imaginative extension of volatile substances as art material that Morris used in his even more ephemeral "steam piece" of 1968–69. And Warhol's Cow Wallpaper, which reached palatial dimensions as the background for the Whitney Museum's installation of his retrospective in 1971, can now be thought of as a counterpart of LeWitt's wall drawings of the early seventies, which similarly disrupted all our deeply ingrained Western assumptions about the proper boundaries of frame and image or the accepted distinctions between primary architectural elements and secondary interior decoration. Moreover, Warhol's accelerating detachment from what to many began to seem an archaic concept of picture-making—a one-to-one, handmade expression of an individual artist's unique craft and sensibility—prophesied many aspects of Conceptual art, in which the artist conceived images whose material execution could be entrusted to other, anonymous hands (as in the case of LeWitt's wall drawings). Indeed, the metamorphosis of Warhol in the sixties from private artist to the head of a factory of art workers who would manufacture his art products is an integral part of the history of the many challenges the seventies offered to those earlier prejudices about art as a sacrosanct avowal of a personal world of touch and feeling, a world that reached its apogee in Abstract Expressionism. Here it should be said, too, that Warhol's devaluation of works of art made solely by the hand of the artist-genius has ample historical precedent, of which Jacques-Louis David's faith in the primacy of his images over his personal facture is the most apt. For instance, not one but two versions of his *Bonaparte at Saint-Bernard* were first exhibited together; and subsequently many copies, mixing in varying proportions his own hand with the work of studio assistants, were made and signed as "Davids," since the image, being his invention, mattered more than the execution.

The importance of Warhol's art in the sixties, whether for the innovations of Pop imagery, new formal structures, or new relationships to second-degree image-making (in the employment of silkscreen techniques and in the faith in photography as the most truthful record of reality for the post-fifties generations nurtured on television) has seldom been doubted, even by his sworn enemies. But it has often been assumed that after the sixties or, with more rhetorical precision, after his near-death in 1968, his art drifted further and further from center stage, catering only to the luxury trade or simply repeating, in ever more diluted form, the once fresh ideas of his youth. In 1979 the Whitney Museum's exhibition of Warhol's portraits of the seventies, a glittering gallery of well-heeled celebrities who filled the pages of *W* and *Vogue,* tended to give most visitors, at least, the idea that Warhol, as a painter, had turned exclusively into a society portraitist—a sensational virtuoso, if one admired the likes of Giovanni Boldini and John Singer Sargent, or a trashy sellout to the jet set, if one still maintained the pre-seventies illusions that artists are beings who should take vows of chastity and poverty.[15] But apart from this specialized exhibition, Warhol's art of the seventies and eight-

ies was surprisingly little seen in the United States, and usually only in erratic presentations of a single series rather than in any cohesive scope.

Now that this huge oeuvre, with its daunting quantity and variety, is at last being sorted out and, as often as not, being seen for the first time, it is slowly becoming clear that Warhol's art after the sixties, far from running on a private and ever more peripheral track, not only intersected the development of his contemporaries (Johns, Lichtenstein, and Stella) but was also concerned with the same issues as any number of younger artists, from David Salle to Philip Taaffe. In formal terms alone, Warhol's art of the seventies and eighties followed general patterns of evolution, from the lean austerity of the early sixties—ascetic in color, sharp in contour, frontal and spaceless in structure—to far more intricate period styles. The passages of bravura brushwork that literally surfaced in the seventies over the silkscreened images below them, shared with Stella and Johns, among others, that growing sense of painterly virtuosity as a kind of homeless, disembodied decoration over a preexistent structure, creating new kinds of spatial layering and transparencies that infinitely complicated the deadpan, frozen lucidity of, say, Johns's first Flags and Targets or Stella's first "stripes." Such visual complexities characterized even more fully Warhol's work of the eighties. For instance, the 1985 paintings of Mount Vesuvius in action[16] were both literally and formally eruptive, centrifugal explosions that would be at home with the most flamboyant Stellas of the same decade. Indeed, Warhol's archetypal forms of the eighties might be the camouflage and Rorschach patterns, ready-made abstractions that provided elaborate surface labyrinths under which a densely concealed imagery could be discerned, the visual opposite of the trumpet-blast clarity of the archetypal soup can of the sixties. In fact, the change from the sixties to the eighties could hardly be seen more clearly than in Warhol's updating of his original Campbell's Soup Cans with a new series of 1985–86 commemorating Campbell's newer product (boxes containing pouches of instant soup) and even some new flavors (Won-Ton).[17] These late images offer infinitely intricate variations on the raw, vintage Warhol of the early sixties, with suggestions of spatial illusion and layering in the compression of the cardboard boxes, with occasional croppings that indicate continuities beyond the frame, with conspicuous off-register disparities between color and enclosing contour, and with hues that deviate totally from the harsh, primary clarity of those now "ancient" soup cans.

But apart from the elaboration of Warhol's visual language, there is also a mood of both personal and public retrospection here, which not only captures the period flavor of the eighties but also belongs to a mode practiced by some of his most eminent contemporaries. The very choice of a newer Campbell's product recalls the way Johns first followed the American flag's change from forty-eight to fifty stars with the addition of Alaska and Hawaii to the Union in 1958 and 1959, and then, much later, reverted to forty-eight stars, as if he were recalling in private meditation an earlier point in his life, in his art, and in public history. These rear-view vistas are, in fact, abundant in late Warhol. He repeated, often with ghostly variations (such as photographic negatives or concealing sweeps of paint), the single images that had made him famous in the early sixties, and he even anthologized his early works in single paintings, thereby selecting what amounts to his own mini-retrospectives. This series, of 1979–80, usually executed on canvases of large dimensions, presents surrogate Warhol shows, compiling, for example, self-portraits, soup cans, cornflake boxes, flowers, cow's heads,

Marilyns, and car crashes. These by now famous Warhol images are often printed backward and/or in black-and-white reversals, which contributes to a phantom mood of floating memory images that confuses both private and public domains. But no less telling is the fact that in the seventies and eighties Stella, Johns, and Lichtenstein all painted comparable anthologies of their own remembrances of art past. Stella will often pick up his own signature motifs from the sixties and quote them in riotous wholes; Lichtenstein, tongue-in-cheek as usual, will populate Matisse-like domestic interiors with a selection of hits from his own past performances; and in the most intensely private, diaristic terms, Johns will also compile fragments of his artistic autobiography (frequently using, like Warhol, such spectral devices as reversals of shape, tone, and color) in the context of solemn meditations on the passage of time and on the grander cycles of life, love, and death.

Such retrospection, to be sure, may be characteristic of many artists as they grow older. Picasso, for one, accumulated in his last decades what seems an infinity of layers of artistic and biographical self-reference. But it should also be noted that Warhol's personal retrospection has a fully public face, typical of the rapidly escalating historicism of the late twentieth century. It is revealing that Warhol's subjects in the sixties were almost all contemporary, culled from the news of the day, the celebrities of the moment, the supermarket shelves around the corner. When he did a series of artists' portraits in 1967, they were not, after all, past heroes like Picasso, Matisse, and Pollock, but rather a selection of his own peers from the Castelli stable—Stella, Bontecou, Rosenquist, Johns, Chamberlain, and Rauschenberg. But by the eighties, Warhol, like everybody else it would seem, began to look constantly backward, conforming to the century's twilight mood of excavating memories. In a decade that is eager to commemorate almost anything that corresponds to historically retrospective round numbers—from the twentieth anniversary of the student revolutions of 1968 to the two-hundredth anniversary of the French Revolution of 1789; from the fiftieth and twenty-fifth anniversaries of the New York World's Fairs of 1939 and 1964, respectively, to the hundredth anniversary of the completion of the Eiffel Tower at the Paris World's Fair of 1889—Warhol, too, kept looking from present to past. As a one-shot commemoration, for instance, he could salute the Brooklyn Bridge when its centennial was celebrated in 1983, or the Statue of Liberty, when it turned one hundred in 1986. And for layered nostalgia, in 1985 he could reproduce modern advertisements that included images from decades past of such now archaic film stars as James Dean, Judy Garland, and Ronald Reagan. But his historical sweep could have epic grandeur as well, continuing in the path of such erratic precedents from the sixties and seventies as Larry Rivers's *History of the Russian Revolution: From Marx to Mayakovsky,* 1965; Gerhard Richter's 1971–72 series of forty-eight portraits of great men of modern history; or Anselm Kiefer's halls of German fame, such as *The Ways of Worldly Wisdom,* of 1976–77 and 1978–80.[18] Warhol, too, began to reach backward in our own century to record, in his later works, such encyclopedically lofty themes as a pantheon of Ten Portraits of Jews in the Twentieth Century (from Sigmund Freud, Albert Einstein, and Franz Kafka to the Marx brothers), a never-completed history of great moments in American television, or, as an industrial commission by Mercedes-Benz, a chronological picture history of its cars, a sequence that provokes the kind of nostalgia we often feel for such forward-looking movements as Futurism.

Here again, Warhol figures large in the mood of the eighties, when the history of art, like the history of everything else, floats about in a disembodied public image-bank where Caravaggio and Schnabel can jostle for equal time in weekly magazines and daily conversations. In this context, Warhol is indispensable to an understanding of the imagery of art about art, or the domain of what is called, more fancily, "simulation" or "appropriation." To be sure, in the sixties, following in the footsteps of Marcel Duchamp (who wanted to desanctify the *Mona Lisa*) and Fernand Léger (who wanted to turn her into a Machine Age product), Warhol took on this art icon, transforming her into a hybrid movie star and dime-store art reproduction in the manner of Rauschenberg's earlier use of the tackiest postage-stamp print of museum masterpieces. But by the eighties, his quotations of earlier art belonged to another frame of reference, a postmodern vision in which any citation from any historical time could turn up in a contemporary context. For example, in 1982, in both paintings and prints, Warhol was able to resurrect, on the one hand, a profile portrait of Alexander the Great to coincide with his historical veneration in an exhibition at the Metropolitan Museum of Art and, on the other, a portrait of Goethe excerpted from the most famous painting of the great man, that by Wilhelm Tischbein.[19] And mirroring the constant buckshot barrage of art-history images that bounces off us daily, Warhol could go on switching channels, usually with a shrewd irony that reflects Lichtenstein's own art-about-art choices, which would single out ostensibly the polar opposite of his own style (the painterly nuance and sensibility of Monet's cathedrals, the strident angst of German Expressionism). It would be hard, for instance, to think of anything less compatible with Warhol's mass-produced imagery than precious details from Quattrocento paintings by Botticelli, Uccello, and Leonardo, but that is what Warhol startled us with in 1984, varying these unique, handmade passages by craftsmen from a remote era of image-making with a shrill rainbow of Day-Glo colors worthy of Stella's comparably extravagant palette of the eighties. And it would be no less difficult to find an artist who, in psychological terms, could better symbolize the denial of Warhol's poker-faced emotional anesthesia than Edvard Munch, whom Warhol nevertheless resurrected by redoing his most unsettling images of fever-pitch hysteria (*The Scream*) and engulfing sexual desire (*Madonna*).

Warhol's canny selections from the data bank of art history also reflected, like Salle's borrowings from Yasuo Kuniyoshi or Reginald Marsh, the revisionist thrust of a postmodernist view of twentieth-century art that would no longer accept the party lines still held in the sixties. Nothing could demonstrate this more acutely than his appropriation of imagery from Giorgio de Chirico in 1982,[20] in exactly the same year that the Museum of Modern Art's retrospective offered the canonic, truncated version of the old master's art, which presumably ended in decades of shame with endlessly diluted replications of his early, epochmaking masterpieces. But Warhol translated the de Chirico story into something appropriate to himself and to the reversals of taste of the last decade, which, in the nostalgic orbit of such three-dimensional re-creations of de Chirico's pictorial theater as architect Charles Moore's Piazza d'Italia in New Orleans (1975–78; see fig. 26), began to value precisely those aspects of layered memory and replication so conspicuous in the artist's paraphrases and self-counterfeits of his own glorious, but remote, historical past. Warhol added new angles to these "Chinese boxes," replicating de Chirico's own replications of his earlier works, such as *The Disquieting Muses* (see fig. 27) and *Hector and Andromache,* and thereby shuffling in this

Pirandellian way not only artistic identities, but early and late dates, originals and reproductions.[21] Warhol could also share the eighties' taste for treating abstraction as a kind of *objet trouvé,* a phenomenon familiar to the work of, say, Salle and Taaffe, who can approach the widest vocabulary of abstract imagery—from Jean-Paul Riopelle and Barnett Newman to Ad Reinhardt and Bridget Riley—as if it were simply part of, and interchangeable with, the rest of the visual data around us. In Warhol's case, however, this attraction to what might be called "ready-made abstraction" occurs in a more public and accidental domain: the usually unheeded abstractions created by cast shadows, by the Pollock-like aftermath of urinating,[22] by the elaborate visual subterfuge of camouflage patterns or Rorschach tests. And in his last years Warhol arrived at what now look like, in terms of religion and art history, the ultimate appropriations, the supreme Christian icons of Western art that fix forever Jesus and the Virgin—Leonardo's *Last Supper* and Raphael's *Sistine Madonna*—quoted in their entirety and in parts, and reaching at times vast pictorial dimensions that, like Schnabel's inflated, scavenged images, echo with a death-rattle irony the mural ambitions and achievements of Renaissance frescoes and altarpieces.

Warhol's connections with art history, however, are not only those of the eighties' quotation-mark eclecticism explored by many of his lively younger contemporaries, but also those of more resonant connections that conjure up a wide range of ancestral charts. In nationalistic terms, Warhol, like Lichtenstein, can stir up a protohistory of Pop art in America between the two world wars. His now famous paintings that replicate the front pages of the newspapers—which extended from the *Daily News,* the *New York Post,* and the *New York Mirror,* of 1961–62, to *Il Mattino* of Naples, of 1981[23]—have been shown to have a fascinating prototype in a ballet set by Gerald Murphy of 1923 for *Within the Quota* (fig. 135).[24] It is within this territory of twenties American modernism that many other Pop previews can be glimpsed, of which the richest may be a small canvas by Stuart Davis, *Lucky Strike*

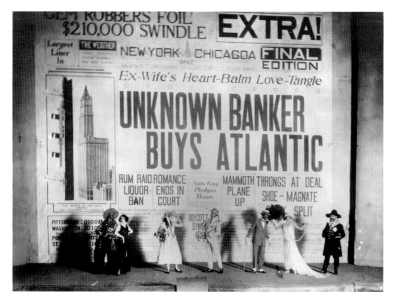

135.
Performance of
Within the Quota,
Théâtre des
Champs-Élysées, Paris,
1923

136.
Stuart Davis,
Lucky Strike,
1924

(fig. 136), now impossible to look at without Warhol's as well as Lichtenstein's instant inter-
vention.[25] For here, in 1924, Davis compiled a virtual inventory of exactly the same kind
of would-be shocking anti-art objects and shocking anti-art style that launched Warhol in
1961–62: the full expanse of newspaper front page (that of the *Evening Journal* sports sec-
tion, which includes a cartoon, complete with dialogue-filled balloons), and a still life of pack-
aged smoking products, from Lucky Strike roll-cut tobacco to Zig Zag cigarette paper, which
replicate the typefaces and logos of their commercial wrappings.

However, such foreshadowings of American Pop have, like Davis and Murphy them-
selves, a widening international dimension, and European Cubism and Dada can also disclose
a multitude of Warhol look-alikes that provide him with a more cosmopolitan pedigree, albeit
one that still has American roots.[26] It was, after all, an American product, a box of Quaker
Oats cereal, as imported to France, that Juan Gris carefully reproduced (including the car-
toonlike emblem of William Penn on the label) in a Cubist still life of 1915 (fig. 137). And it
was the milieu of New York and American mechanical products that excited the Dadaist spirit
of Francis Picabia (whose work caught Warhol's eye)[27] to create, in 1915, such sexually sym-
bolic Machine Age portraits as that of a spark plug representing an American girl in a state of
nudity (see fig. 145) or a flashlight representing a phallic Max Jacob, a prophecy, incidentally,
of the more cryptically erotic implications of Johns's flashlight imagery.[28] In both of these
heretical images from the pages of the magazine *291,* Picabia not only embraced the kind of
ordinary, Machine Age object familiar to the Warhol–Lichtenstein repertoire of the early sixties
but, as much to the point, depicted these mundane appliances to the language of the com-
mercial illustrator, flattening them, clarifying them, and isolating them like disembodied icons
against a totally blank, spaceless ground. Such weightless and homeless relics of our machine
age, seen without context and appropriately rendered in the visual vocabulary of an anonymous
image-maker in a technological civilization, again strike Warholian chords of recognition.

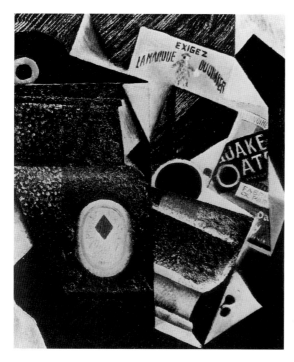

137.
Juan Gris,
Le Paquet de Quaker Oats,
1915

There are more offbeat areas of twentieth-century art as well that have become rec-
ognized as proto-Warhol territory, most particularly, as already noted by Richard Morphet,[29]
the later portraits and news images of the British artist Walter Sickert, whose work, whether
early, middle, or late, still remains unfamiliar to American audiences. From the twenties on,
Sickert based many of his paintings on photographs, such as his portrait of Winston Churchill
of about 1927 (fig. 138), first capturing the flashbulb immediacy of a journalistic snapshot and
then embellishing it with the marks of high art, that is, visibly brushed strokes of paint. The
unsettling combination of a reportorial photographic image and the conventions of hand-
made realist painting is one that now prefigures, in many of Sickert's oil paintings of news-
worthy people and events (King George V; Amelia Earhart's airplane landing in London), an
area that Warhol was to stake out for his own, even if, given the low exposure of Sickert's
work outside of England, this must be a question of coincidence.

Such a fusion of artist and reporter, however, has grander roots that, in terms of voyeur-
istic sensibility, lead back to Manet, who, like Warhol, maintained the stance of an aesthete-
observer in the face of any subject, whether a stalk of asparagus or a murder. Flipping through
Manet's oeuvre, one can stumble upon the most unlike coexistences. For instance, in the
early 1880s, he recorded, as Warhol often would do, the fashionable, under-the-table fact of
the silhouettes of a pair of chic, high-heeled shoes (fig. 139), a rapid glimpse of elegant urban
detail that would hardly prepare one for a different kind of look at modern life, a tumbled bed
on which is strewn the corpse of a well-dressed gentleman who, revolver still in hand, has
apparently just killed himself (fig. 140). This morbid vignette, however, is seen through
Manet's familiar screen of protective, aesthetic detachment, a coolly painted figure in an inte-

138.
Walter Sickert,
Sir Winston Spencer Churchill,
c. 1927

139.
Édouard Manet,
At the Café: Study of Legs,
c. 1880

140.
Édouard Manet,
The Suicide,
1877–81

rior that, on the face of it, would elicit a response no different from any of his uneventful domestic scenes or, for that matter, from a lemon or a bouquet of moss roses. Like Warhol, Manet might have shrugged his shoulders while saying, "There's a disaster every day,"[30] pausing perhaps to record the disaster of the day as Warhol paused to record, on the one hand, a man leaping from a high-rise building (fig. 141) and, on the other, a bunch of poppies. The customary accusation that the deadpan coolness of Manet's news-photograph surrogate, *The Execution of Maximilian,* is inadequate as a response to its brutal subject is one that might equally be leveled at Warhol, who also seems to approach the facts of modern death with no apparent shift of emotional tone. And it is revealing as well that Manet could cut up one of his multiple versions of the Execution of Maximilian (as he had earlier cut up his no less nominally horrific scene of death in a bullring) into fragmentary, undramatic parts that totally cancel the would-be shock of the gory narrative. Warhol's use of electric chairs or car crashes as wallpaper-like repeat patterns or as components of larger wholes similarly underscores and contradicts the terror of modern death, the daily statistic that has become so commonplace that the conventional hierarchy of emotional values begins to look like a naive and outmoded support system for cushioning grief and outrage. Following Manet, Warhol would view death as being as ordinary as the front page of the daily newspaper which might one day announce "A Boy for Meg" and another "129 Die in Jet" and as such, demanding, it would seem, an approach no different from the rendering of a dollar bill or a photograph of Elizabeth Taylor. We may all owe a debt to Warhol, as we do to Manet, for reflecting exactly that state of moral and emotional anesthesia which, like it or not, probably tells us more truth about the realities of the modern world than do the rhetorical passions of *Guernica.*

141.
Andy Warhol,
Suicide,
1962

Yet paradoxically, Warhol also clung to what might seem, in the context of the jet-set glamour of his public persona, an archaic piety, maintaining a quiet, surreptitious devotion to the Catholic Church, which had given him spiritual nurture since childhood and which sustained his attraction to the ultimates of life and death. (He was a daily visitor to the church of Saint Vincent Ferrer at Sixty-sixth Street and Lexington Avenue—located almost symbolically, for him, halfway between his town house and the high-society restaurant Mortimer's—and he never stinted on time and money in his efforts to help, with virtual anonymity, the homeless at the Church of the Heavenly Rest on East Ninetieth Street.)[31] If his approach to the most harrowing images of the American way of death at first seems as reportorial as Manet's, the growing dominance of this morbid leitmotif in his work begins, in retrospect, to take on more personal, obsessive dimensions. It is not only a question of murderers at large and electric chairs, but also the apocalyptic vision of the atom bomb and devastating earthquakes. It is not only a question of death on the road or in the air, but of the glaring presence of the skulls and skeletons that haunt all living flesh. Indeed, these constant reminders of our private and public mortality, whether as reportage or through the traditional emblem of the skull, can rival in abundance and impact the persistent theme of death as the overwhelmingly inevitable adversary that casts its dark shadow over the work of Picasso.[32]

No less remarkably, Warhol, presumably the most secular and venal of artists and personalities, has even been able to create disturbing new equivalents for the depiction of the sacred in earlier religious art. His galleries of myths and superstars resemble an anthology of post-Christian saints, just as his renderings of Marilyn's disembodied lips or a single soup can become the icons of a new religion, recalling the fixed isolation of holy relics in an abstract

space. Elsewhere, the mute void and mystery of death are evoked, whether through the use of photographic reversals that turn their already impalpable images into ghostly memories or, most startlingly, through the use of a blank canvas, as in the case of *Blue Electric Chair* (1963), in which a diptych (the form itself recalling an altarpiece) offers, at the left, three times five electric chairs silk-screened in a flat blue plane and, at the right, the same blue ground left numbingly empty.

But there is also the supernatural glitter of celestial splendor, as when the single image of Marilyn Monroe is floated against a gold background, usurping the traditional realm of a Byzantine Madonna. And even the shimmer of diamond dust, redolent of dime-store dreams and the magic sparkle of Wizard-of-Oz footwear, can waft us to unimagined heights, providing for Joseph Beuys an impalpable twinkle of sainthood, like a pulverized halo, or transforming a touristic snapshot of the vertical sweep of Cologne Cathedral's Gothic towers into an exalted vision of Christian eternity. Both ingenuous and shrewd, blasphemous and devout, Warhol not only managed to encompass in his art the most awesome panorama of the material world we all live in, but even gave us unexpected glimpses of our new formsof heaven and hell.

"Warhol as Art History." Published in Kynaston McShine, ed., *Andy Warhol: A Retrospective* (New York: Museum of Modern Art, 1989), pp. 25–37.

1. As reported in *New York Magazine* (February 29, 1988), p. 38. The birth date "1930," printed on the mock stamp, is incorrect.
2. As illustrated and reported in the American Airlines in-flight magazine, *American Way* (May 1, 1988), pp. 66–67.
3. On these portraits, see Carolyn Christov-Bakargiev, "Interview with Carlo Maria Mariani," *Flash Art* (April 1987), pp. 60 ff.
4. For Wyeth's comments on these reciprocal portraits, see Stuart Morgan, Glenn O'Brien, Remo Guidieri, and Robert Becker, "Collaboration Andy Warhol," *Parkett* (1987), pp. 95–96. The exhibitions were "Andy Warhol and Jamie Wyeth: Portraits of Each Other," Coe Kerr Gallery, New York, June 1976; and "LeRoy Neiman, Andy Warhol: An Exhibition of Sports Paintings," Los Angeles Institute of Contemporary Art, 1981.
5. By Max Kozloff. On this, see the doctoral thesis by Patrick S. Smith, *Andy Warhol's Art and Films* (Ann Arbor: UMI Press, 1986), chap. 6.
6. This viewpoint has been brilliantly argued in the book and exhibition catalogue by Sidra Stich, *Made in U.S.A.: An Americanization in Modern Art, the '50s and '60s* (Berkeley: University of California, 1987).
7. See the issues of January 29, 1965, and February 16, 1970.
8. See the exhibition catalogue *Vesuvius by Warhol* (Naples: Fondazione Amelio, 1985).
9. I myself made some preliminary suggestions in this direction in "Pop and Non-Pop: An Essay in Distinction," *Art and Literature* (Summer 1965), pp. 80–93.
10. John Coplans, *Serial Imagery* (Pasadena, Calif.: Pasadena Art Museum, 1968). For Warhol, see pp. 130–37.
11. Quoted in *Warhol's Campbell's Soup Boxes* (Los Angeles: Michael Kohn Gallery, 1986), p. 28.
12. John Elderfield, "Grids," *Artforum* (May 1972), pp. 52–59.
13. Rosalind Krauss, *Grids: Format and Image in 20th Century Art* (New York: Pace Gallery, 1979).
14. See Richard Morphet, "Andy Warhol," in *Warhol* (London: Tate Gallery, 1971), p. 24 ff.
15. I have explored these ideas further in my catalogue essay "Andy Warhol: Court Painter to the 70s," in David Whitney, ed., *Andy Warhol: Portraits of the 70s* (New York: Whitney Museum of American Art 1979).
16. See above, fig. 7 and n. 8. In terms of Warhol's historicism, it should be noted that these paintings provide an unexpected postscript to a long Romantic tradition of depicting the spectacle of Vesuvius in eruption, examples of which are illustrated in the Naples catalogue. Warhol's detached approach to this obviously awesome sight is, incidentally, prophesied by Edgar Degas, who, in a monotype of c. 1890–93, coolly recorded Vesuvius erupting. (See Eugenia Parry Janis, *Degas Monotypes* [Cambridge, Mass.: Fogg Art Museum, 1968], no. 310.)

17. On these, see above, n. 11, which includes a particularly informative essay by Michael Kohn.

18. See Mark Rosenthal, *Anselm Kiefer* (Chicago and Philadelphia: Art Institute of Chicago and Philadelphia Museum of Art, 1987), pp. 49–51, where a parallel with Warhol's celebrity portraits is discussed.

19. For an excellent account of such images in the context of Warhol's history as a printmaker, see Roberta Bernstein, "Warhol as Printmaker," in Frayda Feldman and Jorg Schellman, eds., *Andy Warhol Prints: A Catalogue Raisonné* (New York: Ronald Feldman Fine Arts, Editions Schellmann, and Abbeville Press, 1985), pp. 15–21.

20. See Achille Bonito Oliva, *Warhol verso de Chirico* (Milan: Electa, 1982). (Reprinted in 1985 for Marisa del Re Gallery, New York.)

21. The New York exhibition of this work (1985) received little serious attention, with the important exception of Kim Levin's account, "The Counterfeiters: De Chirico vs. Warhol," *The Village Voice* (May 7, 1985). (Reprinted in *Beyond Modernism: Essays on Art from the '70s and '80s* [New York: Harper and Row, 1988], pp. 251–54.)

22. Carter Ratcliff also discusses these Oxidation paintings as possible spoofs of Jackson Pollock (*Andy Warhol* [New York: Abbeville Press, 1983], p. 94).

23. Warhol replicated the Neapolitan newspaper's front page of November 28, 1980, with the headline FATE PRESTO, referring to the urgency of saving the thousands of victims of the local earthquake.

24. See William Rubin and Carolyn Lanchner, *The Paintings of Gerald Murphy* (New York: Museum of Modern Art, 1974), pp. 24 ff; and Stich, *Made in U.S.A.,* pp. 114–15.

25. Stich (ibid.) was the first, to my knowledge, to publish this particular Davis, as opposed to his other versions of *Lucky Strike* and *Odol,* within a proto-Pop context.

26. I have already suggested this field of inquiry in my essay "Picasso and the Typography of Cubism," in Roland Penrose and John Golding, eds., *Picasso in Retrospect* (New York: Praeger, 1973), especially p. 75; and have amplified it in a lecture, "High Art vs. Low Art: Cubism as Pop," first given at the Hirshhorn Museum and Sculpture Garden, Washington, D.C., on May 11, 1975, in which I elaborated the many proto-Pop aspects of Cubism, ranging from the use of cartoon imagery to the replication of commercial logos.

27. Warhol's own collection included Picabia canvases of 1934 and 1946.

28. For varying interpretations of these works by Picabia, see William Camfield, *Francis Picabia: His Art, Life, and Times* (Princeton: Princeton University Press, 1979), p. 83; and Maria Lluisa Borràs, *Picabia* (New York: Rizzoli, 1985), pp. 155–56.

29. As first suggested in "The Modernity of Late Sickert," *Studio International* (July–August 1975), pp. 35–38; and then further elaborated in my essay on Warhol's portraiture (see above, n. 15, pp. 9–10). For more on Sickert, see the exhibition catalogue *Late Sickert: Paintings 1927 to 1942* (London: Hayward Gallery, 1981–82).

30. See *Warhol's Campbell's Soup Boxes,* p. 28.

31. The most vivid, informative account of the Slavic religious background that permeated Warhol's life is by John Richardson: "The Secret Warhol," *Vanity Fair* (May 1987), pp. 64 ff.

32. Warhol's Skulls, in particular, and his death imagery, in general, were the subjects of a lecture by Trevor Fairbrother given at the Warhol symposium sponsored by the Dia Art Foundation, New York, on April 23, 1988. The proceedings are to be published.

MEL RAMOS: HOW VENUS CAME TO CALIFORNIA
1994

Like Mel Ramos, I've been part of the art world since the late 1950s, only he's been a performer and I a spectator who tries to keep registering what's going on around me. For more than thirty years, I have watched his art evolve; and now, looking back, I'm amazed to realize how, decade after decade, my responses to it keep changing.

First, of course, came the sixties. In tandem with the outrageous young rebels who, beginning full blast in 1962, contaminated the high-minded atmosphere of the New York art world with soup cans, comic strips, movie stars, and billboard ads, Ramos slowly came into focus for me as an artist who was also out to shake up established pieties. Attracted to the rebellious spirit of Pop art and an instant fan of Lichtenstein and Warhol, I had eyes at first only for what I could see at home in New York; but I still remember how, having been shocked and rejuvenated by years of non-stop events that aroused love and hate at the local New York galleries, I stumbled into the Bianchini Gallery one day in 1964 and saw for the first time a bunch of paintings by an artist whose name was then unknown to me, Mel Ramos. I was instantly delighted by this surge of what looked like yet another new kind of insolent vulgarity that might thoroughly dispose of the lofty moral pretensions and ivory-tower elitism of so much New York painting of the fifties. Here, it seemed, Ramos was proposing something even more offensive, if possible, than Popeye and Coca-Cola. As I recall, what I saw was a new race of sun-kissed pin-up girls, their breasts afloat in seas of grapefruit (fig. 142), their torsos welded to an erect banana, their windswept hair streaming against the male wolf-call of the decade, "hubba hubba."

To be sure, the message of the paintings was familiar enough to New York eyes, namely that instead of wearing blinders to the crass realities of the world outside the museum door, we might be better off trying to adapt to these stubborn facts and turn the visual trash into a new kind of beauty. But there was also the unsettling truth that having got accustomed to the new visual language of New York Pop, with its translation of the most tawdry commercial styles into something that began to look astonishingly like real art, I couldn't help feeling that Ramos's paintings were from another planet, one so different that it didn't quite compute in New York.

That planet, of course, was California, which for most New Yorkers is far more extraterrestrial than Europe; and this strange place of origin, in the context of New York Pop, lent Ramos's paintings a remote, sensual flavor, like Paul Gauguin's Tahiti. With their bounties

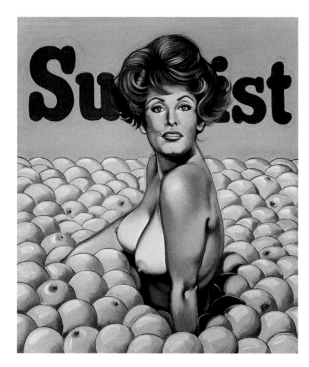

142.
Mel Ramos,
Miss Grapefruit Festival,
1964

of oranges, lemons, grapefruit, and bananas accompanied by such sun-drenched names as Chiquita and Sunkist, these canvases transported me to a tropical Arcadia where, neverthe-less, American commerce and sex could flourish, undisturbed by the weather, grit, and con-tradictions of New York life. The colors themselves were outrageously gorgeous, their synthetic lavenders, chartreuses, and bubble-gum pinks a sensuous rebuttal to the lean-and-mean palette of Roy Lichtenstein and Andy Warhol, who in the early sixties sometimes looked as though they could afford only the coarsest printer's ink primaries, i.e., blacks and whites.

What's more, Ramos's paint surfaces were anathema to the low-budget commercial look of the best New York Pop, offering instead a glistening coat of buttery frosting that seemed to cover the girls with suntan oil and the fruit with a wax preservative. This mix of the seductive and the repellent was similar to certain aspects of New York Pop—to James Rosenquist and Tom Wesselmann, for example—but it was still obvious that Ramos's roots were in the land of the Californian lotus-eaters and that in New York, his pictures looked like exotic intruders.

The more I saw of his work in the sixties, however, the more clearly a picture of him began to emerge for me in both a regional and international context. I became aware, for example, of other California artists, especially from the Bay Area, who made Ramos look a bit less lonely as an occasional reminder of West Coast art. Above all, there was Wayne Thiebaud, whose regimented line-ups of row after row of American junk food were rendered, like Ramos's girls, fruit, and comics, with a jarring combination of the overtly attractive and the covertly ugly, moist surfaces of creamy artifice, offering the visual equivalent of a birthday cake that looked good but tasted awful. I was not surprised to learn, then, that in the fifties

and sixties Ramos had been close to Thiebaud, some fifteen years his senior, and that he had not only taken an art-history course with him but had also traveled several times to New York with him to look at art and to find a gallery to show in. Moreover, Ramos's connections with other artists in the San Francisco region became more clearly discernible, recalling, especially in his dense, brush-marked surfaces and sun-soaked color, aspects of David Park, Richard Diebenkorn, and Nathan Oliveira, all artists who had successfully made the transition to "real" art from commercial art, in which he, like Rosenquist and Warhol, was initially trained. This, at least, provided me with more of a context for Ramos, locating him squarely in California territory.

But even then, in the sixties, when my eyes seldom looked seriously at art made outside Manhattan, I gradually became aware of Ramos's place in a much wider constellation, both national and international. If only in terms of iconographic chronologies in the story of American Pop art, it was a surprise to realize how, even back in 1961, Ramos, quite independently of Warhol and Lichtenstein, was also wrenching the likes of Batman and Superman, not to mention such female counterparts as Phantom Lady and Wonder Woman, from their comic-strip life and plopping them, like icons, into flat fields of colored canvas. From a transatlantic vantage point, it was intriguing to recognize that although Ramos's choice of the most popular erotic fantasies about women, whether as cartoon superheroine dominatrix or smiling, supine pin-up girl, had few if any counterparts in New York Pop, it looked much more at home in the company of some British and French artists of his generation. In England, both Allen Jones and Peter Phillips ventured into what, at the time, was daring erotic territory for ambitious artists, working with modern idols of female sexuality, nude or enhanced with fetishistic undergarments; and in Nice, Martial Raysse offered the Riviera equivalent of Ramos's California beach world with a pageant of bathing beauties whose chic swimming attire and designer sunglasses immediately proclaimed their French origin, just as Ramos's nudes, with their bikini marks on bronzed skin and the swelling carnality of their breasts and buttocks, made it evident that they would expire in a world more arduous than their Pacific Garden of Eden. It was clear that Ramos, even three thousand miles from New York and six thousand from Europe, had touched the very pulse of the sixties.

But after pigeonholing Ramos in that Pop decade in which artists seemed to feign a total disdain for high art in theme or style, I was surprised to discover, at the end of the sixties, that he had begun to invent his own perverse version of the loves of the gods, especially the amorous myths of Zeus, who could instantly become a swan or bull in order to take an earth girl by surprise. Now, in California, Zeus was up to all sorts of new tricks. The most traditional of them may be the 1969 series about the erotic adventures of Leta, the name of Ramos's wife (and favorite model), which, by happy coincidence, evokes the name of the legendary Leda. In a bizarre mix of John James Audubon's *Birds of America* and the kind of pin-up girl that once sent men rushing for the next issue of *Esquire,* Ramos couples a perfect California nude not with Leda's swan, but with a learned catalogue of lone birds—auk, eastern kingbird, hill mynah, white pelican—each rendered with the precision of a textbook on ornithology but obviously living a more provocative life as it approaches on land or in the air the human object of its feathered lust. Even wilder than Europa's bull are the mammals Ramos rounded up as sexy playmates for Leda. In this series of foreplays, her perfect female

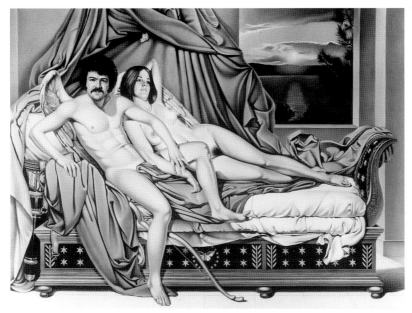

143.
Mel Ramos,
David's Duo,
1973

flesh can rub against a fabulous inventory of animal textures: the cuddly fur of a panda, the antlers of a mule deer, the rubbery hide of a hippopotamus who roars with excitement. A crazy new kind of erotic mythology is invented here, in which the prurient residents of a California zoo are liberated in order to mate with a California Venus.

Ramos's flirtation in the late sixties with the kind of classical myth that fired the old masters' imaginations moved into explicit museum territory in the early seventies. It was then that Ramos confronted a wide-ranging anthology of painted classics by the same masters—François Boucher, Jacques-Louis David, Jean-Auguste-Dominique Ingres, Édouard Manet, Pierre Bonnard—I had been piously teaching in my art-history lectures. Most startling and, as it turned out, most revealing to me was his outrageous takeoff of David's *Cupid and Psyche,* a late painting (1817) now hanging in Cleveland, which at the time was a curiously unloved and misunderstood work that presumably demonstrated the sad decline of David's creative energies during his final years of exile in Brussels. But Ramos, I began to realize, had in *David's Duo* (fig. 143) grasped the disconcerting point of David's late canvas as an insolent parody of Neoclassic idealism, in which Cupid looks not like an antique statue but like the grinning teenage model David had actually used and in which the postcoital entanglements of wings, limbs, and bed linen are presented awkwardly as a spoof on those perfect, graceful couplings familiar from earlier depictions of mythological lovers embracing for eternity. For me Ramos had unveiled David's subversive intentions by updating the master's image to another, more modern time and place. Cupid, of course, is now identified by Ramos's own mustachioed head, crowing his sexual conquest to the spectator. Psyche is here lost in the vacuous reverie of a teenager in love and even sports the pubic hair banished from the Neoclassic female nudes that proliferated in nineteenth-century academic art. And what is even more surprising: David's landscape idyll at sunrise seen through an open window has

become a picture-postcard view of Lake Tahoe, rushing us breathlessly from classical legend back to California.

Ramos displays his playful spurning of tradition even more clearly in his version of Manet's *Olympia*, which had always been recognized as a parody of a classical theme in modern guise. If Manet flouted the tradition of Titian's *Urbino Venus* by turning her into a modern Parisian whore with her black servant, Ramos in turn transported the world of Paris in 1863 to that of California over a century later. Were Venus, we realize, to be carried to the shore on Pacific waves and land on a beach in California, she might well be a sultry blond surf girl who would remove her bathing suit just before usurping the throne of Manet's modernized queen of sex. Ramos, in fact, has resurrected Manet's own contemporaneity, now varnished by time. Even the synthetic colors shrilly wrench us into the present, from the dyed yellow of the new Olympia's hair and the plastic spectrum of the floral bouquets sent by an admirer to the pastel-blue tonality that permeates her bedroom and even the dress of the streetwise black maid who watches suspiciously over her mistress.

These West Coast mutations of museum masterpieces also expanded into more recent territory, taking on, in 1975–77, de Kooning's Woman series of the 1950s (fig. 49), itself an update of art history. In a parallel series of oils and watercolors entitled *I Still Get a Thrill When I See Bill* (fig. 144), Ramos extracted the modern American truths that lay behind the surface of the older painter's frothing brushstrokes, abruptly capping these harpies' wildly fractured bodies with the slickly stylized heads of perfect pin-up girls. In this, too, Ramos taught us a lesson about de Kooning, who in 1950 had actually cut out a lipsticked mouth from a 1949 cigarette ad and pasted it on the head of an early version of the sequence of ferocious women who soon followed. In these, his torrential, slashing brushstrokes tended to camouflage the underlying popular sources, which ranged from Marilyn Monroe herself to more generic fantasies of pink, rounded flesh, made dangerously seductive by red smudges of lipstick and rouge. Once again, Ramos recharged the shock of crass realism that, over the years and decades, had become invisible in the art of the old masters, by revealing here the coarse popular imagery that triggered de Kooning's erotic variations on the American female of the fifties.

Such recycling of earlier art not only gave Ramos's work a new twist, but also located him squarely in the seventies, when so many artists began to quote other works of art, usually in ways that re-created the dead past into a topical present. It is telling that Ramos's de Kooning series quickly elicited a response from another West Coast artist, Robert Colescott, who also began to modernize the old masters. In 1978, in fact, Colescott further updated the progeny of de Kooning's women with another spoof, *I Gets a Thrill Too When I Sees DeKoo,* a painting that substitutes a black-faced Aunt Jemima for Ramos's Miss America heads, thereby adding a new and modern racial twist to the story of art about art. By the end of the 1970s, the ubiquity of these paraphrases in recent works had become so apparent that in 1978 the Whitney Museum of American Art staged an exhibition, "Art about Art," dedicated to this growing phenomenon. Although there had already been forays in this direction in the 1950s, such as Larry Rivers's *Washington Crossing the Delaware,* and still more in the 1960s, such as Roy Lichtenstein's comic-strip versions of Picasso's Dora Maar portraits, it was not until the seventies that American artists, from coast to coast, fully explored the possibil-

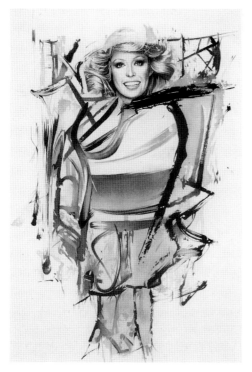

144.
Mel Ramos,
I Still Get a Thrill When I See Bill No. 3,
1977

ity of resuscitating what had once seemed a moribund, pre-modern tradition of museum art. In this expanding territory, which belongs to the retrospective modes of what, for want of a better word, we call postmodernism, Ramos figures as a most original player, specializing in one of Western art's oldest themes, the ideal female nude, which by the 1950s had become an endangered species, relegated mainly to the world of advertising and calendar art.

So it was that by the eighties and on into the nineties, the image I had been forming of Ramos's art began to take on still new dimensions, thanks to, among other things, the many fervent discussions we have recently had about the age-old question of the combat between the sexes and the clear answer that the men had always won. It is now almost impossible to see Ramos's work without thinking of feminist issues, which may make us wonder whether he is, in fact, just another despicable male artist who perpetuates demeaning cultural myths about women as mere vessels of desire or whether his blatant display of this tradition, placed in a contemporary American ambience, is meant to make us all aware, in an amiable, tongue-in-cheek manner, of the ridiculous caricatures of half the human race that Western imagery, both exalted and sleazy, has propagated over the centuries. Ramos casts many lights upon this huge topic. For one, there is the long tradition of the idealized academic nude, most brilliantly explored by Ingres and further popularized by countless imitators, from Cabanel to Bouguereau, a nude whose young, sexually ripe flesh, smoothed to marble or waxen perfection, is devoid of any blemish, including pubic hair or the presence of a reasoning mind.

This subrational breed of flawless animal bodies and vacuously seductive expressions had worked its way down, in our own century, to pin-up illustrators who, like nineteenth-

145.
Francis Picabia,
*Portrait d'une jeune fille américaine
dans l'état de nudité,*
1915

century academic painters, had their own pecking order, with Alberto Vargas and George Petty, now the subject of enthusiastic rediscovery, at the top. It is to this long tradition that many of Ramos's nudes are addressed and the challenge of reviving these erotic goddesses with a satirical twist is one that energized his entire career. He cast a new light on this tradition by showing us how familiar was the American mix of sex and advertising, linking, as he often did in the sixties, American brand names—Kellogg's, Firestone, Lucky Strike, Del Monte, Kraft—with an anthology of sexy girls who hawk these wares. In this context, he even offers a gloss on some of the metamorphic sexual fantasies of New York Dada, which tended to equate nubile American girls with products of the Machine Age. Seen in this way, Picabia's 1915 drawing of a For-Ever spark plug, titled *Portrait d'une jeune fille américaine dans l'état de nudité* (fig. 145), is actually a precursor of Ramos's *A.C. Annie* of 1971 (fig. 146), in which an American girl, also in a state of nudity, fondles the phallic tip of a giant AC spark plug.

By the eighties, however, these gross pairings move, like feminist studies themselves, to more subtle visions of the power play between men and women. In particular, Ramos's artist and model series gives a new spin to this venerable theme in Western art, which itself has provided such a rich field for feminist inquiries into the power dialogues between the passive female model, as often nude as not, and the controlling male artist who scrutinizes his captive with a possessive gaze both erotic and aesthetic. With his gift for pinpointing through exaggeration the concealed assumptions of so much female imagery, whether in the art of museums or the pages of girlie magazines, Ramos sets into contemporary motion the give-and-take between artist, model, and work of art, frequently alluding, as he so often did in the

146.
Mel Ramos,
A. C. Annie,
1971

past, to earlier art. The measured staircase descent of a blond model, towel in hand and ready for a posing session, mixes the mood of a Miss America contest, all eyes on the contestant, with an ironic wink in the direction of Duchamp's notorious symbol of modernism's lunatic fringe. In other studio scenes, the artist's voyeurism works through mirrors, offering in one case a reprise of Henri Matisse's *Carmelina* (1903), in which we are confronted, like the artist, with a nude female model propped up on a table in the manner of a still life while, in the mirror behind her, we glimpse a reflection of the artist at work on this passive, but sexually inviting subject. In terms of the latest feminist discourses from the eighties and nineties, such images speak volumes about both the realities and the cultural myths that continue to define the imbalances of male-female relationships.

On a far less lofty note, however, and one that has more to do with pleasure and humor than with the unveiling of social iniquities, the last decade has also revealed Ramos as a pioneer of kitsch art, a painter able to embrace fully the Technicolor vulgarities and plastic textures of popular imagery and re-create them as works intended to be seen in the elite ambience of galleries and museums. In the way that new art always changes our perception of old art, the work of Jeff Koons, in particular (see fig. 196), has altered our view of Ramos, turning his early work into a prophecy of later excursions into the forbidden territory of erotic kitsch. When we now see Koons's work of the last decade—a gallery ad with the artist posing alongside two pin-up girls in bikinis and a braying mule, or a porcelain sculpture of a blond cuddling a pink panther to her naked breasts—we may be reminded that such willful violations of the conventions of good taste and propriety, in the context of better-mannered art, have a past. And Ramos also appears to be the precursor of such recent explorations of

upside-down feminism as Richard Prince's blow-ups of "biker chick" photographs or Lutz Bacher's new takes on the "Vargas girl."

Here, as elsewhere, Ramos emerges as an artist who has carved out an indispensable niche for himself, facing backward and forward to old masters and Young Turks, and outward to the real world of *Playboy,* California lifestyle, and the pros and cons of political correctness. Who knows where he will lead us next?

"Mel Ramos: How Venus Came to California." Published in *Mel Ramos: Pop Art Images* (Cologne: Taschen, 1994), pp. 4–20.

BILL ANTHONY'S GREATEST HITS

1988

In these days of furrowed brows, when art critics are seeking inspiration in Marx, Derrida, and Baudrillard and art historians are indefatigably excavating in storerooms and library stacks, I often have fantasies about doing an exhibition of works of art that would simply make you smile or even laugh out loud. And when I draw up my special list of candidates, Bill Anthony's name always jumps to the top, a loony touchstone of the kind of artist I have in mind who can cut through all the fog and deftly deflate with a grin one lofty balloon after another. Those of us who have seen only a few of Bill Anthony's drawings will never forget them, tart little comments on this or that sacred cow in a scraggly style instantly recognizable as his. But when these single drawings are all accumulated, categorized, and anthologized, as I'm happy to say they are here, a delirious new empire is born, with Bill Anthony's odd little flags staked out in the most expansive territories, giddily ranging from Hitler to Busby Berkeley, from Manet to the Pollock–Krasner ménage (fig. 147), from dopey teenage sex in America to bank robberies in the Wild West.

Like some extraterrestrial observer, Anthony looks at a crazy assortment of modern culture, history, and mores on our planet and sends back to us one snapshot observation after another as viewed through his tiny, warped lens. It's an odd angle of vision that levels all our activities, whether high art or low life, to a plane of behavior so inconsequentially silly that we can only laugh, not cry, at our follies, even when they include the Second World War. His minuscule but vast universe is inhabited by a population of jerks, both smiling and serious, a race of pure Anthony-people with high-domed foreheads and rag-doll bodies whose all-consuming emotions extend from the dour and murderous to the sex-crazed and playful. Their professional scope also covers the widest grounds, from French Symbolist poet and Bohemian Abstract Expressionist to common whore and Air Force pilot. Gulliver himself never traveled this far.

Part of the fun and mad magic of Anthony's world resides in its microcosmic dimensions, which make us feel we are looking at everything through the wrong end of a telescope. A major Second World War battle in the air and on the sea looks as though it's being played in a puppet theater for lilliputians; a cross-section of the compartmented intricacies of a whorehouse raided by the cops in helicopters and paddy wagons, while a Salvation Army band blares in the street outside, resembles one of those miniature, see-through ant colonies. Reduced to this size and transformed into an Anthony clone, we all look pretty ridiculous.

147.
William Anthony,
Jackson Pollock and Lee Krasner,
1987

148.
William Anthony,
A Clubwoman of Avignon,
1978

Although Anthony's private planet seems so self-sufficient in its ever-expanding bubble that we seldom think of it as belonging to other artists' space-time coordinates, it should be said that Anthony, viewed for just a moment historically, turns out to be one of the earliest of the ongoing generations of "appropriationists," "image-scavengers," or "art-about-art" types, having redone Warhol's soup cans (see fig. 131) and Lichtenstein's comic strips already in the early 1960s. However, such temporal priorities hardly seem to matter in the face of his long-term buckshot assault on all the pieties of the art world. In Anthony's domain, Duchamp's nude ascends a staircase; Rauschenberg's four-trouser-legged Angora goat scratches itself with a human hand; a *demoiselle* from Avignon doubles as a suburban housewife gone berserk with booze, sex, and tobacco (fig. 148); and a whole shooting gallery of art lovers who buy and contemplate our cherished masterpieces look like rows of provincial nerds in a high-school yearbook. As a matter of fact, as I sit here at my typewriter, I can almost see before me a drawing by Bill Anthony entitled, "New York Art Critic Scratching His Head and Wondering How to Write about Bill Anthony." That probably means it's time for me to shut up and to welcome you wordlessly to Anthonyland.

"Bill Anthony's Greatest Hits." Published as the Foreword to *Bill Anthony's Greatest Hits: Drawings, 1963–1987* (Winston-Salem, N.C.: The Jargon Society, 1988), pp. vii–viii.

NOTES ON SOL LEWITT
1978

\mathbf{C}onceptual art? The very sound of those words has chilled away and confused spectators who wonder just what, in fact, this art could be about or whether it is even visible. For like all labels that awkwardly blanket a host of new forms and attitudes, this one could become an out-and-out deception for those who never bothered to look and to discriminate. But this is hardly unfamiliar. Could one ever tell from the word "Cubism" what a typical Cubist work looked like? (A Sol LeWitt modular cube looks more literally "Cubist" than anything by Picasso; fig 149.) Could one ever guess that one catchall phrase, "Abstract Expressionism," ended up by bracketing pictures that look and feel as different as, say, those by de Kooning and Newman? Indeed, wouldn't "Conceptual art" apply far better to the work of Leonardo da Vinci than to that of, say, Vito Acconci, a Conceptual artist who uses his very body and voice in his art? So yet again, one must be careful not to let vague and simpleminded words obliterate the enormous range of intentions and visible results placed under the same umbrella.

Perhaps one should be even more careful this time, since many so-called Conceptual artists have willfully tried to divorce themselves from inherited traditions of "object" art by implying or stating that art can remain gray matter in the mind and still be art. LeWitt himself has written, "Ideas can be works of art; they are in a chain of development that may eventually find some form. All ideas need not be made physical."[1] (But come to think of it, wasn't the physical *fact* of the Parthenon, experienced by relatively few people, infinitely less important than the *idea* of the Parthenon, which was to become a touchstone of Western civilization and architectural theory and practice? And wasn't this belief in perfect thought as opposed to imperfect and transitory matter shared by many Renaissance painters, sculptors, and architects who held that the tangible work of art was only a flawed reflection of an ideal concept, just as later, many Neoclassic artists prized the idea of a work of art more than its palpable materialization?) Some younger art historians, too, have supported the claims of total newness by sensing so drastic a change in the premises of Conceptual art in general and of LeWitt in particular that, as in the case of a recent critical combat (Kuspit versus Masheck)[2] of unusual erudition and intellectual fervor, the very question was raised of whether words and ideas like "beauty" or "style" have not become irrelevant or anachronistic in dealing with LeWitt's work.

Yet, as happens with most innovative art, the passage of time softens the blow of what at first seemed unrecognizably new, slowly uncovering traditional roots and continuities that were initially invisible. How many times in this century, not to mention the last one, were

149.
Sol LeWitt,
Floor Structure,
c. 1966

audiences confronted with an art that was supposed to be intrinsically different from all earlier art, but that ended up being very much a part of it? Cubism, for one, was said to have achieved the most irrevocable rupture with all earlier traditions, but now it often looks more at home with the still lifes, figure paintings, and landscapes of the nineteenth century than it does with most later twentieth-century art. Abstract Expressionism, too, in the first shock of its originality, appeared to be a total break with a Western pictorial past, but it also looks comfortable now in a world of venerable easel painting traditions, so that a Rothko and a de Kooning can hang harmoniously with a Matisse and a Kandinsky, not to mention a Turner and a Hals. Pop art was no less startling an assault; however, its heresies, like those of Abstract Expressionism, became familiar pieties and soon evoked respectable ancestors, so that Lichtenstein, for example, now looks quite as solemnly museum-worthy as Léger or Stuart Davis, who, in turn, must first have looked as brashly unprecedented as the Pop artists. And Earth Works, which seemed to undermine even the material conventions of Western art, have taken on, now that the dust has settled, a historical resonance that permits us to think of the best of them as, among other things, noble efforts to synthesize the grandest powers of man and nature in a geographic union that re-creates, in late-twentieth-century terms, our deepest Western memories of monuments as remote and awesome as Stonehenge or the pyramids of Giza.

 The same sort of thing is now happening with so-called Conceptual art, for not only is it fitting more and more readily into familiar patterns of historical continuity but also, in its wide range of manifestations (which were originally all lumped together in a pro-or-con situ-

ation, as with most new isms or movements that are initially praised or scorned blindly), we are gradually seeing both more trees and more forests, as well as distinguishing more easily between good and indifferent, major and minor work. Over the years now, Sol LeWitt has been looming ever larger as one of the most coherent, innovative, and liberating of those artists who presume to balance the constant eye-mind equation of art in favor of the mind; but even more to the point, his art has turned out to be stunningly beautiful. The use of this old-fashioned adjective may be inflammatory in the context of the rhetoric of both Conceptual artists and their critic-polemicists, but the experienced truth is that the finest of LeWitt's work elicits, especially among younger-generation spectators more quickly at home than their elders with visual idioms of the last decade, an instant response to its sheer visual excitement and daring, an immediate awe that, for better or for worse, has to be translated by the same feeble words—beautiful, elegant, exhilarating—that we use to register similar experiences with earlier art. The theories, the geometries, the ideas may all be called into play for a fuller elucidation of what is going on, but both initially and finally, it is the visible works of art that dominate our attention. The perceptual whole is far more than the sum of its conceptual parts, although the visual memory of LeWitt's executed images, like our imaginary recall of Greek sculpture or of a lost or damaged masterpiece by Leonardo, may outlive the actual objects. Were this not the case, LeWitt's work, as Lucy Lippard wrote in 1967, would be theory rather than art.[3]

There is really nothing new about this. One thinks of Uccello, whose perspectival calculations obsessed his mind and his pen, but whose art—finally more fantastic and beautiful than simply rational—is in no way to be equated with a Renaissance treatise on perspective or, for that matter, with the art of a lesser master who employed the same conceptual systems of projecting three-dimensional forms on a two-dimensional surface.[4] Or one thinks of Seurat, whose quasi-scientific theories—were we to deal only with them—might obscure the fact that his paintings, unlike those conceived or executed by other artists and theorists concerned with similar problems of rationalizing color, composition, and emotion, impose themselves first and foremost as breathtaking visual experiences that later, if we wish, can be dissected and analyzed in the light of Seurat's own writings (which may even be contradicted by his art). Thus, LeWitt's art may be steeped in his cerebral, verbal, and geometric systems, as was that of so many great, as well as inconsequential, artists before him, but its impact is not reducible to words. The immediate experience, like that of any important art that stops us in our tracks and demands lingering attention, is visual and visceral, rather than exclusively intellectual, and as such bears an intensely personal flavor that distinguishes it at once from the work of other contemporary artists concerned with, say, modular systems or the realization of verbal-visual equations. It is comforting here to have LeWitt's own sanction concerning the discrepancies between his own conceptual intentions and the ongoing perceptual life of the work itself: "It doesn't really matter if the viewer understands the concepts of the artist by seeing the art. Once it is out of his hand the artist has no control over the way the viewer will perceive the work. Different people will understand the same thing in a different way."[5]

Gradually, that is, we shall have to find ways of articulating our particular visual and emotional responses to LeWitt's work, as we have for other difficult new work of the past. Thus, Donald Kuspit's comment that LeWitt's objects seem "like a cold bath, at once repres-

sive and exhilarating, instinct-denying and at the same time creating a sense of dammed-up energy,"[6] is one such vivid pinpointing in a simile of something of the peculiarly complex and irrational flavor we are beginning to discern in LeWitt's art. It is true, that is, that LeWitt insists on using words and forms with a logical rigor that implies the tonic, intellectual clarity of a Euclidean theorem. But at the same time, his systems of elementary shapes can proliferate with a crazy extravagance that, to our surprise, puts the rational gray matter of logic, mathematics, and science at the service of a wildly florid artistic imagination. It is as if the computer systems that silently and invisibly permeate our late-twentieth-century world had been freed from their utilitarian duties and had gone berserk in new two- and three-dimensional, cellular or labyrinthine structures at once numbingly simple and bewilderingly complex. The venerable duality in Western art between universal reason and private aesthetic fantasy seems freshly reinvented within a contemporary context.

LeWitt's search for the building blocks of form, for the basic alphabet, vocabulary, and grammar of all structures, is one that has a deeply ingrained tradition in the history of modern art, from its late-eighteenth-century beginnings, with the purist reforms of Neoclassic geometry, to the wealth of twentieth-century investigations of the rudiments of art. A major impulse of all these pursuits, especially the rebellious isms of the early twentieth century—Cubism, Suprematism, de Stijl, Purism, Constructivism—was to bury forever the moribund past and to start on a clean slate with a visual language that approached or attained what were presumed to be unpolluted formal essences—disembodied lines and arcs, squares and circles, verticals and horizontals, whites and blacks, primary colors. Ironically, these lucid, primitive statements would quickly be elaborated into refinements and intricacies that demanded the most sophisticated perceptions, which in turn would provoke yet another purist reform. The need for this ritual housecleaning in twentieth-century art is apparently unquenchable.[7]

In American art since 1945, this impulse to strip art of everything but elemental truths has been unusually passionate and productive. Beginning with the Abstract Expressionists, most of whom pruned their inherited pictorial worlds to the most potent visual and emotional simplicity, this search for the roots of form and feeling has continued into the 1960s and the 1970s. The drive toward what appear to be unadulterated foundations of art has often produced extreme displays of the most overtly rational order (for example, Reinhardt, Kelly, Stella), as well as its obverse, an overtly irrational disorder predicated on impulse and chance (for example, Pollock, Kline, Twombly). At this level of reduction, the ruled line and the scrawl would alternately be proclaimed king. In a similar way, the direct disclosure of seemingly urgent, self-revealing emotion in much Abstract Expressionist art has its counterpart in the willful insistence upon an ostensibly total concealment of the artist's private feelings, as in Warhol's recording of both flowers and suicides with an equally deadpan stance, or in the nominally detached, emotionless look of much Minimal art of the 1960s. But these polarities are more illusory than real. It should be quickly emphasized that these recurrent extremes in art since 1945 are not to be transposed into simpleminded equations in which, say, geometric forms would equal chilly reason and impersonal order, or contrariwise, irregular, spontaneous forms would equal humanist passion and personal communication. We should all know by now that Pollock's or Kline's discipline in harnessing a vocabulary of

apparent impulse was far stronger than that of many lesser artists dealing routinely with the already disciplined forms of geometry. In the same way, the private passions involved in the conceiving and making of Reinhardt's squares, Stella's stripes, or Andre's metal grids may be far more urgent or even irrational than those of a lesser Abstract Expressionist dealing secondhand with a vocabulary that superficially signifies a display of feeling. In short, to associate the look of geometry with a heart of stone or, vice versa, to assume that the presence of spontaneous brush marks or eruptive calligraphy must reveal the outpourings of a passionate soul is as naive as thinking that, say, mathematicians are less "human" or "feeling" than tragedians. Such basic points perhaps need to be made yet again to counter prevailing misinterpretations of so much American art in the 1960s whose cool, minimal, or geometric look prevented many critics and spectators from sensing the often irrational fervor behind the best of this work.[8]

In October 1965 Barbara Rose published "ABC Art,"[9] a lucid and sympathetic analysis of the new Minimalist aesthetic viewed against a broad historical background. At the very same time, LeWitt had his first one-man show in New York. Just missing inclusion in Ms. Rose's article, whose generalizations would have encompassed it, LeWitt's work arrived on the New York scene in the nick of time for Kynaston McShine's manifesto exhibition at New York's Jewish Museum in 1966, "Primary Structures," which featured one of LeWitt's new modular cubes. It was soon clear that LeWitt had joined forces with those artists of the early 1960s—Tony Smith, Frank Stella, Donald Judd, Carl Andre, Robert Morris, and Dan Flavin, among others—who had sought out a new version of modern art's unending quest for the force and purity of a primal statement. In LeWitt's case, the pursuit of these rock-bottom foundations quickly took on a distinctive character, especially in his disarming rejection of our preconceptions about such conventional artistic categories as architecture, sculpture, painting, and drawing (a rejection that was to become so thorough, by the way, that one might well puzzle over which of the Museum of Modern Art's traditionally categorized departments—Painting and Sculpture, Prints and Illustrated Books, Drawings, or Architecture and Design—should be first in command of a LeWitt retrospective.) Already in October 1965, on the occasion of LeWitt's first one-man show at the short-lived John Daniels Gallery in New York, a sharp-eyed reviewer, Anne Hoene, noted incisively that perhaps new phrases such as "sculppecture" or "post-painterly relief" would have to be coined to describe these unfamiliar objects.[10] With this she put her finger on the radical way in which LeWitt seemed to uncover the roots of a structural world so elementary that the conventions that would come to characterize the different visual arts were irrelevant. As LeWitt later demonstrated even more amply, he was determined to free himself from the inherited restrictions of painting versus sculpture versus architecture.

Nevertheless, LeWitt's early works, in their two- and three-dimensional realizations of what seemed to be the foundations of all potential structures, often evoked the themes and variations of purist geometries explored by International Style architects. Although their occasional similarities to actual architectural models of the 1920s may be fortuitous (such as the resemblance between a few of LeWitt's early striped hanging and table structures of 1963 [fig. 150] and Adolf Loos's 1928 project for a house for Josephine Baker), their forms, like those of

150.
Sol LeWitt,
Hanging Structure (with stripes),
1963

many other artists of the 1960s, are related in a deeper sense to traditions of twentieth-century purist architectural design, especially as realized in drawing-board geometries and simplified scale models.[11] It should be recalled here that LeWitt actually worked in the graphics department of I. M. Pei's office in 1955–56; and that his art, like his writing, has always been in close touch with the abstract components of architecture, witness his first using a projecting ziggurat shape in a relief of 1963 (fig. 151) and then recommending, in an article of 1966,[12] not so much the utilitarian, zoning-code aspects of post-1945 ziggurat-shaped office buildings in New York, but rather the sheerly abstract beauty and logic of their set-back forms.

But LeWitt's structures (characteristically, he dislikes their being called "sculptures") can take us even further back in an imaginary history of forms, beyond even the Platonic ideas of cubic, trabeated buildings or of modular utopian city plans. At times these works look like an even more archaic manifestation of the concept of a rectangular aesthetic shape that, lo and behold, would one day become, millennia later, the frame of a painting or, expanded to three dimensions, the volume of a sculpture or of a house. In one such work of 1966 (fig. 152), three square frames—two on perpendicular wall planes, one on the ground—evoke not only two-dimensional, planar areas that might eventually enclose images yet to be painted or drawn, but also, given the frame on the floor, an incomplete cubic volume that might someday contain a sculptural form or, wedded as it is to the floor and walls of a particular interior, go on to articulate architecturally the very room in which the work is seen.

151.
Sol LeWitt,
Wall Structure,
1963

152.
Sol LeWitt,
Wall/Floor Piece (Three Squares),
1966

LeWitt's presentation of the cerebral nuggets that would underlie all two- and three-dimensional forms, all plane and solid geometries, was quickly elaborated in expanding series that, with a relentless inevitability, seem to grow in and take over the very spaces in which we perceive them. Although LeWitt prefers finite series (such as the various demonstrations in both two and three dimensions of all possible combinations of incomplete cubes), the overall visual effect counters this intellectual tidiness by offering a world of endlessly expanding mazes. What Lawrence Alloway has defined as "a spectrum of continuous multiple possibilities"[13] becomes the work of a new Sorcerer's Apprentice, so that the deadpan, inert simplicity of a fundamental component—an open or closed cubic volume, a square plane crossed by parallel lines, or simply a line drawn between two designated points on a surface—is swiftly but logically multiplied by and combined with related components until suddenly the eye and the mind are boggled by the irrational, cat's-cradle complexities that can spring from such obvious foundations. In this LeWitt's work often seems an abstract re-creation of the metamorphic miracles of worlds both organic and intellectual, whether in terms of mirroring biological evolution from single cells to elaborate organisms, mathematical series that start with cardinal numbers and simple geometries and proceed to dizzying theoretical constructions, or linguistic developments from phoneme and alphabet to the intricacies of advanced syntax.

Faced with the absence of any absolute reigning system of order, twentieth-century artists have again and again been obliged to construct their private system of rules, often inventing their own vocabulary and grammar as the basis of a personal and frequently cryptic language. LeWitt's response to this recurrent modern dilemma is one that has a closer precedent in many of Jasper Johns's own permutations and combinations of colors, alphabets, words, and numbers. Especially in his variations on numerical series (as in the 0-9 lithographs of 1960–63), Johns's internal systems of sequence and ordering create, for solely aesthetic purposes, an intensely personal yet logical reconstruction of these numerical means that are usually oriented to public and utilitarian ends. Similarly, LeWitt will take geometric commonplaces (his mathematics is simple and unrelated to that of the later twentieth century) and construct from them his own coherent, but useless, aesthetic systems. Like Johns, too (and before him, Picasso and Braque in their Cubist phases), LeWitt often joins words and abstract shapes in the same work (as in his connection by straight lines of all *ifs, ands,* and *buts* that appear on a printed page), thus establishing a dialogue between two different kinds of symbols that equate and therefore aestheticize both verbal and geometric languages. Words become points on a plane, geometries become abstract patterns, so that these two modes of impersonal communication are rendered void, no longer working in the expected way, but transformed into pawns in a complex visual and intellectual chess game. Such personal fantasies have a special alchemy in which the most ordinary symbols are made magical by their subjection to a newly invented system. At times the most elaborate of these constructions resemble translations of complete philosophical systems into a purely formal language. If anyone could perceive the structural beauty of, say, Descartes' or Kant's treatises and then go on to re-create them as exclusively visual metaphors, it is surely LeWitt.[14]

It is typical of LeWitt that he chose artistic means as immaterial and abstract as the systems that regulate his art. Even the materials of most Minimal art—Andre's bricks and pure metals; Stella's striped, metallic paint surfaces; Flavin's fluorescent tubes; Judd's Plexiglas and

plywood—are somehow, for all their plainness and clarity, too literal, too palpable for LeWitt, who seeks out rather the most abstract-looking materials, or ideally, nonmaterials, to render, in Donald Kuspit's felicitous phrase, "the look of thought."[15] Like Robert Morris, who already in 1961 tried to disembody further a "minimal" eight-foot-high rectangular column by covering its simple plywood volume with Merkin Pilgrim gray paint, LeWitt also selected a substance for his structures—in his case, a white baked enamel—that would seem as free of worldly association and specific identity as possible. As he himself has said, it had to be either white or black, and he chose white. With such clinical material—like the stuff of demonstrations in a solid geometry lesson—the idea appears to take precedence over the palpable material of which the structure is made, so that the physical means to the formal ends remain as intangible and unobtrusive as possible. Indeed, the laws of gravity seem to be repealed in these structures, whose overt weightlessness (they project as easily outward from the wall as upward from the floor) confirms that they belong more to a mental than to a physical realm.

In making flat images—prints or drawings—LeWitt again prefers the most impersonal and impalpable means. Oil paint, usually so viscous and physical in substance and so susceptible to traces of individual facture, is replaced by printer's ink and hard pencil lines, markmakers that seem to imply as little space and weight as possible and that evoke anonymous architectural renderings. It was predictable, too, that when LeWitt began to consider color and its combinations in two-dimensional works, he would choose the four basic colors—red, yellow, blue, black (black being considered a color in this context)—used in the world of color printing, thus paralleling in his art the infinite permutations and combinations of hue and tone achieved by machines using this four-letter alphabet of colors. LeWitt's pure reds, yellows, and blues provide once again, in the history of twentieth-century art, the shock of recognizing the unadulterated beauty of these primary hues, a eureka experience we were taught most insistently by Mondrian, but which every generation feels the need to rediscover (witness Newman, Kelly, Johns, Stella) and to which every important artist lends his personal stamp. (Thus LeWitt's red or blue, for all its allusions to and use of impersonal color-printing processes, is as distinctive as, say, the printer's-ink reds and blues in Matisse's *papiers découpés*.) And just as LeWitt can multiply his simple geometries into constructions of dazzling subtlety, so too can he metamorphose his printer's-ink reds, yellows, blues, and blacks into dense yet intangible weaves that emanate hues and tones of unprecedented fragility and evanescence. There are no words in either the geometry textbooks or the color-theory treatises to define the unfamiliar effects he can attain from these elementary units.

LeWitt's search for the most universal and impersonal means of creating art may at first appear to be the exclusive domain of the Minimal art of the 1960s, in which presumably only basic visual experiences, whether of color, shape, or material, are permitted and in which the idea is so dominant that the actual execution of the work has little or nothing to do with the artist's own hand. But in a broader context, it is worth noting how these attitudes are shared by other artists of the 1960s and 1970s who, at first glance, might seem remote from LeWitt's world. Lichtenstein, for one, has similarly reduced his aesthetic means to an elementary vocabulary of image-making that mimics the regularized printer's formulas of machine reproduction—screens of dots, clean black lines, primary colors—while also molding these commercial techniques into tools of the most personal inflection. The evolution of

his colors in particular parallels LeWitt's. Beginning with the rawest, flattest primary hues, Lichtenstein refined these foundations to a point of such astounding sensibility that even the iridescent shimmer of Monet's haystack and Rouen Cathedral series was not beyond translation into a private language derived from benday dots. The chromatic and tonal results in what might be called a Neo-Neo-Impressionist aesthetic are rivaled by LeWitt's own paradoxical mixture of the thoroughly public means of mass-produced images and the most distinctively personal flavor. (There are provocative analogies, too, between Lichtenstein's and LeWitt's absorption of modern color-printing techniques and Seurat's late use, for equally aesthetic goals, of pure color dots, increasingly inspired by new methods of chromolithographic reproduction developed in the 1880s.[16] Fascinated by this flat, mechanistic regularity and assimilating it into his own pictorial vocabulary, Seurat nevertheless transformed these public, anti-artistic means into thoroughly personal ends that enriched rather than impoverished the language of modern painting.) It is a phenomenon often observable in the 1960s and 1970s, witness the Photorealism of Chuck Close. Insisting, too, on the artist's almost mechanical replication of a predetermined body of data, Close shares many of LeWitt's own concerns with the meticulous, impersonal realization of a given, abstract idea, creating equally individual results that are brilliantly polarized between something startlingly simple and direct and something visually astounding in its infinite detail. As in LeWitt's work, we shift rapidly from micro- to macro-structure in a world where familiar human scale has become irrelevant.

To consider the family resemblances between LeWitt's art and that of both his abstract and figurative contemporaries is to be reminded that despite claims that LeWitt's work is somehow beyond art, beauty, or style, in retrospect it appears most intelligible within the broad context of the art of the 1960s and 1970s, revealing an increasingly discernible period look and redefining, in the freshest terms, many inherited traditions. With this in mind, LeWitt's wall drawings demand particular attention, for they extend the premises not only of his own earlier work but also those of earlier abstract painting. More phantom than substance, these boundless, gossamer traceries appear like mirages on walls and ceilings and seem to be simultaneously nowhere and everywhere. But the magic shimmer and mysterious mathematical symbols of these environmental fantasies are also subject to the kind of simple rationalization that permeates all of LeWitt's work, as if the roles of primitive sorcerer and geometer were combined. The formulas given are easy enough (for example, *Straight Lines in Four Directions, Superimposed* or *Lines Not Long, Not Straight, Not Touching, Drawn at Random Using Four Colors*), and the execution can be entrusted to any number of competent draftsmen (although LeWitt himself made his first wall drawing in 1968), yet the experience of the completed works is not one of dry cerebration but, as Jean-Louis Bourgeois phrased it in 1969, "like yard after yard of exquisite gauze."[17]

In many ways these wall drawings provide a stunning series of contradictions that LeWitt has fused indissolubly. For one, they reconcile two opposing modes of structure that have fascinated many artists of the 1960s: the rigorous order of a simple repetitive system (grids, parallels, concentric circles, etc.) and the abdication of this elemental order in favor of the random (or, in the fashionable word of the period, the aleatory). Artists as unlike as Warhol and Andre have alternated between the A-A-A-A rhythms of repeated patterns and

the contrary look of scatter, freedom, chance. In LeWitt's wall drawings, these antithetical systems of order and anti-order are merged. The predetermined rules for execution are no harder than a first lesson in geometry, but the actual results are in equal part unpredictable, offering such infinite variables as the determination of where, according to the draftsman's choice, certain lines will be drawn or certain relationships located, or how the accidental formats of the wall or room will affect the results. The ephemeral, random look of graffiti is wedded to the stable, tectonic look of the actual wall planes on which the drawings temporarily reside, so that the components of the architecture are dissolved into the illusory plane of the drawing and vice versa. LeWitt wrote that he "wanted to do a work of art that was as two-dimensional as possible,"[18] but in perceiving this two-dimensionality, the viewer is obliged to reexperience the palpable, often three-dimensional presence of the supporting architecture. As LeWitt has stated, "Most walls have holes, cracks, bumps, grease marks, are not level or square and have various architectural eccentricities,"[19] all of which irregularities are simultaneously veiled and emphasized by the two-dimensional wall drawings upon them. The contradictions are comparable to those we experience in, say, the unsized canvases of Morris Louis, where the vast expanses of unpainted cotton duck that support the painted illusion become, by contrast, all the more literal physically, while being transformed at the same time into the pictorial fiction of a luminous field of open space.

In yet another merging of opposites, LeWitt's wall drawings are at once intensely personal and impersonal. Their image immediately evokes a unique artistic invention, LeWitt's, that we tend to associate with traditions of handcrafted painting and drawing; yet the execution, like that of most architecture, is a result of anonymous hands or, theoretically, even of machines. Again, the crossing of the boundaries of the arts and the confounding of our preconceptions about each art are to the point of LeWitt's liberating view of the limits of the separate media. We recognize his individual imprint not literally, in the actual physical execution, but rather in the conception of the work, just as we may recognize the style of a highly personal architect in the overall idea and look of his building rather than in the personal facture of the physical construction of the parts. Looked at this way, LeWitt is simply applying principles of conceptual emphasis we have always taken for granted in architecture—the architect, after all, thinks up and plots his design, which is then materialized impersonally—and applied them to the domain of drawing and, by extension, painting. And LeWitt's method is equally close to that of the composer, whose symbolic musical instructions are there to be reconstructed in performance by anyone who wishes to hear the work executed. Like musical notation and its potential and variable realizations, LeWitt's written rules for the execution of a wall drawing imply both the enduring and the ephemeral, the conceptual and the sensual. Although LeWitt's is hardly the first assault upon the prejudice that a drawing or a painting must bear the artist's own physical, and therefore psychological, marks, it is certainly the most original in terms of unsettling the very conventions that used to distinguish for us the differences in the visual arts between transportable drawings or paintings and immobile architecture, between conception and execution, between the permanent and the impermanent. (For as LeWitt has written, "The wall drawing is a permanent installation until destroyed,"[20] which, in fact, has been the destiny of many of these short-lived but always resurrectable works.)

Yet however much these wall drawings may turn topsy-turvy our inherited sense of these distinctions, they gradually begin to suggest as well deep connections with earlier kinds of abstract painting and drawing that, in turn, seemed heretical when first created. Their very vocabulary, so rigorously restricted to fragmented geometric or quasi-geometric parts, like lines and arcs, recalls that of the drawings and prints of the most cerebral moments of Analytic Cubism in 1910–11, as does their frail, linear scaffolding; and these affinities continue in such Cubist-derived, weblike structures and purified linear segments as found in Mondrian's *Pier and Ocean* and the *Plus-and-Minus* series. And in a more explicitly geometric, ruler-and-compass way, their alphabet of sharp lines and arcs floating in a boundless space finds precedent in many of Rodchenko's line constructions of the early 1920s.[21] But if the geometric vocabulary of LeWitt's wall drawings is rooted in Cubist-Constructivist traditions, their overall syntax belongs more to a mode of pictorial art that recalls the expansive, open fields of the late Monet and of much American painting from Tobey and Pollock on.

A musical analogy may be apt here. LeWitt's wall drawings, in their detail, have the calculated look of a computer world but soon dissolve into diaphanous veils of a strange, engulfing sensuality. It is a quality found as well in the music of Philip Glass (for whose *Music in Twelve Parts,* incidentally, LeWitt has designed a record jacket).[22] Glass's music is constructed from what at first may seem monotonous and endlessly repetitive units of rudimentary melodic and rhythmic fragments, electronically amplified in a way that conceals personal style through associations of a mechanical standardization. But if the intellectual order of Glass's work is as rigorous and systematic as that of LeWitt's, yet again, the total effect is not of dry reason. The experience becomes rather a kind of slow immersion in a sonic sea, where the structural anchors of the score, discernible by the intellect's intervention, tend to be washed away by the mounting sensuous force of the cumulative sound. The musical precedents for such a gradual overwhelming of the senses lie in late Impressionism, in the engulfing swells of Debussy and Ravel at their most shimmering, just as the twinkling expansiveness of LeWitt's wall drawings evokes echoes in late Impressionist painting, especially in the panoramic extensions and vibrant fragility of Monet's water lilies.

It is this quality of potentially infinite, multidirectional expansion, burgeoning into the domain of vast architectural decoration, that locates LeWitt's wall drawings most closely within traditions of American abstract painting from the 1940s on. The development of an "allover" style in Tobey and Pollock provoked the sense that the spectator might be disoriented in a gravity-defiant field of unbounded energies that, pushed one step further, might actually spill over the edges of the canvas into the walls and room. This metaphorical possibility is literally realized in LeWitt's wall drawings, which are often extended to the very ceilings and peripheries of their architectural settings. The "apocalyptic wallpaper" of Abstract Expressionism has left the stretcher and canvas to create an even more encompassing and immaterial visual environment.

Like so much of the best abstract painting of the post-1945 period, LeWitt's wall drawings are based on a rudimentary visual unit that is then amplified to mural dimensions. And despite the simplicity of the given rules for determining each unit, the range of visual possibilities is vast. At times linear arcs of interwoven color may create labyrinthine tangles so fine and yet so dense that in their alternation between hair-breadth thinness and galactic depth

they almost offer a 1970s reinterpretation of the spatial complexities of Pollock's own whirling filaments. In other variations, white lines incised on a black ground (or black lines on a white ground) continue to explore, with their constant shuffling of positive and negative marks and spaces, the rich legacy of black-and-white painting and drawing, from Pollock and Kline through Twombly. Elsewhere LeWitt's use of only a single hue in a wall drawing creates a blaze of color so intense that the color fields of Poons, Olitski, or Stella seem re-created in a vivid new language. If abstract painting of the last quarter-century has pushed ever further in the direction of total dematerialization, freeing line from volume, floating color weightlessly in boundless spaces, concealing even the physical stuff of which the image is made, then LeWitt's wall drawings represent one of the most brilliantly original visions in this persistent quest. Indeed, LeWitt's spiderwebs of line can reach such magical near-invisibility that, on one occasion, at the Lucio Armelio Gallery in Naples in 1975, LeWitt superimposed his own wall drawing on a mural stripe painting by Daniel Buren without disturbing the wholeness or the legibility of Buren's underlying image (fig. 153).

As always, strikingly new art that initially unbalances us ends by joining forces with and rejuvenating the past. Thus, at the Venice Biennale of 1976, in "Ambiente" (a historical survey of total interior environments created by artists), a room covered with LeWitt wall drawings stood almost at the end of a long twentieth-century tradition of abstract mural decoration, from Kandinsky and Mondrian on.[23] And as is well known by those who have had the good fortune to see LeWitt drawings in situ at the North Italian villa of Count Giuseppe Panza di Biumo, these mural fantasies can even coexist happily in rooms also decorated with late Baroque painted ceilings. Finally, LeWitt's threats to convention are more apparent than real. Like the now assimilated challenges of so many modern masters before him, they become the very means of sustaining the vitality of venerable traditions.

"Notes on Sol LeWitt." Published in Alicia Legg, ed., *Sol LeWitt* (New York: Museum of Modern Art, 1978), pp. 15–21.

1. Sol LeWitt, "Sentences on Conceptual Art," *Art-Language* (May 1969), p. 11.
2. Donald B. Kuspit, "Sol LeWitt: The Look of Thought," *Art in America* (September–October 1975), pp. 43–49; with response by Joseph Masheck, "Kuspit's LeWitt: Has He Got Style?" *Art in America* (November–December 1976), pp. 107–11.
3. Lucy R. Lippard, "Sol LeWitt: Non-Visual Structures," *Artforum* (April 1967), p. 46.
4. Visual and evolutionary analogies between Renaissance art and that of LeWitt and his contemporaries have been explored on a more philosophical level by Suzi Gablik in *Progress in Art* (New York: Rizzoli, 1977), pp. 44–45 and passim.
5. LeWitt, "Paragraphs on Conceptual Art," *Artforum* (June 1967), p. 80.
6. Kuspit, "Sol LeWitt," pp. 43–44.
7. The classic discussion of this impulse in modern art is discussed under the heading of "Intellectual Primitivism" in Robert Goldwater, *Primitivism in Modern Art* (New York: Vintage Books, 1967).
8. The situation has been the same with the earlier misreadings of Analytic Cubism, whose complex dissections of line and plane were first rationalized by apologists in vaguely scientific language but now seem ever more mysterious; or similarly, with changing interpretations of Malevich and Mondrian, whose quasi-geometric vocabularies obscured for decades their ardent quasi-religious goals.
9. Barbara Rose, "ABC Art," *Art in America* (October–November 1965), pp. 57–69.
10. A. H. [Anne Hoene, now Anne Hoy], "Sol LeWitt," *Arts Magazine* (September–October 1965), pp. 63–64.
11. For further thoughts on these connections with architecture, see Dan Graham, "Models and Monuments: The Plague of Architecture," *Arts Magazine* (March 1967), pp. 32–35.

153.
Sol LeWitt,
Wall Drawing #242.
Lines 40" Long,
from the Midpoints of
Straight Lines Toward
Specified Random Points
on the Wall,
1975

12. LeWitt, "Ziggurats," *Arts Magazine* (November 1966), pp. 24–25.
13. Lawrence Alloway, "Sol LeWitt: Modules, Walls, Books," *Artforum* (April 1975), p. 43.
14. The abstract beauty of philosophical systems as paralleling LeWitt has been mentioned in John N. Chandler, "Tony Smith and Sol LeWitt: Mutations and Permutations," *Art International* (September 20, 1968), p. 19.
15. Kuspit, "Sol LeWitt."
16. Norma Broude, "New Light on Seurat's 'Dot': Its Relation to Photo-Mechanical Color Printing in France in the 1880s," *Art Bulletin* (December 1974), pp. 581–89.
17. Jean-Louis Bourgeois, review, *Artforum* (December 1969), pp. 71–72.
18. LeWitt, "Wall Drawings," *Arts Magazine* (April 1970), p. 45.
19. Ibid.
20. Ibid.
21. A specific analogy to Rodchenko's 1921 Compass Drawings was suggested by Brooks Adams in his review of Sol LeWitt: Graphik 1970–75 . . . in *The Print Collector's Newsletter* (September–October 1976), p. 123. In broader terms, LeWitt's art has also been seen as a recent manifestation of a long Constructivist tradition. (See Willy Rotzler, *Constructive Concepts* [Zurich, 1977].)
22. An analogy between Glass and LeWitt has been briefly suggested in Germano Celant's "LeWitt," *Casabella* (1972), p. 40.
23. This important exhibition has now been documented and expanded in a book: Germano Celant, *Ambiente/Arte dal Futurismo alla Body Art* (Venice: La biennale di Venezia, 1977). For the LeWitt room, see figs. 222–23.

DAN FLAVIN: NAME IN LIGHTS
1997

The death of Daniel Nicholas Flavin Jr. on November 19, 1996, sent my memory rushing back to the early sixties, now a mythic moment in the history of art. Born on April 1, 1933, Flavin was part of my own generation, for which the complementary austerities of an iconic soup can and a perfect rectangle appeared to launch a visual order in which industrial uniformity and pure cerebration would be the reigning muses. Worshiping early at New York's shrines of modern art (he once worked as a guard at the Museum of Modern Art and attended Meyer Schapiro's lectures at Columbia), by 1963 Flavin had become a pillar of the fiercely intelligent young art establishment whose spirit was nurtured monthly by the then year-old *Artforum*. I can't remember exactly how or when we first met, but it must have been somewhere in those rigorous precincts where the likes of Carl Andre, Frank Stella, and Barbara Rose were drafting new aesthetic constitutions. Yet even within this group of the sharpest cutting edges, Flavin stood out, his toweringly intractable presence always cushioned from reality by his devoted wife, Sonia Severdija.

Teaching then at Princeton, I was only a weekender in this freshly minted world; but in the spring of 1963, my weekend extended through Mondays, when I gave a guest course at Columbia on Neoclassic painting. Always keen on art history and assuming, I think, that I was a student of Schapiro's (which I was not), Flavin asked to audit my lectures, especially those on Ingres, and then thanked me for the favor in the most generous ways. First there was a drawing dated April 25, 1963, which he offered to me with an inscribed dedication. Titled *icon IV (the pure land)*, it copied an earlier construction (now lost), a Formic square topped horizontally by a single fluorescent tube. In 1962, when Flavin was first working on this piece, his twin brother, David John, died, and in my drawing the shrinelike object was turned into a memorial by a tombstone-type inscription that recorded his brother's birth and death date. (There is a telling parallel here to Barnett Newman's *Shining Forth (to George)* of 1961, the painter's abstract altarpiece commemorating his own brother's death in February of that year.)

One month after he executed this drawing, Flavin, echoing Newman's *Onement I* (1948), took a quantum leap, creating his first work made from nothing but a single standard eight-foot yellow fluorescent tube (fig. 154). He originally called it *the diagonal of May 25, 1963 (to Constantin Brancusi),* but in 1963, in a second version shown at the Kaymar Gallery, New York, he replaced Brancusi's name with mine, an apotheosis that still has me

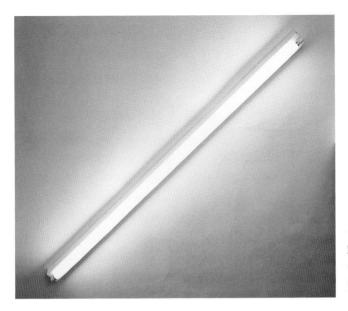

154.
Dan Flavin,
*the diagonal of May 25, 1963
(to Robert Rosenblum),*
1963

reeling. Perhaps he was impressed by my youthfully rash remark that his work had destroyed painting for me, a comment he quoted in Bruce Glaser's radio interview of February 15, 1964, with him, Stella, and Donald Judd (though he subsequently withdrew his own remarks from the publication of this early document of Minimalism).

The next year, our professional paths crossed in a different way that I'll also never forget. Applying for a Guggenheim Fellowship in 1965, Flavin respectfully asked me to write a recommendation. Believing ardently in his genius potential, I of course agreed to do so. But I was dumbfounded when he almost demanded to read my letter before I sent it off, lest I in some way misrepresent his mission. I wrote back that although I could assure him that the letter would be utterly positive, I could not send him a copy, since this violated protocol, and then added, much too breezily for his always furrowed brow, "Who do you think you are? Barnett Newman?" I got back a passionately argued, lengthy, handwritten letter explaining how totally different he was from Newman. This might have been my first awareness that the AbEx fervor for a heroic individuality of cosmic dimensions, a species presumably extinguished by early-sixties cool, had been inherited by at least one member of the next generation. (P.S. He didn't get the fellowship.)

All this was more than three decades ago, and at the time, if memory is to be trusted, Flavin's astonishingly familiar-yet-unfamiliar objects—mass-produced cylinders of artificial light—at first seemed to have everything to do with the tabula rasa of Minimalism and little to do with anything else. At home with the rock-bottom geometries portentously unveiled by other artists of his generation—Andre, Stella, Robert Morris, Judd—and, when lit, ethereally defiant of gravity and corporeal presence, his early work appeared to inhabit a pristine world of disembodied intellect, reexamining elementary principles of mensuration or, as in a *primary picture* (1964), rediscovering, via a hardware store's fluorescent spectrum, the three primary colors once sanctified by Piet Mondrian (and reinvented in the 1960s by Newman

and Roy Lichtenstein). Moreover, the tonic cerebration that allied Flavin to Minimalism was further underlined by a growing awareness of his connection to Marcel Duchamp, for what was a store-bought fluorescent tube if not a readymade that could be declared, by intellectual fiat, a work of art?

By the time of Flavin's death, however, the narrow boundaries that constrained the original perception of his work had vanished. For one thing his evolution, like Stella's, moved relentlessly from minimal to maximal, creating what in the early sixties would have been unimaginable complexities of exquisitely reflected colors, of intricately circular and latticelike patterns that could expand into sumptuously engulfing environments. And the associative power of Flavin's art, at first repressed by the chill of Minimalist polemics, has kept growing too, recalling, for one, the intensity of his Irish Catholic background. Hoping to have a priest for a son, his father had consigned him to a Brooklyn seminary, where he was drawn to the drama of the liturgy and its often luminous artifacts. Perhaps that is why the sometimes funereal or mystical quality of his work, with its fluorescent gloom or triumph, redolent of Machine Age populist spirituality, has become ever more potent.

As early as 1964, in his *monument 4 for those who have been killed in ambush (to P.K. who reminded me of death),* first seen in Kynaston McShine's "Primary Structures" show at New York's Jewish Museum in 1966, Flavin invented one of the relatively few visually and viscerally successful metaphors for twentieth-century mass murder, taking the ironic spatial stalemates of corner art explored by his Minimalist contemporaries and re-creating them as a new kind of Crucifixion, with shopwindow red fluorescence becoming a new kind of blood. At other times his lambent altarpieces sanctified art-historical miracles, as in *monuments for V. Tatlin* (1964–70; inspired by the Russian visionary's *Monument to the Third International*), a long series of variations that not only offers precociously postmodern quotations from the most spiritual pantheon of early-twentieth-century aspiration, but also invents a new vocabulary of symmetrical, often cruciform religious heraldry. And if Flavin can at times be interpreted as a modern theologian working with neo-medieval light, he can also be seen as a practitioner of an oppressively phallic technological power, a reading, proposed by Anna Chave (*Arts Magazine,* January 1990), that used for support the artist's own reference to his first "sculpture" of a fluorescent tube at a firm upward tilt as "the diagonal of personal ecstasy."

Then there is a Flavin who can root us in American soil, master as he is of urban melancholy. I often think of this when, rushing to or from a train, I suddenly notice on some other platform at Grand Central Terminal his public commission *untitled, 1976–77, lighting the platform of tracks 18–19, 39–40, and 41–42.* These funneling modular streaks of pink, daylight, and yellow ceiling tubes may relate, of course, to the issues of calibrated linear extension that haunted many Minimalists, but any would-be purism is almost camouflaged in the station by its utilitarian neighbors on parallel tracks. Seen not in a museum but in a workaday city space, Flavin's fascination with America's ugliest and most commonplace form of public lighting seems to revert to grass-roots sources. The world of George Segal's *Cinema* and Edward Hopper's *Nighthawks* is not far away. And there is a flip side as well to Flavin's American scene, for he was equally capable of plugging into the optimistic electronic rhythms of commerce, witness his spectacularly high-tech installations of 1992 (dedicated to his then

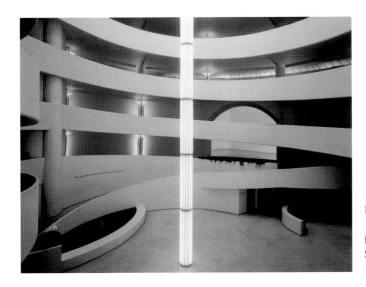

155.
Installation of Dan Flavin's
Untitled to Tracey . . . ,
in the rotunda of the
Solomon R. Guggenheim Museum,
1992

bride-to-be, Tracey Harris) in the cavernous lobby of Chase Manhattan's MetroTech Center in Brooklyn, where his work feels at home with that of Bruce Nauman, R. M. Fisher, and Nam June Paik, and where, like Stella in his later decades, he adjusted comfortably to corporate territory. And then there is his even more surprising alliance with neo-Minimalist fashion, witness his contribution to Calvin Klein's new Madison Avenue emporium (1996).

Now that the light of Flavin's own life has gone out, we may begin to grasp the astonishing range of his art. From a single cylinder of light, the bone-dry attribute of a Minimalist monk of the sixties, he went on to create a teeming infinity of shapes, colors, and phantom spaces, and an equally rich domain of associations, both public and private, sacred and secular. Who could forget his recent triumph in New York (fig. 155), when, in 1992, vastly amplifying a Guggenheim installation of 1971, he transformed Frank Lloyd Wright's rotunda into a neo-Gothic chapel in which a sky-bound column of immaterial pink light was surrounded by a spiraling refulgence splendid enough to provide a setting for his wedding, on June 25? Magician that he was, he could make a fluorescent tube encompass everything from dirge to jubilation.

"Dan Flavin: Name in Lights." Published in *Artforum* 35, no. 7 (March 1997), pp. 11–12.

ALEX KATZ'S AMERICAN ACCENT

1986

ecoming an artist in New York in the late fifties wasn't easy. If you wanted to be an abstract painter and were overwhelmed, and who wasn't, by the heroic grandeur of the greatest Abstract Expressionists, what could you do for an encore? And if, like Alex Katz, you were not only thrilled by the ambitious sweep and universal scale of a Pollock or a Newman, but also thought that commonplace sights like your friends' and family's faces, or the shoes and jackets they wore, were also worth putting on canvas, then things were even tougher. How could you get it all together in one painting? It must have seemed, at the time, that the gulf between the intangible, ideal realm of abstract art and the modest, here-and-now facts of everyday life was unbridgeable. But it turns out, as Katz went on to prove, that it wasn't. His work offers a stunning, indissoluble testimony to what must once have seemed an impossible marriage of the grand and the small, of the epic and the humble.

Take *February 5:30 PM* (1972) or *Thursday Night No. 2* (fig. 156). As their titles suggest, these are paintings that record ephemeral occasions, undramatic social gatherings that are casually clocked by the timepieces on wrist and wall rather than by the cosmic or psychological time of abstract art. The faces are of such individuality that even if we have not met the people, we almost feel an introduction is in order. In the same way, the clothing and hairstyles are so time-bound that a later historian of costume could date the pictures quickly by observing the width of a lapel, the neckline of a sweater, the length of someone's side-

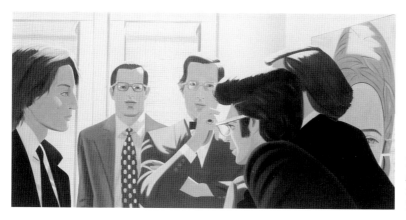

156.
Alex Katz,
Thursday Night No. 2,
1974

burns. But for all this matter-of-factness, these groupings of men and women somehow exist as well in a noble, ideal realm that makes us blink away the specifics of date, place, and name. The interior architecture itself—that of Katz's own loft—imposes, with its head-on view of window frames, the kind of lucid, rectilinear rhythms we feel regulating the spaces of the most dignified old-master compositions; and the figures, too, we realize, follow the subliminal beat of these strong parallel and perpendicular harmonies. Although these people may at first seem to be as easy in their stances as guests at a cocktail party, at second glance, the subtle locking of certain heads and bodies into frontal or profile views freezes the groups as a whole in a serene and unchangeable order. It's as if the noble figures who populate the ideal perspective spaces of those Renaissance paintings Katz has always loved and studied had miraculously been resurrected in the New York of the 1970s and relocated in the architectural spaces of a SoHo loft building.

Even the rendering of details of faces and clothing shares this dual allegiance to present fact and venerable pictorial traditions. For however recognizably Katz records the woven pattern of a tie or skirt, or the exact fall of someone's flowing hair, the level of visual generalization is surprisingly high, with the textures of skin or wall of equal smoothness and the definition of any contour—be it hairline or window blind—of the same, silhouetted crispness. Indeed, in *Thursday Night No. 2* the painted figure of Katz's wife, Ada, in the painting within the painting (on the right wall) belongs to the same realm of abstraction as the presumably "real" figures in the foreground. The instant effect of an almost candid-camera truth slowly disappears, and we find that this seeming realism is everywhere belied, in both the whole and the parts. What begins as a way of seeing that can be literal enough to record, as in *Edwin,* the most particular facts of close-up physiognomy or, as in *Roof Garden,* the very brand name (Vantage) of two packages of cigarettes on a sunlit table is uncannily transformed into a still, imperturbable world that is simultaneously rooted in, but remote from, our prosaic environment.

It is fascinating to watch this phenomenon at work. In *Trio* Katz grasps the spectator's attention instantly with a characteristic device. The three young women are virtually life-size, and they appear to be casually cropped by the frame at hair, elbow, and one shoulder, with one bluntly foreshortened arm extending a water glass outward toward the viewer. We feel that they must be invading our space as we are theirs. Even the light seems to belong to both their world and ours; for it comes from outside the picture on the left, then enters the painted image to glisten for a moment on the two half-filled glasses and a necklace of blue beads, and finally disappears offstage to the right. Moreover, the intricate rainbow weave of the knit sweater is fussy and detailed enough to vouch for on-the-spot visual truth. Yet slowly, the same space, figures, and clothing take on an ever greater distance from the beholder's world. The deep blue monochrome background, whose purity permits no objects or brush marks, leads us to an abstract, spaceless realm; and the light, if shimmering here and there, is suddenly crystallized forever in the broad, clean divisions of luminous against shadowed planes. And with this, the profile and frontal postures again stop the movement of time and space, so that finally, these three young women—Rosalie, Laurie, and Jane—almost seem the contemporary descendants of the Three Graces or perhaps of a trio of silent, motionless saints who stand forever in the limpid geometric spaces of a quattrocento altarpiece. Unexpectedly,

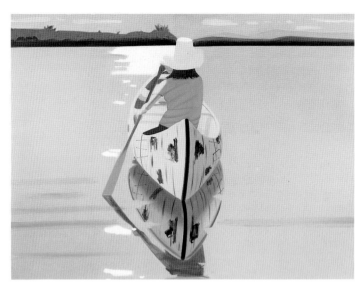

157.
Alex Katz,
Good Afternoon No. 2,
1974

the casual becomes solemn, and even the grave, stepwise ascent of hands on glasses evokes a ritual character.

Throughout Katz's work, the most ordinary, humdrum sights can take on an almost iconic quality. Who but Katz would have chosen to paint, from the experience of an American summer vacation, an empty canoe? And who else would expand it to life-size dimensions across a twelve-foot canvas, and then float it horizontally on a symbolic sea of abstract blue water? Both as real and unreal as its almost, but not quite, unbroken reflection in the still water, the canoe delights and awes us by transforming a lakeside commonplace into an object of mysterious fixity, eternally moored in a horizonless space. Even when the canoe is manned and navigated toward a horizon, as in *Good Afternoon No. 2* (fig. 157), the same spell is cast. The slight irregularities of the coastline and the tilt of the canoe and paddler (typical Katz observations of authentic fact versus arbitrary order) suddenly click into place in a seemingly effortless junction of near and far, parallel and perpendicular. The leisure rhythms of summer have been magically immobilized and preserved in a broad design which, like Katz's simplified modeling in clean-hewn planes, is at once innocent and artful.

In these canoeing scenes, with their quality of plain statements about plain truths, we are often reminded of an American pictorial tradition, harking back, in this case, to those still and silent boating pictures by George Caleb Bingham and William Sidney Mount, which reach their nineteenth-century climax in Thomas Eakins's own paintings of real people in real sculls pinpointed for all time on the watery, but opaque planes of the Schuylkill River (fig. 158). And in this domain, Katz's work can even make us see freshly the likes of Frederic Remington, whose large American idyll *Coming to the Call* (fig. 159) offers surprising previews of Katz's Maine vacation scenes, not only in the sharp, reductive pattern of the canoe and its reflection against water, earth, and sky, but even in the spiky silhouettes of a moose and his antlers, observed with the same startling insouciance as Katz's own close-up encounter with the rear of a moose that has suddenly turned toward the spectator (fig. 160).

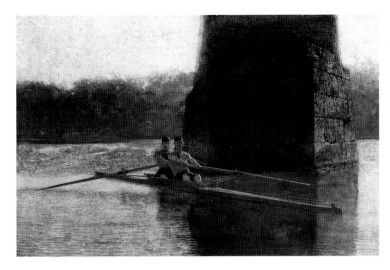

158.
Thomas Eakins,
The Pair-Oared Shell
(The Oarsmen),
1872

159.
Frederic Remington,
Coming to the Call,
1905

160.
Alex Katz,
Moose Horn State Park,
1975

And thinking of the American character of Katz's art, the spirit of more naive folk traditions is also evoked in his straightforward presentation of people, things, and places and in his brusque assertion of palpable fact by a kind of whittled opposition of light and dark surfaces against a flatly patterned ground, a device familiar in the less sophisticated territories of American art, from colonial portraiture to signboard painting and painted wooden figures and animals. At times, we might even think that had the Douanier Rousseau been raised in New York City and had spent his summers in Maine, his pictures might not have looked too different from Katz's.

Nevertheless, this veneer of innocence covers an enormous pictorial sophistication, and Katz's paintings stir up countless sources and references to grander European traditions. As those who know him can attest, Katz talks enthusiastically and knowledgeably about all the old masters, making his points with this Giotto or that Velázquez, and constantly adjusting his own art to their lofty standards. In general, though, it is the domain of Impressionism that offers the most obvious transatlantic counterparts to Katz's vision; and, in particular, it is the likes of Degas and Caillebotte, with their mastery of cropping, of asymmetrical order, of flash-freeze monumentality, whom Katz most often conjures up. *Islesboro Ferryslip*, in its rhythmically measured pier that plunges us swiftly from a close-up to the remote distance and in its seemingly casual confrontation with figures walking out of the picture into our space, has many French ancestors of the 1870s, recalling devices used by Caillebotte a century before in, among other works, the now famous Chicago painting *Paris, a Rainy Day* or by Degas in the portrait of the *Vicomte Lepic and His Daughters*. But the flavor is again that of an American translation, in which softness of atmosphere, delicacy of surface are replaced by a no-nonsense clarity of light and texture.

The point is made even more strongly when Katz depicts scenes familiar in popular memory from the Impressionist repertory of sunstruck leisure. In *Roof Garden,* a double portrait of John Button and Clark Bott enjoying the rooftop of their SoHo loft, the summery world of Manet, Monet, and Renoir is transported from the 1870s to the 1970s and from the suburbs of Paris to the urban core of New York's art scene. Renoir's *Rower's Lunch* provides only one of many French counterparts, where dappled sunlight crosses a trellis pattern and spills over a convivial scene in which smoke and drink contribute to the general détente of mind and muscle. But in Katz's translation of this familiar Impressionist ambience, an American accent again rings clear. Contours are tough and clean, postures of relaxation are frozen, and even the squares of light that float onto the sitters and spot their hair and clothing have as harsh and stubborn a reality as the paired packs of Vantage cigarettes. The fragrant dissolution in the Renoir reverses gears, transforming Impressionist idylls of sensual blur and comfort into an almost puritanical alertness and rigor that would not be alien to the colonial portrait milieu of Copley himself.

As for these pervasive American qualities, it should be said, finally, that Katz's paintings, in the long run, feel most at home with the sophisticated, mainline traditions of American art since 1945. The sheer scale and simplification of his images, with their vast expanses of flat, unbroken color (whether of a lake or of a cheek), join forces both with the most daring inventions of abstract painting in the 1950s and with the kind of billboard-size imagery many Pop artists explored in the next decade. Yet Katz fits into neither category. His absorp-

tion of the structural boldness of such masters as Newman is always at the service of making us see the poetry of the ordinary and never denies the priority of homely detail. And his view of the commonplace, while often attuned to the public, urban scale of Lichtenstein's or Rosenquist's Pop icons, is not an image of social or aesthetic irony, but rather a loving, directly perceived record of the sweet facts of the people and places that provide the continuities of the artist's life. What may finally be most remarkable about Katz's achievement is the way in which he has taken the stuff of daily living and loving we thought suitable only for an uneventful diary entry and transferred it, without a manifesto, to the grand-scale arena of American monumental painting today. Both private and public, modest and proud, these commanding pictures fuse the highest demands of ambitious abstract art with the need to record the quiet truths of personal experience.

"Alex Katz's American Accent." Published in Richard Marshall, ed., *Alex Katz* (New York: Whitney Museum of American Art, 1986), pp. 25–31.

GEORGE SEGAL
1986

W hat first startled me to attention in the glimpses I had of George Segal's most recent work
was a series of painted-relief paraphrases of Cubist paintings and collages by Picasso,
Braque, and Gris. The connection between Segal and this anthology of by now venera-
ble masterpieces in the canon of early modern art initially baffled me. I had always assumed
that Segal insisted on the wholeness of people and things and upon our slow, sustained
response to them, whereas these fragmented, jigsaw-puzzle visions of floating guitars, splin-
tered wineglasses, and shuffled playing cards belonged to an alien territory in which the
tempo was that of a magician providing a kaleidoscopic spectacle so complex and so rapidly
shifting that we could only blink with wonder. What on earth was Segal doing in the land of
Cubist legerdemain where visual artifice reigned? Was this an unexpected leap by Segal into
a younger-generation exercise in postmodernist irony, in which some textbook classics of
Cubism would be wittily restated from a cool, remote distance? That possibility was intrigu-
ing, and I immediately recalled how in earlier works Segal had now and then reincarnated in
his own silent and solemn language the imagery of the great early moderns, whether the
nudes of Matisse (1971–73), a Surrealist chair by Picasso (1973), or the apples of Cézanne
(1981). And, come to think of it, hadn't another Pop artist of Segal's generation, Roy Lichten-
stein, also appropriated famous selections from the anthology of modern art throughout his
own long career?

Yet all such speculations about Segal's joining forces with this erudite, tongue-in-
cheek mode of art-historical quotation began to evaporate before the works themselves. At
first I was dazzled and occasionally amused by Segal's own virtuoso prestidigitations of his
Cubist prototypes. In one, a variation of a Braque still life of 1913, the original Cubist phan-
tom of a pipe—a shadowy void cut out of a strip of newspaper—is solidified into a protrud-
ing plaster reality, as palpable as the plaster bottle, cup, and apples above it; and almost as a
joke, a French newspaper clipping in the same Braque collage is replaced by Dr. Joyce Broth-
ers's column from an American daily. In another variation on a 1913 Braque, Segal's depar-
ture from the original is still more free-wheeling and personal (fig. 161). Here, the specter of
a French wooden table is metamorphosed into a scrap heap of fragments of real wooden table
legs, one of which sticks outward, poking (à la Johns and Salle) into the spectator's space; and
suddenly, we sense that the milieu invoked in these Neo-Cubist reliefs is not so much the
world of Parisian cafés on the eve of the First World War but rather the nostalgic wooden

161.
George Segal,
*Still Life with Shoe and Rooster
(Braque),*
1986

debris of a rural American attic. Moreover, a surprising inventory of still more personal refer-ences begins to reveal itself, from the G.S. monogram on the packing-case fragment in the upper left and the brash red R, familiar from the typeface of Segal's earlier American street signs, to the plaster rooster (an allusion to Segal's own chicken farm in New Jersey?) and the coarse, unlaced farmer's shoe (which again returns us to New Jersey farm soil, as well as to the peasant domain of van Gogh's famous shoe portraits). Indeed, the infusion of a somber, personal reverie into these Neo-Cubist works slowly becomes a strange, overriding presence that reaches an unexpected clarity in his variation on a Picasso motif in which the whimsi-cal, Chaplinesque guitarist of many Cubist originals is first wittily given a real bow tie and then poignantly crowned by a plaster cast of Segal's own face, as if the artist himself had somehow been embalmed and buried with these time-bound relics from the illustrious his-torical past of modern art. And here, definitively, the mood of cerebral virtuosity, with Segal juggling once again the crackling dialogue of Cubist fact and fiction, is transformed into an elegy that smacks of another kind of dialogue far more familiar to Segal's work, that between art and mortality.

So it was that although at first glance, these Neo-Cubist reliefs seemed to compose a coherent series different enough from Segal's usual work to be considered quite apart from it, on second thought, they produced the same disturbing vibrations that characterized the

other new work—painted plasters, drawings, and now, even photography—which has absorbed the artist in the last few years. Thus, the apparently unbridgeable gulf between the ostensible formalism of these homages to Cubism and their most obvious antipode in Segal's latest work, the magisterial and heart-breaking portrait of the late Senator Jacob Javits (fig. 162), becomes ever more narrow. Before the Javits portrait of 1986, executed while this great New Yorker was bravely staving off the imminent conclusion of a fatal disease, we are overwhelmed by the sheer pathos of an intimate human truth, which seizes the particularities of a famous statesman's face and posture, as well as a more universally recognizable sense of resignation and inwardness in the contemplation of an inevitable death.

But this awesome confrontation with the facts of life soon turning into death is also deflected by matters of history and of art. Do we sense, especially in the choice of the traditional senatorial chair to commemorate Javits, that this moving effigy is to be added to the grand American dynasty of Daniel Chester French's giant marble icon of Abraham Lincoln, who, seated in a classical revival chair, is enshrined for eternity in his memorial temple in Washington? But Cubist issues oddly surface here, too, in the thoughtful meditation on the discrepancies between artifice and reality, in which the multiple components at the artist's disposal are itemized and then reintegrated. In this case, the Cubists' constant alternation between the realities of collage fragments and the fictions of picture-making, between the three-dimensional potentials of sculpture and the two-dimensional restraints of painting, is boldly polarized. The life-size sculpture of Javits himself, the seeming epitome of waxworks illusionism, is set in front of what might register as a totally abstract painting, whose dimming clouds and streaks of grisaille shadows recall similar passages in the work of another master of the back-and-forth dialogue between real objects and the disembodied language of painting, Jasper Johns. And in a quiet, penetrating way, this polarity is slowly reconciled, as we realize that the grisaille tonality, fraught with traditions of the artist's technical artifice, casts its melancholy pall on both the "painting" and the "sculpture" in the Javits portrait, so that the entire figure becomes absorbed in a gloomy mortuary light. Indeed, as in many Cubist paintings, the artist's technique of chiaroscuro modeling is at once obedient to the external phenomena of nature (light-and-shadow patterns conform partially to the prosaic expectations of ordinary perception) and to independent, internal systems invented by the artist. One begins to realize here that Segal has extracted from the Cubists' intellectual seesawing between the facts of life and the fictions of art his personal translation of the way in which the inert, enduring stuff of plaster and paint could be ordered into its own vital and independent patterns as well as how it could register the quietly expiring pulse-beat of our own lives. It was a point he had implicitly made much earlier, in 1967, in the white plaster portrait of Sidney Janis contemplating an actual painting by Mondrian on an easel, a work in which the two realms of art and life, of abstraction and reality confront each other in an abrupt collision. But now, in the Javits portrait, these oppositions are more deeply fused, permeated with the introspective, darkening light one associates with the late styles of such old masters as Titian and Rembrandt. With this in mind, even Segal's Neo-Cubist works begin to exude the same aura of retrospection and embalmment, in which the flickering vitality of the original Cubist prototypes—so different from the stillness we expect from Segal—seems to petrify, a fossil from the past of art history and from the artist's own memories.

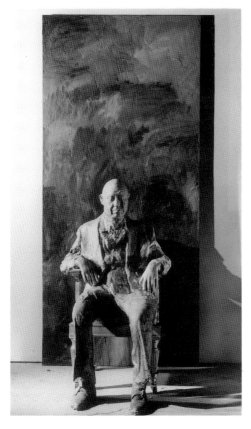

162.
George Segal,
Portrait of Jacob Javits,
1986

 This sense of vital forces slowly being extinguished as we observe them is, in fact, a pervasively tragic theme in these new works. It is found, for instance, in a counterpart to the Javits portrait, a grisaille couple (modeled after members of the artist's own family) seated against another abstract gray-painted wall, whose dully twinkling and clotted light drains away the figures' corporeal presence as sculpture and as people; and it is found again and again in Segal's recent drawings and photographs. As for the former, there are intimate family portrait drawings in which a chiaroscuro web camouflages, like the luminous abstract networks of Analytic Cubist drawing and painting, the faces below that surface and disappear like ghosts; and as for the latter, there are photographs of the facts of human mortality as shockingly true as the Javits portrait. Of these, it is surely the two documents of Segal's own very aged mother, Sophie, on her deathbed in Middlesex Hospital (fig. 163) that will leave the most indelible impressions, balancing as they do the unlikely equation of an intensely traumatic experience for the artist himself and his professional obligation to transform life (or, here, death) into art. For here, the brutal photographic record of a human being's last moments, as revealed in the painful, ultimate scrutiny of a mother's expiring face, is countered by what seems almost an abstract photographic study of light and shadow patterns created by hollow cheek and disheveled white hair, by pillow creases and the fall of hospital sheets. One is reminded of how Monet, in 1879, painted his wife, Camille, on her deathbed

163.
George Segal,
Sophie at Middlesex Hospital,
1985

as an act, to be sure, of wrenching private tribute, but also, as it turned out, as a problem in painting, for he later testified how he could not help being fascinated by the yellow, blue, and gray tones that emanated from the head of his wife's corpse. For Segal, too, and nowhere more than in these recent works, the vitality of art and the inevitability of death converge in a haunting limbo where both triumph.

"George Segal." Published as the introduction to *George Segal* (New York: Sidney Janis Gallery, 1986).

ALFRED LESLIE

19/6

After 1945 abstract art became so brilliantly inventive and demanding that most of us, myself included, assumed that any other kind of painting and sculpture, no matter how appealing it might be, was doomed to play the role of a timid bystander located at a vast distance from the dramatic superhighway of abstraction. But already in the early 1960s, the finest Pop artists successfully challenged the idea that innovative art had to be abstract, although to do so, they had to digest, as well as contribute to, the new kinds of pictorial structure—clear, tough, clean, and diagrammatic—that the best abstract artists of the decade were also exploring. Were this not the case, Johns and Stella, Warhol and Judd, Lichtenstein and Noland would not look as compatible as they do in the great collections of 1960s art. But the realism of the Pop artists was based not on a direct perception of things seen in space and light but, rather, on the recording of images already rendered schematic by the simplifying processes of commercial printing. Pop art's realism was of an oddly abstract kind, much as Seurat's poster-derived late style was drastically unlike, say, the on-the-spot Impressionism of Monet. The question of a more naive, one-to-one relationship with palpable things actually present before the artist was still held aside. But now, in the 1970s, it would seem that the issue of painting from immediate observation has loomed larger and larger, thanks not to any change in theoretical position, which should always follow, not precede, the experience of art, but simply to the fact that for over a decade certain American artists have been painting realist pictures that suddenly have begun to look so strong, so intense, so compelling that we can no longer ignore them. They are finally demanding attention from audiences that had earlier found them invisible.

It is those artists who work primarily with the human figure who seem to make the most passionate bid for our renewed belief that things seen can still be recorded with the kind of full-scale passion and energy we have tended to relegate only to the making of abstract art. Among these painters—and the list would include Philip Pearlstein and Alex Katz—Alfred Leslie occupies a special place. One singular thing about his art is that he began not as a realist but as an abstract painter, whose personal imprint upon the slashing, bravura style of de Kooning was already recognized in 1950 by Clement Greenberg, who selected him that year for a youthful New York debut in a "New Talent" show at the Kootz Gallery. Indeed, Leslie's work of the 1950s has a secure place, along with that of artists like Michael Goldberg and Joan Mitchell, in the history of second-generation painting of the New York School. Leslie's

about-face after 1962—first rejecting his late variation of "action painting" and then exploring full-time the visible facts before him—was therefore a choice made of experience, not innocence, of the potentials he found in abstract art. But what should also be underlined is that, in broader terms, his sense of the exhaustion of the de Kooning branch of Abstract Expressionism corresponded to the response of other younger artists around 1960, whether Johns or Stella, who similarly demanded a kind of pictorial housecleaning in which fixed, lucid, and frontal images replaced the spatter, flux, and shuffle of "action painting." Leslie turned, however, not to abstract but to realist reform, and he did so with an increasingly acute awareness of those old-master predecessors whose historical position was analogous to his.

Leslie's art, in fact, bears conscious affinities with Caravaggio's and David's heroic realism, and for a number of telling reasons. It should be recalled that both Caravaggio and David appear, in retrospect, as great reformers who finally buried the artificialities of style that characterized the generations immediately preceding them (an effete and belated Mannerism in the case of Caravaggio; an equally complex and stylish late Rococo in the case of David). Their rejuvenation of truth and nature in art took the form of a fresh and passionate scrutiny of the simplest physical facts—how a single human form occupies the plainest of spaces; how figures obey the commonplace visible laws of nature; how light and shadow define a clear volume; how muscles and limbs respond to the pull of gravity. Leslie, too, in trying to purge his art of the intricate conventions of a moribund Abstract Expressionism, turned to the starkest kind of reexamination of single figural facts. Works such as his self-portrait (fig. 164) or his nude portrait of Judy Duboff, both of 1966–67, share Caravaggio's and David's ardent, reformatory goals by wiping the pictorial slate clean and imposing the problem of recording, with maximum clarity and minimum artifice, the indivisible presence of a single, standing figure. The stark symmetry and frontality of these figures are complemented by their direct and guileless postures. Any incidentals of the implied interior space, whether walls or furniture, are rigorously excluded so that we may experience, as if for the first time, the raw and truthful confrontation with a human being who occupies a space as real as ours.

The reduction here to the sheer fact of a staring presence may at first look remote from the preoccupations of Leslie's contemporaries, but I think, from a longer-range view, that it is not. A main current of abstract art in the 1960s has been characterized as "minimal art" and "art of the real," implying that this post–Abstract Expressionist generation has rejected the complex illusions of shattered and fluent forms in favor of the more literal, nearly diagrammatic formats of, say, Johns's targets and Noland's concentric circles; of Stella's black rectangles and Andre's floored metal squares; of Tony Smith's and Judd's four-square assertions of inert solid geometry. This insistent literalness of the 1960s may in fact be extended to include such things as Warhol's static and frontal presentations of soup cans or photoseries, and even the kind of Photorealism practiced by Chuck Close, whose blow-ups of portrait photographs are equally unrelenting in their head-on presentation of unmitigated grisaille facts.

The reformatory zeal of Leslie's early realist portraits belongs to this decade, compelling us to stare hard and close up at the simplest visual experiences. But of course art is art and finally different from whatever literal fact it re-creates, so that Leslie's painted figures are no more interchangeable with their models than are Stella's arcs and rectangles to be mis-

164.
Alfred Leslie,
Alfred Leslie,
1966–67

taken for demonstrations of plane geometry. Thus, in Leslie's figures of 1966–67 we already sense the uncommon intensity with which these commonplace mortals are re-created in paint on canvas. This has to do not only with their iconic centrality but also with their uncannily harsh light, which, like that of Caravaggio and his followers, clarifies the volume of the human body while at the same time giving it an almost magical glow and isolation. Fixed for eternity, but time bound in their tumbles of hair, wrinkles of flesh, casual clothing, or blunt nudity, these figures confront us hypnotically. Familiar in homely detail, they are nevertheless unfamiliar in the penetrating stillness and clarity of the whole.

As in the case of abstract artists of the 1960s who started with equally elemental structures and then proceeded to complicate them, Leslie also began to enrich and vary these stark presences of 1966–67. Thus, the portrait of his wife, Constance, of 1968–69 alleviates these stiffly vertical symmetries with a torrent of dress folds as intricate as an excerpt from de Kooning but here translated into a fabric as palpable as the figure's flesh and bone. Indeed, these ambitions to attempt, slowly and cautiously, the rendering of ever more complex textures and foreshortenings and to permit even the inclusion of furniture and still-life detail can be traced in the growingly elaborate and often multiple-figure groupings of the late sixties and seventies. Emotional factors also become more conspicuous and varied in these works, as in the haunted, unblinking gaze of *Dina Cheyette* or the disturbing tug-of-war between intimacy and isolation in the double portrait *Floriano Vecchi and Richard Miller*, where the physical proximity of the sitters is strangely undermined by the psychological distance between two silent heads in abruptly contrasted profile and frontal views.

The most elusive and evocative of these images of inwardness and solemnity is the ambitious three-part grouping of Leslie's wife, entitled (after a section in Spengler's *Decline of the West*) *Act and Portrait.* Conveying the sanctity of a religious triptych from the past but offering a more modern message of an ambiguous, unspecified psychological and dramatic sequence, these meditative portraits move from the passionate determination of a woman who holds the very message (as transcribed by David) Charlotte Corday sent to Marat before murdering him; to the central, taller icon of the same woman in modern clothing considering, shotgun in lap, an act of violence; to the final, more primal image of a naked pregnant woman who, like the Virgin as painted by Georges de la Tour, seems both to irradiate and to reflect a mystical light that serves as metaphor for the fusion of natural and supernatural wonders.

Leslie's dialogue with the old masters is particularly alert in this portrait trio, witness the abundant allusions to David's portraits in the dappled monochrome backgrounds, the spatial muffling of the juncture of wall and floor, the crisp and sharp-focus description of draperies and furniture, the pairing of austere, rectilinear axes with the more undulant linear rhythms of flesh. Indeed, this constant consultation with the past is typical of his more complex works. Old-master authority is again a touchstone in his immense revision of Thomas Cole's 1836 view of the Oxbow, that is, the bend in the Connecticut River near Northampton (fig. 165). Leslie's wish to restate Cole in fresh, empirical terms is rather like Cézanne's desire to redo Poussin after nature, for both artists attempted to maintain the ancient bones of old-master structure while reexamining the way in which these time-honored skeletons could be newly fleshed out with the rejuvenating results of on-the-spot observation. Leslie's reprise of Cole's painting is no less obsessive, as a vision of landscape, than his perception of the human figure. The sublime drama of Cole's blasted, leafless tree and breathtaking vista is resurrected in disarmingly literal terms that force the frailest of wiry branches to hold its own in the expansive foreground against a cliff-hanging, panoramic view that rushes us harshly from the botanical detail at our feet to an abyss of atmospheric haze that merges the far dis-

165.
Alfred Leslie,
View of the Connecticut River as Seen from Mount Holyoke,
1971–72

166.
Alfred Leslie,
*The Killing Cycle (#5):
The Loading Pier,*
1975

tant hills and horizon. By looking this hard at the topographical facts that Cole had softened and poeticized, Leslie would both challenge and resurrect an American landscape tradition.

The same adventurous testing of a classic with its equivalent in contemporary experience is found in Leslie's heroic efforts to commemorate the poet Frank O'Hara's fatal accident at Fire Island in the summer of 1966 (fig. 166); for here, the shrill and modern facts of a pedestrian felled by a beach taxi are translated into a pictorial formula supplied by Caravaggio's *Entombment.* Leslie's characteristic nowhere environment, theatrical lighting, and glazed eyes are now combined with the grandiose structure of Christian tragedy, with results that echo back and forth between sacred past and secular present, between abstractly ordered figural composition and jarringly literal modern dress. In its enormous daring, this is a painting that obliges us to test the possibility today of measuring ideal, old-master conceptions against an unflinching insistence on contemporary truth. And in this difficult and precarious balance, Leslie's painting, we should remember, had an epoch-making American ancestor two centuries ago in Benjamin West's *Death of General Wolfe* (see fig. 2), which similarly translated a traditional Lamentation group into the language of modern journalistic fact.

Whether overtly complex or simple, Leslie's paintings are equally marked by a passionate belief in the importance of recording things seen in the grand and ambitious context of both old-master painting and recent abstract art. It is a hard path to walk, but on the evidence of the paintings, Leslie can do it; we stand still before his work. His full-scale conviction not only makes us eager to see his next achievements (like the quartet of figure paintings that will make their debut in this exhibition), but may even demand a radical rewriting of the last ten years of art history.

"Alfred Leslie." Published as "Notes on Alfred Leslie" in *Alfred Leslie* (Boston: Museum of Fine Arts, 1976).

REMEMBERING JOE BRAINARD

1997

I remember *I Remember.* Joe Brainard first published it in 1970, and way back then, as now,
I usually put aside, unread, most volumes of poetry or arty writing that happened to come
my way.

But this one startled me to complete and loving attention. First there was the cover,
with the archaic kiddie photo of the author announcing what was to come, and then, there
was the achingly honest and sweet litany of childhood memories that we all could share.
Speaking from one heart to another, Joe Brainard brought up on the tender screen of nostal-
gia all those delicious things that nobody before him seemed to think were worth recording.
What a quiet epiphany it was to discover that somebody among us chose to remember
"salt on watermelon" or "not looking at crippled people" or "wondering what the bus driver
is thinking about" or "how unsexy swimming naked in gym class was." I never forgot the
impact of this first-person catechism of ordinary devotions to ordinary experiences that some-

167.
Joe Brainard,
Whippoorwill,
1974

168.
Joe Brainard,
Untitled,
1972

how reached every corner of the childish bodies and minds we carry within us; but I must confess, too, that I almost did forget that Joe Brainard was as extraordinarily touching and authentic an artist as he was a writer. Shy to the point of making you think he was putting an imaginary foot in the sand and becoming the archetypal wallflower he might have remembered from a high-school dance in his native Tulsa, Oklahoma, he never had a careerist temperament. He cared about making art, and when he became dissatisfied with his own, he stopped exhibiting, by his own choice, almost disappearing from view in the eighties and nineties. For those like me who were around in the sixties and seventies, when his art flourished, he became a distant memory. For a younger generation, he was largely unheard-of.

So I, for one, am rejuvenated and cheered by this chance to see again, more than two decades later, the extraordinary lightness and breadth as well as the miniaturist intensity of Joe Brainard's art. Like *I Remember,* it is composed of modest, yet fully heartfelt vignettes of those little experiences most of us would ignore or deem unworthy of our mind's or eye's focus, prosaic details sometimes singled out for individual scrutiny and sometimes pieced together as on a bulletin board or in a scrapbook found in the family attic. I was fascinated to discover in just one work, of 1972 (fig. 168), the kind of inventory of objects and memories that pervade *I Remember,* in this case, a visual buffet of American madeleines. These include, among other things, some edibles—French fried potatoes, two factory-made hunks of candy,

a table wafer—some souvenirs from somewhere about the house—a pickaninny doll, a die, a childhood photo, a saved foreign postage stamp (British), a comic-book snippet (Pluto), a lot of crushed cigarette butts—and also some reminders that nature was just outside—a butterfly, an ant, some mushrooms, a pansy, a kiddie drawing (the artist's own?) of a house in the country under a sunny sky, with one cloud and two trees. Light-years away from the stress and strain of adulthood and the New York art scene, Joe Brainard, without fanfare, wafts us back with him to some childhood or teenage idyll, where nothing is threatening and where the biggest excitement might be a letter from abroad or the Sunday comics. Serenity and comfort prevail. The house pet, a whippet, is painted again and again snoozing this way or that on the couch, carpet, or lawn or just looking through a door (fig. 167). A single cup of coffee or five plucked cherries or a lone trout on a bare white plate is quite enough for a little drawing or painting. And there is no fretting about becoming a big artist with a capital B and A. Why worry about forging a prominent signature style when there were so many agreeably various little ways of drawing and painting, not to mention cutting, pasting, and embroidering? In fact, in a complete indifference to urban tempo and style, Joe Brainard often turned to loving adaptations of the most painstaking, labor-intensive folk-art techniques in tune with the grassroots American summers he would spend in Vermont with his lifetime companion, Kenward Elmslie. There, like some rural granny who had never visited the big city and who had endless time and patience on her hands, he would cut out exquisite filigrees of gorgeously colored paper flowers or butterflies, as teeming as the grass outside the door and as beautiful and bountiful as an advertisement for nature at its best. Or else, putting his Exacto knife aside, he might pick up his rickrack embroidery, turning out cheerful rows of flowers that look like wondrous excavations from another century's yard sale.

Such genuine sweetness and boyish innocence mark as well his pictorial billets doux. One, again reverting to childhood memory, dresses a teddy bear in a T-shirt inscribed with KEN and a heart; another, still more touching, presents everything in loving duos (two hearts, two ties, two pairs of undershorts, two T-shirts, two clouds), a Valentine's card of perfect emotional pitch. And in this ambience of gentle affection, even the crassest stuff of Americana refuses to look vulgar when transported to Brainardland. In this artist's hands, even a Holiday Inn sign, a few boxes of Tide, or a comic-strip character like Nancy looks like something from an imaginary, preindustrial world, viewed with the enchanted love of a remembered first encounter. And his occasional forays into mildly risqué jokes or erotic awakenings are equally tinged with fairy-tale charm, whether it's Nancy lifting her dress to reveal what she'd look like under it "if she was a boy" or an excitingly murky and clandestine view through a shaded window of a cute young guy wearing nothing but Jockey shorts.

Being an art historian, I of course began to think about how, if at all, the precious jigsaw-puzzle pieces left by this unique artist might fit into the big picture of later twentieth- century art; and here, the wheels of history and chronology can start to spin fast. Could we make a place for Joe Brainard as a Pop artist? Turning away, but only when he felt like it, from the self-taught art-school techniques of modeled, realist drawing and painting to the brash flatness of Nancy or Pluto, might he not be put in a lineage with Lichtenstein or Warhol? But on the other hand, where's the irony and the rebellion? Joe Brainard just plain loved Nancy, as a kid would, and was delighted to mix her up with the history of art, as he did on the cover

169.
Cover of the September
1972 issue of *ARTnews*

of the 1968 *ARTnews Annual,* dedicated to the avant-garde, and as he would later do in a drawing of 1972 in which (shades of Peter Saul's, Robert Colescott's, and Mel Ramos's later variations) Nancy suddenly becomes a flailing de Kooning woman. So maybe he's really a postmodernist, as evidenced by his patchwork quilt of mainly art details for *ARTnews*'s seventieth-anniversary issue (fig. 169), which anthologizes famous tidbits taken from the usual pantheon of old masters, from Rembrandt to Stella. But this cheerful historical shuffle also includes everything from a yellow smile-face to a child's happy rainbow, embarrassing us about the very pretentious idea of trying to pigeonhole the work into an "ism." Similarly, when we look at some of the collages and assemblages of this and that, whether of Chiclets, cigar-box owls, playing cards, or religious artifacts, we can quickly cough up names that range from Schwitters and Ernst to Cornell and Thomas Lanigan Schmidt, but these names, too, evaporate before the unpretentious facts of his work. And he can even, if we want, be

brought up to 1990s date, as we realize, say, that his use of a childhood past might give us a preview of the nostalgic regressions of so many recent artists, from Duncan Hannah to Mike Kelly, or that, on a totally different wavelength, Damien Hirst's artistic recycling of crushed cigarette butts might look déjà vu after we've seen what Joe Brainard quietly did at home with the same theme back in the 1970s.

But if his art can look backward, sideways, and forward, it refuses to join the march of history, staking out its own magical territory that, beginning with a totally private world, somehow manages to put us all in the same boat. A recent poem by Geoffrey Young might sum it all up with only a title and three lines:

> *A Quilt Patch*
> *The size of the night sky*
> *& a book of matches*
> *for Joe Brainard.*

"Remembering Joe Brainard." Published in *Joe Brainard: Retrospective* (New York: Tibor de Nagy Gallery, 1997), n.p.

ROBERT MOSKOWITZ

1983

Those of us who were around in 1962 and who were lucky enough to step into Leo Castelli's on the right day never forgot an exhibition of paintings of nothing but window shades by an artist named Robert Moskowitz. The idea of identifying most of a picture's surface with a half-drawn shade, concealing a view beyond, had been explored earlier, and with a more overtly old-fashioned poetry, by Loren MacIver (in 1948), and would be tried later, with a more overtly up-to-date, cartoonlike symbolism by Philip Guston (in 1979); but Moskowitz's 1961–62 window shades were something else again. They seemed to push both the basic language of painting and the fundamentals of image-making to a startling economy, where suddenly the two worlds were forever fused—a flat painting equaling a flat window shade. Since that show, Moskowitz has remained a shadowy figure, exhibiting more often away from than in New York, where he was most likely to be seen in group shows rather than in solo appearances, and where he survived mainly in memory and art-world rumor.

It's a special occasion, then, to be able once more to savor the strange power of his work, which now, more than ever, merges what seems the most pruned and taut of abstract structures with the most purified and isolated of identifiable images. Here, the commonplace becomes magical, with familiar objects, monuments, and natural wonders transformed into the icons of a private sanctuary. Who else would dare to make such a tall, thin painting out of nothing but the dark, flat shape of a smokestack piercing a monochrome ground plane? Who else would think of reincarnating the grandeur of Rodin's *Thinker* by ironing out its agitated sculptural surfaces into the cleanest, yet craggiest silhouette, projected upon a sea of vibrant paint textures?

The seeming simplicity of these icons, which often resemble illustrations from a child's idea of an encyclopedia, relates them to those paintings of the 1960s and 1970s that have been categorized as "New Image" or "Primary Image," and indeed Moskowitz's work can feel at home in the company of a Jenney or a Rothenberg. But this said, his art might be located no less comfortably in the category of the American Sublime or of nocturnal visionaries like Ryder. For one thing, there is the epic scale of his paintings (and, more surprisingly, his drawings), which often puts him closer to the Abstract Expressionists than to his younger imagist colleagues. Like Newman or Still, he provides no anchor, no foothold for the terrestrial viewer, who becomes alien even to a domain that includes not only marvels of a prehistoric landscape but even such monuments of our own modern culture as the Flatiron

Building, the Empire State Building, or Rodin's *Thinker.* Typically, the ground plane disappears entirely, so that a bottomless windmill or skyscraper rises what must be countless miles above the earth, and Rodin's image of primitive ponderation becomes a gravity-defiant colossus without a pedestal, looming over us like a deity. It is characteristic of Moskowitz's wish to dwarf human scale that he stipulated that his horizontal panorama of the image-making pair of Monument Valley rock formations, the Mittens, be hung just six and a half inches from the floor, a position that would locate the viewer above a sublime abyss.

Moskowitz's creation of a mythical scale, of an environment where any event might involve dinosaurs or supernatural beings, is similarly reinforced by his extremes of light and dark, a fairy-tale polarity that excludes the familiar mixes and varieties of daylight and shadow of our waking lives. As dreamed up by Moskowitz, the Flatiron Building is an opaque, windowless expanse of murky black, seen against an even blacker night sky that suggests an uninhabited, perhaps postapocalyptic world where the sun may never rise again. In his black-on-black fantasy of the Eddystone Lighthouse's steadfast column, this nocturnal realm is startlingly interrupted by its luminary extreme: an ominous blaze of light that emanates, without visible human presence, from the upper-story windows in a Genesis separation of light from darkness.

Such stark polarities and reductions pertain as well to his insistence on the most lucid of surface patterns, whose abstract life he emphasizes by underscoring a primary alphabet of the textures of painting. Often he runs the narrowest of colored lines down the painting's edge, as if to reaffirm the decorative continuity of his drum-tight designs; in the painting *Seventh Sister* (1981) he even runs a gold line straight down the center, from top to bottom, intersecting the geological silhouette of the mountain precipice in an effect that might be described as a pictorial wedding of the archetypal abstract images of Still and Newman. (Coincidentally, a similar effect could be observed in the Scandinavian "Northern Light" exhibition, in the painting *Waterfall at Mäntykoski* [1892–94], by the Finn Akseli Gallén-Kallela, in which a naturalistic rendering of mountain rocks and cascades is intersected vertically by five symmetrical bands of gold.) Moreover, far from being inertly flat or opaque, Moskowitz's surfaces constantly call attention to their physical presence as gorgeously painted skins, sometimes burnished to the sleekness of dense slate, sometimes flickering and luminous, but always apparent as a major abstract component in a decorative jigsaw puzzle.

Like most rewarding art that at first seems childishly simple, these works keep resonating with sophisticated layers not only of visual complication but of art-historical allusion. As for the latter, Moskowitz's images may at first seem so direct, so elemental that we can scarcely imagine their having a source; but in fact many of them reverberate with surprising precedents that give them still denser associations. If Rodin's *Thinker* and the Flatiron Building as subjects seem a very odd pair, didn't Edward Steichen select exactly those two motifs to create some of the most evocative, phantomlike photos of the turn of the century? If Moskowitz's ability to extract a haunting, hypnotic mood from a single smokestack seems uncanny, didn't de Chirico prepare the way for this in his own transformation of the tallest Ferrarese factory chimneys into potent dream symbols? If Moskowitz can reconstruct windmills and lighthouses as shrines of stability and faith in times of vast unrest (fig. 170), didn't Mondrian do exactly this in 1909–10, when under the sway of Theosophical mysteries?

170.
Robert Moskowitz,
Mill,
1981

171.
Robert Moskowitz,
Big Picture,
1979–80

Moskowitz has a subtle, almost subliminal way of resurrecting some of modern art's most memorable images in his own stark language, while at the same time repaying his debt to this tradition so amply that his historic references seem only the dimmest, if ever-present, ghosts.

In general, Moskowitz weaves his spell with single images, but at times his ambitions can encompass a broader scope. His triptych, *Big Picture* of 1979–80 (fig. 171) is epic in size and theme, presenting nothing less than a transcontinental panorama that extends from Los Angeles to New York. Against the night sky so ubiquitous in Moskowitz's work we see at the far west the beacon searchlights of Hollywood, a familiar image that had already been translated into art in Ed Ruscha's famous Pop icon, but that is expanded here to astronomic scale. Thousands of miles and two hundred inches away, across the black void of the North American continent, looms a fragment of the Empire State Building, whose Art Deco geometries are magnified almost beyond recognition, transformed, as in Mondrian's *Broadway Boogie-Woogie*, to an archetypal image of the New York skyscraper. This cosmic breadth, this alpha-and-omega vision of the United States, creates here an awesome apparition that is at once dream and apocalypse, a history of America made for the time capsules of science fiction. Once again, Moskowitz leads us on a dizzying voyage from the here and now of modern art and life to his own mythic realm, and once again the New York art world has access to its magic.

"Robert Moskowitz." Published as an introduction to *Robert Moskowitz* (New York: Blum Helman Gallery, 1983), pp. 5–8.

A POSTSCRIPT:
SOME RECENT NEO-ROMANTIC MUTATIONS
1993

No one, I am certain, will ever define Romanticism clearly, but then, no one will ever be able to drive a stake through the heart of a word that, for want of a better one, we cannot refrain from using when we try to describe the protean range of new forms and feelings that emerge in the late eighteenth century. Considering that it may be called into service for both West and David, Goya and Blake, Friedrich and Delacroix, Canova and Rude, logicians could surely tell us that Romanticism means either much too much or nothing at all. Nevertheless, most of us in the business of history know that something shattering happened in the late eighteenth century—T. E. Hulme called it "spilt religion"—and that ever since, the shock waves have been registering with varying intensities on the Richter scales of art. The word, of course, is so slippery that it can accommodate even the most ostensibly anti-Romantic aspects of the modern movement, embracing every contradiction. What could be more Romantic than Mondrian's or Malevich's dream of purging painting of everything but a distilled abstract purity, as untainted by the seen, material world as, say, Flaxman's Homeric outlines? What could be more Romantic than the realization in 1927 of a harmonious community of low-budget houses in Stuttgart, a vision of social and aesthetic utopia in which geniuses as individual as Le Corbusier and Mies van der Rohe joined forces in a brotherhood of reformatory purpose and style whose pedigree could be traced back to the likes of the Nazarenes or the Pre-Raphaelites? What could be more Romantic than Picasso's or Matisse's espousal of African art in an effort to reach under and beyond those moribund Western traditions that Romantic artists as different as Ingres and Blake had already hoped to undermine in a search for more vital and therefore more archaic sources of art? If we choose, the semantic fire of the infinitely molten concepts evoked by Romanticism can ignite speculation about any art of the last two centuries. Nevertheless, the nostalgic revivalist mode of the last few decades, best characterized by a word—postmodernism—as ungraspable as Romanticism itself, but at least restricted in time to the later twentieth century (until perhaps we start using it retroactively to characterize, say, the "proto-postmodernism" of Reynolds's appropriations or Nash's witty architectural eclecticism), has turned up a diverse spectrum of art that, instead of looking forward to the Brave New Worlds promised by modernism and worshiping at the shrine of progress, appears to resurrect with irony or longing (or a mixture of the

two) a wide range of Romantic imagery and attitudes. Here is an anthology of some of these visual events, which have to do mainly with things remembered as the twenty-first century looms on the horizon: Planet Earth and the pageant of art history.

Landscape or, more cosmically put, nature was the site of countless original Romantic meditations on ultimate mysteries. For the modern movement, however, it became an endangered species that deflected attention from the marvels of a new man-made world. But since the late 1960s, it has been resurrected and venerated in countless ways, as we realize with growing alarm that the ratio of what was on this planet and what we added to it has changed drastically and for the worse since the Industrial Revolution.

Earthworks are surely the most spectacular and Romantically heroic efforts to establish some mystical contact between artists and the great universe of earth and heaven out there. As pilgrims to the sublime, breaking free from the confines of museums and galleries, these new voyagers have gone, often literally, to the ends of this earth in order to make a human mark so that we, and perhaps some future extraterrestrials, will know that the impulses that produced Stonehenge and the great pyramids are still, against all odds, alive. Robert Smithson's *Spiral Jetty*, with its earth-hugging organic coil spiraling against a site worthy of an Old Testament miracle, is an archetype here; but others have established no less awesome and fearful dialogues with lightning, ice, and sky. Walter De Maria's *Lightning Field* in New Mexico is, among other things, a human offering to the wrath of a Christian or pagan deity, ready to discharge its malevolent bolts. As a new kind of shrine, it has no less extreme counterparts in the ice sculptures created by Andy Goldsworthy in arctic climes (fig. 172), even at the North Pole itself: purist, crystalline fantasies that conjure up the chilling specter of Friedrich's Romantic vision of an explorer's ship wrecked for eternity in a Gothic tombstone of icebergs. And still under way—perhaps the most ambitious of all earthworks and all attempts to reunite us pitiful mortals with cosmic time, light, and space—is James

172.
Andy Goldsworthy,
Touch North,
April 24, 1989,
1989

173.
James Turrell,
Roden Crater,
near Flagstaff, Arizona,
begun 1982.
Aerial view looking east

Turrell's *Roden Crater* (fig. 173) in Arizona, an extinct cinder cone in a volcanic field that is being subtly altered by the artist's painstaking wizardry in order to put us in regulated synchrony with the cycles of sun and moon, with the unimaginable time of earth's history, and with the changing phenomena of the void of the sky above being suffused with celestial light, day after day. Next to this total immersion in the universe, even Friedrich's *Monk by the Sea* seems only a modest contemplation upon the minuscule place of a lonely wanderer in the scheme of things. Less macrocosmic explorers of our planet also extend Romantic discoveries about the organic world we inherited from prehistory and are now swiftly killing. For one, Richard Long, whether in his relics of stone, wood, or mud brought back from arduous walks in unpolluted landscapes to the spaces of galleries and museums or in his quiet documentation of these ambulatory communions with the British countryside, recalls the painstakingly slow, antimodern tempo of walking and of observing nature for days, weeks, and months familiar to the experience of such great British Romantics as Constable and Wordsworth.

The high seriousness of these artists, their total willingness to sacrifice earthly and urban pleasures in order to worship nature connects them to older Romantic traditions still filled with faith in the healing powers of art as virtually a substitute religion. But more familiar, especially in the restricted conventions of painting and drawing, is a sense of quiet retrospection about a lost world not only of real landscape but of its poetic equivalent in Romantic landscape painting. An early example of this awareness of an unbridgeable gulf between past and present is found in Alfred Leslie's *View of the Connecticut River as Seen from Mount Holyoke* (see fig. 165), a painting of 1971–72 that updates, some 135 years later, Thomas Cole's *Oxbow,* a panoramic view, after a thunderstorm, of the very same site in which the great circular twist in the river looks almost like an earthwork *avant la lettre.* Revisiting this spot, Leslie repaints it with a hard and documentary clarity that transforms Cole's poetry into topographic prose, permitting us to see, in what was once God's valley, the ribbons of roads and cultivated earth adulterating Cole's vision of Eden. The sweeping vista that fuses fact and

174.
Diane Burko,
Après-Midi,
1990

memory, past and present, prompts the kind of melancholy meditation on a civilization's life cycles that Cole, like so many other Romantics, had enjoyed.

Such layers of recall lie behind many recent variations on the motif of landscape. Again and again we move from earthbound observations, like Leslie's, to fairy-tale domains that reawaken the twilight mood of reverie especially cultivated in the last fin de siècle under the banner of Symbolism, itself a variant on the more ineffable aspects of Romantic introspection. The British painter Christopher Le Brun often evokes dreamlike landscapes which, as in the paintings of Gustave Moreau, turn into mirages inspired by strange geological formations or phantom silhouettes of trees. And in the same Symbolist realm, Monet's painted fantasies on his water gardens at Giverny can be resurrected by Diane Burko, who would revive the master's immersion in an immaterial world of tremulous leaf, flower, and water (fig. 174), where there are no space-time coordinates with the modern world and where up and down, reflection and substance are confounded in a pulsating vision of nature almost more imagined than seen. Even more conventionally "Romantic" sites are explored by April Gornik, who takes us to dramatically remote extremities of unpopulated land and sea where water, sky, cloud, and moonlight create molten fusions evoking an awesome turbulence or a no less uncanny stillness in nature (fig. 175). But these gloomy cloudscapes are also permeated with a nostalgia for a lost world that can only be quoted by traveling backward in historical time to the paintings of Friedrich, Turner, and their American progeny or experienced by traveling to ever more distant territories that, on our threatened planet, may be destroyed

175.
April Gornik,
Virga,
1992

by the time we get there. These moody responses to a rapidly disappearing landscape, pre-
served in nineteenth-century painting, are familiar today. Joan Nelson, for instance, resusci-
tates that Romantic sense of the brink before the void, locating us on the perilous edges of
nature (fig. 176). Against the vast skies that usually dominate her intensely concentrated
paintings, we often see not land but only the tops of trees, as if we could go no farther in our
escape from an earthbound world of gravity. Her preference for the smallest dimensions,
which sharpens our awareness that we are looking at something rare, a relic to be cherished,
is shared by Mark Innerst (see fig. 194), who often seems to be replicating, as in a reducing
glass, a nineteenth-century American landscape painting that would capture, for instance,
the fragment of a coastline dominated by the expansive reaches of glowing sky and water
familiar to Luminist artists such as Kensett and Heade (see figs. 67 and 4). And his use of elab-
orate nineteenth-century frames, whose material weight and ornate carvings imprison the
tiny painted images, further confirms the irrevocable distance between the modern world
and these precious time capsules of what was only recently a primeval continent.

Such journeys in time, a revival of Romantic historicism, can produce as well the most
eccentric fantasies about nineteenth-century visions of landscape remote from the relentless
proliferation of urban blight and industrial ugliness. When, in 1971–72, Gilbert and George
performed their epoch-making *Singing Sculpture,* impersonating music-hall automatons in
the grimiest London pub, they used a backdrop of huge drawings as a pastoral foil. In these, the
duo appeared dressed in their usual uniform of city clothing but were uncannily set adrift,
like displaced persons, in the midst of a dense wood in which the minute description of every

176.
Joan Nelson,
Untitled (#292),
1991

branch, leaf, and blade of grass set up retrospective vibrations, recalling the obsessive realism of so much British nineteenth-century landscape painting. Moreover, this poignant anachronism, particularly jolting in the modern gallery settings where the urban performances took place, was further underlined by the Romantic captions below the drawings, which extolled, with phrases of Romantic innocence and faith, the pious values of nature, beauty, and the mission of art.

Of all these drawn and painted reversions to the mythologies of Romantic landscape, perhaps none is so unforgettably ambitious as the four-panel fantasy of Alexis Rockman titled *Evolution* (fig. 177). This panoramic spectacle of the slimy mutations of living things, moving from water to earth to apocalyptic sky, revisits not only the cosmic travelogues of Romantic masters such as Frederic Church, but also the conventions of educational dioramas created for museums of natural history. That the creatures depicted here with pseudoscientific accuracy are often evolving into monstrous new species adds a grotesquely disquieting edge, mixing our late-twentieth-century anxieties about the biological future of our planet with nostalgic dreams from the age of Darwin.

In most of these paintings the muse of art history is as weighty a presence as the facts of nature. Indeed, this kind of historicism permeates as broad a range of contemporary art as it did in the early nineteenth century and represents an about-face from the modern movement's frequently willful rejection of the historical past as irrelevant to a new art for a new epoch of civilization. But now, for artists as well as for the rest of us, the past even includes the achievements of the heroic days of early-twentieth-century art, which may seem as

177.
Alexis Rockman,
Evolution,
1992

remote from the younger generation as Greek or Gothic art was for the original Romantics. In the 1980s and 1990s, anything, from a Doric temple to a canvas by Clyfford Still or Bridget Riley, exudes the seductive aura of past history.

It is fitting that the Neoclassic mode of the late eighteenth century, itself impregnated with longing, both melancholic and rebellious, for an irretrievable golden age, should once more be revived, a doubly ironic situation found in the garden sculpture, landscaping, and typography of the Scotsman Ian Hamilton Finlay and in the painting of the Italian Carlo Maria Mariani (see fig. 129), who excavates antiquity a second time by bringing back to marmoreal life the statuary style propagated by the disciples of Winckelmann, from Mengs to David. His reconstructions of the first Romantic visions of a classical ideal of beauty even include an archaeological re-creation of David's famous, lost memorial to a revolutionary martyr, Le Peletier de Saint-Fargeau; but his scope, typically, extends beyond what has been called neo-Neoclassicism and includes as well what are now classic icons of early-twentieth-century art, for instance, Duchamp's readymades. Such remembrances of things past involve a remarkable variety of time travel. There is, for one, the case of David McDermott and Peter McGough, who not only try to paint and to photograph in the past tense (fig. 178) but also to live in it, usually sporting dandified clothing of Edwardian vintage and residing, like Romantic aristocrats, in re-creations of period rooms and houses. Typically, the titles of their works include a fictive date from the nineteenth or twentieth century—1867, 1925, 1942—with images that would recapture particular historical moments, whether through the look of Art Deco modernism, Victorian samplers, Hudson River landscapes, or old magazine advertisements from a more ingenuous America than ours.

Another artist pair, in this case the twins Mike and Doug Starn, are explorers of a different kind of time in their innovative photography. Often frayed, torn, and Scotch-taped together, like fragments preserved from a destroyed civilization, their camera images seem to live, breathe, and wither before our eyes, a phenomenon of special magic when applied to photographic reproductions of works of art. Among the most moving of these transformations are their many variations upon Philippe de Champaigne's *Dead Christ,* a painting in the Louvre they have eerily reanimated (see fig. 200). Presented in triplicate, like a documented sequence of

178.
David McDermott and Peter McGough,
The Fanatics, 1915,
1990

three different moments in time à la Muybridge, and printed in a wide range of tonal values that move from luminous clarity to murky blackness, the seventeenth-century sacred image, with its added rips and patches, becomes almost a new kind of Holy Shroud that can convey in the present tense the martyrdom and slow expiration of Christ.

Tragedy of epic proportions seen in historical retrospect is also the theme of Anselm Kiefer's work, which, as if in cathartic expiation, would embrace with words and images the most lofty as well as the most infernal episodes of German history and culture. His sweeping vistas, with their perspective lines rushing, as in Friedrich's landscapes, across bleak, doom-laden plains (fig. 179), can capture everything from the tomb of the first-century German hero

179.
Anselm Kiefer,
Märkische Heide,
1974

Arminius (also painted by Friedrich) to the nightmarish memories conjured up by Nazi buildings that revived the first German Romantic espousal of both Greek and Gothic architecture.

The overtly Romantic drama and passion in the work of both Kiefer and the Starn twins is far less familiar in recent reinterpretations of past art and culture than the cool, ironic tone of artists who would pay homage to, and even replicate, the canonic history of art, including, for a younger generation, the art of the early twentieth century that has become the Old Testament of modernism. No artist is a more devout believer in this faith than Mike Bidlo, who lovingly and painstakingly reproduces by hand the icons wrought by the masters who now reside on the Olympus of modern art. Beginning with Cézanne and moving onward to the likes of de Kooning and Warhol, Bidlo, like a monk in a twentieth-century scriptorium, has copied one precious work of art after another, often even having retrospectives, such as a "de Chirico" or a "Léger" show or, in recent New York memory (January 1988), a "Picasso's Women" show at Leo Castelli's, complete with the *Demoiselles d'Avignon* in a full-size facsimile (see fig. 188). When we see an artist piously copying these museum-worthy masterpieces, as David's students slaved away copying the antique, we realize that the prospective vision common to the early twentieth century has drastically reversed itself, in the last decades, to become a rearview mirror. Even art of the 1950s and 1960s now seems distant enough for historical revival, as in the work of Philip Taaffe, who wittily looks at the now-classic images of Abstract Expressionism or Op art as something that happened in a long-ago world, to be used as a kind of dictionary of abstract ornament. His remakes of Barnett Newman, in particular, undo the master's sublime ambitions in paint and words, so that the fearful symmetry, for example, of one of Newman's canvases from the series Who's Afraid of Red, Yellow, and Blue? is transformed into a coolly decorative field of primary colors titled *We Are Not Afraid* (fig. 180).

This kind of stylistic eclecticism, with its encyclopedic retrospection, is in its own way another episode in a tradition first fully cultivated in the Romantic period not only by painters (Ingres, for example, could reincarnate everything from Greek vases, van Eyck, and Fouquet to Masolino, Raphael, and Le Brun; and Turner could conjure up, as in a pictorial seance, the ghosts of Claude, Poussin, Rosa, van de Velde, and Canaletto, among others), but more obviously by architects who give their buildings a universal range of historical memory by working with an increasingly vast inventory of Western and exotic styles. In the last decades, even the look of the modern movement can be resurrected, extracting unexpected historical nostalgia for the antihistorical vocabulary of the modernist pioneers. Richard Meier's Shamberg house of 1972–74 in Chappaqua, New York (fig. 181), for instance, is instantly haunted by the clean-slate, heroic optimism of Le Corbusier as displayed in his domestic architecture (from the Ozenfant House to Pessac) of a half-century earlier, the utopian 1920s. And if Le Corbusier can be re-created on the other side of an unbridgeable historical gulf, so, too, can other architectural memories, both real and fictional. For example, Charles Moore's Piazza d'Italia in New Orleans (see fig. 26) looks like a learned stage set compiled from the pages of Banister Fletcher and given further dimensions and historical poignancy through the allusions to de Chirico's painted piazzas, with their unpopulated fragments of Renaissance and Roman architecture. Such reveries on a lost architectural past can provoke not only brilliant theater but even combative, polemical campaigns for a kind of social time travel that, in the

180.
Philip Taaffe,
We Are Not Afraid,
1985

181.
Richard Meier,
Shamberg house,
Chappaqua, New York,
1972–74

182.
Geodesic Dome and
Communicore Building,
Epcot Center,
Orlando, Florida,
1980

case of Quinlan Terry (and Prince Charles) would take England back to the civilized felicities of Georgian life and style. Terry's Thames-side project at Richmond of 1988 materializes a fantasy that would revive, in the most imaginary of contexts, the gracious beauty and craftsmanship of a community of eighteenth-century buildings, right down to every quoin and dentil. But the ultimate in this Romantic time travel may well be in Disney World, at Epcot (fig. 182), where one can find not only archaeological reconstructions of world architecture, from the Eiffel Tower to the Piazza San Marco—a new kind of virtual reality for instant tourists— but also strange memories of a more innocent world that the Second World War brought to an apocalyptic end. With its harmonious league of facsimile nations and its recycling of the myths of technological progress into a glorious future, complete with neo–Buckminster Fuller geodesic dome, Epcot would cheerfully embalm forever the spirit of nineteenth-century optimism that permeated the great world's fairs from 1851 to 1939. From our late-twentieth-century vantage point, this may be the most popular as well as the most melancholic example of Romantic retrospection on our planet.

"A Postscript: Some Recent Neo-Romantic Mutations." Published in *Art Journal* (special issue: *Romanticism*) 52, no. 2 (Summer 1993), pp. 74–84.

SCOTT BURTON: THE LAST TABLEAU

1991

Although it was generally assumed that Scott Burton's art, like his life, had come to a painfully premature end on December 29, 1989, in the year of his fiftieth birthday, it turns out that in his typically canny and future-oriented way he had kept a major surprise in store for posterity. During the last two years that remained for him under the darkening shadow of AIDS, he was dreaming up an extraordinary sculptural tableau that now, in retrospect, might well be read as the summa of his career. Happily, as with his other projects, he had calculated with maquettes, exact measurements, and the most precise choice of materials, every last, incisive detail of his austere fantasy, so that should anybody care to do so, it could eventually be fabricated, even after his death.

This, in fact, is just what has happened here at the Whitney Museum, where the curtain has at last been raised, with a mixture of posthumous sorrow and living triumph, on the final drama of Burton's art. This last tableau is a work whose spare, ritualistic clarity instantly commands the most fixed and wide-eyed attention, postponing for a long while our bewilderment in confronting something that belongs comfortably to no familiar category, including even the innovative furniture-sculpture hybrids that preoccupied the better part of Burton's energies in the late seventies and eighties. What we see first is something like a stage set with four immobilized players who are at once as inert as scenery and as emotionally commanding as the odd scenario that seems to have been frozen in its tracks (fig. 183). The two figures in the background preside as an identical pair of ominous guardians who, a good foot taller than average human height, tower above this strange rite like grandfather clocks. The center-stage figure, the object of this protected veneration, is a reclining goddess; like the sentries that frame her from behind, she confronts the spectator head-on. And the fourth figure, closest to the imaginary audience and placed at a diagonal before this implacable frontality, is a humbled slave who, with bent knees and elbows, remains eternally prostrate in a submissive posture of worship and sacrifice. Before these dramatis personae we feel privy to the unveiling of an archaic mystery cult that could range anywhere from a newly discovered deity in the Aztec pantheon to H. Rider Haggard's *She* or a science-fiction fantasy on Planet X.

So awesome is this theatrical disclosure of a mythic shrine belonging to the realm of both imaginative anthropology and Freudian psychodrama that we almost forget we are also looking at an entirely different order of things, perhaps more comic than grave. For suddenly, these humanoid actors are transformed into totally utilitarian pieces of furniture of a kind that

183.
Scott Burton,
Guardian Cabinets (A Pair), 1987–89 (fabrication 1991);
Slave Table, 1987–89 (fabrication 1991);
Bench Goddess, 1989 (fabrication 1991)

Burton, on the occasion of his first one-man show of two chairs and two tables at the Droll/Kolbert Gallery, New York, in 1977, had called "pragmatic structures." Indeed, the four units fulfill the requirements of a sparsely but completely furnished room. The guardians turn out to be usable cabinets—almost literally *garderobes*—and can be opened to reveal shelf storage space for clothing in the torso and legs, much as the gleaming bronze surfaces of their circle-heads might be used as the mirrors over a vanity. The goddess herself is also a bench, suitable for the most vain and majestic of sitters; and the abject worshiper at the lowest of these three levels does double service as a table, ready and willing to support on its flat back the most oppressive of weights. But soon, the ritual performed by these actors disguised as a set of luxuriously ascetic furniture becomes yet something else, a surrogate museum display of sculpture that belongs not only to the relatively recent realm of Minimalism, which reigned when Burton was a New York student in his twenties, but also to a wide anthology of ancestral styles and deities in the kingdom of modern art. It should be recalled here that Burton was often a part-time art critic and art historian and that, in this role, he wrote essential articles on artists of particular relevance to his work, such as Tony Smith and Gerrit Rietveld. But on less formal and especially conversational occasions, he could sport a staggering array of erudition and passionate responsiveness, reacting with lucid fervor to anything from late Victorian Arts and Crafts designers like Christopher Dresser to a diverse group of American realist painters: Guy Pène du Bois, Kenneth Hayes Miller, Philip Pearlstein. The whole world of art was in his ken, and he looked at it all with the sharpest eyes and the rarest historical intelligence, often absorbing into his work, overtly or almost subliminally, this broad encyclopedia of references. From this point of view, he was fully a member of the postmodernist, historicizing generation of the eighties. A survey of Burton chairs (fig. 184), for example, is also a history of modern furniture, filled with re-creations, at once respectful and

184.
Scott Burton,
Bronze Chair, 1972
(cast 1975)

playful, of a chronological sweep of classics, from American vernacular and Thonet through Josef Hoffmann, Frank Lloyd Wright, Le Corbusier, Gerrit Rietveld, Mies van der Rohe, Marcel Breuer, and beyond.[1]

The climax of these enthusiasms and these dialogues between his art and that of others, living and dead, took place in the last year of his life, 1989, when he was honored by being asked to launch the "Artist's Choice" exhibition series at the Museum of Modern Art. He chose to present his long-beloved Constantin Brancusi, concentrating on the master's pedestal bases and other furniture-like aspects of Brancusi's work.[2] But even without our knowing this, we would quickly sense the omnipresent ghost of that rock-bottom genius throughout Burton's tableau, which was being prepared at the same time as his Brancusi show for MoMA. There is, for one, the precious inventory of immaculately polished, smoothed, and pristine materials—a porous pink granite; a veneered and lacquered cherry plywood grain; a disk of bronze whose circular sheen reflects the world above eye level. For another, there are metamorphic mysteries which, as in the fearful symmetry of a tribal totem, can transform inert matter into living specters of archaic power. And there is also the willful blurring of boundaries between sculpture, furniture, and architecture that Brancusi had achieved in his park at Tîrgu-Jiu, whose *Endless Column* and *Table of Silence* constantly obsessed Burton's own imagination and informed his writings about the sculptor.

Yet it is hardly Brancusi's muse alone who reigns in this tableau. Despite the laconic and elemental look of Burton's art, the individual sculptures in this composite tableau seem

dense with association. The primitivist guardians may nod in Brancusi's direction, but wouldn't they be equally at home as dressing tables in one of the Art Deco period rooms that Burton would ferret out in the decorative-arts collections of museums from London to Zurich? As for the bench goddess, she too taps many veins in the history of modern art. Initially, her odalisque-like posture, defined by the most amazing economy of lines incised on granite, may recall Matisse's evolving distillations of the female nude to pure outline. But her lapidary permanence conjures up as well a different genealogical table that may take us to the twentieth-century view of Precolumbian sculpture as resurrected in obdurate stone by Henry Moore's neo-Mayan recumbent figures. And then there is the most modern-looking intruder in this endlessly allusive group, the slave table, whose gleaming stainless steel gives a more recent technological resonance to the other, more venerable sculptural media chosen here—stone, bronze, wood. Moreover, this taut metal construction of seemingly weightless, hard-edged planarities touches upon other modes of modern sculpture, so that this bizarre object might for a moment be slipped into a museum installation that included, say, David Smith and Anthony Caro. But of course, it is also an image of furniture and of a human being, which sets off another wave of references. Here Burton may well have been thinking not only of the late sculpture of Picasso, who could turn metal cutouts into humanoid chairs or chairlike people, but the stick figures of Joel Shapiro, whose work Burton admired. And then there is the kinkiest and most famous prototype for this sadomasochistic twist on the caryatid theme, Allen Jones's 1960s coffee table, in which a rectangular glass top is supported by the half-nude, life-size back of a spike-heeled pin-up on all fours.

Yet apart from these expanding associations with the work of other artists, Burton's final tableau is also a Proustian recall of his own two-decade-long career, a fusion of images and ideas that concerned him through the seventies and eighties. There is, most startlingly, the now explicit anthropomorphism of the individual pieces, all the more disarming because their first impression is of the leanest, most abstract geometries. But from the beginning, Burton's furniture had evoked, as in a séance, the human auras that, even in real life, we often see hovering over an empty couch or dining-room table. Already in 1970, in his *Furniture Landscape,* he had placed grass-roots American interior furnishings—a table and chairs, an upholstered sofa, a mirrored bureau—in overgrown foliage, creating the potent presence of human absence. And even more emphatically, in 1979, in the *Pastoral Chair Tableau,* he had arranged, as in a stage set, groups of one, two, and three chairs that immediately wrote their own scenarios of three different psychological states—a loner, an intense tête-à-tête, and a convivial trio. And from his later, and far more elegant and costly, furniture pieces we could even call into being the wide range of humanity that might use them. These after-image actors might become Wagnerian deities for Burton's rock chairs, 1920s vamps for his chaise longues, international businessmen for his table settings for ten, country porch sitters for his Adirondack chairs, or anonymous city dwellers for his many public commissions which, after all, are actually inhabited daily, if only temporarily, by real people who unwittingly play roles in the uneventful urban theater of a quick lunch on Fifty-first Street off Sixth Avenue or a leisurely stroll through Pearlstone Park in Baltimore. And not only did Burton always extract from his furniture-sculpture the anatomy, the psychology, and even the sociology of the human species, but back in the 1970s, he had dealt more literally with the equation of living,

185.
Scott Burton,
Pair Behavior Tableau, 1976.
Performance at The Solomon R. Guggenheim
Museum, New York

feeling people in stage sets of the sparest and most plebeian furniture—bare cots, waiting-room benches, junk-shop tables and chairs. In these performance pieces, which he called Behavior Tableaux (fig. 185), the actors would animate the furniture with repetitive, rhythmic movements that set off a wide spectrum of public and private psychological vibrations.

Now, in this last of Burton's tableaux, all of these memories have resurfaced, merged in a seamless unity of performance, stage set, sculpture, and furniture that becomes the ultimate inner sanctum. Within this most rarefied of theaters and with a touch at once light and tragic, Scott Burton directed an unforgettable drama about such imponderables as the threshold that separates earthly desire from a chilly, otherworldly eternity, opening haunting vistas for both his audiences of the future and for those of us who thought they already knew his art.

"Scott Burton: The Last Tableau." Published in *Scott Burton: The Last Tableau* (New York: Whitney Museum of American Art, 1991), n.p.

1. The richest discussion of these multiple art-historical references in Burton's work is found in the essay by Charles F. Stuckey in *Scott Burton Chairs* (Cincinnati: The Contemporary Arts Center, 1983), pp. 7–17.
2. "Artist's Choice: Burton on Brancusi," The Museum of Modern Art, New York, April 7–June 28, 1989.

STURTEVANT

1987

The art of the present has always made the art of the past look different. These days, the late twentieth century has stirred up endless reshufflings and disclosures about how what used to look bad can suddenly look good (as in the new enthusiasm for the later work of Picasso, de Chirico, or Picabia), or about how individual artists who once appeared peripheral and singular may now seem voices in the wilderness, announcing artistic events to come. I can think of no more startling example of the phenomenon of a newly discovered prophet than the case of Sturtevant. Between 1965 and 1975, during which time she had nine solo shows and participated in nearly a dozen group shows, she raised a storm of controversy by re-creating exactly, down to their very dimensions, paintings and objects by not only Duchamp, that old master of confounding original and reproduction, but also, still more bewilderingly, a roster of her contemporaries—Johns (fig. 186), Stella, Warhol, Lichtenstein, Rosenquist, Oldenburg, Beuys. For some her work was outrageous plagiarism. But for others her role in the art world was distinctly disturbing, far more than an abstruse meditation on questions of artistic originality.

And then, oddly enough, came the 1980s, when our retrospective century, possibly readying itself for the Last Judgment of the year 2000, suddenly produced a crop of artists who were passionately preoccupied with the resurrection and embalming of the ever more widely disseminated images in the Hall of Twentieth-Century Fame. Under the verbal banners of "appropriation," "simulationism," or "image-scavenging," such painters as Sherrie Levine, Philip Taaffe, Mike Bidlo, and David Salle have copied everything from Schiele, Malevich, and Picasso to Newman, Riopelle, and Pollock. This new visual world of double-takes has not only raised a lot of unsettling questions but has also moved Sturtevant's work far closer to the center of the history of art in the last quarter-century.

Now that we have a wider range of experience of artists who replicate other artists' work, what makes Sturtevant's art her own and nobody else's (apart from its clear historical priority) continues to nag us. Part of her audacity is doing works by her immediate contemporaries rather than by remote and venerable father figures. Part of her clarity, which complicates things further, lies in proclaiming that these works belong to her aesthetic domain alone.

On a more complex level, she opens the Pandora's box of the meaning of originality; and mirroring the preoccupations of Duchamp, she raises the specters of truth versus falsehood, conception versus execution, and other mind-bending issues. Her own fiercely

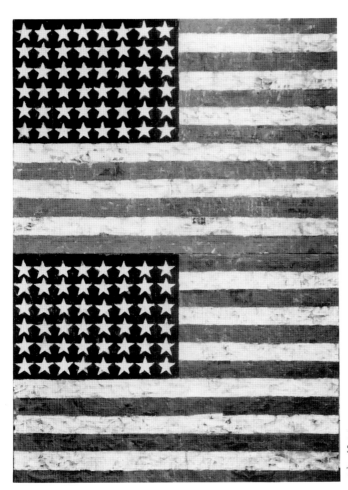

186.
Sturtevant,
Johns Double Flag,
1965

absolute consistency makes her, paradoxically, infinitely more original than an infinity of willfully original artists.

Sturtevant-watchers may wonder what she's been up to lately, and, not surprisingly, she has plenty of surprises in store for us. Following her earlier patterns, she has just duplicated some subway drawings of one of her most renowned younger contemporaries, Keith Haring, thereby adding a disconcerting dimension to an artist whose work has been so susceptible to endless reproduction that even children can instantly recognize his graphic signature. And she has other surprises, too, which look backward, as well as sideways and forward. For now she has re-created some of Johns's first targets, much as she re-created in the sixties his first flags. And what will happen when a younger artist copies one of these? Not the least of Sturtevant's unsettling powers is to trouble the future of art as well as its past and present.

"Sturtevant." Published in *A Different Corner: Definition and Redefinition—Painting in America* (Cuenca, Ecuador: U.S. Pavilion, I Bienal Internacional de Pintura, Museo de Arte Moderno, 1987), pp. 26–27.

MIKE BIDLO

1989

recently attended a party at M.K., a trendy New York club much frequented by the art scene. Of the many paintings decorating the walls there, one, a large horizontal Jackson Pollock, attracted the most attention, prompting many casual inquiries about its authorship. There was, of course, not a moment's doubt that it was *not* by Pollock even though it was clearly a painted facsimile of one. Who, after all, would ever expect to find a vintage masterpiece of about 1949 in a crowded new hangout on Fifth Avenue? When pressed, a few of the art people there ventured a guess that the Pollock was a Mike Bidlo. I myself, and others, disagreed, and then the question was dropped. But it continued to bother me. Not too long after, I asked Mike Bidlo himself whether by any chance he had painted the "Pollock" in M.K., and he pleasantly explained that he knew nothing about it. I haven't troubled yet to find out who did paint it, but I did feel good, as well as perplexed, about being so certain that the fake Pollock was not an authentic Bidlo; and more peculiarly, that it really wasn't *good* enough to be a Bidlo.

In this minor encounter with a problem of connoisseurship of a sort familiar in old-fashioned times, when scholars would debate the attribution of a Giotto or a Caravaggio, a more major mystery is beginning to emerge. Bidlo's art, as the international art world now knows, consists of willfully accurate, handmade replications (right down to the same dimensions) of well-known works, and frequently masterpieces, of twentieth-century art.

His pantheon begins with Cézanne's great late *Bathers* at the Philadelphia Museum, launching the earliest years of our century, and then continues through the canonic Hall of Fame, undaunted by the hugest achievements in size and importance. The *Demoiselles d'Avignon, Guernica,* Matisse's *Dance* and *Red Studio,* Léger's *City,* Pollock's *Blue Poles*— Bidlo has taken them all on. Indeed, the works of Bidlo, even this early in his career, already constitute a surrogate survey of the high points of modern art, from Picasso, Kandinsky, and Duchamp through de Kooning, Klein, and Warhol.

Such seemingly slavish replication is at first, and maybe even at last, both completely familiar and completely unbalancing, so much so that Bidlo's work has quickly earned responses of both puzzled enthusiasm and dismissive outrage. As for its traditional character, there is little doubt that, on one level, Bidlo is doing what has been done for centuries in the history of art and what has never before evoked the kind of antagonism that so often greets this young artist's work. Hadn't Roman sculptors chiseled with love, veneration, and metic-

187.
View of Mike
Bidlo's studio on
Forty-second Street,
New York City,
1985

ulous craftsmanship countless copies of cherished Greek originals from a golden age, and aren't we now grateful to them that they have provided us with some memory of these lost or fragmented works? Hadn't the greatest of old-master painters cut their teeth or tipped their hats by making respectful copies of paintings by artists who attracted them, with Titian, say, copied by Rubens; with Rubens copied by Delacroix; with Delacroix copied by Manet; with Manet copied by Gauguin? How else, after all, is tradition to be maintained, and how else can artists display more clearly their choice of a personal pedigree from the hallowed walls of the museum? Even Gorky (with whom Bidlo has recognized an unexpected affinity) was happy to spend a long apprenticeship immersed in the paintings of Picasso, thoroughly concealing his own personality within his efforts to paint like the master. As such, Bidlo's activities, far from being unsettling to spectators of the 1980s, could well offer the comfort of age-old artistic procedures.

But of course, Bidlo is also an artist of the 1980s, and one who represents not so much the endangered species of an artist who, locked up in a conservative academy, is slowly learning his trade by first looking backward and making painstaking imitations of revered masterpieces, but rather an artist of a newer, less familiar species who is confronting the countless demons that have been released from our Pandora's box of photography, of Xerox, of electronic reproduction, from an age when even a signature on a fax may be considered legally as an original document. Moreover, Bidlo has much to reveal about the rampant historicism of the late twentieth century, when suddenly the wildest rebels of early- and mid-twentieth-century art have been transformed into ancestral figures of remote nostalgia from a lost age, textbook classics no longer capable of disturbing the status quo or the future, but saints of another, now distant era whom we can only resurrect with every possible homage, whether it be yet another

retrospective traveling from New York to Tokyo to Paris, a comic-strip biography for children, or a reproduction on a shopping bag sold in museum gift shops around the world.

In the world of these strange and recent phenomena that surround us daily, Bidlo's art provides both a lighthouse and a mirror, illuminating and reflecting endless questions without necessarily providing the answers. For one, there is the nagging, seesawing confusion in his art between originality and subservience, between the handmade and the mechanically reproduced. At a time when tradition would have it that young artists make their name and fame by trying to look as little as possible like their elders, Bidlo reversed gears totally by looking so much like his ancestors in the dynasty of modern art that his own personality appeared to be nonexistent, trampled underfoot by the tyranny of history. Yet exactly the opposite has begun to happen. How else—to go back to the story of the "Pollock" at M.K.—could viewers have learned so quickly to seek out the nuances between a genuine Bidlo and a Bidlo imitation? Then, too, we have learned to change our ideas about how to define an artist's originality, since what now becomes intriguing is the element of choice that Bidlo has made and will make from the encyclopedia of modern art images. We may well expect him to kneel at the altar of this or that major Chagall or Brancusi, or to compile, as he did at Leo Castelli's in January 1988, a mini-retrospective of Picasso's women (fig. 188), but what accounts for his more offbeat choices—for example, a large group of Morandi still lifes? In this, the way we are obliged to construct Bidlo's personality as an artist intersects with the way, these days, we recognize the personality of museum curators or collectors, whose aesthetic contours are discerned through the acquisitions they make. Furthermore, Bidlo's willingness to define his own art exclusively by replicating the art of others is hardly unique. Already in the 1960s, Elaine Sturtevant began to do this, making perfect clones of works by Johns (see fig. 186), Stella, Rosenquist, Warhol, and others, and is still going strong today; and other younger artists of Bidlo's own generation, such as Sherrie Levine, have expanded this territory into the domain of a less handmade look, counterfeiting the impersonal surfaces of photographs and reproductions of paintings and drawings.

All of this has helped to make it clear that Bidlo's position corresponds to an experience shared by more and more artists of our time, and that we spectators are going to become attuned to discerning the differences among them, much as we learned, say, to separate de Kooning from his imitators or to distinguish between a comic strip painted by Lichtenstein and one painted by Warhol. Is this a new breed of artists who become uniquely themselves on the basis of their individual selections from the vast image-bank of the historical past or on the basis of their varying attitudes toward copying originals or reproductions? As for this, Bidlo again makes us stumble over one contradiction after another. To be sure, he is clearly celebrating the age of fax, the climax of an era in which we have now seen so many color reproductions that the original work of art may appear to be only an intangible abstraction, which, like a computer program, is useful only for its ability to produce infinite print-outs that cover our globe with memories from the chronicles of art history. (How many millions of people, after all, know and respond passionately to *Guernica* without actually having seen it?) It is telling in this context that Bidlo, too, is inspired by and works from reproductions, not originals, and often of works he has never seen. Yet he also spends days, weeks, and months scrupulously reconstructing through the traditional means of the artist's handcraft what he

188.
Mike Bidlo,
Installation view of the exhibition
"Picasso's Women,"
Leo Castelli Gallery, New York,
1988

hopes will be convincing facsimiles of the widest variety of personal facture, from the delicacy of Pollock's poured skeins of pigment to the aggressive thrust of Picasso's hatchings and thick impasto. (Contrariwise, if appropriate, Bidlo will imitate the impersonal, machine-made look of Duchamp.) Here, there is not only the odd paradox of an old-fashioned craftsman-artist rather than a machine or a computer contributing yet another reproduction to the infinite realm of multiples, but a still odder personal twist of almost religious flavor. For there is something disconcertingly humble and pious about these long, arduous labors, reminiscent of a new kind of ancestor worship in which the relics of modernism have become so sacred, so embalmed behind museum walls all over the world, that an artist must virtually do penance before them, desperately resurrecting their magic by making loving, handmade copies to be laid at the invisible shrines of the originals.

Perhaps that is another reason for what many find the disquieting, haunting power of Bidlo's private history of modern art. On the one hand, it has almost the awed, innocent quality of youth, of firsthand love and infatuation with our century's aesthetic marvels. On the other hand, it shares the more cynical and sophisticated rear-view vision of the late twentieth century, a literally postmodern viewpoint in Bidlo's case, since he looks back over a his-

torical gulf to the glorious epoch that carried us from the dawn of Cubism to the dawn of Pop. Looked at as an anthology of relics, Bidlo's art even takes on science-fiction aspects, as if somebody, in the years before whatever unthinkable apocalypse confronts us, had re-created and preserved, with the self-effacing devotion and patience of a saint, the most precious artifacts of the modernist era, perhaps for a time capsule that may survive us. Future archaeologists on Planet Earth may well be grateful to have these records of a lost civilization. Meanwhile, for the here and now, we may continue to be fascinated by the way Bidlo makes us see double, first, mirroring the multiple ways we look at and think about art in our mind's eye and, second, reflecting the persistent shadow of an artist whose seeming absence from his work has become a mysterious, recognizable presence.

"Mike Bidlo." Published as "Notes on Mike Bidlo" in *Mike Bidlo: Masterpieces* (Zurich: Bruno Bischofberger, 1989), n.p.

ERIC FISCHL
1984

ver since Freud's generation, artists, together with the rest of us, have tried to pinpoint and savor the memory of some long-ago childhood trauma, of some indelible image that haunts like a recurrent dream. Already by the 1890s, Edvard Munch had succeeded in seizing, within everyday settings of domestic interiors and local landscape, the immobilizing chill of a family deathbed, the throbbing excitement and terror of puberty, the lonely pressure point of the one excluded from the eternal triangle. By the time of the Surrealists, this territory of disturbing, buried emotions was excavated in an almost programmatic way. Whether through the uncanny, miniaturist clarity of 20/20 dream photographs or through the pulsating fluidity of abstract shapes and colors that, as in a nightmare just beyond recall, keep eluding final definition, this shadowy prey of repressed psychological biography was pursued. But by the 1980s, such goals must have seemed like old-hat art history. Who would ever have guessed that a young American painter, Eric Fischl, could resurrect them in a completely unexpected way, in the language of the plainest American prose?

De Chirico may well have evoked his father's towering tyranny; Dalí, his teenage guilt as a masturbator; Bellmer, his morbid obsession with dolls; or Balthus, his Lolita syndrome; but these excursions into the more perverse paths of psychodrama occur in an arty, theatrical environment, where we expect to relish a bizarre case history, more fiction than fact. With Fischl, the shock is of a different, more American kind, as if Winslow Homer, in the 1860s, had been obliged to illustrate his first experience of genital turmoil, or as if Edward Hopper, in the 1930s, sought to depict the erotic innuendos of a high-school girls' locker room. For the environment that Fischl spreads before us as decor for these sexual revelations is of the most startlingly contemporary Americana. Familiar enough to viewers of *Dynasty* and readers of pulp fiction, Fischl's milieu, which documents the material facts of the lives of Preppies, Yuppies, JAPs, and their families both at home and on vacation abroad, is alien to most of our expectations about serious settings for deeply unsettling paintings. In place of de Chirico's phallic towers, Dalí's detumescent watches, or Gorky's feathery orifices, Fischl rivets our viscera with an inventory of the most familiar objects, things we feel we have never seen in a painting before: a towel rack, a bidet, a wind-up monkey toy, a slice of lemon, bathroom tiles, a bedside wall telephone, a poolside sling chair. This insistence on the common coin of our environment is oddly disturbing, for it provides a deadpan background of ordinary truths to a domain of pounding emotions, presumably inaccessible to a painter who would

189.
Eric Fischl,
Daddy's Girl,
1984

trouble to get the color of haircurlers or the reflections in a suburban swimming pool exactly right. But it is Fischl's special gift to fuse these two worlds of outer fact and inner feeling, as if he had selected, from the infinite number of objective images left in the storage rooms of the mind's retina, precisely the one that cuts the sharpest into a psychological biography.

In *Daddy's Girl* (fig. 189), we at first may see only the most mundane Polaroid view of a well-heeled New Yorker's vacation paradise, a sun-bleached Eden of sea and sky, flip-flop slippers, cool drinks, and the whitest, cleanest resort architecture and furniture; yet suddenly, within this banal setting, the human protagonists—a naked, sunbathing, middle-aged father and his equally naked female child—rush us into the kind of shocking flashback revelation that might ultimately be dredged out of the same little girl's subconscious many years later, when, under some analyst's guidance, she probes the demons of incest that have always plagued her. Again and again, Fischl makes us empathize with these at once private and universal disclosures of sexual ignition: the carnal expectancy of *Master Bedroom* (fig. 191), whose sleazy, dog-hugging teenager offers a harshly modern variant of the head-on confrontation with bed linens and prurient flesh that Manet disclosed in *Olympia;* the gross candor of *Dog Days* (fig. 190), with its diptych montage of two beachside hotel balconies, whose metal and concrete stages enclose primal dramas of animal arousal, whether that of two dogs turning to a teenage girl, who is naked except for shoes and beach bag, or that of a teenage boy, whose painful awkwardness in gingerly approaching a teenage femme fatale who has dropped her bikini is so psychologically incisive that the disarming depiction of his erect penis somehow registers as poignant rather than pornographic.

This capturing of moments of high sexual voltage, the kind that is branded in the groin and the heart forever, would seem a strange goal for a painter, especially one as ostensibly poker-faced and scrupulous as Fischl is in documenting the material facts of those wealthy locales, from the Hamptons to the Club Meds of our planet, where clothes and city

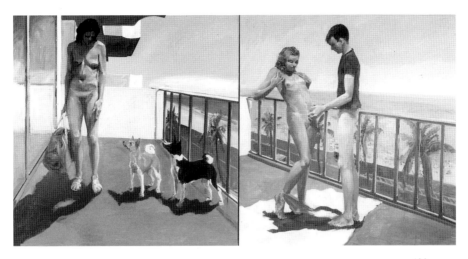

190.
Eric Fischl,
Dog Days,
1983

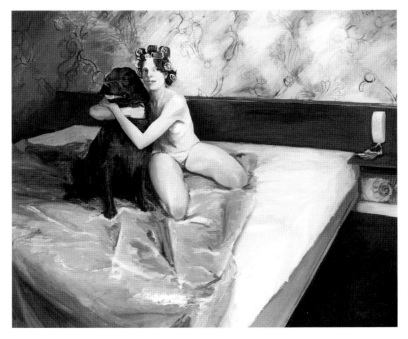

191.
Eric Fischl,
Master Bedroom,
1983

mores are shed in artificial Arcadias of sun and water. Yet it is clearly a familiar ambition for many photographers and film directors, who so often release uncommon erotic charges in the most common settings. Fischl, in fact, is a master of cinematic staging. He can rush us into a scene with the harsh cut of an oblique, overhead angle, which, as in *Master Bedroom,* drops us right into the king-size bed with its tacky occupants, or he can space a poolside drama with high-wire tension, as in *The Brat II,* where the sullen heroine, white-wine glass in hand, turns her back and gaze from what appears to be her black lover, who in turn looks far past the head of the quietly crouching son, playing in the right-hand corner, within whom we sense the emotional fallout of this fraught drama of adult sex and guilt. And in his role of director, Fischl also makes every object essential and unforgettable, from the glass of iced tea precariously perched beside a slippered foot in *Daddy's Girl* to the Pan Am flight bag plopped by Westerners on the exotic beach of *Cargo Cults.*

Although these days, when new categories are swiftly invented, Fischl is generally lumped together with a broad cluster of international neo-Expressionists, his work, I find, is neither international nor Expressionist, but rather very American, even regionally so, and very realist, rejuvenating the tough Yankee tradition of Homer and Eakins, who, though always respected, hardly seemed to offer useful nourishment to any ambitious young artists of the 1980s. But, like them, Fischl has the most tough and honest of wills, seeking to set down, in what deceptively appears to be a neutral, artless style, the plain truths about things seen and things felt and repressed in a land dominated by a puritan chill. Even on the sunniest of days, Fischl's vacationland pools and beaches, like Eakins's Schuylkill River and Homer's Long Branch, New Jersey (see figs. 158 and 5), look like joyless environments, the very opposite of their French counterparts, where landscapes smile along with the people in them and where erotic juices produce pleasure, not shock and guilt. And Fischl's rendering of naked-ness, for all its reflections of the candor of post-1960s sexual liberation, makes us wince at the rawness and fallibility of human bodies, marked as they are by sagging bellies or by the ugly absence of beach clothing, imprinted as white silhouettes on red or tanned flesh. Like Philip Pearlstein, Fischl can instantly squelch sexual appetites by telling us nothing but the truth about his unclothed models.

As in the work of so many American artists who have a strong national flavor—Hopper is another conspicuous example—the indigenous character of Fischl's work is all the more potent when we sense the ghosts of European masters hovering about. Fischl himself has spoken of the importance to him of Beckmann's concern with tragic narrative, but he has also realized that the German's dense layering of cultural myth and symbol was alien to the American plain statement that is his own natural idiom. Degas, too, is often evoked, as in the almost clinical account of the private ablutions of *Sisters* (one of whom has shaved pubic hair, like a nineteenth-century academic Venus, and still wears unstrapped shoes), or in the many odd croppings and oblique views that not only give us a split-second slice of life, but even, on occasion, bizarrely decapitate or amputate passing figures. But finally, the French master seems totally foreign to Fischl's willful rejection of visual hedonism. For appetites only satisfied by gorgeousness and delicate nuance, Fischl offers lean fare: awkward figural com-positions, pallid yet harsh colors, abrupt spatial jumps, a dead and flattening light. Yet this conscious mastery of an ungainly, unsensual language of painting is essential to his shrill dis-

closures. Any artist who has set for himself the unlikely task of making us feel the clumsy truths about the sexuality of America's privileged classes would be crazy to worship at the shrine of Matisse or Bonnard. Fischl's success is in good part dependent upon exactly this aversion to transatlantic aesthetics and cultures. Even in the company of his own generation of American painters, most of whom explore a lingua franca of abstraction or of myth-making expressionism, Fischl stands out like a sore American thumb. But it is precisely this visual and emotional soreness that gives the measure of his probity and achieves such steady and unforgettable results. At a time when most of Fischl's contemporaries are involved with high-blown poetic fictions, he works in an old-fashioned prose style that, as in the case of Winslow Homer, absorbs the stuff of popular illustration but also transcends it, in order to transcribe with blunt honesty the facts of American experience that would elude the artifice of most painters. In so doing, he not only asserts the possibilities of narrative painting on an epic scale, but reawakens, at a time when national traditions, especially in Germany, have become issues for younger artists, the heritage of a provincial, but stubbornly persistent, vein of American Realism that has always preferred truth to beauty and that has always reminded us, even on gallery walls, how life can be made to look more important than art.

"Eric Fischl." Published in *Eric Fischl* (New York: Mary Boone, Michael Werner Gallery, 1984), n.p.

DAVID SALLE
1985

Working under the banner of Realism, painters continue to stare at and to describe with pigment on canvas this or that isolated fragment of the vast visible world out there, whether it be as palpable as the sagging flesh we scrutinize on a nude model within arm's reach or as ungraspable as the reflections on a bottle of vodka in a still-life set-up. But Realism, of course, is the most slippery of words, and in the late twentieth century, it is more slippery than ever. At a time when the image on the TV screen keeps usurping the gravity-bound reality of the tabletop below it, when the original painting in the museum looks like an offshoot of its color reproduction rather than the other way round, when we rush to look at and record a memorable tourist spot with a portable camera rather than see it with our own eyes, then we know that many artists are going to have new things to tell us about whatever it is reality might be today.

David Salle is one of these artists. Although only in his early thirties, he has already called into being a full-scale vision of what this new reality might be about. Conjured up as if by free association, a mirage of seemingly disconnected fragments from art and life is suspended in an elusive twilight zone that never stops seesawing between tangible matter and filmy phantoms, between the codified languages of abstraction and those of figurative art. At first glance, the typical Salle painting is a kind of visual Tower of Babel, an inventory of magnified quotations from a contemporary image-bank that can include anything from the schematic chiaroscuro drawing style taken from the coarsest popular illustrations to thick pigment scribbles excerpted from an Abstract Expressionist canvas. Both surfacing and disappearing within these wide-screen vistas, Salle's compilation of floating parts may be as assertively real as a chair leg or a stuffed duck head that actually projects from the canvas, as impalpably ectoplasmic as the translucent grisaille figures that hover, like the after-image of a photograph, in some unchartable depths, or as matter-of-factly flat as a swatch of some 1950s patterned fabric collaged onto the canvas and running both over and under the ostensibly 3-D images.

In all of this, a strange chill and neutrality appear to reign. If we are deceived for a moment into thinking that a rapidly painted scrawl is a mark of impulse and spontaneity, we are rapidly undeceived when we realize that it is probably a close citation from, say, a painting by Riopelle and that it is given equal time with passages of light-dark modeling as impersonal as the diagrams in how-to-draw manuals. And as soon as we decide to capture the illusion of a rounded, shadowed image, it is instantly taken away from us by a cropping edge

across our field of vision or subverted by an insistently opaque material, whether fabric, wood, or flat paint. Salle's paintings, in fact, create an eerie, nowhere environment, part mental and part physical, where incomplete and often almost illegible fragments from the widest range of visual languages wander about like displaced persons. Moreover, no one voice is allowed to drown out this resonant arena of refugee images and styles. Instead, Salle pushes for a disconcerting equality of all components in which even the most sexually charged passing fantasy seems no more important than the nondescript blandness of, say, a blue-and-white pattern extracted from a Chinese kitsch design. This constant assertion and denial of every kind of priority—the murkily erotic versus the flatly decorative, the figurative versus the abstract, the opaque versus the transparent—ends in a dreamlike stalemate that destroys all hierarchies and leaves us in a state of suspension. Like a modern spiritualist who can summon up the ghost of, on the one hand, a news photograph and, on the other, the upholstery of a 1950s chair, Salle maintains an amazing juggling act, whose apparent lack of commitment to any single visual truth or any sense of major and minor style or value may speak for a whole generation of artists and viewers in the late twentieth century.

Such points can be quickly made with one of Salle's most concise and indelible images, *The Disappearance of the Booming Voice* (fig. 192), a work whose very title, like most of Salle's titles, reflects his fascination for incomplete narrative clues. What spectator would not be quickly rushed into this almost X-rated, drastically foreshortened close-up con-

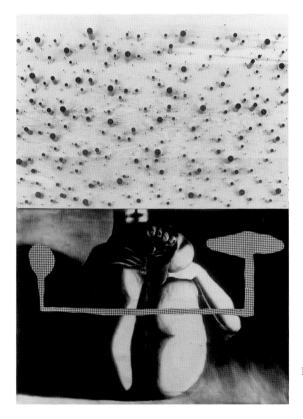

192.
David Salle,
The Disappearance of the Booming Voice,
1984

frontation with a woman's nude bottom, her legs in mid-air? For sheer, head-on vulgarity it can even rival one of Courbet's grossest Realist assaults on aesthetic distance, his *Woman with White Stockings* (1861; Barnes Foundation), a painting that also offers virtually a voyeur's or a gynecologist's view of the coarsest thighs and buttocks. But Salle, as usual, stops this immediate reality short, so that it becomes frustratingly remote, like an after-image in the retina or the dim recall of a sexual encounter. That it is painted in grisaille, like Ingres's later variants upon his *Grande Odalisque,* immediately cools and desexes it somewhat; but this defusing continues in far more unexpected ways. Pasted over, but not concealing this shameless exposure, is an oddly limp, meandering shape cut out of the most innocuous fabric, a foreground intrusion that literally and figuratively keeps sex at bay and cancels its startling frontal attack. And above, a wooden panel of equal size almost physically pushes us away from this erotic magnet by presenting a barrier of projecting pegs with painted ends, an aggressive bed of nails that wards us off from what finally becomes an erotic daydream that no longer belongs to here-and-now reality but to the domain of memory and desire, of photographic imagery of pornographic drawings. With only these three components—the sexual image, the collaged fabric, the abstract wooden construction—Salle has pinpointed the muffled shufflings of fact and fiction, of personal confession and the embalmments of art which he has always tried to hold in a tightrope balance. A similar effect can be seen in *A Collapsing Sheet* (fig. 193), in which another sexual mirage would assault us, this time an abruptly foreshortened rear view of a crouching female nude who, like Eve, holds a fruit (a peach?) in one hand behind her, but who refuses to materialize into graspable fact. Again, the grisaille drawing, like the collaged and painted environment of sleazy decorative patterns that might be taken from discarded Woolworth's stock, diffuses the sexual charge of the nude; and even more, should we try to pursue this immaterial presence in her erotic capers, we might well be bruised by a chair leg that protrudes above her, a pronged wooden obstacle that, like a fragment of bedroom furniture, might call an uncomfortable halt to a sexual fantasy. Moreover, because this chair leg projects horizontally rather than vertically (like the surprise of Rauschenberg's famous *Bed* flat up against a wall), our sense of gravity is confounded, as if we were watching a movie projected on the ceiling.

The very presence of furniture fragments affixed to canvas immediately evokes here, as in a sophisticated quotation, the knowledge of earlier art, in this case that of Johns and Rauschenberg; and even more broadly speaking, the components of Salle's art touch many bases in any art-historical litany. There would be, as a broad foundation, the Pirandellian mix of fact and illusion, of multiple visual languages explored early in our century by the Cubists; and there would be, too, Magritte's irrational shifts in scale, or his deadpan collisions of nature and artifice. And closer to home, in time and space, there is Pop art's wholesale appropriation of the tacky, artificial world of reproductive images filtered through individual aesthetic temperaments, which, in the case of Rosenquist in particular, often prophesy Salle's own billboard scale, crass commercial facture, and cinematic, split-screen constructions. And for the transformation of this public domain into an arena of private, even intimate biography, there are always, as major signposts to Salle's ambitions, Johns and Rauschenberg, artists to whom he alludes constantly, whether in word (as in *Tennyson*) or in attached object (as in the occasional stuffed bird).

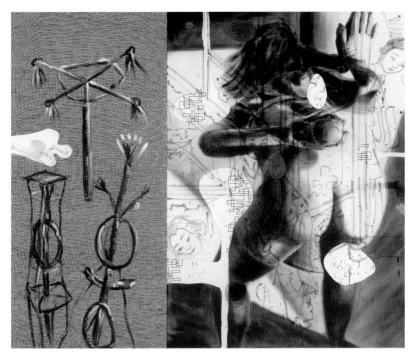

193.
David Salle,
A Collapsing Sheet,
1984

But such allusions, after all, are as ordinary a part of our late-twentieth-century surfeit of visual information as the TV commercials we all carry with us. Everything Salle includes, in fact, no matter how initially illegible it may at first look, has been culled from sources we might all ultimately recognize. The 1980s nostalgia for the period style of the 1950s, for instance, may turn up in both fragments from Abstract Expressionist paintings and borrowings from the laminated free-forms or loony hard-edge geometries of the decade's most pedestrian decorative arts. Even when a shape seems so magnified as to be unrecognizable, as in the skeletal object on the right of *A Minute,* it turns out that it is something we can all finally identify, in this case one of the Art Nouveau finials from Guimard's renowned Paris métro stations; and similarly, in *Abandoned Shells,* when a Warholian triptych of repeated background images strikes a distant bell, the sound is made by our subliminal recognition of a photograph of Balanchine at rehearsal.

Yet within this public territory, Salle has chosen to navigate a personal course. Although it might at first appear that Salle's images are totally disconnected, selected almost by chance from the infinite examples of high and low art, interior decoration, photography and commercial illustration that glut our image-banks, the accumulation by now of a substantial body of his work has begun to define coherent principles of choice, as if we had got to know through the medium of stream-of-consciousness the unique contours of an artist's public and private personality. A consistent attraction to images, textures, materials that seem removed by one or two degrees from any absolute reality informs all his work. The colors, usually applied as tints over broad geometric divisions, belong to a new chemical and electronic world of flatly luminous, synthetic hues, totally remote from nature, as if Brice Marden's lov-

ingly worked rectangles of precious pigments had been translated into the language of TV reception; the figural drawing, too, looks as if it had been copied unfeelingly from a pre-existing photograph or film frame; the fabrics and decorative patterns look like debased machine-made reproductions of lost originals; and even the occasional painterly touch, in the ragged outlines of abstract or figurative shapes, betrays a facture no less mechanical than the collage elements. In short, all these fragments belong to a world of complete artifice, of reproductions, of frozen and incomplete narrative sequences, so that even the recurrent sexual motifs that provide, so to speak, an id to the super-ego of art-world references become anesthetized by this pervasive vision of a second-hand reality. Natural laws of perspective and gravity are also jettisoned in favor of a kind of disembodied theater of superimposed scrims, where near and far, solid and void keep changing roles, as they might in split-screen TV images or, more introspectively, in the nonstop flow of visual memories projected behind closed eyelids.

In all of this, Salle may well belong to what is commonly categorized these days as a postmodernist aesthetic, in which an earlier twentieth-century struggle for an original style, for authentic, firsthand feeling has been abandoned in favor of a detached awareness of the widest range of visual specters that have come to haunt us from places as disparate as the sanctuaries of the Museum of Modern Art and the lurid illustrations of pulp fiction. Original, singular images and emotions have become, ironically, abstractions, whereas their multiple facsimiles have become our realities. By accepting this jungle of surrogate experience, Salle not only mirrors the new facts of life that surround us, but he can also transform them into a new art of shadow-boxing images that we recognize both as property common to us all and as an achievement uniquely his.

"David Salle." Published as "Notes on David Salle" in *David Salle* (Zurich: Bruno Bischofberger, 1985).

MARK INNERST'S TIME CAPSULES

1990

Travel in time and space can shrink things to lilliputian dimensions. Already on our way to the airport, the city we are leaving behind begins to shrivel into the phantom reality of the past tense, and after takeoff, our lofty, extraterrestrial view puts the final seal on a time capsule to be stored within the fluid scale of memory. And now, confronting the unimaginable mirage of the twenty-first century just over the horizon often produces a similar effect, stirring a mood of retrospection, both historical and personal, that has been welling in the art of our century's final decades. In a strange about-face from the passion for the future that marks the origins of twentieth-century life, many younger artists have been looking to the past, as if it were disappearing so rapidly before the onslaught of the next millennium that it had to be scrutinized, cherished, and preserved like the most precious relic.

Such an impulse is central to Mark Innerst's work and is proclaimed immediately by two of its most conspicuous features. For one thing, there is the actual size of his paintings and drawings, whose miniature dimensions can even be sensed instantly in reproductions. Often, his works can be held in the palm of one hand, sometimes reaching such diminutive extremes that we feel we must reach for a magnifying glass to see them at all. And should they expand beyond a foot in width, this modest breadth is probably justified by containing nothing less than the panoramic infinities of a cosmic, if still recognizably American landscape, perhaps on the verge of an undefined apocalypse. Contrary to our prevailing habits of quickly absorbing from a distance paintings hung on the other side of large rooms, Innerst forces us to look at his works up close, one at a time.

Second in prominence is the startling emphasis on the proportionately large size and age of his old-fashioned frames, which at times overpower the minuscule images they enclose, as if they were venerable treasure chests in which the unique records of a vanishing experience were buried. Whatever we see—an easel painting of a frescoed ceiling from the Italian Renaissance; a cuckoo clock or a gold pocket watch inherited from an earlier generation; a still unpolluted fragment of the American landscape or a vault of toxic sky over the industrialized Mississippi River—is instantly detached from the present tense, to be transformed, like a butterfly pinned to a page, into a magically small but intense souvenir of an experience that now exists only in a nostalgic realm of recall. In Innerst's work, an aerial view of a miniaturized Brooklyn from an eagle's height may seem as remote in time and space as a tiny facsimile of a painting by Bronzino. Both experiences have been fitted to manageable sizes for safekeeping in the artist's image bank.

In this new group of works from 1990, Innerst continues to create layers of history and memory with the mysterious reducing glass of his art, once again wedding the private and the public (fig. 194). Paralleling Duncan Hannah's and Eric Fischl's concern with excavating reveries of childhood innocence and experience, Innerst offers two venerable deities from the pantheon of American boyhood—one, a baseball player, who we feel must have struck a home run; the other, a Boy Scout, hand and hat on heart, who would aspire to the ancient virtues—reverence, cleanliness, thrift, cheer, trustworthiness—that are literally inscribed like a litany around the painting's edge. Avoiding the campy, ironic potential of these icons, Innerst seems rather to remember with wistful feeling the idols of a provincial youth in America as well as to share a public nostalgia for a long-lost American fantasy of wholesome simplicity that now looks as distant as the Renaissance art he often depicts.

A more complex resonance emanates from the series of immaculate, unpopulated urban environments that may also fuse our century's cultural history with the artist's early biography (fig. 195). Reduced to the size of a rare manuscript page, these dollhouse constructions, with their pristine geometries, fragmented poster writing, and at once huge and tiny scale, conjure up a wide range of early-twentieth-century utopian dreams—the modern translations of the heavenly city of Jerusalem that sparkled on Hugh Ferris's drawing board; the clockwork perfection of Léger's Brave New Worlds; the zigzagging rhythms of Art Deco skyscrapers that inspired such interwar abstractionists as John Storrs and Charles Shaw. Such prospective visions pinpoint with almost heartbreaking distance the age of faith in industrial progress that we now remember as something that belonged to an era as uncynical about human potential as was the Boy Scout Innerst re-created as an icon. Moreover, these mythical cityscapes are rendered with the utmost fragility, microscopic stage sets calibrated in planes that look millimeters thin and that can make plunging urban views collapse into the paper frailty of scrapbook collages. And their colors are no less delicate, bled, one feels, of their original strength into a more faded realm of recollection.

Such spirit-rapping from the dawn of our century must also be tinged with the artist's personal recall of youthful experiences in life and art. It should be observed that Innerst was born in York, in eastern Pennsylvania, just across the Susquehanna River from Lancaster, a city made famous to art history through the work of Charles Demuth, who could even mix memories of ancient Egypt with the utilitarian grandeur of the region's local factory buildings. Indeed, Demuth's ascetic and translucent vision of the bold billboard lettering and pure linear geometries of this vernacular modern architecture echoes throughout the faraway peaks and canyons of Innerst's floating ghosts of the ideal twentieth-century city. Haunting the imagination of many earth-dwellers before the Second World War, these futuristic visions of urban order have been transformed into rare documents of science fiction from what might well be another planet but was, in fact, ours. Like everything else touched by Innerst, these mirages of what only decades ago was newly minted modernity now seem light-years away, to be savored as the most gossamer remembrances of things past.

"Mark Innerst's Time Capsules." Published in *Mark Innerst* (New York: Curt Marcus Gallery; Santa Monica: Michael Kohn Gallery, 1990), n.p.

194.
Mark Innerst,
Vacation Spot,
1990

195.
Mark Innerst,
The New Building,
1990

JEFF KOONS
1992

Although he is not quite in the same media league as Madonna, Donald and Ivana Trump, or his avowed idols, the Beatles and Michael Jackson, Jeff Koons has been doing pretty well for a mere artist. Featured both on the cover and in the pages of countless art periodicals, he has also turned up again and again in practically every glossy magazine or newspaper at hand, from *Time, People, Newsweek, Cosmopolitan, Vanity Fair,* and *Playboy* to the *New York Post,* the *Orlando Sentinel, Le Figaro,* and the *Düsseldorf Express.* Born in 1955 and trained in art schools in Baltimore and Chicago, Koons in 1977 moved to New York, where he launched his professional career at the Museum of Modern Art in a perfect prophecy of his now famous fusion of art, publicity, and money. Beginning at the ticket booth, he ended up in the membership department where, at least by his own count, he raked in $3 million a year for his employer and then went on to hone his financial skills more finely by working as a Wall Street commodities broker. Inevitably, he also immersed himself in the world of advertising, using its visual blitz for, among other things, some direct sources for his own art, which, in his Luxury and Degradation series of 1986, replicated in billboard size seductive, tête-à-tête ads for alcoholic bliss (Bacardi rum, Gordon's gin, Hennessy cognac, Frangelico liqueur). And in the same year he also designed ads to publicize his own gallery exhibitions using come-on photos, where he would pose like a starry-eyed, teenage rock star, adored by bikini-clad girls who would help him round up trade for his latest art hits to be seen in New York, Chicago, and Cologne. His wish "to communicate with as wide an audience as possible" and his belief that the way to do it now is through the media, "through TV and advertising, through the film and entertainment industries" may sound disarmingly crass, but its combination of dumb innocence and shrewd calculation is clearly, for an artist born in the 1950s and emerging in the climate of the 1980s, less affectation than just plain honesty and common sense for someone pursuing a career in the arts, including those high-minded art critics who are always eager to expand their own fame and power through the media but who sneer aristocratically at Koons for doing the same thing.

Ever with his eye on the consumer, this paragon of a successful artist, 1980s style, has built up year by year, from 1979 on, what amounts to a Jeff Koons Gift Shoppe. In his inventory of immaculately wrought, gleamingly new objects, usually produced as multiples, the range of consumer temptations is vast. There are such useful items as Spalding basketballs, teakettles, Hoover Deluxe shampoo polishers, Shelton wet/dry vacuum cleaners, Aqua-

Lungs, Baccarat crystal sets and travel bars, as well as a broad spectrum
sories that can adorn nurseries, rumpus rooms, and boudoirs for eve
Venetian-glass erotica, stainless-steel trolls and flower arrangements, gi
wooden Yorkshire terriers, sculptured icons of veneration such as super:
Bob Hope, and the artist himself, and for the more conventionally pio!
porcelain Saint John the Baptist worthy of a Neapolitan souvenir shop. Moreover, by
when Koons's liaison with another media star, Ilona Staller, better known as La Cicciolina, had
been sanctioned by the proprieties of old-fashioned romantic love and marriage, even the
couple's most intimate indoor and outdoor sexual raptures could be translated into col-
lectibles in both two and three dimensions, quasi-religious glimpses of an ecstatic, celestial
joy that has barely been witnessed since the days when Counter-Reformation artists prosely-
tized the church with a sensuous theater of transported bodies and souls.

With over a decade's full-power barrage of art, glamour, fame, bliss, and shopping, it
is no wonder that the Koons phenomenon has provided grist for every mill. Students of 1980s
consumerism can have a field day with his styles of salesmanship, the baroque translation of
Barbara Kruger's tough, terse, and hard-edged visual slogan: I SHOP THEREFORE I AM. Auto-
graph hounds haunting art-world personality cults are happy to identify him as the legitimate
heir to Warhol and Dalí with his mix of self-display and instant global media coverage.
Observers of the once out-of-bounds territory of democratic taste can now add him to the cul-
tural company of those sophisticated, jet-setting architects—Michael Graves, Robert Stern,
Arata Isozaki, Frank Gehry—who are happy to put their populist tents down in the Disney
Empire. Porno stars like Annie Sprinkle can take on another side of Koons by writing a nuts-
and-bolts review of his X-rated exhibition, "Made in Heaven," speaking as one hard-core per-
former to another (see *Arts Magazine,* March 1992). And even the duller domain of art-world
lawyers can now claim Koons as a major player, after he became the victim of a court ruling
that he had violated copyright by appropriating, for one of his polychrome wooden sculp-
tures, a cornball commercial photograph of a couple holding eight German shepherd puppies,
an outrageous verdict that could have frightening consequences for countless artists, from
van Gogh and Picasso to Lichtenstein and Mike Bidlo.

All these unbalancing angles of vision, naturally, create endless fodder for every form
of juicy gossip, snobbish contempt, dropped-jaw bewilderment, or even cool sociological
analysis. Koons deserves all of this and more; yet the aura of publicity around him often
deflects attention from the bottom-line fact that he is first of all an artist, and one whose work
belongs to the history of art, looking backward, forward, and sideways in the visual company
of not only his contemporaries but also of older generations.

In terms of first-person experience, I still recall the shock of my initial confrontation
with Koons's lovingly hideous and accurate reconstructions of the lowest levels of three-
dimensional kitsch, from porcelain Pink Panthers (fig. 196) and Popples to painted wooden
bears and angels. We all, of course, have been seeing this kind of stuff for years in every shop-
ping center and tourist trap, but never before have we been forced, as one is in a gallery set-
ting, to look head-on and up close at its mind-boggling ugliness and deliriously vapid
expressions. The bells that finally rang, at least for me, chimed all the way back to 1962,
when I first saw Lichtenstein's earliest Pop paintings at Leo Castelli's and stared with disbe-

196.
Jeff Koons,
Pink Panther,
1988

lief at the colossal gall of an artist who would pollute the space of art with such contemptibly lowbrow images. But then, having regained a bit of balance, I stared again with a wide-eyed awe and fascination before the both familiar and somehow never-before-seen visual and emotional facts of that flood of cheap commercial and comic-strip illustrations that gluts us in the real world but that had been censored out of an art world where educated taste was thought to reign. Just as Lichtenstein, in the early 1960s, compelled us to peer in amazement, like modern Gullivers, at this alarmingly grotesque but ubiquitous visual environment in which we were all living, like it or not, so, too, did Koons, two decades later, proclaim a new segment of popular bad taste as his own, rubbing our eyes in it and forcing us to look, really look, at this bizarre species of art that covers our planet and that pleases millions.

If it is true that one of the exalting effects of art is to make us see, often for the first time, the commonplace realities that surround us, by transforming and relocating them in a more purified, contemplative terrain, then Koons's success is total. Over and over again, what might have been a boring or trashy spectacle in this or that corner of a department store, mail-order catalogue, or toy shop has magically been reincarnated as art. At the shopping mall or airport store, we can now pause before, say, a particularly repulsive cuckoo clock, complete with smiling peasants in lederhosen, artificial geraniums, and an airborne flurry of chirping, Disneyesque birds, and tip our hats toward the artist who made it suddenly visible, wrenching it into the surprising context of prolonged scrutiny in the loftier territory of art

seen in museums and galleries. "This," we think, "would make a perfect Jeff Koons," just as a line-up of Campbell's soup cans or a city wall covered with graffiti is now quickly converted into this or that modern artist. Art has a miraculous way of exorcising and healing what used to be eyesores.

In this, Koons often resurrects, as do many artists of his generation, the spirit of 1960s Pop, which enthusiastically embraced the visual pollutions of the crass world out there as if to say, "If you can't lick it, join it." Of course, by the 1980s this battle had already been won, and Koons and his contemporaries, unlike Warhol and his, no longer had to fight their way through the elitist assumptions of abstract art and could stand comfortably in the triumphs of a now venerable tradition of wallowing in, rather than shielding themselves from, the faces of daily life in a civilization bombarded by commercial come-ons. So it is, for example, that Koons's five-foot-wide clones of liquor ads update in a less rebellious and ironic way Rosenquist's innovative re-creations, in the 1960s, of the overscaled, textureless consumer bait dangled on American billboards, much as Koons's early selection of products that would join the hygienic, high-tech war on dirt and wear—vacuum cleaners, electric brooms, floor polishers—had its ancestor in Lichtenstein's more low-budget encyclopedia of products such as kitchen sponges, spray cleaners, step-on garbage cans.

Koons's inventory of ads and goods from the 1980s (fig. 197), which updated the consumer catalogues of Pop art, was shared, in fact, by many of his contemporaries. His choice of sexy liquor ads, for example, parallels Richard Prince's rephotographing of the macho cowboys who would addict us to Marlboro cigarettes. Similarly, his infatuation with the pristine, commercial arrangement of brand-new, dust-free factory products, often in airtight plastic vitrines and arranged as multiples, has its counterpart in the department-store shelf displays of Haim Steinbach, just as his attraction to the visual complexities of technological gear over-

197.
Jeff Koons,
Art Magazine Ads,
1988–89

laps Ashley Bickerton's science-fictional explorations of the spotless intricacies of equipment so strange that it looks ready for use on the moon or the bottom of the sea.

Often too, Koons's isolation of the odd artifacts of our culture, whether utilitarian, playful, commemorative, or aesthetic, harks back to many earlier artists' efforts to embalm objects we take for granted, as if they were to be treasured as rare archaeological finds from our century, the stuff of time capsules. Duchamp, father of so many things, may have set this twentieth-century form of taxidermy into motion by transforming, in a deceptively direct way, anything from a urinal to a bicycle wheel into a mysterious witness of our civilization; and Johns, closer in spirit to the world into which Koons was born, continued to make these modern relics by petrifying forever, in bronze or sculp-metal, the now useless fossil remains of flashlights, toothbrushes, lightbulbs, and ale cans. Koons's more glitzy, 1980s nouveau-riche approach involves a comparable form of flash-freezing for posterity. A basketball is preserved like a precious object in a museum vitrine, afloat forever in an aquarium on a pedestal. An inflatable dinghy with its oars is immobilized in a bronze cast. A child's dime-store toy, such as a throwaway blow-up vinyl bunny with carrot in hand and jerky smile, first used in its original form in 1979, is seven years later metamorphosed for eternity in one of Koons's favorite media, stainless steel, creating a bizarrely indestructible idol like something from an unidentified cult. And the reflective, unperishable armor of this archetypal twentieth-century synthetic metal (in Koons's words, "the symbol of the proletariat, a poor man's luxury") is also used to stop in its tracks both past and present time, whether in a 3-D caricature of comedian Bob Hope, with grotesquely swollen head, or in a baroque bust of a bewigged absolute monarch, à la Louis XIV, works that might evoke, beneath their ever-glistening surfaces, anything from seventeenth-century hand-carved marble craftsmanship fit for a king to an infinity of factory-made reproductions in a souvenir shop. Koons's Hall of Fame demonstrates his faith that "statuary presents a panoramic view of society; on the one hand there is Louis XIV and on the other hand there is Bob Hope." Leveling different centuries and different kinds of glory to a populist, Disney World perspective, he makes portrait busts for modern consumers interested in a serious purchase for home display that, like an Oscar or an athletic trophy, will also become a precious heirloom.

In many of the earlier works from 1979 to 1986 Koons often seemed to offer belated, though original, variations on the repetitive, Minimalist geometries of the 1960s and 1970s (his Spalding basketballs symmetrically suspended in their tanks are odd deductions from the abstract tradition of juggling pure spheres and cubes), and even the sleek ovoid shapes of his stainless-steel bunny have been located under the shadow of Brancusi's organic distillations. But he also began to move away from these modernist austerities into a far more startlingly unfamiliar language of Baroque style, especially as seen in its most debased twentieth-century progeny. Koons, in fact, explored not only the folkloric mode found in kitsch souvenirs in which the painstakingly realist description of cherubs, poodles, or cuddly pigs offers the last vulgar gasps of the stone- and wood-carver's veristic handicraft that had contributed to the glories of Baroque and Rococo sculpture, but also the grander, more palatial baroque heritage familiar to the world of Liberace and Mafia furniture emporiums, and often encountered in late-nineteenth-century extravaganzas such as Ludwig II's Bavarian castles Herrenchiemsee (neo–Versailles) and Linderhof (neo–Louis XV). And in one unforgettable tour-de-force, Koons

even managed to wed the genuine and the neo. In the summer of 1992, as part of an exhibition of contemporary art held at Schloss Arolsen, less than an hour from Kassel's Documenta 9, he was able to join forces with the early-eighteenth-century castle, which became the theatrical setting for a Koons extravaganza, a colossus of kitsch in the form of a puppy, almost forty feet high, who sits in the courtyard like the most adorable of guard dogs. Made of thousands of flowering plants, from petunias and geraniums to begonias and chrysanthemums, this giant topiary toy telescopes the old and the new baroque, mixing memories of the kind of fantastic garden follies that were meant to dazzle the absolute monarchs who could afford them with the most deliriously deviant branches off that old tree, whether the flower floats at the annual Rose Bowl pageants or the animal-shaped hedges that greet visitors to Orlando's Disney World.

Given the fact that the Baroque and Rococo styles have been, for the better part of this century, uncomfortably at odds with good taste and with the look of modern art and design, Koons's espousal of this historical vocabulary of decorative excess, often demoted in our time to things like vintage carousels and early movie theaters, was a startling transgression, outside even the most relaxed modernist canons. His own aphorisms declare his admiration for the church's use of Baroque and Rococo styles to give a false sense of luxury and economic security in order to concentrate on more spiritual experiences, a goal he at times claims to

198.
Jeff Koons,
Christ and the Lamb,
1988

pursue. Initially, Koons's productions in this historic language were objects of modest orna-mental ambition, such as a gilded Rococo mirror or a stainless-steel version of a porcelain eighteenth-century couple in a Cinderella coach, but soon they soared to a would-be spiritual peak on the crest of the oceanic waves of love that swept him and La Cicciolina away and bore out to an infamous degree his succinct statement "My art and my life are totally one." Koons was to produce the greatest love story of all time, his own.

In what quickly was to become his most startling and publicity-hungry works, an ongoing series offered under the cinematic title "Made in Heaven," he and La Cicciolina car-ried the bliss of perfect love, marriage, and sex to such celestial climes that we would hardly be surprised to find a Jesuit saint ascending with them to a joyful, cloud-borne eternity. Indeed, Koons's overtly outrageous boast that his work "functions very much on the level of the church" may not be so off the mark. So lofty were his spiritual ambitions for this paean to erotic fulfillment that in one of the over-life-sized photographs he even paraphrased the posture of Michelangelo's nude Adam, joining himself to an almost-nude Eve (who wears a few modern accessories such as silver spike-heel shoes and an open bra) and setting this dou-ble allegorical portrait against a cosmic turmoil that provides an appropriately extraterrestrial backdrop for the primal scene. "We are the contemporary Adam and Eve" is, in fact, just what he said when commenting about the 1989 billboard that advertised his forthcoming but eventually scrapped movie *Made in Heaven.* And if biblical and old-master archetypes lurk behind this conception, so, of course, does the more up-to-date mythology of the movies. Their eternal embraces recall, among other unforgettable shots in our collective image banks, Deborah Kerr and Burt Lancaster's *From Here to Eternity* clinch amidst the passionate roar of surf against sand. Koons's constant advice—"to embrace your past"—is almost literally heeded in this epic fusion of memories both lofty and popular, ancient and modern.

These images of transcendental sensuality were first presented at the 1990 Venice Biennale, where, seen in the company of so many other artists' displays, their candid cou-plings in both mural-sized color photographs and waxworklike statues produced the clan-destine peep-show mood that decades ago made it possible only for gentlemen tourists, but not ladies, to see behind locked museum doors the "dirty" Roman art culled from Pompeii and Herculaneum. Rapidly, the sexual pressures of these embraces pushed the images into X-rated territory, so that the 1991 Christmas show at New York's Sonnabend Gallery was to be kept out of the sight of unaccompanied minors and may even have traumatized those rela-tively few innocent SoHo art lovers who stumbled upon the show by accident, without hav-ing heard through the media that pornography and contemporary art had been scandalously wedded for a month.

Among other amazing things about this group of images, which replaced the earlier, relatively discreet concealment of pudenda with gynecologically bald close-ups of genital unions worthy of the Kama Sutra, was that, of all unlikely things, art totally vanquished, or rather absorbed, sex. Instead of a porno show, the effect was like that of Japanese erotic prints, where the degree of stylization is so exaggerated that the sexual acrobatics as such are quickly submerged in an all-engulfing artifice. Here, the Cinemascopic baroque universe that would fuse heaven and earth, flesh and spirit exorcised the lurid parts, which, at least as far as La Cicciolina was concerned, were so thoroughly depilated, cherubically pink, and spot-

lessly clean, that they almost would have been at home in an exhibition of nineteenth-century academic nudes, at once wanton and idealized, by the likes of Bouguereau or Cabanel. And in *Made in Heaven* the heat of the torrid images was also cooled and sweetened by the inclusion, as in a wrap-around installation, of other kinds of Koonsiana, from soulfully chaste neo-Baroque marble busts of the artist and his blessed wife to the more familiar repertory of dogs, birds, cats, and flowers—all works that invoked such wholesome Disney World family values that their very presence at this exhibition provided a fortress against any thoughts of obscenity. After all, back in 1988, Koons had already displayed an almost Victorian faith in the virtues of innocence by creating a childhood version of Adam and Eve on a flower-strewn heart: two stark-naked children who sweetly embrace in a world unpolluted by Freud. Could the creator of this old-fashioned banality be identified as your everyday pornographer? If we may take the artist at his word, it was not pornography at all that interested him, but love, reunion, and spiritual matters, exalted emotions whose corny but time-honored rhetoric quickly eclipsed the X-rated components of *Made in Heaven*. Moreover, by showing his kitschy flower arrangements, with exposed pistil and stamen, in the midst of a display of usually secret human orifices and projections, Koons was eager to underline the biological equation between the world of botany and our own private parts.

Made in Heaven also became a revelation in terms of testing the limits of late-twentieth-century censorship. Until something is shown, no one can guess what new breach of propriety is permissible in a public art space. It was only in the 1980s that X-rated Picassos, featuring delirious copulations and every kind of indecent exposure, could be included comfortably in museum retrospectives and tour the world without protest; and it was in 1988 that the Brooklyn Museum offered in its Courbet exhibition the landmark debut of the artist's notorious *Origin of the World,* a formerly secret painting for a private patron that offered a head-on disclosure of what lay between a woman's thighs. Seen within the context of artists of great stature who had many other things to offer besides genitals at rest or in action, these works were absorbed with little or no fuss into the art-world repertory.

Looked at from this vantage point, Koons's art also belongs to the collective history of the public acceptance, at least in the domain of art, of overt sex. It is telling that only months after Koons's New York show of winter 1991, Cindy Sherman also unveiled in SoHo a series of equally theatrical photographs of grotesquely prosthetic male and female sexual parts, devouring each other in infantile, nightmarish scenes that seem to have been invented in Freud's id. This series provided almost the perfect counterpart to Koons's *Made in Heaven* and might even have been aptly titled *Made in Hell.* Both artists flagrantly violated earlier standards of sexual decorum in public, mural-scaled art and both did so by translating their erotic imaginations into a language of total artifice, fraught with art-historical echoes. If Koons reincarnated Bernini's Santa Teresa, Sherman took us on a contemporary trip to Bosch's hell.

Once again, Koons, who may seem to be living in a distant media world surrounded by the same news reporters and cameramen who go after Michael Jackson, is also living right in the middle of the world of less flashy fellow artists. No matter where we look, he figures large. If we consider how the old-fashioned classifications of painter, sculptor, photographer have become anachronisms for many younger artists who belong to all or none of these cat-

egories, then Koons is a key player. If we think about the strange new race of three-dimensional humanoids and mannequins spawned in the last few decades by artists as different as Duane Hanson and Charles Ray, or about the way in which, as with Mike Kelley, the real toys and souvenirs of an American childhood have become central to a new repertory of artists' themes, he plays a no less central role. And if we think about that breed of artists whose life and art appear inseparable, such as Joseph Beuys, Gilbert and George, McDermott and McGough, then Koons is also a major figure. Self-promoting as he may sound when he claims that "Jeff Koons is a person who is trying to lead art into the twenty-first century," he also happens to be right.

"Jeff Koons." Published as "Notes on Jeff Koons" in *The Jeff Koons Handbook* (London: Thames and Hudson and Anthony d'Offay Gallery, 1992), pp. 11–28.

MIKE AND DOUG STARN

1990

Despite its now venerable history—150 years old in 1989—the medium of photography still arouses many of the same expectations it held at its birth. We intuit, for one thing, that a photograph tells us the truth about an instant in time and a fragment in space, flash-freezing for posterity sights as dramatic as the ruins of Richmond, Virginia, in 1865 or as prosaic as a family gathering in Absecon, New Jersey, in 1961, the place and the year of the birth of Mike and Doug Starn. And we expect, too, that a photograph, in its role as a time-capsule document of our communal and individual lives on earth, should be preserved for the future in as pristine a form as possible, an unchanging image fixed on paper that might survive the ravages of time and death. Many photographers, of course, have challenged some of these stubborn assumptions, creating, for example, montages and dreamworlds that subvert the initially objective premises of photography; but few, if any, have mounted so personal yet so full-scale an attack upon the conventions and restrictions of the medium as Mike and Doug Starn. For them, photography, which usually delivers its messages in the present tense, could be opened to a vast new range of temporary experiences that include the slow and layered accumulation of memory and history and the melancholy decay of flesh and matter. It is no accident that many of their works, like those of Cézanne that were painted and repainted over months and years, are often left looking as if they were still in a state of becoming.

The haunting and at times even ectoplasmic environment created by the Starns suggests a hermetic world, the stuff of a Gothic novel, a uniqueness of vision surely fostered, too, by our awareness of the uncommon phenomenon of their being identical twins who work as one artist. Indeed, their twinning creates resonant psychological dimensions that are clearly reflected in their preferred configurations. For instance, paired or mirrored motifs recur throughout their work, often creating surrogate double portraits. At times, as in one of their variations (fig. 199) on a Rembrandt in Chicago (a portrait presumably of the artist's father), the head is reflected upside down, playing-card fashion, in a Narcissus-like pattern that is also used for the twins' self-portraits as well as for less personal images. And insofar as their work often evokes an archaic mood from the history of photography, their frequent use of stereoscopic double formats is one that intersects both their private identity and the technological history of their medium. Such a magnetic attraction to doubled imagery can even be found in many of their choices from earlier art. It is telling that when they selected a painting by Picasso for photographic inspiration, they originally considered the 1921 trio of neoclassic

199.
Mike and Doug Starn,
Double Rembrandt with Steps,
1987–88

women at the Museum of Modern Art, but then dropped it for an earlier, lesser-known version of the painting in Düsseldorf in which this monumental trio is only a duo. And, startlingly, in one of their variations on a seventeenth-century Dutch painting of a huge, threatened swan by Jan Asselijn, the bird's neck suddenly bifurcates in a mirrorlike sprouting of not one but two hissing heads.

The strange intimacy of their work is further borne out by its way of making us feel like intruders, unexpectedly discovering these precious, aging relics in an attic that was locked up decades ago. Although their images may range from Hawaii to the Tuileries, from the Crucifixion (fig. 200) to Anne Frank, from a Minoan ivory bull-jumper to a portrait of the late photographer Mark Morrisroe (one of their few early influences), these facts of the public domain are transformed into records of private responses that almost seem like mirages, withdrawing from view as we look at them. What, in fact, may at first be most disconcerting about the Starns' work, in both an obvious and a subliminal way, is their insistence on the material life span of their medium, images on paper; for they are determined to undo the scientific look usually associated with photography's techniques of laboratory precision, cleanliness, and impersonality. The fact and the illusion of accident and of the handmade are everywhere. Fragments are Scotch-taped together; edges are furled and torn; black tape defaces images; photographic surfaces are crumpled or, at times, seen through the transparency of ortho film; pushpins pierce ragged holes into paper and wall; frames look haphazardly chosen in shape or style. We sometimes feel that we have stumbled upon the rubble of both public history and intimate journals, deteriorating fragments for some future archaeologist who would reconstruct our past from what looks like a site unearthed after the apocalypse.

But even odder, a pulse of life and memory continues to beat in these withering ruins, which blur the distinction between the quick and the dead, between things once alive and embalmed and those that never lived at all but are now coming to life. Typical is the recurrent motif of a horse's head, frozen in movement. In an early appearance, this doubled image was that of a pair of real horses belonging to the Starns' sister, descendants of the kind documented in Muybridge's photographic studies of animal locomotion; but the literal premises of such a factual document were thoroughly undermined by the strange way in which it was mutilated, recomposed, veiled by extended exposure, or even tinted in the colors of old-fashioned photographs—smoky sepias, otherworldly blues, bleaching yellows. Already transformed into wisps of memory that both congeal and evaporate, this horse head was later to be reincarnated as a detail of a late classical sculpture, a bronze actually observed on a visit to Greece, but one that now looks like the petrified, yet once living version of its modern kin. The boundaries between these two animals, one preserved by the lens of a camera, the other by the hand of an ancient sculptor, were melted by the Starns in a terrain of photographic phantoms where time could be as fluid as the difference between sentient beings and lifeless matter.

The Starns' ability to resuscitate as well as to distance photographic images is uncanny, verging on hallucination. Like many artists of the 1980s, they are often concerned with quot-

200.
Mike and Doug Starn,
Crucifixion,
1985–88

ing earlier works of art, but they do so in an eerie way that explores the potential life and death of what are literally only photographic reproductions of inert objects in museums. They can work their magic, for instance, on a neoclassic painting by Picasso, whose sculptural nudity already conjures up the archaic ghosts of a lost Mediterranean past but whose remoteness is made still more layered by their re-creation of the painting as fragmented, recomposed, tattered, and tinted photographic images that seem to have survived from an epoch equally remote from the present. Even more ambitious are their astounding variations on a lesser-known seventeenth-century painting in the Louvre, a fleshy, totally supine dead Christ by Philippe de Champaigne (see fig. 200). Printing a photograph of this painting under their usual conditions of lengthy exposure already began to complicate the image, which seemed to exist in a shadowy territory somewhere between the record of a real oil painting on canvas and a photograph of the no-less-real hair, flesh, and muscle of a full-bodied male corpse who might well have been Christ. The effects were like a modern version of Veronica's veil or the Holy Shroud of Turin: muffled, impalpable, sacred records and memories of a painful, palpable, secular truth. But from this motif they proceeded to a further reincarnation, wrenching the supine body upward at a full ninety degrees, in order to evoke the Crucifixion itself. This bramble of wood, photographs, and coiling wires inspired by the crown of thorns in the original painting connects the repeated details of Christ's body left and right, discharging shock waves of suffering that also make us feel we are watching a real crucifixion in progress. Since the debut of Francis Bacon, it would be hard to think of any late-twentieth-century artists who have tackled this archetypal tragedy with such harrowing immediacy.

Within only a matter of five years, in fact, the Starn twins seem to have mastered their private imagination sufficiently to take on the most relentless specters of public history, including the Holocaust itself. Their 1989 memorials to Anne Frank on the occasion of the sixtieth anniversary of her birth in 1929 are records of individual history, scaled to what recall heartbreaking souvenirs from the scrapbooks of a doomed family; but these reminders of unbearable facts can also be amplified to global dimensions in the Starns' history of martyrdom, titled *The Lack of Compassion* and destined for the Israel Museum in Jerusalem. The open-ended history of human suffering, ranging from individual martyrs, like Christ or Martin Luther King Jr., to collective victims, like those from the concentration camps or Tiananmen Square, are compiled here in an encyclopedic inventory of death, where memorials in the form of wooden planks that bear the photographs of the deceased create the litter of a mass grave, poignantly incomplete and ready to accommodate the next chapter in this narrative.

Given the seeming privacy of the Starns' world, which in literary terms might be the equivalent of intimate, unpublished diaries, it is startling to realize that they can create work of such epic and universal dimensions. And it is no less surprising that what begins as the most eccentric, personal art ends up occupying an ever more central position in any international community of art culled from the last decades. Their concern with the traumas of the Third Reich, for example, may be relatively alien to their artist compatriots in America; but their contributions to this theme of bottomless terror join forces with the gloom-ridden, elegiac visions of the Nazi era offered by such Europeans as Anselm Kiefer and Christian Boltanski. Yet their art belongs to an American milieu as well. It would be difficult to think of their mix of photographs and art reproductions within an environmental poetry of disorder and disin-

tegration without summoning up the spirit of Rauschenberg in the 1950s; and as for Warhol, his ever-lengthening shadow is cast throughout their work, whether we look at their early attraction to repetitive photo patterns or their pervasive sense of death, which can range from a traditional skull still life and images of corpses and public tragedies to the rendering of photographic portraits as ghostly afterimages. Moreover, any consideration of the historicizing character of the 1980s would have to take the Starns into account, not only in terms of their remembrance of things past, but in terms of their constant scrutiny of earlier works of art as grist for their image mill. Much as David Salle might offer fragmentary quotations from a surprisingly diverse repertory of artists, from Watteau to Kuniyoshi, so, too, will the Starns seize details from painting and sculpture that range from classical gravestones to paintings by Bouts, Leonardo, Copley, works that at times come to life like spirits from a museum tomb or at times serve to recall the displacements of travel experience, as in the jolting juxtaposition of a detail from a Rembrandt in the Art Institute of Chicago against one of the city's classic skyscrapers, the Rookery. And even on the level of twinning, their art has echoes on both sides of the ocean in other examples of couples who, though not twins, also share their life and art. In London, Gilbert and George provide a parallel in their double portraits and double vision of a vast panorama of experience that would document both their personal history and the public world outside their door; and closer to home, in New York, Peter McGough and David McDermott offer, like the Starn twins, a willful recall of the historical past, whether the 1890s or the 1940s, which, in their paintings as well as in their tinted photographs, they would resurrect as period reconstructions capable of transporting them from an alien present to an earlier decade. Initially as lonely and peripheral as the most personal of family albums, the work of Mike and Doug Starn is becoming unexpectedly central to the history of contemporary art. That this has happened in less than five years opens vistas for their future that only they could begin to imagine.

"Mike and Doug Starn." Published as the introduction to Andy Grundberg, *Mike and Doug Starn* (New York: Harry N. Abrams, 1990), pp. 13–16.

MCDERMOTT AND MCGOUGH:
THE ART OF TIME TRAVEL

1997

There must be ways of connecting the unforgettably unique art of David Walter McDermott (born 1952) and Peter Thomas McGough (born 1958) with that of their contemporaries, but they are not easy to find. One link might be the curious phenomenon of artists who are twinned not only in their work, but in their life, love, or genes. Examples include Mike and Doug Starn, Dinos and Jake Chapman, Bernd and Hilla Becher, Gilbert and George, Komar and Melamid; but of these, it is only Gilbert and George who approach McDermott and McGough in terms of constructing a private universe that would totally fuse their art with a codified, full-time lifestyle. Another, more far-reaching way of relating McDermott and McGough to their contemporaries might involve the domain of retrospection, so pervasive in art of the late twentieth century. Judging from recent decades, there must be something very

201.
David McDermott
and Peter McGough,
photographic portrait
of the two artists

frightening about the prospect of the millennial year A.D. 2000; for one artist after another has been looking backward to public and private memories from a distant time. Carlo Maria Mariani and Ian Hamilton Finlay, for example, have often turned back nostalgically to the eighteenth century's own nostalgic revival of antiquity; and Mike Bidlo and Sherrie Levine have done the same for the classics of early-twentieth-century art, which they replicate as if these were the holy relics of a buried era. Artists such as April Gornik, Joan Nelson, and Mark Innerst have resurrected lost visions of the remote, unpolluted landscapes that were venerated by Romantic painters and poets but were then pushed into the dead past by our century's fervent worship of the machine. Duncan Hannah, Joe Brainard, and Mike Kelly have been roaming around the souvenirs of their own childhoods, gathering material for their adult art.

None of these artists, however, can come anywhere near McDermott and McGough's total refusal to live in the historical present. Their obsession with the historical past extends not only to the subjects and styles they choose to resurrect in their canvases and photographs, but also to the period costumes they insist on wearing, the often unelectrified houses they have lived in, and the very dates, whether 1889 or 1927, they inscribe on their art. For such time travel, they generally focus on the modern historical era. On one occasion, a canvas titled *French Revolution* (fig. 202), they have gone all the way back to those critical years, listing the epochal dates from 1789 to 1793 (the last inscribed in the bloody red of the Reign of Terror) against a pale wash background of historical vignettes that carry us from the demolition of the Bastille to corpse-littered battlefields. But in general, they prefer to reincarnate later decades that touch more closely on their own personal heritage, namely, the America of the late nineteenth and early twentieth centuries. There they chronicle a sweeping panorama of art and culture, both high and low, turning their attention to religion, to beauty, to sexual morality, to landscape, or to good penmanship, as well as tackling the arrival of a new industrial era, where one finds everything from electric lightbulbs, high-minded advertisements, and newfangled men's accessories to tawdry popular entertainment, modernist art movements, and even the ruminations of Sigmund Freud.

In their paintings, such chronological fluidity is often made as explicit as a chalked blackboard diagram in a nineteenth-century school. For example, *Time Travel,* a painting fictitiously dated 1923, is an intricate checkerboard of minutely hand-painted dates, running backward and forward, year by year, from the seventeenth century to the year 2000, the terminus of this numerical voyage. On closer inspection, we realize that this chart also provides a patchwork-quilt camouflage for a faint, underlying image explained by the authors' accompanying text. What we can just discern through the tidy, paint-by-numbers patterns is the ghostly presence of a gentleman of 1725 encircled by four dancers of 1923. In the words of the artists, "The past moment *1725* and the present moment *1923* now co-exist."

And in another version of these flowcharts, *Turn of the Century* (this one dated 1901), McDermott and McGough would capture the mysterious alpha and omega of our century's birth (its first year actually beginning in 1901, not 1900). In this eye-popping but tidy explosion of concentric circles, we seem to be in the hands of a hypnotist who would make us stare at the magical junction of past and future that spins numerically forward and backward between the dawn of the nineteenth century and the twilight of our own millennium. If both paintings evoke the look of scientific diagrams that might have been used by anyone

202.
David McDermott
and Peter McGough,
French Revolution,
1989–90

from a Victorian chemistry teacher explaining the periodic table of the elements to Mme. Blavatsky demonstrating to her Theosophical disciples the stepwise evolution from matter to spirit, such quaint reveries can also yield more sophisticated vibrations in the territory of recent art history. So it is that these abstract grids and circles can unexpectedly point to more exalted levels of modern art, reminding us that McDermott and McGough do, in fact, live in the late twentieth century and that they are saturated, like their contemporaries, with the familiar canon of museum-worthy achievements. What often emerges is something resembling a marriage of Grandma Moses and Jasper Johns. Indeed, speaking of Johns, McDermott and McGough perform their usual art-historical alchemy in a work that typically suggests a painted facsimile of an advertisement from the 1920s. Titled *Five Cents,* it simulates a 1925 promotion for waxed and starched collars at five cents a throw but then sweeps through the corridors of high art as it echoes Johns's own iconization of the number five, which, in turn, quotes the chronologically relevant painting by Charles Demuth, *I Saw the Figure Five in Gold* (1928), based on a poem by William Carlos Williams.

Such an acute awareness of art history, usually concealed quite slyly beneath their American grass-roots subjects from old-fashioned popular art and culture and by their equally

203.
David McDermott
and Peter McGough,
Dandysmo, 1913,
1987–88

homespun, quilt-making type of pictorial craftsmanship, at times turn into an outright, but unexpectedly poignant spoof on the mad heyday of modern art's proliferation of zany "isms" before the First World War. Lo and behold, McDermott and McGough have rediscovered, in one of their time travels, an obscure modernist movement of 1913 named Dandysmo (fig. 203), an apparent response to the Italian Futurismo and its explosive European kin that landed conspicuously on American shores with such events as the Armory Show of 1913. In the first of two versions of these mock-manifesto paintings of early cultural revolution, the artists define not only the visual rebellion of Dandyism (free-floating levers à la Marinetti and Apollinaire; disks of rainbow color à la Kupka and Delaunay), but the sexual one as well. The dandies of this new ism (one of them being Oscar Wilde, a frequent point of reference) bob about in this modernist cocktail of abstract shapes, colors, and letters, and, according to the accompanying text, are nothing less than proselytizers for "the rarefied sub-Culture of the Homo Erotick." In the second version these three stylishly dressed gentlemen, presented as Cubo-Futurist fragments, disappear entirely into a more Kandinsky-like spiritual plane. The artists' explanatory words again evoke the year 1913 and sound particularly like Kandinsky's own highfalutin meditations on art's transcendental powers, except that once more, McDermott and McGough's subtext leads us to an occult dreamworld of gay history, proclaiming, with their familiar capriciousness about grammar, spelling, and punctuation. "It is at that Homo Erotick Annunciation, when the decorative Material will to be transcend'd with the masculative Spiritual, that truly it will be said that Beautiful Love reigneth here."

The fantasized history of a gay subculture in America is a constant inspiration to McDermott and McGough's reconstructions of same-sex desire repressed by the convoluted

rituals of nineteenth- and early-twentieth-century decorum. We see such an eruption of gay yearning at its most heart-rending, criminalized form in *Peep Hole* (fig. 204), where we focus on one wide-open eye staring furtively through a hole drilled into a wooden fence. On our side of the fence, the word QUEER has been chalked by some macho graffitist in order to put the voyeur back in his sexual ghetto. Such raw souvenirs of teenage awakenings can also be translated into more complex Victorian narratives, or even post-Surrealist dream images. As for the former, there is *The Flower Show,* the depiction of an event of 1907 that finds a city and a country boy sitting uncomfortably side by side in the section devoted to the tropical rain forest. Dressed now like a dandy, the coarse country lad has his eye on the elegant youth from the city who, by posture and gaze, rejects this hoped-for romance. Like a Victorian painter or novelist, McDermott and McGough present this conflict of city and country, rich and poor, cultivated and crude as the drama of romantic coupling, doomed to joy or sorrow. And when McDermott and McGough choose to illustrate romantic success rather than fail-ure, they can even encapsulate it within the symbolism of modern technology in the year

204.
David McDermott
and Peter McGough,
Peep Hole,
1988

205.
David McDermott
and Peter McGough,
No Arguments, 1903,
1986

1903. *No Arguments* (fig. 205) does just this, selecting one of the new icons of the early twentieth century, the electric lightbulb, and using it as a bell jar for the incandescent union of two respectably dressed young men's bodies and souls. Here the electrical wonders venerated by the likes of the Futurists and Dadaists join forces with the nineteenth-century bathos of ladies' novels. But inevitably, within this world of courtly rites and spiritual aspiration, the Freudian snake in the Victorian Garden of Eden will occasionally raise its frightening head.

So it is that in the boldly titled *Erotic Landscape,* the ghost of Salvador Dalí takes over what looks like an American primitive painter's voyage to a natural paradise in New York State, complete with waterfall, pine trees, and rocks. Concealed, however, in this unpolluted vision of a past century's innocence, we suddenly discover a clandestine world of double images within the slumbering dreamer below. Here the shocking triumph of the unconscious is disclosed. Behind the veils of nature lies a fellatio fantasy in the sleeping mind of the most properly dressed young bachelor, whose perfect gold cuff link reads "us."

Such febrile sexual longings can even be integrated into the world of popular entertainment, as in the *Erotic Circus* of 1900, where, within the gaudy pageantry of a circus crammed with barbells, a trained pug, and an array of luridly painted decor in every imaginable pattern and color, the local strongman, in full frontal nudity, lifts his muscular weight by supporting himself with two firm grips upon the erect penises, black and white, of two local clowns. Hard to believe, but this X-rated fantasy, which could easily be as torrid as a page out of Tom of Finland's macho pornography, emerges with an old-fashioned aura of Victorian innocence, a delicious irony explained this way in the text: "If women desire to see the show

perhaps it is fine for them; perhaps it is wrong for us to show them the show. Anyway, no man nor boy child could take offense at such amazing sensational skill and fun."

For McDermott and McGough, gay desire, couched in antiquated rhetoric, is a constant motif. When, in imitation of an academic art school manual on how to draw classicizing heads, they replicate the perfect eyes, nose, lips, and ears of a male youth, the result is titled *Forget Me Not,* a memory of ephemeral ideal beauty that, in the form of, say, the Apollo Belvedere, once made Winckelmann and his antique-loving contemporaries swoon with a mixture of aesthetic and homoerotic passion. A platonic handshake of bonding trust and friendship between two men offered under the rubric of "Brotherly Love" is, in another painting, the target and victim of homophobic prejudice, its glass shield smashed, even while the image remains untouched. But if the artists' trompe-l'oeil calling card in the lower left-hand corner affirms the fictive date, 1869, the ensemble, with its compilation of broken glass, sign-painter's hands, and illusionistic tricks, also becomes a witty homage to Duchamp, yet another example of McDermott and McGough's dizzily anachronistic voyages from one time zone to another.

In this sexually charged fantasy world, articles of clothing from other decades can also take on fetishistic magic. The commercial pages of early-twentieth-century American periodicals that the artists collect in steamer-trunk quantities are re-created here as boldly emblazoned icons of cuffs, collars, or shoes charged with a bizarre intensity. We are again reminded of classic modern art, in this case the way such Dada masters as Ernst and Picabia could translate similar commercial sources into strange new deities. But the voice of religion and morality can also be coaxed out of these vulgar commodities, as in the many paintings that purport to raise consumer consciousness by pointing out how some 70,000,000 dead animals may go into the manufacture of these spiffy-looking new sports shoes. In other series, we can almost escape in our time capsule from such modern problems to a trouble-free, if somewhat ruinous, world of the purest nineteenth-century landscape tradition. Fragments of would-be pastoral bliss—grazing cows, cloud-filled blue skies, verdant forests—are re-created, but their state of preservation is desperately poor, as if they were found in the dusty attic of someone who had bought a painting by Frederic Church and then shut the door on it for a century. With their trompe-l'oeil scratches and torn edges, even these Gardens of Eden seem threatened by time, poignant relics of a lost world perhaps beyond even these time travelers' long reach.

Nevertheless, their mission to live in the past and to work in the past remains undaunted, despite their need to deal with the living facts of the present. So it is in their series of portrait commissions, for which they resuscitated the lost art of silhouette portraiture. Their sitters—who include the artists themselves—have been eternalized as profile silhouettes in black, crowning their Sunday-best clothing from another remote decade, whether the 1870s or the 1920s, and presented against backgrounds emblematic of the sitters' interests and personality. Adapting themselves to the practical world of artist and patron, they can even produce a mock advertisement for their artistic wares. Dated 1908 and including a photographic double portrait of the artist-couple (fig. 206), it reads in the bold and clear letters of the original Sears Roebuck catalogue guarantee from which it was copied: WE MUST FURNISH A QUALITY OF MERCHANDISE THAT WILL EFFECTIVELY DISPROVE EVERY ARGUMENT OF EVERY KIND RAISED AGAINST US. But the tone of this combative commercialism can also be soft-

206.
David McDermott
and Peter McGough,
Advertising Portrait, 1908,
1989

ened to the art-for-art's sake whispers of a more subtle affirmation of faith in their rarefied, handmade products, of a sort that might even belong to their mythical dandyist movement. In this effete guise, the inscription on another canvas, almost fading to illegibility in its ethereal nuances of a celestial pale green and blue, should perhaps be given the last word here: THIS IS ONE OF OUR FAVORITE PAINTINGS. WE HOPE YOU WILL LIKE IT AS WELL.

"M[a]cDermott and M[a]cGough: The Art of Time Travel." Published in *Messrs MacDermott and MacGough: Paintings, Photographs, and Time Experiments, 1950* (Bruges: Stichting Kunstboek; Ostend, P.M.M.K. [Museum of Modern Art], 1997), pp. 9–12.

A BIBLIOGRAPHY OF WRITINGS
by Robert Rosenblum

COMPILED BY KATHLEEN ROBBINS

1953
"The Paintings of Antoine Caron." *Marsyas* 6 (1950–53), pp. 1–7.

1954
"Marin's Dynamism." *Art Digest* 28, no. 9 (February 1954), p. 13.
"New York Revisited: Church of the Ascension." *Art Digest* 28, no. 12 (March 15, 1954), pp. 11, 29.
Review of *Charles Rennie Mackintosh and the Modern Movement,* by Thomas Howarth. *Arts Digest* 29, no. 2 (October 1954), pp. 18–19.
"Varieties of Impressionism." *Arts Digest* 29, no. 1 (October 1954), pp. 6–7.

1954–55
Exhibition reviews in *Art Digest* 28, nos. 9–18 (February–July 1954), vol. 29, nos. 3–19 (November 1, 1954–August 1, 1955), including: Roy Lichtenstein, February 15, 1954; Paul Klee, March 1, 1954; Philip Pearlstein, February 1, 1955; Vincent van Gogh, April 15, 1955; Age of Mannerism, May 1, 1955; Gorky, Matta, de Kooning, Pollock, June 1, 1955; seventeenth-century Dutch masters, July 1, 1955.

1955
"The Kress Collection: Past and Future." *Arts Digest* 29, no. 11 (March 1955), pp. 16, 23.
"The New Decade." *Arts Digest* 29, no. 16 (May 15, 1955), pp. 20–30.
Review of *Klassizismus und Utopia: Interpretationen zu Werken von David, Canova, Carstens, Thorvaldsen, Koch,* by Rudolf Zeitler. *Art Bulletin* 37, no. 7 (March 1955), pp. 70–74.
Review of *Watercolors by Albrecht Dürer*, ed. Anna Maria Cetto. *Arts Digest* 29, no. 7 (January 1, 1955), pp. 16–17.

1956
Review of *Ben Nicholson: Painting, Reliefs, Drawings,* vol. 1, by Herbert Read. *Arts* 30, no. 4 (January 1956), p. 45.
Review of *Gian Lorenzo Bernini,* by Rudolf Wittkower. *Arts* 30, no. 4 (February 1956), pp. 43–44.
"A Rodin Bronze." *University of Michigan Museum of Art Bulletin,* no. 7 (April 1956), pp. 40–42.
Reprinted as "Auguste Rodin, *The Young Mother*" in *Eighty Works in the Collection of the University of Michigan Museum of Art.* Ann Arbor: University of Michigan Museum of Art, 1979, cat. no. 65.

1957
"British Painting vs. Paris." *Partisan Review* 4, no. 1 (Winter 1957), pp. 95–100.
"The Duchamp Family." *Arts* 31, no. 7 (April 1957), pp. 20–23.
"The Origin of Painting: A Problem in the Iconography of Romantic Classicism." *Art Bulletin* 39, no. 4 (December 1957), pp. 279–90.

Review of *Art in European Architecture,* by Paul Damaz. *Arts* 31, no. 5 (February 1957), pp. 45, 70.
"The Unity of Picasso." *Partisan Review* 24, no. 4 (Fall 1957), pp. 592–96.

1958

"Arshile Gorky." *Arts* 32, no. 4 (January 1958), pp. 30–33.
"Jasper Johns." *Arts* 32, no. 4 (January 1958), pp. 54–55; reprinted in Susan Brundage, ed., *Jasper Johns: 35 Years; Leo Castelli.* New York: Harry N. Abrams, 1993. n.p.
"La Peinture américaine depuis la seconde guerre mondiale." *Aujourd'hui: Art et architecture* 3, no. 18 (July 1958), pp. 12–18.
"Robert Rauschenberg." *Arts* 32, no. 6 (March 1958), p. 61.

1959

"Albert Urban." In *Sixteen Americans.* New York: Museum of Modern Art, 1959, pp. 80–81.
Introduction to *Edward Plunkett: L'Invitation au Voyage.* New York: David Herbert Gallery, 1959.
"Louise Nevelson." *Arts Yearbook 3: Paris/New York* (1959), pp. 136–39. Reprinted in Laurence J. Trudeau, ed., *Modern Arts Criticism,* vol. 4. Detroit: Gale Research Inc., 1994, pp. 178–79. Excerpt reprinted in *Sixteen Americans.* New York: Museum of Modern Art, 1959, pp. 52–53.

1960

"Benjamin West's *Eagle Bringing the Cup of Water to Psyche*: A Document of Romantic Classicism." *Record of the Art Museum, Princeton University* 19 (1960), pp. 66–75.
Contributions to *Encyclopedia of World Art.* New York, Toronto, and London: McGraw-Hill, 1960–66. Entries for: Chagall, vol. 3 (1960), pp. 355–56; de Chirico, vol. 3, p. 578; Dalí, vol. 4 (1961), p. 225; Daubigny, vol. 4, p. 235; Delaunay, vol. 4, p. 286; Derain, vol. 4, pp. 354–55; Fantin-Latour, vol. 5 (1961), p. 358; Gros, vol. 7 (1963), p. 182; La Fresnaye, vol. 8 (1963), p. 1066; Millet, vol. 10 (1965), p. 91; Prud'hon, vol. 11 (1966), p. 750; Redon, vol. 11, p. 894; Rouault, vol. 12 (1966), p. 583.
Cubism and Twentieth-Century Art. New York and London: Harry N. Abrams, 1960. Revised edition, 1966.
"Jasper Johns." *Art International* 4, no. 7 (September 1960), pp. 74–77. Reprinted in Steven Henry Madoff, ed., *Pop Art: A Critical History.* Berkeley: University of California Press, 1997, pp. 11–13. Reprinted in Susan Brundage, ed., *Jasper Johns: 35 Years; Leo Castelli.* New York: Harry N. Abrams, 1993, n.p.
Review of *Benjamin West and the Taste of His Times,* by Grose Evans. *Art Bulletin* 42, no. 1 (March 1960), pp. 76–79.
Review of *Essais sur Diderot et l'antiquité,* by Jean Seznec. *The Romantic Review* 51, no. 2 (April 1960), pp. 138–40.
Statement. *Jasper Johns.* Columbia Museum of Art, South Carolina. 1960.
"Wright of Derby, Gothick Realist." *ARTnews* 59, no. 1 (March 1960), pp. 24–27, 54–55.

1961

"The Abstract Sublime." *ARTnews* 59, no. 10 (February 1961), pp. 38–41. Published in German as "Das Sublimen in der Abstrakten Malerei" in Wieland Schmied, ed., *Zeichen des Glaubens Geist der Avantgarde, Religiöse Tendenzen in der Kunst des 20. Jahrhunderts.* Berlin: Schloss Charlottenburg, Grosse Orangerie, 1980, pp. 132–36. Reprinted in Henry Geldzahler, *New York Painting and Sculpture: 1940–1970.* New York: E. P. Dutton, 1969, pp. 350–59. Reprinted in Joseph J. Schildkraut and Aurora Otero, eds., *Depression and the Spiritual in Modern Art: Homage to Miró.* Chichester: John Wiley and Sons, 1996, pp. 187–95.
"Gavin Hamilton's *Brutus* and Its Aftermath." *Burlington Magazine* 103, no. 694 (January 1961), pp. 8–18, 21.
Introduction to *The Romantic Temperament.* New York: Alan Gallery, 1961.
Review of *Romantic Art,* by Marcel Brion, and *Painting and Sculpture in Europe, 1780–1880,* by Fritz Novotny. *ARTnews* 60, no. 3 (May 1961), pp. 40, 54–55.

1962

"Jasper Johns." In *4 Amerikanare: Jasper Johns, Alfred Leslie, Robert Rauschenberg, Richard Stankiewicz.* Stockholm: Moderna Museet, 1962, pp. 9–10. (Includes excerpts from "Jasper Johns," *Art International,* September 1960.)
"A New Source for David's *Sabines*." *Burlington Magazine* 104, no. 709 (April 1962), pp. 158–62.

"Les Oeuvres récentes de Jasper Johns." *XX Siècle* 24, no. 18 (February 1962), n.p.

Review of *The Architecture of Sir John Soane,* by Dorothy Stroud. *Journal of the Society of Architectural Historians* 21, no. 3 (October 1962), p. 154.

"Sources of Two Paintings by Joseph Wright of Derby." *Journal of the Warburg and Courtauld Institutes* 25, nos. 1–2 (January 1962), pp. 135–36.

1963

Introduction to *Jasper Johns: 0–9* (portfolio of lithographs). West Islip, N.Y.: Universal Limited Art Editions, 1963. Reprinted in *Jasper Johns 0–9* (exhibition catalogue). Tokyo: Minami Gallery, 1967. Reprinted as "Jasper Johns: The Magic of Numbers" in *Jasper Johns: Printed Symbols.* Minneapolis: Walker Art Center, 1990, pp. 27–29.

"Morris Louis." In *Toward a New Abstraction.* New York: The Jewish Museum, 1963, pp. 18–19.

"Morris Louis at the Guggenheim Museum." *Art International* 7, no. 9 (December 1963), pp. 24–27. Reprinted in Dutch in *Morris Louis.* Amsterdam, Stedelijk Museum, 1965, n.p.

"*Moses and the Brazen Serpent:* A Painting from David's Roman Period." *Burlington Magazine* 105, no. 729 (December 1963), pp. 557–58.

"Roy Lichtenstein and the Realist Revolt." *Metro,* no. 8 (April 1963), pp. 38–44. Reprinted in John Coplans, ed., *Roy Lichtenstein.* New York: Praeger, 1972, pp. 115–16, 133–36, and in Steven Henry Madoff, ed., *Pop Art: A Critical History.* Berkeley: University of California Press, 1997, pp. 189–93. Published in French, in abridged version, in *Lichtenstein.* Paris: Galerie Ileana Sonnabend, 1963, n.p.

1964

"Picasso as a Surrealist." In *Picasso and Man.* Toronto: Art Gallery of Toronto, 1964, pp. 15–17. Reprinted in *Artforum* 5, no. 1 (September 1966), pp. 21–25; and in Amy Baker, ed., *Working Critically: 21 Years of Artforum Magazine.* Ann Arbor, Mich.: University of Michigan Press, 1984, pp. 41–44.

1965

"Frank Stella: Five Years of Variations on an 'Irreducible' Theme." *Artforum* 3, no. 6 (March 1965), pp. 20–25. Published in German in *Frank Stella: Werke, 1958–1976.* Bielefeld: Kunsthalle, 1977, pp. 103–5.

Introduction to *Nicholas Krushenick.* New York: Fischbach Gallery, 1965.

Introduction to *New York Ten* (portfolio of prints). New York: Tanglewood Press, 1965.

"Letters: Jacques-Louis David at Toledo." *Burlington Magazine* 107, no. 750 (September 1965), pp. 473–75.

"Neoclassicism Surveyed." *Burlington Magazine* 107, no. 742 (January 1965), pp. 30–31.

"On a Painting of Milo of Crotona." In Marsyas, ed., *Essays in Honor of Walter Friedlaender.* New York: Institute of Fine Arts, New York University Press, 1965, pp. 147–51.

"Pop Art and Non-Pop Art." *Art and Literature,* no. 5 (Summer 1965), pp. 80–93. Reprinted in *Canadian Art* 100 (January 1966), pp. 50–59, in John Russell and Suzi Gablik, *Pop Art Redefined.* New York: Praeger Publishers, 1969, pp. 53–56, in Judith Goldman, *The Pop Image: Prints and Multiples.* New York: Marlborough Graphics, 1994, pp. 114–16, and in Steven Henry Madoff, ed., *Pop Art: A Critical History.* Berkeley: University of California Press, 1997, pp. 131–34.

"Victorian Art in Ottawa." *Art Journal* 25, no. 2 (Winter 1965–66), pp. 138–43.

1966

"Caspar David Friedrich and Modern Painting." *Art and Literature* 10 (Autumn 1966), pp. 134–46.

"Notes on Mondrian and Romanticism." In *Piet Mondrian, 1899–1944.* Toronto: Art Gallery of Toronto, 1966, pp. 17–22. Reprinted in *ARTnews* 64, no. 10 (February 1966), pp. 32–35; and in Laurence J. Trudeau, ed., *Modern Arts Criticism,* vol. 4. Detroit: Gale Research Inc., 1994, pp. 149–52.

"Roy Lichtenstein." *XXXIII International Biennial Exhibition of Art.* Venice: United States Pavilion, 1966, pp. 32–35.

1967

Contributor to David Whitney, ed., *Leo Castelli: Ten Years—A Commemorative Album.* New York: Leo Castelli Gallery, 1967.

"The Ingres Centenary at Montauban." *Burlington Magazine* 109, no. 775 (October 1967), pp. 583–87.

"Ingres, Inc." In Thomas B. Hess and John Ashbery, eds., *ARTnews Annual XXXIII: The Academy.* New York: Newsweek, Inc., 1967.

"James Bishop: Reason and Impulse." *Artforum* 5, no. 6 (February 1967), pp. 54–55.

Jean Auguste Dominique Ingres. New York: Harry N. Abrams, 1967. Concise edition, *Ingres.* New York: Harry N. Abrams, 1985.

"Picasso at the Philadelphia Museum of Art." *Bulletin: Philadelphia Museum of Art* 62, no. 292 (January–March 1967), entire issue.

Transformations in Late Eighteenth-Century Art. Princeton, N.J.: Princeton University Press, 1967. Paperback reprint, 1970. Italian edition, *Trasformazioni nell'arte: Iconographia e stile tra neoclassicismo e romanticismo.* Rome: La Nuova Italia Scientifica, 1984. French edition, *L'Art au XVIIIe siècle: Transformations et mutations.* Brionne: Editions Gerard Monfort, 1989. Spanish edition, *Transformaciones en el arte de finales del siglo XVIII.* Madrid: Taurus Ediciones, 1994.

1968

"British Art and the Continent, 1760–1860." In *Romantic Art in Britain: Painting and Drawings, 1760–1860.* Detroit: Detroit Institute of Arts, 1968, pp. 11–16.

"A Century of British Romantic Painting." *Art in America* 56, no. 1 (January–February 1968), pp. 84–91.

"Professor Hitchcock's Acquisitions." In *An Exhibition in Honor of Henry-Russell Hitchcock.* Northampton, Mass.: Smith College Museum of Art, 1969, pp. 15–18.

"Who Painted David's *Ugolino*?" *Burlington Magazine* 110, no. 788 (November 1968), pp. 620–26.

1969

"Frank Stella." *Vogue* 154, no. 8 (November 15, 1969), pp. 116–17, 160.

"Charles Robert Cockerell." In *Encyclopedia Britannica,* vol. 6. Chicago, London, and Toronto: William Brenton, 1969.

"Girodet" and "Ingres" (exhibition reviews). *Revue de l'art* 3 (1969), pp. 100–101, 101–3.

"The Nineteenth-Century Franc Revalued." In *The Past Rediscovered: French Painting 1800–1900.* Minneapolis: Minneapolis Institute of Arts, 1969. Reprinted in Barbaralee Diamonstein, ed., *The Art World: A Seventy-Five Year Treasury of "ARTnews."* New York: ARTnews Books, 1977, pp. 368–75.

1970

"Picasso and the Anatomy of Eroticism." In Theodore Bowie and Cornelia V. Christenson, eds., *Studies in Erotic Art.* New York: Basic Books, 1970, pp. 337–50. Reprinted in Gert Schiff, ed., *Picasso in Perspective.* Englewood Cliffs, N.J.: Prentice-Hall, 1976, pp. 75–85. Published in German as "Picasso und die Anatomie der Erotik" in Ulrich Weisner, ed., *Picassos Surrealismus: Werke, 1925–1937.* Bielefeld: Kunsthalle, 1991, pp. 223–31.

Review of *Neoclassicism,* by Hugh Honour, and *On Neoclassicism,* by Mario Praz. *New York Review of Books* 14, no. 7 (April 9, 1970), pp. 33–35.

"A Source for David's *Horatii.*" *Burlington Magazine* 112, no. 806 (May 1970), pp. 266, 269–73.

1971

"American Painting and Alex Katz." In Irving Sandler and Bill Berkson, eds., *Alex Katz.* New York: Praeger Publishers, 1971, pp. 7–9.

"The Dawn of British Romantic Painting, 1760–1780." In Peter Hughes and David Williams, eds., *The Varied Pattern: Studies in the 18th Century.* Toronto: A. M. Hakkert, 1971, pp. 189–210. Reprinted in *Rococo to Romanticism: Art and Architecture, 1700–1850.* Garland History of Art, vol. 1. New York and London: Garland Publishing Inc., 1976, pp. 135–86.

Frank Stella New Art (Series). Baltimore and Harmondsworth: Penguin, 1971.

"Picasso and the Coronation of Alexander III: A Note on the Dating of Some *Papiers Collés.*" *Burlington Magazine* 113, no. 823 (October 1971), pp. 602, 604–7.

1972

"*Caritas Romana* after 1760: Some Romantic Lactations." Thomas B. Hess and Linda Nochlin, eds., *Woman as Sex Object: Studies in Erotic Art, 1730–1970* (ARTnews Annual 38). New York: Newsweek Books, 1972, pp. 42–63.

"Caspar David Friedrich: A Reappraisal." *Studio International* (September 1972), pp. 73–75.

"German Romantic Painting in International Perspective." *Yale University Gallery Art Bulletin* 33, no. 3 (October 1972), pp. 23–36.

A BIBLIOGRAPHY OF WRITINGS

1973

"David's *Funeral of Patroclus*." *Burlington Magazine* 115, no. 846 (September 1973), pp. 556–76.

"The *Demoiselles d'Avignon* Revisited." *ARTnews* 72, no. 4 (April 1973), pp. 45–48.

"Picasso and the Typography of Cubism." In Roland Penrose and John Golding, eds., *Picasso (1881–1973)*. London: Paul Elek, 1973, pp. 48–75 (published as *Picasso in Retrospect*. New York: Praeger, 1973). Reprinted in Katherine Hoffman, ed., *Collage: Critical Views*. Ann Arbor: UMI Research Press, 1989, pp. 91–120.

"Robert Goldwater (1907–1973)." *New York Times,* April 8, 1973, section 2, p. 25. Reprinted in *College Art Journal* 32, no. 4 (Summer 1973), p. 484.

"Something Old, Something New, Something Borrowed, and Something Blue: An Art Historian's Report." *Art Journal* 32, no. 3 (Spring 1973), pp. 275–77.

1974

"'L'Epidémie d'Espagne' d'Aparicio au Salon de 1806." *La Revue du Louvre et des musées de France* 24, no. 6 (1974), pp. 429–36.

"La Peinture sous le Consulat et l'Empire (1800–1814)" and "La peinture sous la Restauration." In *De David à Delacroix: La Peinture française de 1774 à 1830*. Paris: Réunion des Musées Nationaux, 1974, pp. 163–77, 233–47. Published in English as "Painting Under Napoleon, 1800–1814" and "Painting During the Bourbon Restoration, 1814–1830" in *French Painting, 1774–1830: The Age of Revolution*. Detroit: Detroit Institute of Arts; New York: Metropolitan Museum of Art, 1975, pp. 161–74, 231–46. Abridged version of "Painting Under Napoleon" published as "Inherited Myths, Unprecedented Realities" in *Art in America* 63, no. 2 (March–April 1975), pp. 48–57.

1975

Modern Painting and the Northern Romantic Tradition: Friedrich to Rothko. New York: Harper and Row, 1975. French edition, *Peinture moderne et tradition romantique du Nord*. Paris: Éditions Hazan, 1996. Japanese edition. Tokyo: Iwasaki Bijutsu-sha, 1988. Abridged excerpts published as "Other Romantic Currents: Klee to Ernst," in Patricia Kaplan and Susan Manso, eds., *Major European Art Movements, 1900–45*. New York: E. P. Dutton, 1977, pp. 91–100. One chapter published in Spanish as "Munch y Hodler," in *Figures de Fin de Segle,* vol. 4. Barcelona: L'Escola Técnica Superior d'Arquitectura de Barcelona, 1987, pp. 51–62.

"Picasso and History." In *Picasso*. New York: Acquavella Galleries, 1975.

"Then and Now." *Partisan Review* 42, no. 4 (1975), pp. 566–69.

1976

The International Style of 1800: A Study in Linear Abstraction. Ph.D. diss., Institute of Fine Arts, New York University, April 1956. Facsimile edition, New York: Garland Publishing, 1976.

"Notes on Alfred Leslie." In *Alfred Leslie*. Boston: Museum of Fine Arts, 1976.

"Painting America First." In *America 1976: A Bicentennial Exhibition Sponsored by Department of the Interior*. Washington, D.C.: Corcoran Gallery of Art, 1976, pp. 5–12. Abridged version published in *Art in America* 64, no. 1 (January–February 1976), pp. 82–85. Reprinted in full in Alan Sonfist, ed., *Art in the Land: A Critical Anthology of Environmental Art*. New York: E. P. Dutton, 1983, pp. 225–32.

"The Primal American Scene." In Kynaston McShine, ed., *The Natural Paradise: Painting in America, 1800–1950*. New York: Museum of Modern Art, 1976, pp. 15–37.

1977

"Alex Katz: Some Recent Paintings." In *Alex Katz*. Fresno, Calif.: Fresno Arts Center, 1977, n.p.

"Caillebotte: The 1970s and the 1870s." *Artforum* 15, no. 7 (March 1977), pp. 46–52.

"The Greuze Exhibition at Hartford and Elsewhere." *Burlington Magazine* 119, no. 896 (February 1977), pp. 145–49.

"Picasso's *Woman with a Book.*" *Arts Magazine* 51, no. 4 (January 1977), pp. 100–105.

1978

"Edvard Munch: Some Changing Contexts." In *Edvard Munch: Symbols and Images*. Washington, D.C.: National Gallery of Art, 1978, pp. 1–9. Published in Spanish as "Edvard Munch: Algunos cambios de contexto," in *Edvard Munch (1863–1944)*. Madrid: Salas Pablo Ruiz Picasso, 1984, pp. 55–67.

"Mondrian's Late Style." *Allen Memorial Art Museum Bulletin* (Oberlin College) 35, nos. 1–2 (1978), pp. 68–77. Reprinted in Laurence J. Trudeau, ed., *Modern Arts Criticism,* vol. 4. Detroit: Gale Research Inc., 1994, pp. 154–57.

"Notes on Sol LeWitt." In Alicia Legg, ed., *Sol LeWitt.* New York: Museum of Modern Art, 1978, pp. 15–21.

Statement in "The Late Cézanne: A Symposium." *Art in America* 66, no. 2 (March–April 1978), p. 93.

1979

"Andy Warhol: Court Painter to the 70s." In David Whitney, ed., *Andy Warhol: Portraits of the 1970s.* New York: Whitney Museum of American Art, 1979, pp. 9–20. Reprinted in *Andy Warhol Celebrity Portraits.* Hong Kong: OLS Club Ltd., 1982, pp. 5–16. Reprinted, with the addition of the postscript "Andy Warhol: Portraits of the 80s," in Henry Geldzahler and Robert Rosenblum with Vincent Fremont and Leon Paroissien, *Andy Warhol: Portraits of the Seventies and Eighties* London: Anthony d'Offay Gallery in association with Thames and Hudson, 1993, pp. 139–53.

Editor of reprint, E. Bellier de la Chavignerie, *Dictionnaire général des artistes de l'école française,* 5 vols. New York: Garland Publishing, 1979.

"Francis Gray Godwin (1908–1979)." *Art Journal* 38, no. 3 (Summer 1979), p. 282.

"Frank Stella's New Art: Eye Openers." *Vogue* 169, no. 2 (February 1979), pp. 246–47, 296.

Introduction to *El Negro: Obra reciente de Beatriz Zamora.* Mexico City: El Colegio de México, 1979. Reprinted in *Diálogos* (Colegio de México), no. 86 (March–April 1979), pp. 37–38.

"Néo-classicisme." In *Petit Larousse de la peinture,* vol. 2, Paris: Larousse, 1979, pp. 1276–78.

1980

"El Arte Cubista de Diego Rivera" (interview). *Excelsior* (Mexico City), October 9, 1980, p. 3.

"Art Ignored: The Other Twentieth Century." *Art Journal* 39, no. 3 (Summer 1980), pp. 288–89. Reprinted as "How About a Show of the Ten Highest-Priced Artists Whom No Right-Thinking Museum Would Ever Consider Exhibiting?" in *ARTnews* 80, no. 1 (January 1981), p. 133.

Catalogue essay in *Explorations in the Seventies.* Pittsburgh: Pittsburgh Plan for Art, 1980, pp. 4–9.

Catalogue essay in *Horace Vernet (1789–1863).* Paris: École des Beaux-Arts, 1980, pp. 13–19. Published in Italian in *Horace Vernet (1789–1863).* Rome: Accademia di Francia, De Luca, 1980, pp. 13–19.

Catalogue essay in *Rodrigo Moynihan.* New York: Robert Miller Gallery, 1980.

Interview with Patricia Leighten and Wayne L. Roosa. *The Rutgers Art Review* 1 (January 1980), pp. 67–75.

"Pyramids in Modern Art." In *Pyramidal Influences in Art.* Dayton: The Fine Arts Gallery, Inc., Wright State University, 1980, pp. 37–38.

"Ten Images." In *Picasso from the Musée Picasso.* Minneapolis: Walker Art Center, 1980, pp. 29–79. Published in Danish as "Picassos billedverden" in *Louisiana Revey* (Humlebaek, Denmark) 21, no. 3 (March 1981), pp. 18–62.

1981

"Alfred H. Barr, Jr. (1902–1981)." *ARTnews* 80, no. 9 (November 1981), p. 167.

"Fernand Pelez, or the Other Side of the Post-Impressionist Coin." In Moshe Barasch and Lucy Freeman Sandler, eds., *Art the Ape of Nature: Studies in Honor of H. W. Janson.* New York: Harry N. Abrams, 1981, pp. 707–18.

Foreword to Jean Clay, *Romanticism.* New York: Vendome Press, 1981, p. 3.

"Gregory Battcock (1937–1980)." *Artery: The National Forum for College Art* (Wayne, N.J.: William Paterson College), 4, no. 4 (1981), p. 26.

"Notes on Rothko's Surrealist Years." In *Mark Rothko: The Surrealist Years.* New York: Pace Gallery, 1981, pp. 5–9. Reprinted as "The Surrealist Years, 1944–1946" in Marc Glimcher, ed., *The Art of Mark Rothko: Into an Unknown World.* New York: Clarkson N. Potter, 1991, pp. 13–19.

"Rothko: *Red, Blue and Black,* 1958." In Edwin Mullins, ed., *Great Paintings.* London: BBC Publications, 1981, pp. 36–40.

1982

Catalogue essay in *Alain Kirili.* Frankfurt am Main: Frankfurt Kunstverein, 1982, pp. 7–15. Excerpt reprinted as "Les Thèmes de la sculpture" in *Art Press,* no. 71 (June 1983), p. 42.

"Elementos populares en el cubismo." In *La iconografía en el arte contemporaneo: Coloquio internacional de Xalapa.* Mexico City: Universidad Nacional Autónoma de México, 1982, pp. 233–42.

Foreword to Suzanne Slesin and Stafford Cliff, *French Style.* New York: Clarkson N. Potter, 1982, pp. 10–12.

"Gedanken zu den Quellen des Zeitgeistes." In *Zeitgeist (Internationale Kunstausstellung)*. Berlin: Albert
 Hentrich, 1982, pp. 11–14. Published in English as "Thoughts on the Origin of *Zeitgeist*" in *Zeitgeist*.
 New York: George Braziller, 1982, pp. 11–14.
Introduction to *Fernando Botero: Recent Sculpture*. New York: Marlborough Gallery, 1982, pp. 5–6.
"Notes on Picasso's Sculpture." In *The Sculpture of Picasso*. New York: Pace Gallery, 1982, pp. 6–11.
 Reprinted in *ARTnews* 82, no. 1 (January 1983), pp. 60–66.
"The One and the Many: Art and Mass Reproduction." *ARTnews* 81, no. 9. (November 1982), pp. 112–14.
"Picasso's *Girl Before a Mirror:* Some Recent Reflections." *Source: Notes in the History of Art* 1, no. 3
 (Spring 1982), pp. 1–4.
"Reconstructing French Art." In *Four Guest Galleries from Paris and Paul Rosenberg & Co.: French
 Painting, 1600–1900*. New York: Paul Rosenberg & Co., 1982, pp. 4–8.
Review of *The Meanings of Modern Art,* by John Russell. *Art in America* 70, no. 1 (January 1982),
 pp. 21–23.
Statement in *A Curator's Choice, 1942–63: A Tribute to Dorothy Miller*. New York: Rosa Esman Gallery,
 1982. Reprinted as "An Appreciation," in *Dorothy C. Miller: With an Eye to American Art*.
 Northampton, Mass.: Smith College Museum of Art, 1985, n.p.

1983
Catalogue essay in *Abstract Painting: 1960–69*. New York: P.S. 1, The Institute for Art and Urban
 Resources, 1983, n.p.
"Down Memory Lane with Holly Solomon." *Holly Solomon Gallery: Inaugural Exhibition*. New York:
 Holly Solomon Gallery, 1983, pp. 11–13.
"Francis Picabia: The Later Work." In *Francis Picabia*. New York: Mary Boone /Michael Werner Gallery,
 1983, n.p.
Introduction to *The Frances and John L. Loeb Collection*. London: White Bros., 1983, n.p.
Introduction to *Robert Moskowitz*. New York: Blum Helman Gallery, 1983, pp. 5–8.
"Reading Lists." *ARTnews* 82, no. 9 (November 1983), p. 60.
"Stella's Third Dimension." *Vanity Fair* 46, no. 9 (November 1983), pp. 86–93.

1984
19th-Century Art (with H. W. Janson). New York: Harry N. Abrams, 1984. British edition, London:
 Thames and Hudson, 1984. Italian edition, *L'Arte dell'ottocento*. Rome: Fratelli Palombi, 1986.
 Spanish edition, *El arte del siglo xix*. Arte y estética, no. 28. Madrid: Akal, 1993.
"Eric Fischl." New York: Mary Boone/Michael Werner Gallery, 1984, n.p. Reprinted in *Contemporanea* 1,
 no. 1 (May–June 1988), pp. 62–65.
"Frank Stella" and "Cy Twombly." In *Art of Our Time: The Saatchi Collection*. London: Lund Humphries,
 1984; New York: Rizzoli, 1985, pp. 20–23, 24–27.
"Myths of Order: The Grand Prix de Rome." *Art and Antiques,* premier issue (March 1984), pp. 54–63.
"Reflections on the Tremaine Collection." In *The Tremaine Collection: 20th-Century Masters—The Spirit
 of Modernism*. Hartford: Wadsworth Atheneum, 1984, pp. 9–14. Abridged version published as
 "The Tremaine Collection" in *Christie's International Magazine* 8, no. 8 (October 1991), pp. 2–5.
"Resurrecting Darwin and Genesis: Thoughts on Nature and Modern Art." In *Creation: Modern Art and
 Nature*. Edinburgh: Scottish National Gallery of Modern Art, 1984, pp. 9–15.

1985
"Art: In a Northern Light—Penetrating Interiors in Danish Painting." *Architectural Digest* 42, no. 8
 (August 1985), pp. 126–30.
"Chagall: *Ich und das Dorf.*" In Wibke von Bonin, ed., *100 Meisterwerke aus den grossen Museen der
 Welt*, vol. 2. Cologne: Schulfernsehen, 1985, pp. 259–64.
"L'Emprunt ne saurait être traité de plagiat: Reynolds et le contexte international." In *Sir Joshua Reynolds*.
 Paris: Réunion des musées nationaux, 1985, pp. 61–81. Published in English as "Reynolds in an
 International Milieu," in Nicholas Penny, ed., *Reynolds*. London: Royal Academy of Arts, 1986,
 pp. 43–54.
"Excavating the Fifties." In Paul Schimmel et al., *Action/Precision: The New Direction in New York,
 1955–60*. Newport Beach, Calif.: Newport Harbor Art Museum, 1985, pp. 13–17.
Interview with Deborah Gimelson. "Barbara Novak and Robert Rosenblum: Talking about the 19th Century
 over Tea at the Pierre." *Art & Auction* 7, no. 10 (May 1985), pp. 120–27.

"Notes on Archipenko's *Cleopatra.*" In *Archipenko: Drawings, Reliefs, and Constructions.* Annandale-on-Hudson, N.Y.: Edith C. Blum Art Institute, Bard College Center, 1985, pp. 9–10.

"Notes on David Salle." In *David Salle.* Zurich: Edition Bischofberger, 1985. Reprinted in *David Salle.* Edinburgh: Fruitmarket Gallery, 1987, pp. 10–12. Published in Spanish as "Apuntes sobre David Salle," in *Universidad de México: Revista de la Universidad Nacional Autónoma de México,* no. 545 (June 1996), pp. 30–34.

"Notes sur Picasso et de Kooning." In Dominique Bozo et al., *Willem de Kooning.* Paris: Musée National d'Art Moderne, Centre Georges Pompidou, 1984, pp. 11–15. Published in English, in abridged form, as "Fatal Women of Picasso and de Kooning," in *ARTnews* 84, no. 8 (October 1985), pp. 98–103.

"Observations." In *Art at Work: The Chase Manhattan Collection.* New York: E. P. Dutton, 1985, pp. 43–58.

"Ricostruendo la pittura dell'ottocento." In *Il valore dei dipinti del'ottocento Italiano (Annuari di Economia dell'Arte),* vol. 3. Milan: Umberto Allemandi, 1985–86, n.p. Reprinted in French as "Reconstruire la peinture aux XIX siècle," in *Le débat,* no. 44 (March–May 1987), pp. 85–89. Published in English as "Reconstructing Nineteenth-Century Painting," in *Scritti in onore di Giuliano Briganti,* Milan: Longanesi, 1990, pp. 285–87.

1986

"Alex Katz's American Accent." In Richard Marshall, ed., *Alex Katz.* New York: Whitney Museum of American Art, 1986, pp. 25–31. Reprinted in David Sylvester, ed., *Alex Katz: Twenty-five Years of Painting from the Saatchi Collection.* London: Saatchi Gallery, 1997, pp. 182–84.

"Art: Beautiful Breeds—Endearing Portraits of Man's Best Friend." *Architectural Digest* 43, no. 7 (July 1986), pp. 86–90.

"The *Demoiselles:* Sketchbook No. 42, 1907." In Arnold Glimcher and Marc Glimcher, eds., *"Je suis le cahier": The Sketchbooks of Picasso.* New York: Pace Gallery, 1986, pp. 53–79.

Foreword to reprint edition of Alfred H. Barr Jr., *Cubism and Abstract Art* (1936). Cambridge, Mass.: Harvard University Press, 1986, pp. 1–4.

Interview with Alvar González-Palacios. *Il giornale dell'arte* 4, no. 39 (November 1986), pp. 40–41.

Introduction to *George Segal.* New York: Sidney Janis Gallery, 1986, n.p.

Introduction to Lawrence R. Rubin, *Frank Stella: Paintings, 1958 to 1965—A Catalogue Raisonné.* New York: Stewart, Tabori and Chang, 1986; London: Thames and Hudson, 1986, pp. 16–23.

"On de Kooning's Late Style." In *Willem de Kooning: Recent Paintings, 1983–1986.* London: Anthony d'Offay Gallery, 1986, n.p. Reprinted in *Art Journal* 48, no. 3 (Fall 1989), p. 249.

"Picasso." In Paul Gardner, "What Would You Ask Michelangelo?" *ARTnews* 85, no. 9 (November 1986), p. 95.

"Reconsidering Modern Art." *New York University Magazine* 1, no. 1 (Spring 1986), pp. 48–54.

"Resurrecting Augustus Vincent Tack." In *The Abstractions of Augustus Vincent Tack (1870–1949).* New York: M. Knoedler & Co., 1986, pp. 2–4, 15.

Statement in "Renoir: A Symposium." *Art in America* 74, no. 3 (March 1986), pp. 112–16.

1987

"Art: The Boston School of Painters." *Architectural Digest* 44, no. 5 (May 1987), pp. 189–92.

"Art: Tiny Paintings." *Architectural Digest* 44, no. 11 (November 1987), pp. 222–27.

"The Ascendancy of Art: An Interview with Robert Rosenblum." *Art & Design* 3, nos. 9–10 (1987), pp. 5–18.

"Benjamin West's *Tod des Nelson:* Beobachtungen und Bemerkungen." In *Triumph und Tod des Helden: Europäische Historienmalerei von Rubens bis Manet.* Cologne: Wallraf-Richartz-Museum, 1987, pp. 5–18. Published in English as "Notes on Benjamin West and the Death of Nelson," in Christian Beutler, Peter-Klaus Schuster, and Martin Wernke, eds., *Kunst um 1800 und die Folgen: Werner Hofmann zu Ehren.* Munich: Prestel, 1988, pp. 81–86. Published in French as "Remarques sur Benjamin West et la 'Mort de Nelson,'" in *Triomphe et Mort du Héros: La Peinture d'histoire en Europe de Rubens à Manet.* Milan: Electa, 1988.

"Between Apocalypses: Art after 1945." In Steve A. Nash ed., *A Century of Modern Sculpture: The Patsy and Raymond Nasher Collection.* Dallas: Dallas Museum of Art, 1987, pp. 99–132.

"British Twentieth-Century Art: A Transatlantic View." In Susan Compton, ed., *British Art in the Twentieth Century: The Modern Movement.* London: Royal Academy of Arts, 1987, pp. 89–98.

"David's *Farewell of Telemachus and Eucharis,*" in *Sotheby's Art at Auction 1986–87.* London: Sotheby's, 1987, pp. 80–85. Abridged as "Jacques-Louis David's *Telemachus and Eucharis,*" in *Sotheby's Preview,* no. 68 (January/February 1987), pp. 4–5.

"Elaine Sturtevant." In *A Different Corner: Definition and Redefinition—Painting in America*. Cuenca, Ecuador: United States Pavilion, I Bienal Internacional de Pintura, Museo de Arte Moderno, 1987, pp. 26–27.

"Life Versus Death: The Art World in Crisis." In *Art Against AIDS*. New York: American Foundation for AIDS Research, 1987, pp. 28–32.

"Notes on Rothko and Tradition." In *Mark Rothko (1903–1970)*. London, Tate Gallery, 1987, pp. 21–31.

"Protean Portraitist John Singer Sargent." *Quality* (Winter 1987), pp. 96–97.

"Space in Nineteenth- and Early Twentieth-Century Painting" (summary). In *International Symposium in Honor of the Council of Europe Exhibition "Space in European Art."* Tokyo: Keidauren Kaikan, 1987, pp. 122–31.

Statement in "Interchanges: British and American Painting, 1945–87." Interview with Hugh Cumming. *Art & Design* 3, no. 9–10 (1987), p. 80.

1988

"Art: Architectural Caprices—Imagined Views by Italian Artists." *Architectural Digest* 45, no. 10 (October 1988), pp. 242–47.

"Art: Artists' Sketchbooks." *Architectural Digest* 45, no. 3 (March 1988), pp. 132–37.

"Arts, Culture and the French Revolution." *Horizon: The Magazine of the Arts* (special issue: *The Bicentennial of the French Revolution*) 31, no. 7 (September 1988), pp. 8–9.

The Dog in Art from Rococo to Post-Modernism. New York: Harry N. Abrams, 1988. German edition, *Der Hund in der Kunst von Rococo zur Postmoderne*. Vienna: Passgen Verlag, 1989. French edition, *Le Chien dans l'art: du chien romantique au chien post-moderne*. Paris: Adam Biro, 1989. Spanish edition, *El perro en el arte del rococo al posmoderno*. Madrid: Editorial Nera, 1989.

Foreword to *Bill Anthony's Greatest Hits: Drawings, 1963–1987*. Winston-Salem, N.C.: The Jargon Society, 1988, pp. vii–viii.

Foreword to *Bill Jacklin: Urban Portraits*. London: Marlborough Gallery, 1988, pp. 4–8.

"Future Past." In *Q / 50* (Queens College, Flushing, N.Y.) 1, no. 1 (1988), pp. 28–31.

"Ingres and His Progeny." In *The Presence of Ingres*. New York: Jan Krugier Gallery, 1988, n.p.

Interview with Ann Hindry about Warhol. "Andy Warhol, quelques grands témoins." *Artstudio* 8 (Spring 1988), pp. 119–27.

Interview with Lucas Samaras on the subject of age. *Artforum* 26, no. 6 (February 1988), p. 73.

Introduction to *Jackson Pollock: Images Coming Through*. New York: Jason McCoy, Inc., 1988, n.p.

"Notes on Mike Bidlo." In *Mike Bidlo: Picasso's Women, 1901–71*. New York: Leo Castelli Gallery, 1988.

"Picabia: The Later Work." In *Picabia (1879–1953)*. Edinburgh: Scottish National Gallery of Modern Art, 1988, pp. 81–86.

The Romantic Child from Runge to Sendak. London: Thames and Hudson, 1988.

"Romanticism and Retrospection: An Interview." *Art & Design* (special issue: *The New Romantics*) 4, nos. 11–12 (1988), pp. 6–19. Reprinted in Axel and Christa Murken, eds., *Romantik in der Kunst der Gegenwart*. Cologne: Wienand Verlag, 1988, pp. 35–43, and as "Towards a Definition of New Art," in Andreas Papadakis, ed., *The New Art: An International Survey*. New York: Rizzoli, 1991, pp. 43–69.

Statement in "The Musée d'Orsay: A Symposium." *Art in America* 76, no. 1 (January 1988), pp. 92–95.

"Through Duchamp's Door." In Valentine Moncada, ed., *Marcel Duchamp: 11 rue Larrey 1927*. Rome: Editore L'Attico, 1988. Revised version published as "Duchamp's Revolving Door" in *Tema Celeste*, no. 36 (Summer 1992), pp. 58–61. Published in Italian as "La porte girevole di Duchamp," in Elio Cappuccio, ed., *Duchamp dopo Duchamp*. Syracuse: Tema Celeste Edizioni, 1993, pp. 75–81.

1989

"Art: Artists by Artists." *Architectural Digest* 46, no. 7 (July 1989), pp. 133–37.

"The Art of Quotation" (interview). *Art & Design* (special issue: *New York New Art*) 5, nos. 7/8 (1989), pp. 6–15. Reprinted as "Towards a Definition of New Art," in Andreas Papadakis, ed., *The New Art: An International Survey*. New York: Rizzoli, 1991, pp. 43–69.

"Gilbert and George: The AIDS Pictures." *Art in America* 77, no. 11 (November 1989), pp. 152–55.

Introduction to *Igor Mitoraj: Sculptures, 1989*. New York: New York Academy of Art, 1989.

Introduction to *Roy Lichtenstein: The Mirror Paintings*. New York: Mary Boone Gallery, 1989.

"A Mid-Atlantic Conversation." In *Michael Craig-Martin: A Retrospective, 1968–1989*. London: Whitechapel Art Gallery, 1989, pp. 69–74.

"Notes on Mike Bidlo." In *Mike Bidlo: Masterpieces*. Zurich: Bruno Bischofberger, 1989, n.p.

Paintings in the Musée d'Orsay. New York: Stewart, Tabori & Chang, 1989. Also published in Chinese (Taipei: Greenland, 1995), French (Paris: Nathan, 1989), German (Cologne: Dumont, 1989), Italian (Milan, Magnus, 1991), Japanese (Tokyo, Chuokoronsha, 1991), and Russian (Moscow: Mezhduna-rodnaya Kniga, 1998). Excerpt published as "Nineteenth Century Art: A Post-Modern View," in *Sotheby's Preview* (February/March 1990), pp. 6–10.

"Picabia in the Land of Kitsch." In *Francis Picabia: Nudes.* New York: Panicali Fine Art, 1989, pp. 5–6.

"Picasso: Then and Now" (The Third Christensen Lecture, 1988). Perth: Art Gallery Society of Western Australia, Vanguard Press, 1989.

Preface to *Keith Milow: One Hundred Drawings, 1988–1989.* London: Nigel Greenwood Gallery, n.p.

"Remembering John Button." In *John Button.* Manchester, N.H.: The Currier Gallery of Art, 1989, n.p.

"Remembrance of Fairs Past," in *Remembering the Future: The New York World's Fair from 1939 to 1964.* New York: Queens Museum, 1989, pp. 11–18.

"Warhol as Art History." In Kynaston McShine, ed., *Andy Warhol: A Retrospective.* New York: Museum of Modern Art, 1989, pp. 25–37. Also published in German, French, and Japanese.

1990

"Art: Chicago Impressionists." *Architectural Digest* 47, no. 3 (March 1990), pp. 206 ff.

"Art: Modernist Still Lifes." *Architectural Digest* 47, no. 11 (November 1990), pp. 244–49.

"Critics and the Marketplace" (panel discussion). *Art & Auction* 12, no. 8 (March 1990), pp. 170–75.

"Cubism as Pop Art." In Kirk Varnedoe and Adam Gopnik, eds., *Modern Art and Popular Culture: Readings in High and Low.* New York: Harry N. Abrams, in association with The Museum of Modern Art, 1990, pp. 116–32.

"Friedrichs from Russia: An Introduction." In Sabine Rewald, ed., *The Romantic Vision of Caspar David Friedrich: Paintings and Drawings from the U.S.S.R.* New York: Metropolitan Museum of Art, 1990. Excerpts published as "On the Edge of the Abyss," *ARTnews* 89, no. 10 (December 1990), pp. 144–49. Published in German as "Werke Caspar David Friedrichs aus Russland" in Sabine Rewald, ed., *Caspar David Friedrich: Gemälde und Zeuchnungen aus der USSR.* Munich: Schirmer/Mosel, 1991, pp. 13–27. Excerpt published as "Caspar David Friedrich: At the Edge of the Natural World," in *The Chronicle of Higher Education* 37, no. 24 (February 27, 1991), p. B56.

"In Search of the New" (interview). *Art & Design* (special issue: *New Art International*) 6, nos. 1–2 (1990), pp. 7–13. Reprinted as "Towards a Definition of New Art," in Andreas Papadakis, ed., *The New Art: An International Survey.* New York: Rizzoli, 1991, pp. 43–69.

Interview with Alan Sonfist in *Alan Sonfist, 1969–1989.* Brookville, N.Y.: Hillwood Art Museum, Long Island University, 1990, pp. 3–28.

Introduction to Andy Grundberg, *Mike and Doug Starn.* New York: Harry N. Abrams, 1990, pp. 13–16.

Introduction to Donald Goddard, *American Painting.* New York: Hugh Lauter Levin Associates, Inc., 1990, pp. 10–15.

Introduction to *Gilbert and George: Twenty-five Worlds.* New York: Robert Miller Gallery, 1990, n.p.

Introduction to *Richmond Burton.* New York: Simon Watson Gallery, 1990, pp. 3–7.

Introduction to Robert James Bantens, *Eugène Carrière: The Symbol of Creation.* New York: Kent Fine Art, 1990, pp. 8–15.

"Mark Innerst's Time Capsules." In *Mark Innerst.* New York: Curt Marcus Gallery; Santa Monica: Michael Cohn Gallery, 1990, n.p.

"Notes on de Kooning." In *Willem de Kooning: An Exhibition of Paintings.* New York: Salander-O'Reilly Galleries, 1990, n.p.

"Reconstructing David." *Art in America* 78, no. 5 (May 1990), pp. 188–97.

Statement in "Art Power: A Worldwide Survey." *The Art Newspaper* 1, no. 1 (October 1990), n.p.

"Yo crecí con el MOMA," *El Mundo* (Madrid), magazine section, November 11, 1990, p. 39.

1991

"After Abstract Painting." *Tema Celeste,* nos. 32–33 (Fall 1991), p. 80.

"American Landscape Painting: An Endangered Species?" In *The Landscape in Twentieth-Century American Art: Selections from the Metropolitan Museum of Art.* New York: American Federation of Arts and Rizzoli, 1991, pp. 7–16.

"Un Aperçu de Lalanne." In *Les Lalanne.* Geneva: Skira, 1991, pp. 7–12.

"Art: Nineteenth-Century French Flower Painting." *Architectural Digest* 48, no. 4 (April 1991), pp. 195–98.

"Art: Oil Sketches—The Immediacy of Plein Air Landscape Studies." *Architectural Digest* 48, no. 10 (October 1991), pp. 148–53.

"Art: Paintings of the American West." *Architectural Digest* 48, no. 6 (June 1991), pp. 142–47.

"Art: Woodstock Painters." *Architectural Digest* 48, no. 11 (November 1991), pp. 211–12.

Catalogue essay for *Scott Burton: The Last Tableau.* New York: Whitney Museum of American Art, 1991, n.p.

"Entrevista a Robert Rosenblum" (interview with Jorge Luis Marzo and Jeffrey Swartz). Supplement to *La Vanguardia* (Barcelona), January 15, 1991, pp. 2–3.

Eulogy for Gert Schiff. *In Memoriam: Gert Schiff, 1926–1990.* New York: Institute of Fine Arts, New York University, March 1991. Reprinted as "Gert Schiff (1926–1990)," in *AICA (International Association of Art Critics) Newsletter* (Summer 1991), pp. 6–7.

"The Fall and Rise of Jacques-Louis David in Dublin." In Brian P. Kennedy, ed., *Art Is My Life: A Tribute to James White.* Dublin: National Gallery of Ireland, 1991, pp. 167–71.

Foreword to *Just Add Color: A Coloring Book with Drawings by Contemporary Artists.* New York: Homeward Bound Project, 1991.

Introduction to *Five Masterpieces of Impressionist Paintings* [sic]. Tokyo: Zen International Fine Art, 1991.

Introduction to *Keith Haring.* New York: Chase Manhattan Bank, 1991.

Introduction to *Six Masterpieces of Twentieth Century* [sic]. Tokyo: Zen International Fine Art, 1991.

"Mark Rothko: *Yellow and Orange,* 1949." In *The Rita and Taft Schreiber Collection.* Los Angeles: Museum of Contemporary Art, 1991, n.p.

"Perfiles: Con Robert Rosenblum" (interview with Jorge Luis Marzo and Jeffrey Swartz). *Kalías: Revista de arte* (Valencia) 3, no. 6 (October 1991), pp. 99–106.

Response to "(Why) Is David Lynch Important? A *Parkett* Inquiry." *Parkett,* no. 28 (June 1991), pp. 153–54.

"Resurrecting Bouguereau." In *William-Adolphe Bouguereau: "L'Art Pompier."* New York: Borghi & Co., 1991, pp. 7–11.

"Roy Lichtenstein: Past, Present, Future." *Artstudio* 20 (Spring 1991), pp. 34–43.

"Selling Out or Trading Up? Museum Deaccessioning." In *The Art Show.* New York: Art Dealers Association of America, 1991, pp. 38–40.

"Too French: An American Viewpoint." In *Too French: Contemporary French Art.* Hong Kong: Hong Kong Museum of Art and Cartier Foundation for Contemporary Art, 1991, pp. 187–91.

"The Withering Green Belt: Aspects of Landscape in Twentieth-Century Painting." In Stuart Wrede and William Howard Adams, eds., *Denatured Visions: Landscape and Culture in the Twentieth Century.* New York: Museum of Modern Art, 1991, pp. 33–41.

1992

"Art: Old-Master Bird Paintings—Images of Exotic Avian Life." *Architectural Digest* 49, no. 3 (March 1992), pp. 174–79.

"Art: Paintings of Central Park." *Architectural Digest* 49, no. 11 (November 1992), pp. 174–77.

Discussant in Lynn Zelevansky, ed., *Picasso and Braque: A Symposium.* New York: Museum of Modern Art, 1992.

"Edition No. 46: Jeff Koons, *Baby & Eimer.*" *Süddeutsche Zeitung (Magazin),* no. 45 (November 6, 1992), p. 40.

Foreword to William Seitz, *Art in the Age of Aquarius, 1955–1970.* Washington, D.C.: National Gallery of Art, 1992, pp. xiii–xv.

Introduction to *Source: Notes in the History of Art* (special issue: *Essays in Honor of Gert Schiff*) 11, nos. 3–4 (Spring–Summer 1992), p. 2.

"Notes on Jeff Koons." In *The Jeff Koons Handbook.* London: Thames and Hudson and Anthony d'Offay Gallery, 1992, pp. 11–28.

"Paintings of the Artistic Interior." *Architectural Digest* 49, no. 10 (October 1992), pp. 204–7.

"Pearlstein: The Early Work." In *Philip Pearlstein: The Abstract Landscapes and Other Early Works on Paper.* Youngstown, Ohio: Butler Institute of American Art, 1992, pp. 4–5.

"Reconstructing Benton." In Rudy Chiappini, ed., *Thomas Hart Benton.* Lugano: Museo d'Arte Moderna, 1992, pp. 135–44.

"War and Peace: Antiquity and Late Picasso." (Also in Spanish as "Guerra y Paz: la antigüedad y el último Picasso.") In Gary Tinterow, ed., *Picasso Clásico.* Málaga: Palacio Episcopal, 1992, pp. 365–72, 173–93.

1993

"Art: Contemporary Romantic Landscapes." *Architectural Digest* 50, no. 5 (May 1993), pp. 193–95.

"Art: Precisionist Painting." *Architectural Digest* 50, no. 3 (March 1993), pp. 140–43.

Catalogue essay in *David Bowes*. Monterrey, Mexico: Galeria Ramis Barquet, July 1993, n.p. Reprinted in *Universidad de México*, no. 514 (November 1993), pp. 28–32.

Contribution to "Matisse: A Symposium." In *Art in America* 81, no. 5 (May 1993), pp. 75–76.

"Essai de synthèse: *Les Sabines*." In Régis Michel, ed., *David contre David*. Louvre conférences et colloques, vol. 1. Paris: La Documentation Française, 1993, pp. 451–70.

"Edward Fry." *AICA Newsletter (Association Internationale des critiques d'art)*, (Spring 1993), p. 15.

"Geoffrey Hendricks' Cloudscapes." In *Geoffrey Hendricks: Day into Night*. Odense, Denmark: Kunsthallen Brandts Klaedefabrik, 1993, pp. 6–7.

"Introducing Gilbert and George." In *Gilbert and George: China Exhibition*. Beijing: National Art Gallery, 1993, p. 8.

"Jack Boulton." *American Photo* 4, no. 2 (March–April 1993), p. 77.

"Jeff Koons: *Christ and the Lamb*." *Artforum* 32, no. 1 (September 1993), pp. 148–49.

"Keith Milow." *Contemporary Art* 2, no. 1 (Winter 1993–94), pp. 26–28. Reprinted as the introduction to *Keith Milow: Recent Work*. New York: Nohra Haime Gallery, 1995, n.p.

Las Pinturas de August Strindberg: la Estructura del Caos (Lecciones Alfons Roig). Valencia: Instituto Valenciana de Arte Moderna, 1993. English edition, *The Paintings of August Strindberg: The Structure of Chaos*. Hellerup, Denmark: Edition Bløndal, 1995.

"A Postscript: Some Recent Neo-Romantic Mutations." *Art Journal* (special issue: *Romanticism*) 52, no. 2 (Summer 1993), pp. 74–84.

"Revisiting *The Singing Sculpture*." In *Gilbert and George: The Singing Sculpture*. New York: Anthony McCall, 1993, pp. 4–7.

Statement in Barbara MacAdam, "Anyone Who Doesn't Change His Mind Doesn't Have One." *ARTnews* 92, no. 9 (November 1993), pp. 148–49.

1994

"The Afterlife of Romantic Art." In Sandy Ballatore, *Romantic Modernism: 100 Years*. Santa Fe: Museum of Fine Arts, Museum of New Mexico, 1994, pp. 17–20.

"Alfred Leslie: *View over Holyoke, Massachusetts, 1983*." In Irene S. Sweetkind, ed., *Master Paintings from the Butler Institute of American Art*. New York: Harry N. Abrams, 1994, pp. 330–31.

Catalogue essay in *Diane Burko, Paintings: Luci ed ombra di Bellagio*. Philadelphia: Locks Gallery, 1994.

"Goya frente a David: La muerte del retrato regio." In *El retrato en el museo del Prado*. Madrid: Anaya, 1994, pp. 161–81. Published in English as *David and Goya: Royal Portraiture in the Age of Revolution*. (The Beall-Russell Lectures in the Humanities, October 1995). Waco, Texas: Baylor University, 1996.

"Mel Ramos: How Venus Came to California." In *Mel Ramos: Pop Art Images*. Cologne: Taschen, 1994. Reprinted by Taschen in bilingual English and German edition, 1997, pp. 4–21.

"A Personal Chronology." In "Miró at 100," *Artforum* (special issue on Miró) 32, no. 5 (January 1994), pp. 76–77.

Response in "The Best and Worst of 1994." *Artforum* 33, no. 4 (December 1994), pp. 65–66.

Response in "Clemet Greenberg: As the Art World Remembers Him," *The Art Newspaper* 5, no. 39 (June 1994), p. 4.

Response in "Jeffrey Slonim on the Afterlife [of Warhol]." *Artforum* 33, no. 1 (September 1994), p. 9.

Response in "Sister Acts: Jeffrey Slonim on the Book Picture, Take Two." *Artforum* 32, no. 7 (March 1994), p. 7.

Response in "Who Are the Most Underrated and Overrated Artists?" *ARTnews* 93, no. 2 (February 1994), p. 114.

Review of *C.F. Hill* by Georg Baselitz. *Artforum* 32, no. 10 (Summer 1994), p. 10 (*Bookforum* supplement).

"The Tablada Suite V, 1992." In *Guillermo Kutica: Burning Beds—A Survey, 1982–1994*. Amsterdam: Contemporary Art Foundation, 1994, pp. 62–63. Reprinted as "Guillermo Kutica," in Richard Armstrong, *Carnegie International 1995*. Pittsburgh: Carnegie Museum of Art, 1995, p. 110.

1995

"Art: Contemporary Collage." *Architectural Digest* 52, no. 5 (May 1995), pp. 162–67.

"From *Guernica* to Gap Ads" (interview with David Edwards). In *Modern America: Politics, Art, Culture* (Summer 1995), pp. 65–67.

"Keith Sonnier's Electronic Meditations." In *Keith Sonnier: Computographics*. Tampa: Graphicstudio, University of South Florida, 1995, pp. 1–4.

"Mondrians I Have Known." *Artforum* 34, no. 2 (October 1995), pp. 84–88, 125.

Response to "The Best and Worst [of 1995]." *Artforum* 34, no. 4 (December 1995), p. 63.

Response to "Verdict on Hockney." *The Daily Telegraph* (London), November 4, 1995, Art and Books section, p. 1.

"True Romance." In Michael J. Rosen, ed., *Dog People*. New York: Artisan, 1995, pp. 114–15.

1996

"Adventures in Picassoland," in *Picasso: A Contemporary Dialogue*. Salzburg and Paris: Galerie Thaddaeus Ropac, 1996, pp. 18–20.

Contribution to *Philip Johnson: A Birthday Festschrifn*. Special issue of *Any* 90 (1996), pp. 16–17.

"A Dada Bouquet for New York." In Francis Nauman with Beth Venn, *Making Mischief: Dada Invades New York*. New York: Whitney Museum of Art, 1996, pp. 258–65.

"De Chirico's Long American Shadow." *Art in America* 84, no. 7 (July 1996), pp. 46–55.

"Dinos and Jake Chapman." *Artforum* 35, no. 1 (September 1996), p. 101.

"Edvard Munch: Charting the Psyche." In *Love, Isolation, Darkness: The Art of Edvard Munch*. Greenwich, Conn.: Bruce Museum, 1996, pp. 6–32.

"Impressionism, the City and Modern Life." In *Impressionists in Town*. Copenhagen: Edition Bløndal, 1996, pp. 7–22.

Introduction to *Erik Steffensen: Turner Sketches, Short Cuts*. Zurich: Irène Preiswerk, 1996.

"Picasso's Blond Muse: The Reign of Marie-Thérèse Walter." In William Rubin, ed., *Picasso and Portraiture: Representation and Transformation*. New York: Museum of Modern Art, 1996, pp. 337–83. Published in French as "La Muse blonde de Picasso: le règne de Marie-Thérèse Walter," in *Picasso et le portrait*. Paris: Réunion des Musées Nationaux, 1996, pp. 337–83. Abridged as "Rapturous Masterpieces: Picasso's Portraits of Marie-Thérèse." *MoMA: Magazine of the Museum of Modern Art*, no. 22 (Summer 1996), pp. 2–8.

"Reconstructing Tamara de Lempicka." In *Tamara de Lempicka: Exhibition of Paintings*. New York: Barry Friedman, 1996.

Response to "The Best and the Worst Exhibitions of 1996," *Artforum* 35, no. 4 (December 1996), p. 92.

"*The Singing Sculpture*, Gilbert & George, 1971." In Ann Douglas, "High Is Low." *The New York Times Magazine*, September 29, 1996, p. 176.

"The Spanishness of Picasso's Still Lifes." In Jonathan Brown, ed., *Picasso and the Spanish Tradition*. New Haven and London: Yale University Press, 1996, pp. 18–20.

"Towards a New Millennium." *The Berardo Collection*. Sintra, Portugal: Sintra Museum of Modern Art, 1996, pp. 83–94.

1997

"Apuntes sobre la pintura paisajística española." In *En torno al paisaje: De Goya a Barceló—Paisajes de la colleción Argentaria*. Barcelona and Madrid: Lunwerg Editores, 1997, pp. 16–19.

"Braque: The Late Works." *Artforum* 35, no. 10 (Summer 1997), pp. 128–29.

Dan Flavin: "Name in Lights." *Artforum* 35, no. 7 (March 1997), pp. 11–12.

"Danish Golden Age Painting: An International Perspective." *Thorvaldsens Museum Bulletin, 1997* (Copenhagen), pp. 45–58.

Exhibition preview. "The Dark Mirror: Picasso and Photography, Houston Museum of Fine Arts." *Artforum* 36, no. 1 (September 1997), p. 60.

Exhibition preview. "Arthur Dove: A Retrospective Exhibition, The Phillips Collection." *Artforum* 36, no. 2 (September 1997), p. 54.

"Gilbert and George: From Here to Eternity." In *Gilbert and George: Art for All, 1971–1996*. Tokyo: Sezon Museum of Art, 1997, pp. 16–19.

"El *Guernica* de Picasso: El conjunto y las partes." In *El museo del Prado: Fragmentos y detalles*. Madrid: Fundación Amigos del Museo del Prado, 1997, pp. 175–89.

Introduction to *Gilbert and George: The Fundamental Pictures, 1996*. London: Alexander Rossos, 1997.

"Jasper Johns: The Realm of Memory." In *Jasper Johns: Werke aus dem Besitz des Künstlers / Loans from the Artist*. Basel: Fondation Beyeler, 1997, pp. 25–32.

"McDermott and McGough: The Art of Time Travel." In *Messers MacDermott and MacGough: Paintings, Photographs, and Time Experiments*. Bruges: Stichting Kunstboek; Ostend: P.M.M.K. (Museum of Modern Art), 1997, pp. 9–12.

"Neo-Historicism." In *XLVII esposizione internazionale d'arte: La biennale di Venezia*. Milan: Electa, 1997, pp. 562–63.

"Picasso in Gósol: The Calm Before the Storm." In Marilyn McCully, ed., *Picasso: The Early Years, 1892–1906*. Washington, D.C.: National Gallery of Art, 1997, pp. 263–75.

"Reflections on the Collection." In *The Evelyn Sharp Collection of Modern Art*. New York: Sotheby's, 1997.

"Remembering Joe Brainard." In *Joe Brainard: Retrospective*. New York: Tibor de Nagy Gallery, 1997, n.p.

"Revelations: A Conversation between Robert Rosenblum and Dinos and Jake Chapman." In *Unholy*

Libel: Six Feet Under. New York: Gagosian Gallery, 1997, pp. 147–53.

"Sir James Thornhill and Raphael." *Apollo,* n.s. 145, no. 419 (January 1997), pp. 56–57.

"Top Ten." *Artforum* 36, no. 4 (December 1997), pp. 84–86.

"Unlocking Genius" (interview about Picasso with Nisha Mohammed and Chad Weinard). *Rutherford* (Charlottesville, Va.) 6, no. 1 (January 1997), pp. 16–17.

"Vilhelm Hammershøi—hjemme og ude," In *Vilhelm Hammershøi.* Copenhagen: Edition Bløndal, 1997, pp. 31–48. Published in French as "Vilhelm Hammershøi, chez lui et à l'étranger," in *L'Universe poétique de Vilhelm Hammershøi, 1864–1916.* Paris: Musée d'Orsay, 1997. Published in English as "Vilhelm Hammershøi, At Home and Abroad," in *Vilhelm Hammershøi, 1864–1916: Danish Painter of Solitude and Light.* New York: Solomon R. Guggenheim Foundation, 1998, pp. 31–47.

"Warhol's Eggs." In *Eggs by Andy Warhol.* Cologne: Jablonka Galerie; Bielefeld: Kerber Verlag, 1997, pp. 11–18.

"Warhol's Picassos." In *Andy Warhol: Heads (after Picasso).* Paris and Salzburg: Galerie Thaddaeus Ropac, 1997, pp. 11–13.

1998

"Art at the New York World's Fair: A Personal Perspective." In Claudia Swain, ed., *1939: Music and the World's Fair.* New York: Eos Music, 1998, pp. 1–9.

Catalogue entries on Picasso, Pollock, Lichtenstein,. In Libby Lumpkin, ed., *The Bellagio Gallery of Fine Art: Impressionist and Modern Masters.* Las Vegas: Bellagio Gallery of Fine Art, 1998, pp. 110–18, 138–46, 168–74, 221–26.

"Exhibition Preview: Andy Warhol Drawings, 1942–1987." *Artforum* 36, no. 9 (May 1998), p. 59.

"Exhibition Preview: Jackson Pollock." *Artforum* 37, no. 1 (September 1998), p. 39.

"Interview with James Rosenquist." In *James Rosenquist: The Swimmer in the Econo-Mist.* Berlin: Deutsche Guggenheim, 1998, pp. 7–11.

"An Interview with Sandy Skoglund." In *Sandy Skoglund: Reality Under Siege: A Retrospective.* Northampton, Mass.: Smith College Museum of Art, 1998, pp. 12–25.

"Isn't It Romantic? The Art of Mark Rothko." *Artforum* 36, no. 9 (May 1998), pp. 116–19.

"Juror's Statement." In *The Hugo Boss Prize. 1998.* New York: Solomon R. Guggenheim Foundation, 1998, pp. 29–30.

"Mike Bidlo's Magrittes." In *René Magritte and the Contemporary Art* [*sic*]. Ostend: Museum voor Moderne Kunst, 1998, p. 66.

"Pavel Tchelitchew." *Artforum* 37, no. 3 (November 1998), p. 107.

"Picasso's Disasters of War: The Art of Blasphemy." In Steven A. Nash, ed., *Picasso and the War Years.* New York: Thames and Hudson, 1998, pp. 39–53.

Review of *Dog Days,* by David Hockney. In *Bookforum* (Summer 1998), p. 37.

Review of *Norman Rockwell,* by Karal Ann Marling. In *Bookforum* (Summer 1998), p. 3.

"Sargent Major" (on John Singer Sargent). *Artforum* 37, no. 1 (September 1998), pp. 52–53.

"Top Ten." *Artforum* 37, no. 4 (December 1998), pp. 102–3.

"War and Peace: A Half-Century of Franco-American Art Memories," in *American Artists in the American Ambassador's Residence in Paris.* New York: Anthony McCall, 1998, pp. 17–21.

"Warhol's Knives." In *Andy Warhol Knives: Paintings, Polaroids, and Drawings.* Cologne: Jablonka Galerie, 1998, pp. 9–15.

1999

"Art History According to Dogs: An Interview with Robert Rosenblum, *Bark* 7 (1999), pp. 16–17.

"Bidlo's Shrines." *Art in America* 87, no. 2 (February 1999), pp. 102–4.

"Cards of Identity." In *Deborah Kass: The Warhol Project.* New Orleans: Newcomb Art Gallery, Woldenberg Art Center, Tulane University, 1999, pp. 13–17.

"Exhibition Preview: Mel Ramos." *Artforum* 37, no. 5 (January 1999), p. 55.

"Exhibition Preview: Robert Gober: Sculpture+Drawing." *Artforum* 37, no. 5 (January 1999), p. 47.

"Gilty Pleasure [on Gustave Moreau]." *Artforum* 37, no. 5 (January 1999), pp. 45–46.

"Ingres's Portraits and Their Muses." In Gary Tinterow and Philip Conisbee, eds., *Portraits by Ingres: Image of an Epoch.* New York: Metropolitan Museum of Art, 1999, pp. 3–23.

Introduction to *Art at Work: Forty Years of the Chase Manhattan Collection.* Houston: Museum of Fine Arts and the Contemporary Arts Museum, 1999, pp. 3–12.

"Warhol's Crosses." In *Andy Warhol/Crosses.* Cologne: Diözesanmuseum, 1999, pp. 7–11.

LIST OF ILLUSTRATIONS

North Carolina Museum of Art, Raleigh, Gift of Mr. and Mrs. Gordon Hanes, 1982. ©1960 Morris Louis

80. Louise Nevelson, *Ancient City,* 1945. Wood, black and red paint, 36 x 42 x 20 in. (91.4 x 106.7 x 50.8 cm). Birmingham Museum of Art, Gift of Mr. and Mrs. Ben Mildwoff through the Federation of Modern Painters and Sculptors. ©1999 Estate of Louise Nevelson / Artists Rights Society (ARS), New York

81. Louise Nevelson, *Sky Cathedral,* 1958. Assemblage; wood construction, painted black, 135½ x 120¼ x 18 in. (344.1 x 305.4 x 45.7 cm). The Museum of Modern Art, New York, Gift of Mr. and Mrs. Ben Mildwoff. Photo: ©1999 The Museum of Modern Art, New York. ©1999 Estate of Louise Nevelson / Artists Rights Society (ARS), New York

82. Installation view of James Bishop exhibition at Fischbach Gallery, November–December 1966, showing (from left to right) *Bathing and Fading, Roman Numbers, Other Colors, Folded,* and *Reading.* Photo: Eric Pollitzer, New York

83. Cy Twombly, *Untitled [Lexington, Virginia],* 1956. Oil-based house paint, lead pencil, wax crayon on canvas, 48¼ x 69 in. (122.6 x 175.3 cm). Formerly the Saatchi Collection, London. Photo: Courtesy Heiner Bastian Fine Art, Berlin

84. Cy Twombly, *Sahara,* 1960. Lead pencil, oil paint, wax crayon, colored pencil on canvas, 78¾ x 108¼ in. (200 x 245 cm). Private collection. Photo: Courtesy Thomas Ammann Fine Art, Zurich

85. Cy Twombly, *Leda and the Swan [Rome],* 1960. Lead pencil, wax crayon, oil paint on canvas, 75¼ x 79 in. (191.1 x 200.6 cm). Collection Reinhard Onnasch, Berlin. Photo: Courtesy Heiner Bastian Fine Art, Berlin

86. Cy Twombly, *Untitled [New York City],* 1968. Oil-based house paint, wax crayon on canvas, 69 x 85 in. (172.7 x 216 cm). Private collection, San Francisco. Photo: Courtesy Heiner Bastian Fine Art, Berlin

87. Cy Twombly, *Untitled [Bolsena],* 1969. Oil-based house paint, wax crayon, lead pencil on canvas, 78¾ x 94⅝ in. (200.7 x 240.5 cm). Galerie Karsten Greve, Cologne, Paris, Milano

88. Installation view of two Flag paintings by Jasper Johns in the exhibition "16 Americans" at the Museum of Modern Art, New York. Photo: Rudolph Burckhardt, New York. ©1999 Jasper Johns / Licensed by VAGA, New York, N.Y.

89. Jasper Johns, *Target with Plaster Casts,* 1955. Encaustic and collage on canvas, with objects, 51 x 44 x 3½ in. (129.5 x 111.7 x 8.9 cm). Collection David Geffen, Los Angeles. ©1999 Jasper Johns / Licensed by VAGA, New York, N.Y.

90. Jasper Johns, *Target,* 1958. Conté crayon on paper, 15½ x 15 in. (39.3 x 38.1 cm). Collection Denise and Andrew Saul. ©1999 Jasper Johns / Licensed by VAGA, New York, N.Y.

91. Jasper Johns, *Tennyson,* 1958. Encaustic and canvas collage on canvas, 73½ x 48¼ in. (186.7 x 122.6 cm). Nathan Emory Collection of the Des Moines Art Center, purchased with funds from the Coffin Fine Arts Trust, Nathan Emory Coffin Collection of the Des Moines Art Center, 1971.4. ©1999 Jasper Johns / Licensed by VAGA, New York, N.Y.

92. Jasper Johns, *Book,* 1957. Encaustic on book and wood, 10 x 13 in. (25.4 x 33 cm). Margulies Family Collection, Miami, Fla. ©1999 Jasper Johns / Licensed by VAGA, New York, N.Y.

93. Jasper Johns, *Hook,* 1958. Conté crayon, charcoal, and chalk on paper, 18⅛ x 23 in. (45.9 x 58.4 cm). Sonnabend Collection. Photo: Rudolph Burckhardt, New York. ©1999 Jasper Johns / Licensed by VAGA, New York, N.Y.

94. Jasper Johns, *Thermometer,* 1959. Oil on canvas with thermometer, 51¾ x 38½ in. (131.4 x 97.9 cm). Seattle Art Museum, fractional interest gift of Bagley and Virginia Wright and collection Bagley and Virginia Wright. ©1999 Jasper Johns / Licensed by VAGA, New York, N.Y.

95. Jasper Johns, *Three Flags,* 1958. Encaustic on canvas, 30⅞ x 45½ x 5 in. (78.4 x 115.6 x 12.7 cm). Whitney Museum of American Art, New York, 50th Anniversary Gift of the Gilman Foundation, Inc., The Lauder Foundation, A. Alfred Taubman, an anonymous donor, and purchase, 80.32. Photo: Geoffrey Clements, New York. ©1999 Jasper Johns / Licensed by VAGA, New York, N.Y.

96. Jasper Johns, *Souvenir,* 1964. Encaustic on canvas with objects, 28¾ x 21 in. (73 x 53.3 cm). Collection the artist. Photo: Rudolph Burckhardt, New York. ©1999 Jasper Johns / Licensed by VAGA, New York, N.Y.

97. Jasper Johns, *Study for Skin I,* 1962. Charcoal on drafting paper, 22 x 34 in. (55.9 x 86.4 cm). Collection the artist. Photo: Rudolph Burckhardt, New York. ©1999 Jasper Johns / Licensed by VAGA, New York, N.Y.

98. Jasper Johns, *Tantric Detail,* 1980. Charcoal on paper, 58 x 41 in. (147.3 x 104.1 cm). Collection the artist. ©1999 Jasper Johns / Licensed by VAGA, New York, N.Y.

99. Jasper Johns, *Fall,* 1986. Encaustic on canvas, 75 x 50 in. (190.5 x 127 cm). Collection the artist. ©1999 Jasper Johns / Licensed by VAGA, New York, N.Y.

100. Jasper Johns, *Untitled (Red, Yellow, Blue),* 1984. Encaustic on canvas (three panels), 55¼ x 118½ in. (140.3 x 300.9 cm). Collection the artist. Photo: Dorothy Zeidman / photography, New York. ©1999 Jasper Johns / Licensed by VAGA, New York, N.Y.

101. Jasper Johns, *Between the Clock and the Bed,* 1981. Oil on canvas (three panels), 72 x 126¼ in. (182.9 x 320.7 cm). Collection the artist. ©1999 Jasper Johns / Licensed by VAGA, New York, N.Y.

102. Jasper Johns, *Cicada,* 1979. Watercolor, crayon, and graphite pencil on paper, 43 x 28¾ in. (109.2 x 73 cm). Collection the artist. ©1999 Jasper Johns / Licensed by VAGA, New York, N.Y.

103. Jasper Johns, *Flag,* 1972 and 1994. Carborundum wash (1994) over 1972 lithograph, 17⅛ x 23½ in. (44.5 x 59.7 cm). Collection the artist. Photo: Dorothy Zeidman / photography, New York. ©1999 Jasper Johns / Licensed by VAGA, New York, N.Y.

104. Frank Stella, *Die Fahne Hoch,* 1959. Black enamel on canvas, 121½ x 73⅞ in. (308.6 x 185.4 cm). Whitney Museum of American Art, New York, Gift of Mr. and Mrs. Eugene M. Schwartz and purchase with funds from the John I. H. Baur Purchase Fund; the Charles and Anita Blatt Fund; Peter M. Brant; B. H. Friedman; the Gilman Foundation, Inc.; Susan Morse Hilles; the Lauder Foundation; Frances and Sydney Lewis; the Albert A. List Fund; Philip Morris Incorporated; Sandra Payson; Mr. and Mrs. Albrecht Saalfield; Mrs. Percy Uris; Warner Communications Inc., and the National Endowment for the Arts, 75.22. Photo: Geoffrey Clements, New York. ©1999 Frank Stella / Artists Rights Society (ARS), New York

105. Installation view of Stella exhibition, Leo Castelli Gallery, New York, 1962, showing (from left to right) *Lake City, Ophir,* and *Telluride.* Photo: Rudolph Burckhardt, courtesy Leo Castelli Gallery, New York. ©1999 Frank Stella / Artists Rights Society (ARS), New York

106. Installation view of Stella exhibition, Leo Castelli Gallery, New York, January–February 1964. Photo: Rudolph Burckhardt, courtesy Leo Castelli Gallery, New York. ©1999 Frank Stella / Artists Rights Society (ARS), New York

107. Frank Stella, *Jasper's Dilemma,* 1962–63. Alkyd on canvas, 77 x 154 in. (195.5 x 391.1 cm). Private collection. ©1999 Frank Stella / Artists Rights Society (ARS), New York

108. Frank Stella, *Nunca Pasa Nada,* 1964. Metallic powder in polymer emulsion on canvas, 110 x 220½ in. (279.4 x 560 cm). Collection Lannan Foundation, Santa Fe, New Mexico. Photo: Tom Vinetz. ©1999 Frank Stella / Artists Rights Society (ARS), New York

109. Charles Shaw, *Untitled,* 1937. Oil on wood panel, 36¼ x 22¼ in. (92.7 x 56.5 cm). Weatherspoon Art Gallery, University of North Carolina at Greensboro, Gift of Mr. and Mrs. Herbert S. Falk, 1973. Photo: John A. Ferrari, Staten Island, N.Y.

110. Louis Sullivan, the Getty tomb at Graceland Cemetery, Chicago, 1890

111. Frank Lloyd Wright, Annie Pfeiffer Chapel, Lakeland, Florida, dedicated 1941. Photo: Courtesy Florida Southern College, Lakeland, Fla.

112. Carl Andre, *Cedar Piece,* original 1959, reconstruction 1964. Cedarwood, 72 x 36¼ x 36¼ in. (173.5 x 92 x 92 cm). Oeffentliche Kunstsammlung Basel, Museum für Gegenwartskunst. ©1999 Carl Andre / Licensed by VAGA, New York, N.Y.

113. Frank Stella, *Steller's Albatross, 5.5x,* from the Exotic Birds Mines series, 1976. Mixed media, 120 x 165 x 9 in. (304.8 x 396.2 x 22.8 cm). Present location unknown. ©1999 Frank Stella / Artists Rights Society (ARS), New York

114. Frank Stella, *Darabjerd III,* from the Protractor series, 1967. Synthetic polymer on canvas, 120 x 180 in. (304.8 x 457.2 cm). Hirshhorn Museum and Sculpture Garden, Smithsonian Institution, Washington, D.C., Gift of Joseph H. Hirshhorn, 1972, 72.278. ©1999 Frank Stella / Artists Rights Society (ARS), New York

115. Roy Lichtenstein, *Little Aloha,* 1962. Oil on canvas, 44 x 42 in. (111.7 x 106.6 cm). Private collection. Photo: Courtesy Leo Castelli Gallery, New York. ©1999 Estate of Roy Lichtenstein

116. Roy Lichtenstein, *The Kiss,* 1962. Oil on canvas, 80 x 68 in. (203.2 x 172.7 cm). Private collection. Photo: Rudolph Burkhardt, Courtesy Leo Castelli Gallery, New York. ©1999 Estate of Roy Lichtenstein

117. Roy Lichtenstein, *Eddie Diptych,* 1962. Oil on canvas (two panels), 44 x 52 in. (111.8 x 132.1 cm) overall. Sonnabend Collection, New York. Photo: Eric Pollitzer. ©1999 Estate of Roy Lichtenstein

118. Roy Lichtenstein. *Step-on Can with Leg,* 1961. Oil on canvas (two panels), 31⅞ x 52 in.

©1999 Artists Rights Society (ARS), New York / DACS, London

139. Édouard Manet, *At the Café: Study of Legs,* c. 1880. Watercolor on paper, 7¼ x 4⅝ in. (18.5 x 11.9 cm). Cabinet des Dessins, Musée du Louvre, Paris. Photo: ©1999 Réunion des Musées Nationaux, Paris

140. Édouard Manet, *The Suicide,* 1877–81. Oil on canvas, 15 x 18½ in. (38.1 x 47 cm). Foundation E. G. Bührle Collection, Zurich

141. Andy Warhol, *Suicide,* 1962. Silkscreen ink on paper, 40 x 30 in. (101.5 x 76 cm). The Menil Collection, Houston, Texas, Gift of Adelaide de Menil Carpenter. ©1999 The Andy Warhol Foundation for the Visual Arts / Artists Rights Society (ARS), New York

142. Mel Ramos, *Miss Grapefruit Festival,* 1964. Oil on canvas, 40 x 34¼ in. (101.6 x 87 cm). San Francisco Museum of Modern Art, Anonymous gift. ©1999 Mel Ramos / Licensed by VAGA, New York, N.Y.

143. Mel Ramos, *David's Duo,* 1973. Oil on canvas, 70 x 96 in. (177.8 x 243.9 cm). Private collection. ©1999 Mel Ramos / Licensed by VAGA, New York, N.Y.

144. Mel Ramos, *I Still Get a Thrill When I See Bill No. 3,* 1977. Watercolor, 30½ x 22½ in. (76.2 x 57.2 cm). Private collection. ©1999 Mel Ramos / Licensed by VAGA, New York, N.Y.

145. Francis Picabia, *Portrait d'une jeune fille américaine dans l'état de nudité,* 1915. India ink on paper. Location unknown. Photo: Reproduced in Maria Lluisa Borràs, *Picabia* (Milan, 1985), fig. 274. ©1999 Artists Rights Society (ARS), New York / ADAGP, Paris

146. Mel Ramos, *A. C. Annie,* 1971. Collotype, 30¾ x 25¼ in. (80 x 64.1 cm). ©1999 Mel Ramos/Licensed by VAGA, New York, N.Y.

147. William Anthony, *Jackson Pollock and Lee Krasner,* 1987. Pencil on paper, 8⅝ x 12½ in. (20.8 x 31.7 cm). Collection Mr. M. Riklis, Beverly Hills. Photo: D. James Dee, New York

148. William Anthony, *A Clubwoman of Avignon,* 1978. Pencil and airbrush (watercolor), 5⅛ x 5 in. (13.1 x 12.7 cm). Collection A. G. Rosen

149. Sol LeWitt, *Floor Structure,* c. 1966. Painted steel, 36 x 36 x 36 in. (91.4 x 91.4 x 91.4 cm). Location unknown. Photo: Courtesy Susanna Singer, New York. ©1999 Sol LeWitt / Artists Rights Society (ARS), New York

150. Sol LeWitt, *Hanging Structure (with Stripes),* 1963. Painted wood, 55 x 55 x 30 in. (139.7 x 139.7 x 56.2 cm). Destroyed. Photo: Courtesy Susanna Singer, New York. ©1999 Sol LeWitt / Artists Rights Society (ARS), New York

151. Sol LeWitt, *Wall Structure,* 1963. Oil on canvas and painted wood, 62 x 62 x 25 in. (157.5 x 157.5 x 63.5 cm). Collection Sondra and Charles Gilman Jr. Photo: Courtesy Susanna Singer, New York. ©1999 Sol LeWitt / Artists Rights Society (ARS), New York

152. Sol LeWitt, *Wall/Floor Piece (Three Squares),* 1966. Painted steel, each square 48 x 48 in. (121.9 x 121.9 cm). Photo: Courtesy Susanna Singer, New York. ©1999 Sol LeWitt / Artists Rights Society (ARS), New York

153. Sol LeWitt, *Wall Drawing #242. Lines 40" Long, from the Midpoints of Straight Lines Toward Specified Random Points on the Wall,* 1975. Black pencil description, black crayon lines. Collection Daniel Buren. Photo: Courtesy Susanna Singer, New York. ©1999 Artists Rights Society (ARS), New York

154. Dan Flavin, *The Diagonal of May 25, 1963 (to Robert Rosenblum),* 1963. Cool white fluorescent light, 96 in. (243.8 cm) long. Private collection. Photo: Courtesy PaceWildenstein Gallery, New York. ©1999 Estate of Dan Flavin / Artists Rights Society (ARS), New York

155. Installation view of Dan Flavin's *Untitled to Tracey, to celebrate the love of a lifetime,* expanded version of *"Untitled to Ward Jackson, an old friend and colleague who, during the Fall of 1957, when I finally returned to New York from Washington and joined him to work together in this museum, kindly commmunicated,"* 1992. System of two alternating modular units in fluorescent light, 16 white bulbs each 21 in. (61 cm) long, 4 each of pink, yellow, green, and blue bulbs, each 96 in. (243.8 cm) long. Installed in the rotunda of the Solomon R. Guggenheim Museum, New York, partial gift of the artist in honor of Ward Jackson, 1972. Photo: David Heald ©The Solomon R. Guggenheim Foundation, New York (FN72.1985). ©1999 Estate of Dan Flavin / Artists Rights Society (ARS), New York

156. Alex Katz, *Thursday Night No. 2,* 1974. Oil on canvas, 72 x 144 in. (182.9 x 365.8 cm). Collection Paul Jacques Schupf. Photo: Courtesy Marlborough Gallery, New York. ©1999 Alex Katz, courtesy Marlborough Gallery

157. Alex Katz, *Good Afternoon No. 2,* 1974. Oil on canvas, 72 x 96 in. (182.9 x 243.8 cm). Collection Paul Jacques Schupf. Photo: Courtesy Marlborough Gallery, New York. ©1999 Alex Katz, courtesy Marlborough Gallery

158. Thomas Eakins, *The Pair-Oared Shell (The Oarsmen),* 1872. Oil on canvas, 24 x 36½ in. (61 x 92.7 cm). Philadelphia Museum of Art,

INDEX